MAGRITTE
Ideas and Images

MAGRITTE
Ideas and Images

Translated by Richard Miller

HARRY TORCZYNER

HARRY N. ABRAMS INC. PUBLISHERS NEW YORK

Editor: John P. O'Neill
Assitant Editor: Ellen Schwartz

Jacket illustration
Décalcomanie (Decalcomania). 1966. Oil on canvas,
31⅞ x 39⅜″ (81 x 100 cm). Collection Mme. Chaim
Perelman, Brussels, Belgium

Library of Congress Cataloging in Publication Data

Torczyner, Harry.
 Magritte, ideas and images.

 Translation of René Magritte, signes et images.
 Bibliography: p.
 Includes index.
 1. Magritte, René, 1898-1967. I. Title.
ND673.M35T6713 759.9493 77-79323
ISBN 0-8109-1300-3

Library of Congress Catalogue Card Number: 77-79323
Copyright © 1977 in France by Draeger, Editeur, Paris
Published in 1977 by Harry N. Abrams, Incorporated, New York
All rights reserved. No part of the contents of this book may be
reproduced without the written permission of the publishers

Printed and bound in France

WITH THE COLLABORATION OF BELLA BESSARD

In Memoriam Ernest Marc Torczyner, 1941–1970, my nephew

TABLE OF CONTENTS

ACKNOWLEDGMENTS

I should like to express my special gratitude to Madame Georgette Magritte, without whose friendship the several editions of this book could not have been published. The many letters, notes, and new and hitherto unpublished documents these editions contain were provided by Pierre Alechinsky, André Blavier, André Bosmans, Dominique de Menil and the Menil Foundation, Pierre Demarne, Mirabelle Dors and Maurice Rapin, Marcel Mariën, and Irène Hamoir and Louis Scutenaire. I thank them for their generosity. I was first encouraged to undertake this work by George Aldor, and Claude Draeger, the publisher of the French edition, had the courage to entrust this work to me. René Toutain, a master of the art of layout, gave me his enthusiastic support. Bella Bessard gave me the benefit of her experience and her critical sense, her constant understanding and devotion, in bringing to a successful conclusion my adventure aimed at presenting René Magritte as he truly was.

With regard to the English edition of this work, I want first of all to thank Richard Miller for his sensitive translation that, at one and the same time, preserves both the style and the idiom of the original and is faithfully accurate, and, second, Margaret Kaplan, the executive editor of my American publisher, for assembling the able and congenial team who produced this English edition. Especial thanks go to John P. O'Neill, who integrated the efforts of all those involved in this complex project; to Ellen Schwartz, who assisted him with diligence; and to Ellen Grand, who made superhuman efforts to see that the captions and the index are as accurate and complete as possible.

HARRY TORCZYNER

à Harry Torczyner
en toute sympathie
René Magritte
25 octobre

2 Illustration for *Les Chants de Maldoror* by Lautréamont, 1948

PREFACE

"May Heaven grant that the reader may without confusion find his way through these pages"—even though I have given a sequence to the past and cast light upon it according to the arbitrary detours of my recollections and memories.

René Magritte and I were destined to meet. Indeed, if a film projectionist were simultaneously to flash two series of images—one dealing with the first forty years of Magritte's life and the other with the first forty years of mine—onto adjoining parts of a screen, there would unroll before the viewer many of the same figures of both men and women playing various roles at different moments in both films. Some members of this cast of characters, deliberately or capriciously brought together by fate during the last decade of Magritte's life, would appear synchronously in both films.

Magritte and I were both born in Belgium, although in different centuries. Only a fortnight separated our birthdays, and we were both born under the sign of Scorpio. Magritte once pointed out to me that his birthday, November 21, meant he was born under the same sign as Edgar Allan Poe, whom he admired enormously.

However, he did not enjoy it when I remarked that Charles de Gaulle, whom he disliked, was also a Scorpio. In order to tease Magritte a little about his birth date, I told him that it was on a November 21, in 1811, that the German dramatist and poet Heinrich von Kleist had taken his own kind of revenge on fate and on the victor of Wagram, Napoleon, by first killing his beloved, Henriette Vogel, and then by firing a bullet into his own head.

These remarks were exchanged during my first meeting with René Magritte and his wife Georgette, which occurred on a Saturday afternoon, October 26, 1957, at their apartment on the Boulevard Lambermont, Brussels. Their black Pomeranian Loulou was present at this meeting as a certified witness. Politely but systematically, Magritte subjected me to a close cross-examination. "Did I know his work?" "Truly?" "What was an international lawyer?" To the last question I explained that an international lawyer was one who traveled a great deal. Magritte later handed me a book. With some emotion I realized I held in my hands Magritte's copy of Lautréamont's *Les Chants de Maldoror,* a volume that in my youth had completely changed my views on life. Upon turning the pages, I discovered the images that Magritte had drawn to accompany Lautréamont's text.

"Where did my travels take me?" Magritte continued. Was I, like Maldoror, in Madrid today, in St. Petersburg tomorrow, Peking yesterday? "No, no, you'll find me in Brussels today," I explained, "Abidjan tomorrow, then Moscow, Jerusalem, even Paris!" Magritte replied, "You must travel the skies for me. It would be a pleasure to discover through you distant lands and half-barbarous tribes. Since you live in the United States, you could also give me news about my dealer, my pictures, my friends, even my critics. You could send me reports, minutes, dispatches." "So you need an ambassador to the United States?" I queried. "Exactly," he said, and then Magritte burst out laughing.

After my return to Manhattan, I received my Magrittian credentials, but they had been issued from 97 rue des Mimosas instead of the apartment on the Boulevard Lambermont, because René and Georgette had moved. They were now occupying the whole of a white house. It was in this dwelling that I visited them five or six times a year.

My conversations with Rene Magritte dealt principally with what he called his "labors." As I became a familiar visitor, I grew to know exactly the hiding places of his latest gouaches, or "grist," as his close friend Louis Scutenaire called them. These canvases might be casually set on the floor with their faces to the wall, like mislaid or forgotten objects. Sometimes Magritte would spontaneously show me a completed work or a sketch, observing my reaction closely out of the corner of one eye.

Oddly, despite his outward assurance and his certainty of being on the path of truth, Magritte needed reassurance. This is the reason why those friends who had formed part of his intimate circle at the outset of his career continued to be his necessary companions, despite the occasional falling-outs and misunderstandings that led frequently to touching reconciliations, and de-

3 Illustration for *Les Chants de Maldoror* by Lautréamont, 1948

spite the dissensions that lent a perverse spice to his everyday life. I met one after the other in Magritte's home, when he still saw them, or at their own homes after they had become estranged from him, all of the members of the old-guard Surrealist group in Brussels, the true friends of Magritte. This group included Paul Nougé, biochemist, poet, and thinker; Pierre Bourgeois, the first poet to write a work inspired by one of Magritte's paintings; Camille Goemans, writer and gallery director; Marcel Lecomte, poet and essayist; André Souris, composer; E. L. T. Mesens, musician, poet, and collagist; Louis Scutenaire, Magritte's spiritual brother, and the author of epigrams, poems, and stories, whose "Inscriptions" were engraved on the painter's mind; Irène Hamoir, poet; Marcel Mariën, an iconoclast by birthright,

a *poète-agitateur,* a native of Antwerp, who became the devoted computer in whose memory are stored the accomplishments, deeds, and writings of this group of friends. Paul Colinet, the poet and intimate friend of the Magrittes, was also a member of this circle, but I never met him because he was dying throughout the autumn of 1957, at the time of my first visit to the Magrittes. With this group of friends, Magritte signed manifestos and took part in demonstrations, playing his intermittent role of *homo ludens;* in their company he could be solitary without being lonely. From one of their number, Paul Nougé, he had learned that "We are responsible for the universe" and that "Everything is still possible."

Much later new voices joined the chorus to which René Magritte often turned for comment. Among the new arrivals was the youthful André Bosmans, with whom Magritte shared his thoughts. When Bosmans wrote to Magritte that "Nothingness is the sole wonder of the world," it became even clearer to the artist that despair must be faced with the courage of hope.

Most of these Belgian thinkers and poets, known today in the United States and England, for example, remain unknowns in France. At the time of writing, Magritte has not been honored with a single retrospective exhibition in any French museum, although many of the prestigious museums of the United States, Japan, The Netherlands, Sweden, Germany, and England have mounted exhibitions of his work that have unfailingly attracted an astonished and enthusiastic public. This situation is a gloss on one of the strangest phenomena of all cultural geog-

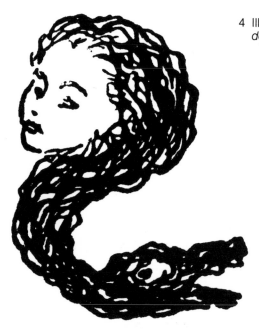

4 Illustration for *Les Chants de Maldoror* by Lautréamont, 1948

raphy. From the French side the common border with Belgium consists of quicksands and redoubtable barriers difficult if not impossible for even great artists and thinkers, such as Magritte was, to traverse or to surmount.

In 1926, the members of Magritte's circle, like the artist, began to welcome the French Surrealists. From 1927 to 1930, René and Georgette, while living at Le Perreux-sur-Marne, France, often visited André Breton and his friends at Breton's house in the Rue Fontaine, Paris.

Here they met Aragon, Ernst, Éluard, Duchamp, Man Ray, and Dali. Magritte witnessed the minor and major excommunications from the Surrealist movement and participated in all its discussions. He and his work were taken seriously, but in 1928, André Breton did not mention Magritte in his volume *Le Surréalisme et la Peinture.* Magritte's relations with Breton and his circle remained courteous, but the timid artist had no intention of allowing

himself to be intimidated, and he and Georgette returned to Brussels. Despite all the ensuing disagreements, Magritte and Breton retained a sincere admiration for one another. One day, when I mentioned Breton to him, Magritte said: "It was hard for me to be in tune with a man who didn't like music."

During World War II, André Breton, along with his entourage, went into exile in New York. He visited the Haitians and the Hopi Indians exactly in the manner that he had once visited the Belgians. During his New York years, I met him frequently. Early in 1945, Brentano's published a new text of Breton's essay *Le Surréalisme et la Peinture.* The cover of this edition bore a reproduction of Magritte's *Le modèle rouge (The Red Model),* a painting that Magritte had executed in 1937. In the sole paragraph of his text that Breton devoted to Magritte, the French Surrealist both judged correctly and wrote with a masterful hand:

Magritte's nonautomatic but on the contrary fully deliberate progress is the buttress of Surrealism. Alone among us, he has approached painting in the spirit of an "object lesson," and from that angle he has presided over the systematic trial of the visual image, emphasizing its shortcomings and indicating the dependent nature of the figures of language and of thought. A unique and totally rigorous undertaking, within the confines of the physical and the mental, bringing into play all the resources of a mind demanding enough to con-

ceive each picture as the site of the solution of a new problem.

To mark the publication of Breton's volume, my colleague Robert Tenger installed in Brentano's show window on Fifth Avenue a model of *Le modèle rouge* surrounded by copies of the book. Two large black boots ending in cleverly sculpted, flesh-colored toes were placed on the graveled floor of the window. This sight brought thousands of passersby to an abrupt halt.

The United States discovered Magritte early. In 1936, Julien Levy, a disciple of Surrealism and an art dealer, acquired Magritte's painting *La clé des songes (The Key of Dreams),* and he showed the artist's work. Shortly after its opening, the Museum of Modern Art, New York, hung on its walls in 1939 Magritte's painting *Le faux miroir (The False Mirror),* that eye with its hypnotic pupil, that black sun floating among the clouds. When the time would come for the endless hours devoted to the collective delights of shared mental sloth, millions of Americans of all ages, with eyes and ears only for their television sets, would be shaken awake and brought back to reality by this image borrowed to become the emblem of one of the largest American television networks.

In 1946, Magritte's credo, *La Ligne de Vie,* was published *in extenso* in English in an issue of the magazine *View* devoted to him. In 1947, Alexandre Iolas, a young Greek immigrant to New York, born in Egypt, exhibited paintings by Ernst and Magritte in the Galerie Hugo,

which he had opened off Madison Avenue. For more than thirty years, until his retirement, Iolas was the spendid herald of these artists in the New World. That same year William Copley, who later became an imaginative painter and a unique Maecenas, began to make Magritte known in California. Copley subsequently lived for many years in Longport-sur-Orge (Seine-et-Loire), where René and Georgette often visited him.

From London, Mesens contacted the Sidney Janis Gallery, New York, to arrange the Magritte exhibition entitled *"Les Mots et les Choses,"* which opened in 1954. The young Robert Rauschenberg and Jasper Johns studied Magritte at that show. However, only one buyer materialized—Saul Steinberg, the witty virtuoso draftsman. Magritte was not yet appreciated by the art press nor by museums, except for those in New York. Modern Belgian art has not as a general rule attracted either international attention or interest. Only James Ensor was known, but who else?

The large New York exhibition of Belgian art held during the summer of 1960, a show in which I collaborated, was organized by Baron Jan Albert Goris, then minister plenipotentiary of Belgium to the United States. (Under his pseudonym Marnix Gijsen, Goris is the most brilliant contemporary author writing in Dutch.) The three paintings most often reproduced in the magazine and newspaper reports of this exhibition were by Magritte: *Le plagiat (Plagiarism), Le château des Pyrénées (The Castle of the Pyrenees),* and *Au seuil de la liberté (On the Threshold of Liberty).*

My assigned tasks as ambassador to the United States had to be carried out at Magritte's convenience. "I'm giving you a lot of difficulties," he wrote in October 1960, "but they are those given to a magnificent and outstanding ambassador." The excessive flattery of these adjectives was a diplomatic indication of the urgency of this particular dispatch.

René Magritte's letters constitute a précis of authentic Magrittism, and they reflect his spirit of precision. One word in a preface, a single turn of phrase in a text—everything in his writings was examined, reviewed, minutely gone over. His handwriting is clear, each sign giving each letter even greater impact because of his fine calligraphy.

Magritte applied his typical rigor to everything he undertook or advised someone else to undertake. When I was having difficulties in choosing the exactly right frame for *Le château des Pyrénées,* Magritte offered to make me a "Doctor of Framing." He sent me a detailed plan for the frame, while at the same time evidencing a certain amicable tolerance: "I ask you not to take my indications as ultimate dogma. If you are calling in an experienced framer (and not a mere carpenter), he may be able to suggest another shape of frame than the one I have designed."

Magritte cared little for chronology. The order in which his paintings were hung in an exhibition was unimportant to him; only the works counted, not their dates. Often, to confuse those animated by a passion for art historical exactitude, or to confound the compilers of so-called

catalogues raisonnés, he would inscribe a fanciful date in large numerals on the back of a picture. *Le tombeau des lutteurs (The Tomb of the Wrestlers),* painted in the peaceful summer of 1960, bears the fateful date "1944." Even the dates of his letters often mock time: for example, "Almost the end of September 1958" and "Already February 2nd, 1959." A banner bears the date "July 14," but there is no indication of the year of this particular "July 14."

The first museum exhibitions devoted solely to René Magritte's painting finally took place. They marked an end to those invitations extended to two artists at the same time because of the parsimony and narrowmindedness of curators. The Museum of Modern Art exhibition in New York in 1961, in the honorable company of Yves Tanguy, was the last show in tandem in which Magritte participated. In accord with Magritte, Douglas McAgy put together an important group of paintings, gouaches, drawings, and documents for the exhibition "René Magritte in America," which took place in 1961 at the Dallas Museum of Fine Arts, Dallas, Texas, and then moved to the Houston Museum of Fine Arts, Houston, Texas. That same year, however, the Tate Gallery in London barred its doors to the Belgian painter of mystery, despite the intervention of Mesens, Sir Roland Penrose, and other enlightened and educated spirits. Magritte's images did not illuminate this museum until after his death, when David Sylvester organized a retrospective.

As a result of continuous efforts and initiatives, a series of *vernissages* took place in the United States: "René Magritte in New York Private Collections," at the Albert

Landry Galleries, in 1961; "The Vision of René Magritte," at the Walker Art Center, Minneapolis, Minnesota, in 1962; "Magritte" in 1964 at the Arkansas Arts Center, Little Rock, Arkansas; and "René Magritte," at the Museum of Modern Art, New York, in 1965, an exhibition that later toured among several important American museums. Plans and projects for these exhibitions were submitted to Magritte for his approval. The artist often sent me directives, he expressed his wishes, and we collaborated on the texts and drew up meticulous memoranda for me to discuss with the authors of catalogue introductions—who often dared both to engage in explanations of his work and to indulge in comparisons that Magritte felt to be insufferable.

The triumphant and moving reception given Magritte during the opening of the Museum of Modern Art exhibition in December 1965 in New York remains unforgettable. *Le jour de gloire* had come at last. That was the day Magritte chose to pay a visit to a lifelong friend. On that rainy Sunday afternoon, I accompanied Georgette and René to Edgar Allan Poe's residence in the Bronx. What had his invisible friend said to him in that tiny bedroom? Magritte was in tears.

At the beginning of our relationship, Magritte had insisted that I create new verbal expressions, and sensitive to his taste for precise terminology, I began calling his pictures "Magrittian children," began to use the adjective "Magrittian" to describe images and ideas characteristic of him, and began to speak of "Magrittism," all with his approval.

Often, plays on words—by which I mean the spiritual exchange of serious thoughts—brought forward a problem whose solution called for Magritte's presence of mind. Thus Max Jacob's line "Seen against the light or otherwise, I do not exist, and yet I am a tree," and my lines, "Let the day sleep/Let the night wake/The living green Tree/Watches over the life/The survival of man,"

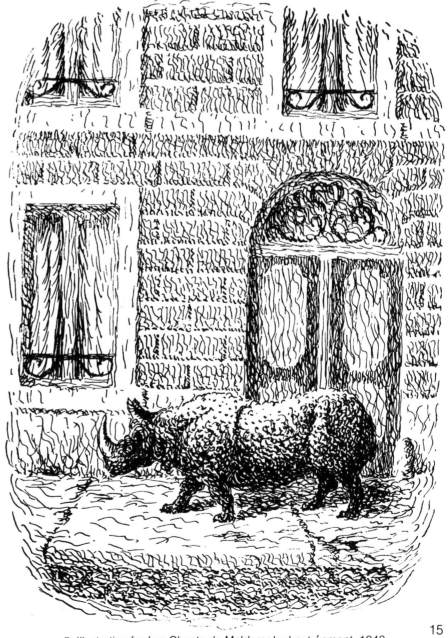

5 Illustration for *Les Chants de Maldoror* by Lautréamont, 1948

15

posed this kind of question to him. Magritte's inspired solution was that tree enhaloed with sparse leaves, that glorious image with its greens and blues that was given the only title worthy of it: *L'arc de triomphe (The Arch of Triumph)*.

On the other hand, other kinds of word games might lead not to an image but to a title that Magritte would decide to give to a work. He told me of the origin of the name of the rue du Pain Perdu, Brussels. The name, he said, was derived from a mispronunciation of the words *peine perdue (wasted effort)*. Every winter, it seems, a small bridge that crossed a stream in the old section of Brussels would be washed away, and year after year it had to be rebuilt. *Peine perdue* indeed! I suggested to Magritte that he give the title *La peine perdue* to the painting that shows two blue curtains, two others made up of clouds, all against a background of blue sky, at the foot of which has been placed a Magrittian bell. Magritte saw the legitimacy of this title. It was on this occasion that I asked him why he had painted the bell where it was. "It was," he told me, "merely to bring all the elements of the picture together at one point."

When Magritte painted my portrait, he executed it from a photograph, just as if he did not know me. In so doing he was following the example set by Albrecht Dürer, who made a drawing of a rhinoceros on May 20, 1515, from a friend's sketch, which had been made in Lisbon where a rhinoceros had been sent to King Manuel by an Indian grandee. Would the portrait be better if I had posed for it? One day at Le Perreux-sur-Marne, Magritte painted in one sitting the portrait of a friend of Éluard, a Madame Pomme or Apfel. When it was finished, the pretty little face resembled the sitter's face, but the head was completely bald. Do Ionesco's *Rhinoceros* and *The Bald Soprano* speak Magritte's language?

Magritte disliked turning toward his past, but his loyalty was constant. He gratefully preserved the memory of those who had believed in him when he was the object of derision and contempt from a hostile world and those who had remained devoted to him throughout his over-long, difficult years.

Magritte introduced me to three stalwart friends who had been among the first to recognize his works—P. G. Van Hecke, M. Schwarzenberg, and Geert Van Bruaene. In 1959, when the most prestigious art dealers in the world were making proposals to him that would have quadrupled his earnings, Magritte firmly refused them and remained faithful to Alexandre Iolas, with whom, he always said, he had a contract. In fact Magritte had no contract with Iolas, but Magritte did have respect for his given word, and he never forgot that Iolas had encouraged him and continued to represent him despite the failure of the 1947 show at which not one single canvas had been sold. Magritte explained his point of view in his "pomp and circumstance" style in a letter to me, dated November 19, 1959: "Since the end of the war, Iolas has been faithfully buying from me all or almost all of my 'output.' This faithfulness (which at the outset was some-times translated with difficulty into monetary form) is a kind of dogma.... A perfect dogma, with the minor imper-

fections inherent to anthropology, nevertheless, and which would be just as imperfect were that dogma adhered to by some other Iolas."

Magritte talked to me about his paintings, but he did not indulge me with talk about his family. I never met his two brothers. One day when Magritte was giving me several musical compositions of his younger brother Paul to show to New York publishers, he mentioned in passing a brother named Raymond who was comfortably off and whom he never saw.

Nonetheless, Magritte took an interest in genealogy. Were the Magrittes of the same family as General Jean-Antoine Margueritte, the unhappy hero of the charge at Reichshoffen, of which the king of Prussia, the future Emperor William I, had remarked that it had been "as beautiful as it had been useless"? Magritte could have been related to this general's sons, Paul and Victor Margueritte, preferably Victor (the author of the scandalous novel *La Garçonne* [the literary forerunner of today's liberated woman], who was stricken from the lists of the Legion of Honor for having "insulted French woman-hood"), as his genealogy was elective. According to Georgette, three Margueritte brothers came from France to Pont-à-Celles, in the Belgian province of Hainaut, during the French Revolution. Léopold Magritte, René's father, was supposed to have been the direct descendant of one of these brothers, Jean-Louis Magritte, known as de Roquette, the local pronunciation having altered the orthography of his name.

Magritte, however, told me many times that he had neither a predecessor nor a successor in painting. The question of influences seemed to him a superfluous one.

6 Illustration for *Les Chants de Maldoror* by Lautréamont, 1948

His moving discovery of Chirico's *Le chant d'amour,* which has so often been alluded to, was a revelation to him, but not the beginning of an influence, no more so than was the discovery of certain elements or aspects of Max Ernst's work.

On the question of the quantity and the numerous variations on his images, I once asked him if he was trying to make the Magrittian children as numerous as the stars in the sky. "Yes, that is my wish," he replied. He encouraged the reproduction of his paintings in every medium, mechanical or otherwise, as posters or as postcards. Magritte disliked the orthodox, conformist notion of the unique *exemplum*. However, while preaching the multiplication and dispersion of his images, he hated plagiarism and its ramifications. His curtain, his stone balustrade, were sincerely considered by him as trademarks that were intended to discourage or unmask counterfeiters. Unlike most artists, Magritte had no de-

7 Illustration for *Les Chants de Maldoror* by Lautréamont, 1948

sire to retain a finished painting for study or for his personal collection. As soon as they were born, the Magrittian children were sent out into the world to make their way; however, he did not lose interest in them and he remained curious as to who took them in and how they were appreciated. For example, in regard to *L'art de la conversation (The Art of Conversation),* he was eager to know how I thought it was getting on in the New Orleans museum that had given it a home. Some of Magritte's other canvases met with a cruel fate. *Le messager (The Messenger),* now known as *Le voyageur (The Voyager),* was damaged by fragments from a V-bomb explosion in 1945 and later returned to the artist. A long time afterward, some friends saw it in his home in its sad state, and upon their urging Magritte gave it to them with permission to have it restored. In this way this astounding image was saved.

Magritte's relations with those who liked or were purported to like his painting were ambivalent. An amateur who had been interested in Magritte's work at the time when he was still comparatively unknown continued to enjoy the artist's affection because of his obvious sincerity. But after Magritte became famous, he spoke to me—not without some bitterness — about the latecomers, the *"visiteurs du soir,"* who brought him nothing and who wanted to take away everything, at any price. Just as an Englishman thinks a man should not be hanged if he is a duke, so did Magritte feel that one should not despise a man for being rich. But he also felt that there was nothing admirable about this quality. One day in New York, when a millionaire collector of Magritte's work took the artist by his arm in a familiar manner, Magritte whispered to me,

"He leads me around like a racehorse wearing his colors."

Magritte fortunately had friends in the world of Belgian officialdom who formed at the same time part of his spiritual family. Émile Langui of the Ministry of Fine Arts and Robert Giron of the Brussels Palais des Beaux-Arts both served his cause. They saw to it that frescoes were commissioned from Magritte and that a large sum of money was granted to him as a "prize to crown his career"—but only after the entire world had come to know Magritte's name. Nevertheless, when the Belgian government seriously began to consider making Magritte a baron, the artist found it both ridiculous and not enough. "Tell them," he said to me, "that Maeterlinck was at least a count!"

In refusing to singularize himself, Magritte showed the world that he was not like everyone else and that he intended to protect himself from everyone else. Out of politeness, he did not interfere with the literati when they described him as they imagined him to be: as the hero of a detective story or a spy novel. To please these writers he allowed them to believe that he was a character in search of an author. Herein was born the legend that threatens to be handed down from book to book. No one was more intelligently direct than Magritte; he had no artifice. He was not a secret agent. He made known his likes and dislikes, his opinions and his prejudices. He openly confronted everyone who attempted to impose the conventional lies upon mankind, under the pretext of whatever religion or ideology.

Magritte was curious, voyeuristic, and analytical. He was often negative, like the Geist der Verneint in Goethe's

Faust, like that Spirit of Denial who stalks the dunes, the moors, the mists in Caspar David Friedrich's landscapes, with which the artist was familiar.

Georgette was Magritte's lifelong companion. In the house that she had decorated on the rue des Mimosas, Magritte was surrounded by the *Magies noires* for which she had posed and by her portraits. For him, Georgette represented "The Likeness." For her, he had a tenderness and a concern that were evident to any visitor. He was displeased with the film Luc de Heusch had made about him because Georgette was not in it. In Nice one day in June 1964, as I was strolling with Magritte, he stopped before a shop window in which he had espied a porcelain rooster. "I must buy that for Georgette," he said to me. "She'll love it." "Are you still courting her, René?" "It's true," he replied, smiling.

I saw Magritte for the last time on the afternoon of August 8, 1967, in his room in the Clinique Edith Cavell in Brussels. Georgette, René, and I chatted as though nothing were wrong. Georgette related how Stéphane Cordier of the review *L'Arc* had just called to request authorization to publish Magritte's drawings for *Maldoror* in an issue of the review to be devoted to Lautréamont, and she added that René had agreed. His room gave onto the garden. That pleased him. Magritte was walking around in his dressing gown and eating some dried beef he had had smuggled in. He was completely yellow. He wasn't in great pain and he told me he was suffering from jaundice. Georgette and I looked at each other. I kissed Georgette and I kissed René and I left for New York. What could I think? What could I believe? On August 12, I telephoned

the clinic and was informed that Magritte had left the hospital and gone home. I was overjoyed. I called the house on the rue des Mimosas. Georgette came to the telephone, sobbing: "It's bad, very bad," she told me.

On August 15, at 3:55 PM, I received the following telegram:

FIA 112 (27) CDV296
04918 B229221 7 PD INTL FR CD
BRUXELLES VIA WUI 15 1815
TORCZYNER
(DELR) 521 FIFTHAVE NYK
RENE DECEDE
GEORGETTE.

Magritte's Ideas and Images give evidence of a life worth living. More than fifty years ago, Magritte gave the starting signal to his Lost Jockey, that rider whose mysterious race will persist as long as men exist who know that everything is always possible. What he thought, what he believed, what he created, needs neither interpreters nor exegetes. "Women, children, men who never think about art history," Magritte said, "have personal preferences just as much as aesthetes do."

It is in this spirit that I have conceived and structured this book.

HARRY TORCZYNER

New York, New York
May 8, 1977

THE LIVING MIRROR

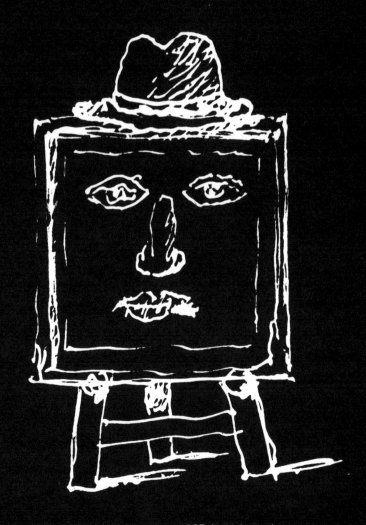

THE MENTAL UNIVERSE

His gray eyes interrogated you with a curiosity mingled with a real and strange tenderness, for he knew you were the prisoner of his look, that you deserved his compassion, and yet he kept you in this uneasy state. He spoke French slowly, in an even voice, with a strong Walloon accent he made no attempt to conceal. He expressed himself in short, clear, concise sentences.

Magritte attached no importance whatsoever to his art, but the greatest importance to the problems that art posed for him. These problems obsessed him until he had solved them. He was meticulous in all things: each day had its schedule. Whatever the weather, he was on time for appointments. He liked neatness and cleanliness. He liked to receive letters, but didn't want to be burdened with them. He was a shy man, a solitary man who avoided unexpected meetings. One did not enter either his mind or his home without knocking. No physical contact. Although he liked those with whom he was on familiar terms, he detested familiarities. He expected everything from everyday life, but nothing from life itself.

Under the rain-drenched Belgian sky, the apartments and houses in which Magritte lived were all the same to him and all alike. When in 1963 he decided to build, he tried to oversee the most unimportant details and suffered the presence of an architect as had Ludwig Wittgenstein. In a short time, however, these concerns began to appear ridiculous to him and he lost interest in the project, as well as in the architect, and went back to indifference.

For Magritte, Woman was a far different thing from the synthetic, artificial, mythological creature that was the fashion with the Surrealists. She was neither destructive goddess nor guardian muse. In his work, no Pygmalion appears to bring the marble statue to life. He knew love and loved love, about which he spoke openly and without equivocation. He wished his friends a good night of love as naturally as he wished them "*bon appetit.*"

Magritte abhorred violence. He hated soldiers and detested those organized massacres, wars. Yet, under the Nazis he worked for the Resistance.

He was a hypochondriac. After he had reached sixty, however, his imaginary illnesses were succeeded by real ones: violent headaches, neuralgias, liver attacks. He injured his right wrist, which depressed him deeply, for he was afraid he had lost that absolute manual mastery that had enabled him to paint without a single smudge. He fought against and tried to master fate up until the day he succumbed to his final illness.

9 *Le miroir vivant (The Living Mirror).* 1926. Oil on canvas, 21¼ x 28¾" (54 x 73 cm). Collection Mme. Sabine Sonabend-Binder, Brussels, Belgium

10 Photograph of René Magritte (holding his mother's hand) with his parents and two younger brothers, Raymond and Paul

Man

I think that if it is impossible to explain oneself to certain people, it's because a feeling we have come to know after years of effort cannot be communicated in a few hours, just like that. "Efficient" explanations would have to be used to obtain a result.

Conversations in which one gives up trying to discuss things with clarity always leave a disagreeable memory behind; one is ashamed.
——*Letter from René Magritte to Paul Nougé, February 1928*

I have few illusions; the cause is lost in advance. As for me, I do my part, which is to drag a fairly drab existence to its conclusion.
——*Letter from René Magritte to Louis Scutenaire, June 25, 1943*

I despise my own past and that of others. I despise resignation, patience, professional heroism, and all the obligatory sentiments. I also despise the decorative arts, folklore, advertising, radio announcers' voices, aerodynamics, the Boy Scouts, the smell of naphtha, the news, and drunks.

I like subversive humor, freckles, women's knees and long hair, the laughter of playing children, and a girl running down the street.

I hope for vibrant love, the impossible, the chimerical.

I dread knowing precisely my own limitations.
——*René Magritte, Le Savoir Vivre, Brussels, 1946*

Painting *bores* me like everything else. Unfortunately, painting is one of the activities—it is bound up in the series of activities—that seems to change almost nothing in life, the same habits are always recurring. . . .
——*René Magritte, statement reported by A. Gomez, May-June 1948*

I hope I will never stoop to pulling strings to achieve success, which I can get along without.
——*Letter from René Magritte to André Souris, March 1953*

I dislike money, both for itself and for what it can buy, since I want nothing we know about.
——*René Magritte, statement reported by Maurice Rapin, "René Magritte," Aporismes, 1970, p. 23*

"According to my doctrine," it is forbidden (under pain of imbecility) to foresee anything. What I will do *in all* situations is as unpredictable as the emergence of a real poetic image. . . .
——*Letter from René Magritte to Mirabelle Dors and Maurice Rapin, December 30, 1955*

I will tell you . . . that I have some patience with the rich from whom I derive my livelihood; on occasion I may give the impression that I am their "valet": for example, I obey their idiotic caprice that I paint their portraits. I've never claimed to be a "luxury item" in the arts though, and in fact I often make gaffes *au-to-mat-i-cal-ly*. (At my Brussels retrospective in '54: the Minister of Education came to visit the exhibition and I accompanied him through the rooms "like a servant," as Breton would say. However, when looking at *Le civilisateur,* whose title surprised him, I served him with: "Indeed, we have a lot to learn from dogs," etc.)
——*Letter from René Magritte to Mirabelle Dors and Maurice Rapin, March 7, 1956*

I can write texts that are interesting to people who don't play a conventional game. If one wants to reach other people, one must appear to play on their terms, while at the same time avoiding in any way being for an instant conventional. In short, I take pains never to be conventional when I am painting, and insofar as possible when I am not painting, I appear to play a conventional game: to paint, for example, or to live in a house, to eat at regular mealtimes, etc. . . . Maybe because some conventions are not stupid, but then those are not the annoying ones. Still, it's a fact that despite the conventional appearance of my paintings, they look like paintings without, I believe, fulfilling the requirements defined by the treatises on aesthetics.
——*Letter from René Magritte to Mirabelle Dors and Maurice Rapin, March 15, 1956*

I am *very* sensitive in some instances, I take it as a personal insult when stupidity is calmly displayed right under my eyes. On the other hand, I am delighted and my vanity is not injured when someone corrects a mistake I have made. It's not easy to correct mistakes and to say something good about something bad. It requires only a moment's discomfort.
——*Letter from René Magritte to Mirabelle Dors and Maurice Rapin, March 30, 1956*

I too have some horrible memories, but I'll never understand "repentance," I only feel remorse.
——*Letter from René Magritte to Mirabelle Dors and Maurice Rapin, November 1956*

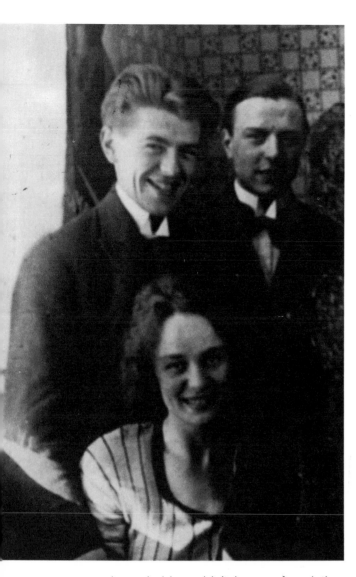

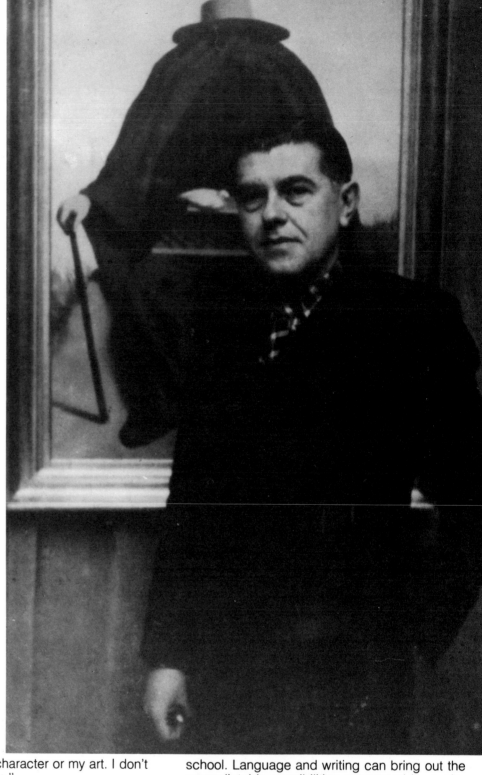

. . . my household wouldn't have refused the Guggenheim dollars.* Still, I am not disappointed, having expected nothing. I didn't apply for it; it was the Brussels museum that put me "in the running," without even telling me (it was only after the decision had been made that they remembered me and told me that I was "being considered"). Here's something amusing in this story to think about: the treacherous English cubistic-decorator doubtless felt highly honored by having won the prize? Well, if there's any honor, I consider it healthy to think that if I had been given the prize, the jury and the Guggenheim prize would have been honored, not I! A "prize" that really meant something would be one that honored itself by its being awarded to someone "worthy." If Curie is "worthy" (I know nothing about that), it's the Nobel Prize and not Curie that is honored, etc. But that makes prizes morally invalid, since the "worthy" couldn't care less.
——*Letter from René Magritte to Maurice Rapin, December 13, 1956*

*Magritte is alluding to the Guggenheim prize awarded the British abstract painter Ben Nicholson.

RESPONSE (draft)

1) My father was in the real estate business, buying and selling factories, etc. I was married when I was about 20 years of age, and I had to "earn my living," my father's support having been withdrawn (as the result of bad business deals). I don't think I know the circumstances that may have determined my character or my art. I don't believe in "determinism."

2) Married circa 1920.

3) No children.

4) Married or not, it's easy either to frequent or avoid cafés.

5) Experimentation ended in 1926, and gave way to a concept of the art of painting to which I have remained faithful. The term "composition" supposes a possible "decomposition," for example, in the form of analysis. To the extent that my pictures have any value, they do not lend themselves to analysis.

6) The critic or the historian can do better than to put a facile label on a school or so-called school. Language and writing can bring out the unpredictable possibilities suggested by a picture. I hope so. I don't want to give a name to the images I paint.

7) My wife and I have preferred to observe Paris from a distance. This has not affected my relations with the Surrealists.

8) There is no explicable mystery in my painting. The word *Vague* (Wave) inscribed on the picture manifests inexplicable mystery.

9) The objects accompanying my wife's face are no more symbols than the face is. "Why?" is not a "serious" question; it is too easy, for example, to reply: "Familiar objects have been assembled together in the portrait to obtain a sensational result."

10) "Total portraits" are to me not worth looking at. All the information they give is meaningless.

11) Political ideas or current ideas about art cannot help me paint a picture, nor imagine one. Thus I am not *engagé,* as one generally hears. The only thing that engages me is the mystery of the world, definitively, I believe.

12) I am not trying to "provoke" anything or anyone when I paint: I have barely enough attention for the painting itself.

13) I do not feel I am "adding" something to the world: where would I get what I am adding if not from the world?

14) I have never thought such a thing. Progress is a preposterous notion.

15) André Gide's "morality" may have contributed to an increase in the criminal court clientele. But I doubt it: that clientele is not at all literary.

16) The absurd is the belief that a particular logic (called reason) can dominate the logic of mystery. A picture seems valid to me if it is not absurd and if it is capable, like the world, of dominating our ideas and our feelings, good or bad.

17) There is no choice: no art without life.

18) The basic thing, whether in art or in life, is "presence of mind." "Presence of mind" is unpredictable. Our so-called will does not control it. We are controlled by "presence of mind," which reveals reality as an absolute mystery.

19) Without art, of course, there would be no pictures to look at. But although painters are sometimes stimulated by the strangest of motives, I recognize only one motive for the act of painting: the desire to paint an image one would like to look at.

20) Whether art is made for this or that reason makes very little difference: what counts is what it will be.

21) The language of symbols makes me miss the precision one loses in employing it. For example, a key, diamonds, insofar as they are symbols, signify confusion.

22) Great artists are against the "common meanings," but is it urgent to draw a conclusion from that (urgent for our happiness)?

23) This question seems to me to involve the isolation of the human being, whether or not he is an artist, whether or not he is "aware" of it. It is basic enough to cease being a "question" and to stand revealed as an affirmation of the mystery in which we live.

24) Like some madmen, artists have achieved similar *tours de force.* We exist within mystery, whether we know it or not.

25) The "subject," which in my opinion is the essential thing, cannot without losing this importance yield to or share its "place" with completely secondary pictorial material.

26) An object does not become more remarkable because it is represented in a picture. The error of certain painters resides in thinking the opposite.

27) In the case of great painters, "pictorial material" plays a large role on the *secondary* level. Indeed, it must be perfect and *stay in its place.*

28) In fact, looking at my pictures sometimes gives me a strange feeling. This fact is not an end I pursue, since any "end" I might imagine seems ridiculous to me.

——*Rough draft of a response to a questionnaire sent to René Magritte by M. Pierredon, pen name of Louis Thomas, journalist of La Lanterne. Included in a letter to Maurice Rapin, June 20, 1957*

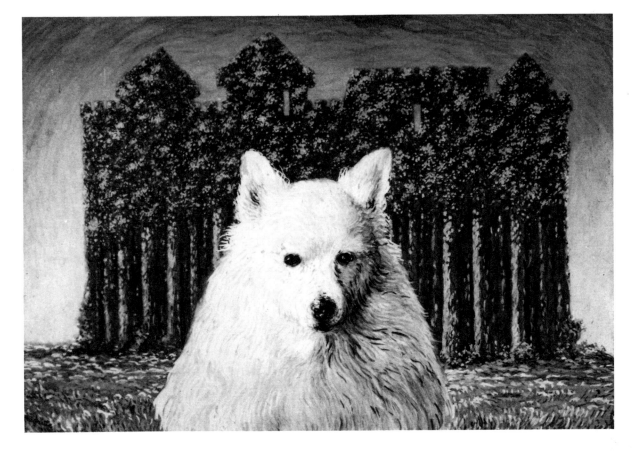

13 *Chien: le civilisateur (Dog: The Civilizer).* 1946. Gouache, 15¾ x 23⅝" (40 x 60 cm). Private collection, Brussels, Belgium. The dog in the painting is one of the many "Loulous" belonging to the Magrittes over the years

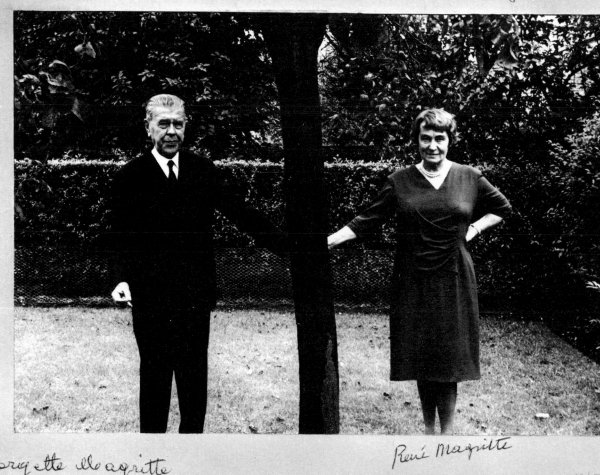

14 Photograph of René and Georgette Magritte in front of their home at 97 rue des Mimosas, Brussels, Belgium, in 1966

15 *L'espion (The Spy)*. 1927. Oil on canvas, 21¼ x 28¾" (54 x 73 cm). Private collection, Brussels, Belgium

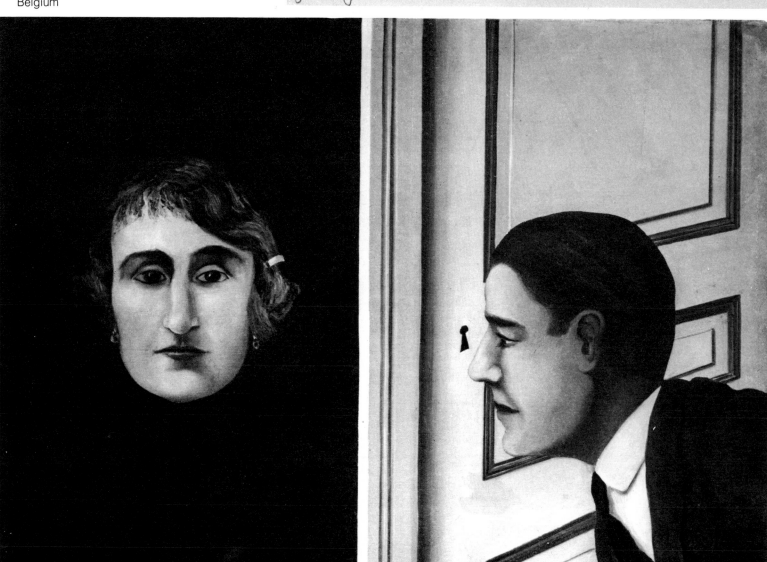

I find that the "pleasure" comes after the painting, the latter being a fairly fatiguing labor. True, there is also a pleasurable fatigue, boredom. . . . You can see the state I'm in with regard to *all* painting. . . . Yet I still have one thing: I cannot set limits on thought, everything is always possible, evil as well as good, alas! If suicide were "good," there would be no hesitation about it, but suicide is tantamount to a stupid pretension: believing that we know the limits of thought.

——*Letter from René Magritte to Maurice Rapin, October 20, 1957*

Even notwithstanding my current mental state (I am overwhelmed with questions of plumbing, electricity, carpeting, etc.), I would have no confidence in any "activity" whatsoever. In this regard, I am a total defeatist, to the point where I have neither the strength nor the desire to defend this defeatism. I paint without either pessimism or optimism, and most of the time I am concerned with the possibilities I may discover. . . . My defeatism means nothing, it's just a fact.

——*Letter from René Magritte to Maurice Rapin, December 2, 1957*

16 Untitled drawing. 1954. Black crayon on paper, 8½ x 10⅞" (21.5 x 27.5 cm). Caricatures (left to right): Louis Scutenaire, René Magritte, Paul Colinet. Collection M. and Mme. Louis Scutenaire, Brussels, Belgium. *See* Appendix *for translation*

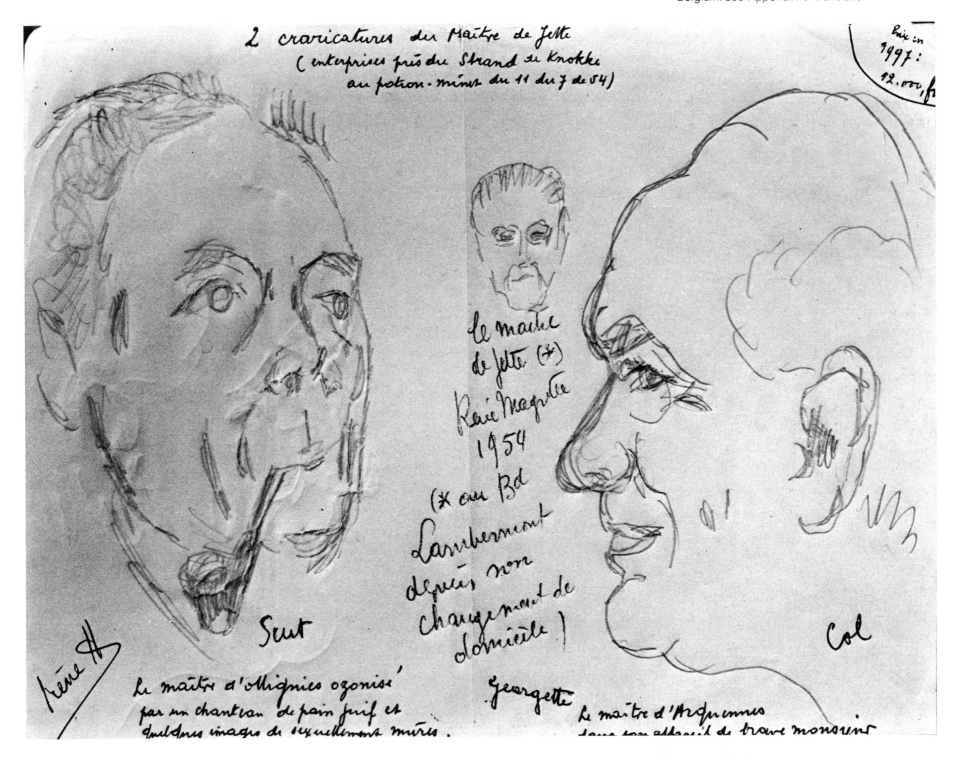

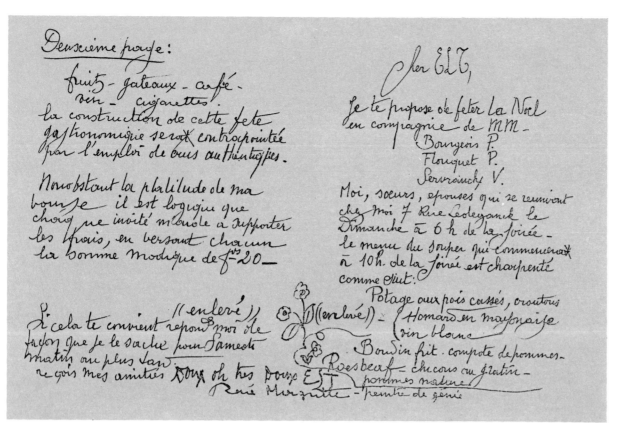

18 Untitled drawing of Suzi Gablik. n.d. Pencil on paper. Collection Suzi Gablik, London, England

17 Letter from René Magritte to E.L.T. Mesens, not dated. *See* Appendix *for translation*

It happens that I still sometimes "go along," that I believe one can argue with people—whether they be sincere or insincere—whose ideas are singularly lacking in charm. It is true that I give up fairly quickly without being annoyed at giving the impression that I am on the whole unable to defend my "point of view."
——*Letter from René Magritte to Maurice Rapin, December 17, 1957*

I visited the fair* a bit, I had to attend some openings. I took advantage of the occasion to take a look at the U.S. pavilion, which is funnier than the U.S.S.R.'s (the latter being as unpalatable as possible). I was thus able to try a "hamburger," the Perry Mason books having made me curious as to what it was.
——*Letter from René Magritte to Harry Torczyner, April 23, 1958*

*1958 Brussels World's Fair

Sometimes I am as curious as a monkey.
——*Letter from René Magritte to Harry Torczyner, June 28, 1958*

"Great quantities"* rapidly use up my energy and my goodwill, whereas "great qualities" give me enthusiasm and the concomitant mental vigor.
——*Letter from René Magritte to Harry Torczyner, November 3, 1959*

*Magritte is referring to commissions for paintings.

As for "news," I've just been given a 150,000 franc prize by the state, which thereby intends to "crown" my career. Nonetheless, I continue to consider myself as being still valid enough to continue that career—neither less well nor less badly than in the past.
——*Letter from René Magritte to Harry Torczyner, January 11, 1960*

You must have seen the ridiculous figure I cut last night on television and how I talked more or less nonsense. It seems I'm not "photogenic." Is that good or bad? I suppose this has little importance, but it's not pleasant to see and hear oneself on television.
——*Letter from René Magritte to André Bosmans, December 8, 1961*

For a treat, I would greatly appreciate two or three cans of pork and beans—with or without potatoes.
——*Letter from René Magritte to Harry Torczyner, March 27, 1963*

I'm delighted with what you tell me about the composition of the "delegation" that's coming from America to open a hotel in Brussels,* since it has given me the pleasure of having "got out of it"; this morning I declined the honor of "speaking on elegance," since the organizer of the festivities had invited me, along with other "personalities": a sports figure, a journalist, etc. . . . Indeed, you would be hard put to see me "speaking on elegance" to ambassadors, consuls, and snobs. What is more, I hate the "thing" they are going to inaugurate; it is part of that which is replacing what is good . . . with what is bad: the "functional" (financially profitable) buildings that are uglifying the world. It should be noted that the "elegant" people are going to take part innocently in the inauguration of something totally lacking in elegance (if indeed elegance cannot coexist with ugliness, "practical" as it may be).
——*Letter from René Magritte to Harry Torczyner, April 24, 1963*

*Inauguration of the Hotel Westbury in Brussels (closed in 1977).

I have been functioning very little as the painter by appointment of "Magrittism," having been absorbed in overseeing construction. (I had to, since the paintings I had in the house would have been handled by the various workmen with the same care they give to moving cement blocks, for example. People believe that because there are stones represented in my pictures, they are like stones when it comes to handling them.)
——*Letter from René Magritte to Harry Torczyner, September 1964*

Yes, I am very meticulous. In life as in my painting. I am also a traditionalist, even a reactionary: I detest modern furniture, machines, and science with a capital "S."
——*René Magritte, statement reported by Claude Vial, Femmes d'Aujourd'hui, no. 1105, 1965*

Received . . . a young Englishman—armed with an interpreter from the Berlitz School and with the hairdo of a young girl, trousers covered with splashes of color—who wanted to acquaint himself with my ideas. I think I disappointed him with my statements denying any desire on my part to behave other than as a normal man.
——*Letter from René Magritte to Harry Torczyner, July 23, 1966*

I'd rather refuse to sell, live in poverty, than be a businessman. I'm not responsible enough for that. I'm too detached, and I would rather be worried by material questions than have to deal with them.
——*A statement reported by Goris, 1966*

I am unaware of the real reason why I paint, just as I am unaware of the reason for living and dying.
——*From an interview by Christian Bussy, August 1966*

The Difficult Crossing

Obviously, life cannot be improved by the "profession" of arms. Is the time you have to spend in barracks time lost? This way of thinking, however, may be too obvious: although military service is unable to enchant us, it is all the same able to give a meaning to the world that might be true, and that we must therefore recognize, however it may revolt us. As for lost time, I don't believe we can either "win" or "lose" time if we are aware of living in a mysterious world, and if we are sure that, whatever we may think or do, whatever happens, even death (understood as absolute nonbeing), that *all the mystery is still there.* I am assured of this by virtue of reason, and sometimes by a feeling in which reasonable certainty counts for very little.
——*René Magritte to André Bosmans, undated, 1958*

…"I went through it," without being overdramatic about the display of impenetrable stupidity that prevails in our military establishments. On the contrary, I regarded the whole thing from the angle of "a pain in the ass" one had to get rid of as well as possible. There are various ways, a little of your intelligence would suffice to find effective ones. Since I was already an *artiste-peintre* then, I painted a portrait of my commanding officer that was worthy of hanging in God's own collection. And for some time that earned me what amounted to a permanent pass. I also "passed" as an employee of the War Ministry, "off post," that is, sleeping and eating at home and forced only to show up for a few hours a day at an office. I pulled every string I could until they nearly made a rope. I even managed to get around the few office hours by pretending I had doctor's appointments. Of course, it was still a pain in the ass, though it was mitigated by the pleasure of putting one over on the "brass."
——*Letter from René Magritte to André Bosmans, November 11, 1958*

My situation is not very easy at the moment. Since coming back here, I've been looking for a job, but have found nothing. I plan to return to Brussels for good if the attempts I've made don't come to something by the end of the month. I have to, since I can't count on anyone here to help me.

In the meantime, though, do you think I'd have any luck presenting myself as a commercial artist employed if possible in a department store such as Bon Marché or Innovation? I think you know some people who could give you some information about this? You would be doing me a huge favor, you know, if you could think about it.
——*Letter from René Magritte (Paris) to Paul Nougé, May 1930*

I did the poster with hands on a black background; the lettering was white. The effect was remarkable, in the same way as a successful

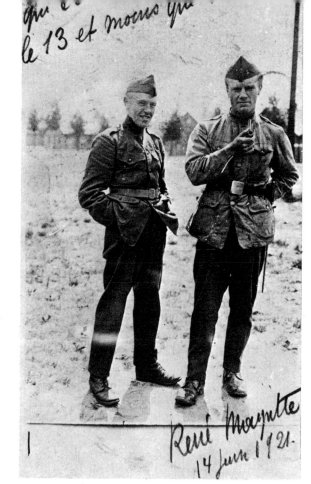

21 Photograph of René Magritte and Pierre Bourgeois at Camp Beverloo, June 14, 1921

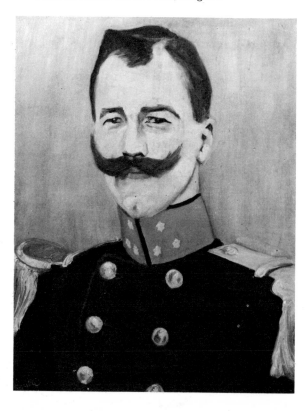

22 *L'officier (The Officer).* 1921. Oil on canvas, 19⅝ x 15¾" (50 x 40 cm). Collection M. and Mme. Marcel Mabille, Rhode-St.-Genèse, Belgium

picture. Only for the public, you absolutely must have something mediocre. Sunlight [a soap] turned the design down, but for a different reason than one would have thought: this poster made too great an effect and would have been good for launching a brand name. This store wants only very discreet advertising. As for the Bon Marché, they're asking me to change the first design: they want a camel's shadow, a veiled woman, etc. All this is not very encouraging. Really, it's only on rare occasions that one can hope to slip a great idea past them. At Tabacofina, the "Message of the East" design has been turned down; they've already used this idea of an Eastern prince offering a pack of cigarettes to a European woman. The color design made a big contrast between the two figures. I had given the man an air of mystery, he seemed to come from some strange land. The color of his face made him a very different type from the white woman who watched him approach. . . . On seeing this design, my brother, without having been told anything, suddenly began talking about magic.
——*Letter from René Magritte to Paul Nougé, undated, 1931*

Before, during, and after my stay in France, I underwent influences that were enlightening rather than determinant.
——*From an interview with Christian Bussy, August 1966*

After many mishaps, I've managed to get to Carcassonne. I unfortunately had to leave my wife in Brussels, since she was recovering from an attack of appendicitis and such a difficult trip was impossible for her.

As you can imagine, I'm in a fairly middling state. I feel very isolated, and if it weren't for the hope of seeing Georgette again one day, I wouldn't be able to go on living. That is what overshadows everything for me right now, so if you should have any way of letting her know that I'm well, I would have great hope.
——*Letter from René Magritte (Carcassonne) to Roland Penrose, May 23, 1940*

Should I perish en route, tell Georgette when you see her again that my last thought was of her.
——*Letter from René Magritte (Carcassonne) to Louis Scutenaire and Irène Hamoir, August 4, 1940*

RAPIN: What a shame all the same that none of these sumptuous art magazines reproduce any of our works, and that we have to do without in order to publish at our own expense little illustrated publications using poor and obsolete typographical techniques. We too deserve to benefit from the improvements in the art of printing.
MAGRITTE: But it's just that our works are not yet owned by real *possessors;* you can be sure that when they are, they won't ask our permission before reproducing them in what you call *sumptuous art magazines.* In this regard, however, I call the

23 *Georgette (Georgette).* 1934. Oil on canvas, 21⅝ x 17¾" (55 x 45 cm). Collection Mme. René Magritte, Brussels, Belgium

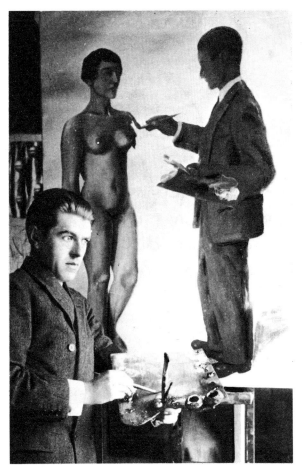

24 René Magritte in front of *La tentative de l'impossible (Attempting the Impossible).* 1928. At the left is a partial view of *La masque vide (The Empty Mask)*

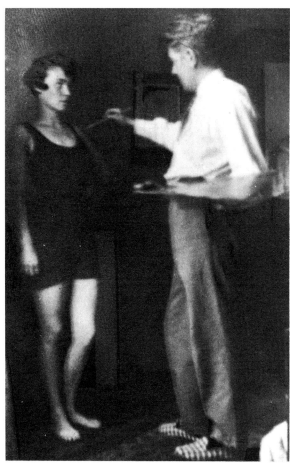

25 Photograph of Georgette and René Magritte at Le Perreux-sur-Marne, France, 1928

following to your attention: these magazines are a lot less "artistic" than they seem; in fact, there is no real difference between them and the financial papers—they are the *mirrors* the rich use to dazzle us and to show off their wealth, a wealth duly protected by the police, religion, and the army. As for our works (as elements of wealth—for the wealthy), I have discovered that they slip through our fingers altogether and in the following manner: either the painter makes a fortune and his work goes bankrupt, or the painter goes bankrupt and the work makes a fortune.
——*Exchange between René Magritte and Maurice Rapin, "René Magritte," Aporismes, 1970, p. 36*

One day I thought of the possibility of painting the picture presently known as *Georgette;* this possibility *resembled nothing* hitherto known in the world, and was unconnected to any kind of conventional meaning. This possibility resisted and *still* resists explication. There is thus no conventional symbolic meaning that can justify the gathering of objects such as described in *Georgette.* . . . Love does without justification and explanation . . . or else it's a parody of love.
——*Letter from René Magritte to Mr. and Mrs. Barnet Hodes, undated, 1957*

Éluard arrived Monday and left again this morning. . . . He found a good title for the lion and the egg: *Ce qui est beau est un oeuf* (What Is Beautiful Is an Egg).* It's an old proverb he plans to use as the title for *Rencontres,* the title of his book.
——*Letter from René Magritte (Carcassonne) to Louis Scutenaire and Irène Hamoir, July 2, 1940*

*First entitled *Le Voyage,* Magritte's "lion and egg" was finally baptized *Le Repas de Noces* (The Wedding Breakfast). It was executed in 1940 at Carcassonne, where Magritte had taken refuge during the exodus from Brussels during Nazi occupation.

26 *Le repas de noces (The Wedding Breakfast).* 1940. Gouache, 12⅜ x 16½" (31.5 x 42 cm). Private collection, France

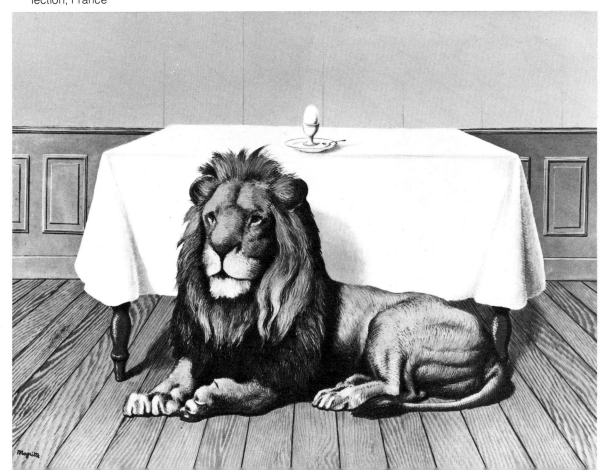

Dwellings

Cher Bourgogne,
Vous êtes un charmant Bourgoignies,
(Et j'ai vécu jadis à Soignies)
Pour avoir apporté des plantes charmantes
à Georgette qui en était toute contente.
Je pense que vous m'écrirez: je pense
que la Pensée est ceci: elle ressemble
à la Pensée, à ce que je pense.
Et grâce à votre réponse, nous ferons ensemble
Un joli petit recueil pour l'édification
Des esprits respectueux des constitutions.
A ma future nouvelle adresse, dès le 18
de ce mois, faisant une sorte de 207
Boulevard Lambermont, je ferai de s'8
une réunion pour la mise au net
des projets relatifs à la recherche
des choses, pour les capturer avec votre perche
qui renforcera nos perches respectives
un peu démunies de forces vives.

<div align="right">Mag.</div>

——*Letter from René Magritte to Paul Bourgoignie, May 8, 1954*

[Dear Bourgoignie,

You're a charming man, Bourgoignies (I once lived at Soignies), for having brought the lovely plants for Georgette, who liked them very much. I guess you're writing to me: I think the following Thought: like Thought, it resembles what I think. And thanks to your answer, we will make a nice little collection for the edification of people who like that sort of thing.

I'll be at my future new address from the 18th of this month, leaving 207 Boulevard Lambermont, and I will at once call a meeting to settle the plans with regard to the research into objects, or to catch them with your pole, all of which will reinforce our respective positions, which are somewhat drained of vital force.

<div align="right">Mag.]</div>

Translator's note: This translation reflects the poem's primary, literal meaning. It is replete with aural and visual puns, which the reader fluent in French may enjoy deciphering but which cannot be rendered into English.

27 Letter from René Magritte to Paul Colinet, 1957. *See Appendix for translation*

28 *Union libre (Free Union).* 1933. Oil on canvas, 23 x 31½″ (58.5 x 80 cm). Collection William N. Copley, New York, New York

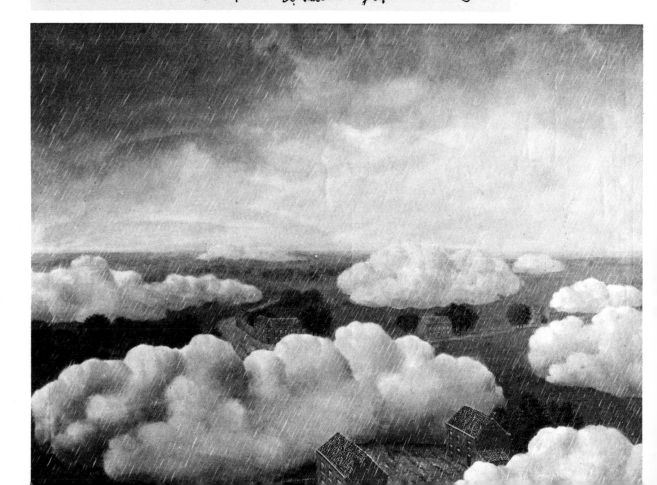

La maison que je viens de louer est un point d'interrogation aussi. J'ai, depuis mon mariage, toujours habité dans des appartements. Peut-être y serai-je trop "tranquille"?

Voici le plan du rz de chaussée :

If all goes well, my address from the first of the year will be: 97 rue des Mimosas. In many respects, it will be better there for "living" and "working."

—*Letter from René Magritte to Maurice Rapin, December 17, 1957*

29 Photograph of René and Georgette Magritte at 97 rue des Mimosas, Brussels, Belgium, 1965

30 Photograph of René Magritte painting at 97 rue des Mimosas, Brussels, Belgium, 1965

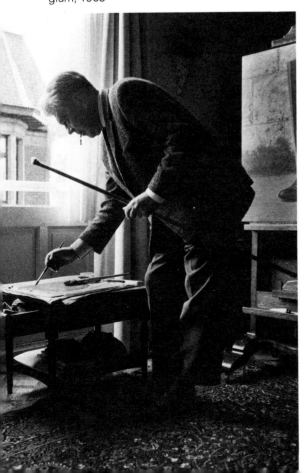

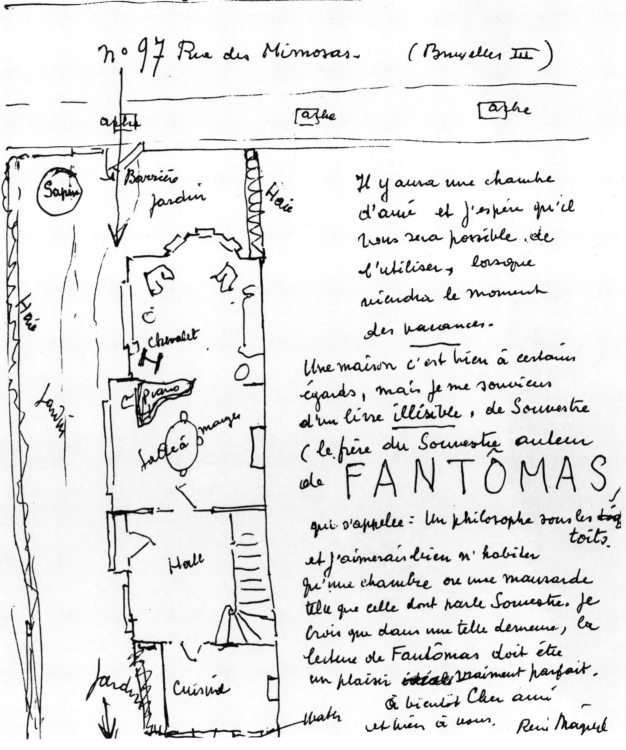

nº 97 Rue des Mimosas. (Bruxelles III)

Il y aura une chambre d'ami et j'espère qu'il vous sera possible de l'utiliser, lorsque viendra le moment des vacances.

Une maison c'est bien à certains égards, mais je me souviens d'un livre illisible, de Souvestre (le frère du Souvestre auteur de FANTÔMAS, *qui s'appelée : Un philosophe sous les toits, et j'aimerais bien n'habiter qu'une chambre ou une mansarde telle que celle dont parle Souvestre. Je crois que dans une telle demeure, la lecture de Fantômas doit être un plaisir vraiment parfait.*

À bientôt Cher ami et bien à vous. René Magritte

31 Floor plan of the Magritte house at 97 rue des Mimosas, Brussels, Belgium, included in a letter from René Magritte to Maurice Rapin, December 20, 1957. *See* Appendix *for translation*

33

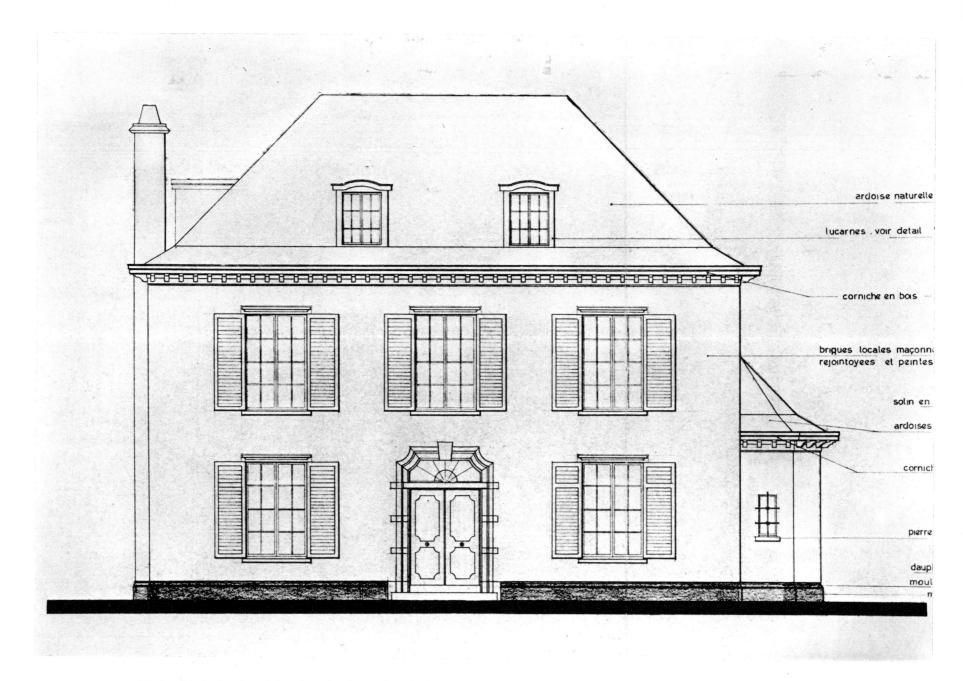

ardoise naturelle

lucarnes . voir detail

corniche en bois

briques locales maçonn
rejointoyees et peintes

solin en

ardoises

cornich

pierre

daupl

moul

32 Architect's drawing of elevation of main east façade of a house to be built for Magritte at
Avenue Fond' Roy, Uccle, Belgium

I received a visit from an architect who is a "be-liever" (yet without going to Confession, to Communion more than once a year, or to Mass more than once on Sunday). He's a rather lukewarm "believer." He finds my paintings to his liking and expresses himself with the words: "How special" . . . He also admires Dali's *Christ* and is convinced that a distinction can be made between how to paint any old "subject" and what should be painted. To paint Christ or to paint a Black Mass requires no genius.

However, if one needs a "technician" to put up a building and this one or someone else can do it, it would be better perhaps if he had no genius. I'd hesitate having one at my disposal: a famous architect such as Le Corbusier, for example.
——*Letter from René Magritte to André Bosmans, July 31, 1963*

My current venality can be explained by a housing issue: I'm going to build. The land I've picked out is on the Avenue Fond'Roy at Uccle (Number 9, I think), and the deed will be signed on September 3. Thus Georgette and I will have a house to our liking and will no longer be subjected to the whims of a landlord. Our architect promises that in September of next year the house will be ready.

(This house, Neoclassical in style, would certainly not suit the taste of any architectural committee chosen by the Guggenheim Museum.)
——*Letter from René Magritte to Harry Torczyner, August 25, 1963*

Is it because of this state of health* that I've decided to give up building? Possibly. The prospect of the aggravations—familiar, it would seem, to all builders—seems to me a more formidable reason. In any event, I've informed my architect of this decision, basing it on as few "materialistic" arguments as possible. I have hereby done away with a source of superfluous worries. The proportion of possible aggravations that plague builders is really, upon thinking about it, too great in relation to the anticipated pleasure.
——*Letter from René Magritte to Harry Torczyner, February 27, 1964*

*Magritte was recovering from severe bronchitis.

Woman

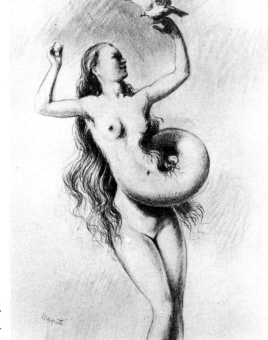

34 *L'amour (Love).* n.d. Red chalk, 17¾ x 13⅜″ (45 x 34 cm). Collection Lacroix, Brussels, Belgium

In dreams
Bordellos make
A very strong impression.
One feels one is entering
A conservatory.
——*René Magritte, 391, no. 19, October 1924, p. 130*

REPLIES TO THE QUESTIONNAIRE ON LOVE
I. All I know about the hope I place in love is that it only needs a woman to give it a reality.
II. The progression from the idea of love to the fact of loving is the event whereby a being appearing in reality makes his existence felt in such a way that he makes himself loved and followed into the light or shadows. I would sacrifice the freedom that is opposed to love. I rely on my instincts to make this gesture easy, as in the past.

I am prepared to abandon the cause I defend if it corrupts me with regard to love.

I am unable to envy anyone who will never have the certainty of loving.

A man is privileged when his passion obliges him to betray his convictions to please the woman he loves.

The woman has the right to demand such a pledge and to obtain it, if it serves the exaltation of love.
III. No, imposing limits on the powers of love must be done by experiment.
IV. Love cannot be destroyed. I believe in its victory.
——*René Magritte, La Revolution Surréaliste, no. 12, December 15, 1929, p. 2*

35 *Il ne parle pas (He Doesn't Speak).* 1926. Oil on canvas, 23⅝ x 29½″ (60 x 75 cm). Private collection, Belgium

33 Photograph of René and Georgette Magritte, 1932

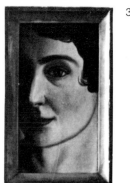

36

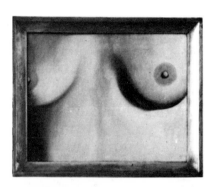

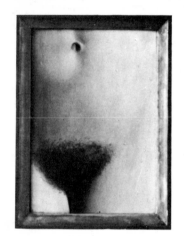

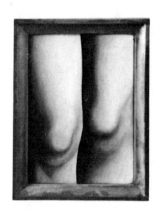

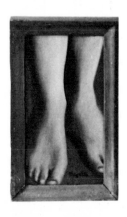

36 *L'évidence éternelle (The Eternal Evidence)*. 1930. Oil on canvas, 5 panels, top to bottom: 8⅝ x 4¾″ (22 x 12 cm), 7⅛ x 9″ (18 x 23 cm), 10⅜ x 7¼″ (26.5 x 18.5 cm), 8½ x 6⅛″ (21.5 x 15.5 cm), 8½ x 4½″ (21.5 x 11.5 cm). Collection William N. Copley, New York, New York

37 *L'univers mental (The Mental Universe)*. 1947. Oil on canvas, 19⅝ x 28¾″ (50 x 73 cm). Private collection, Brussels, Belgium

38 *L'attentat (Act of Violence)*. 1934. Oil on canvas, 27⅝ x 39⅜″ (70 x 100 cm). Private collection, Belgium

39 *La pose enchantée (The Enchanted Pose)*. 1927. Oil on canvas. Painting destroyed

40 *Le palais d'une courtisane (A Courtesan's Palace)*. 1928–1929. Oil on canvas, 21½ x 28¾″ (54.5 x 73 cm). Collection de Menil, United States

I love a woman finding herself in a man, but to my taste it becomes boring if the Holy Scriptures play the least role in this feminine inclination for X, Y, or Z. In fact, the sexual relationship should be "directed," as a doctrine of my own would prescribe, toward innocence.
——*Letter from René Magritte to Marcel Mariën, late 1937*

This afternoon, in bright sunlight, I saw a young woman waiting for the streetcar, accompanied by her body.
——*René Magritte, Le Surractuel, no. 1, July 1946*

Sexual acts amount to very little as soon as they are used to shock or to educate. There is a kind of comfortable misunderstanding that regards the understanding of sexuality as self-knowledge. Sexuality is compatible only with disinterested thought.
——*Letter from René Magritte to G. Puel, February 22, 1954*

37

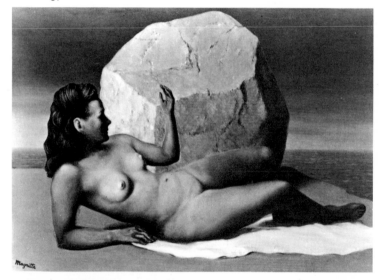

38

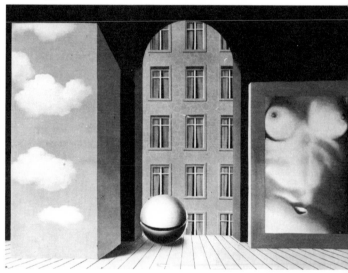

39

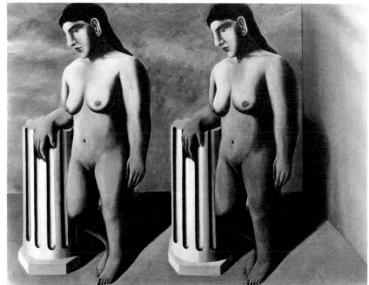

40

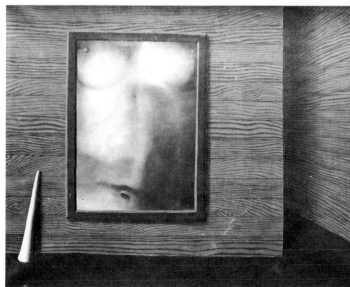

War

41 Untitled drawing. 1952. Pen and ink, 2¾ x 3⅛" (7 x 8 cm). Location unknown

42 Painted plaster cast from Napoleon's death mask. c. 1935. Height 12⅝" (32 cm). Collection Edward James Foundation, Chichester, England

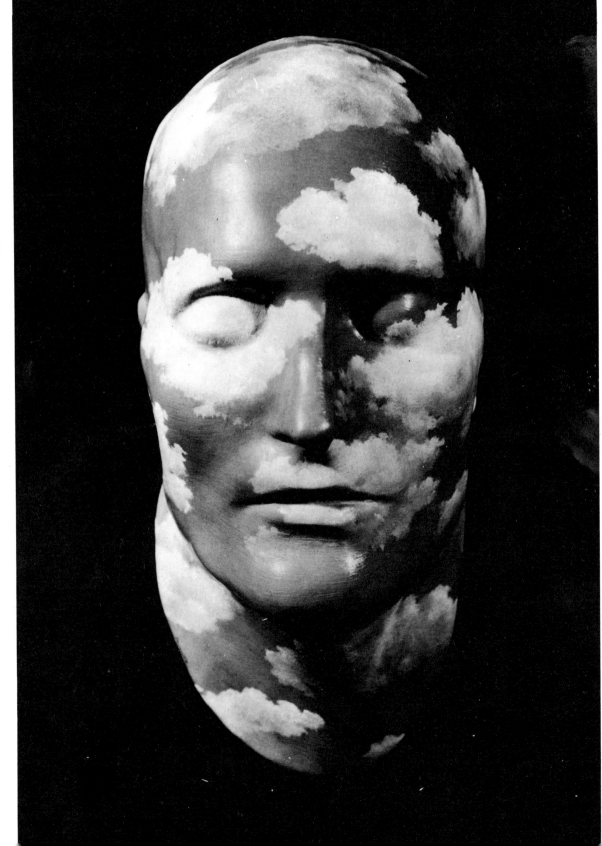

Napoleon *fils,* at his general staff outpost, attended the Battle of Namur in 1924. A bright figure, he stood out clearly against the variegated background of uniforms and the red, ash-filled sky. He put his left hand through an opening in his white jacket, resting it on his stomach in an automatic gesture that indicated the site of his historic ulcer. A shell suddenly exploding with more than usual force, the chiefs of staff drew back instinctively. But the emperor did not shrink, and his austere mask did not reveal his thoughts, always governed by reality: "Another grenadier's arm taken off by a bullet," he observed to himself.

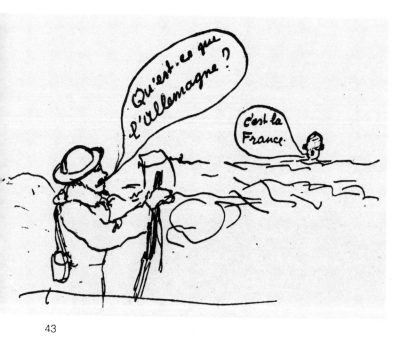

43

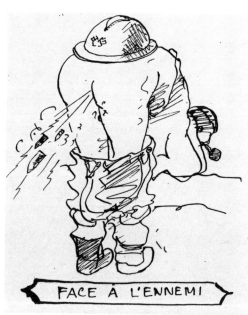

44

45

46

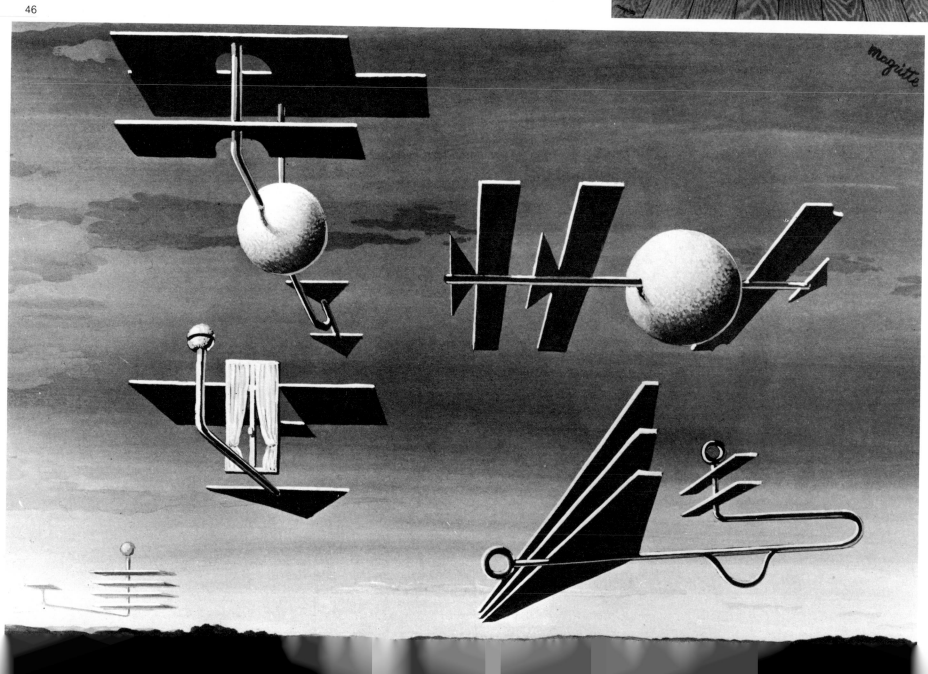

But now it was noon. Thanks to the devotion of the kitchen scullions and the abundance of the emperor's supplies, a substantial meal—three entrées, two soups, and a huge main dish—had been prepared under enemy fire, and was served to him in a splendid porphyry dish. Despite his stomach ulcer, Napoleon was a fine trencherman and his helpings were large. His busy mind did not slow down while he took in his nourishment; it [raced along] so intensely that when he had barely wiped his mouth he was already issuing orders: "Form a square here and a square there to flank my center and pierce the right flank of the Dutch king's infantry." And he returned to his battle observation post, a bright figure, with, however, a spot of green sauce on his breeches.

Evening came, and after a restful night, his cleaned breeches would once again be as impeccable as Paul Éluard's signature. He would be rested and ready for the attack at first light. Having taken a final pinch of gunpowder snuff and having unburdened himself by one last explosion, thus startling his personal subalterns in the peaceful evening, the emperor, his gaze turned inward, made contact with his personal mattress.
—Réne Magritte, 1958

... when I was thinking of moving, I avoided streets with names commemorating military, social, or patriotic feats. The Boulevard Lambermont is not called the Boulevard General Lambermont; I learned that Lambermont was a general, and it's a lucky oversight not to have indicated that on the street sign.
—Letter from René Magritte to Mirabelle Dors and Maurice Rapin, September 27, 1957

Each country seeks only to defend itself and to leave aggressive intentions to others.
—Letter from René Magritte to André Bosmans, July 29, 1958

As for the "military man," of course he doesn't exist. There are only individuals who play at this role, whether they take it "seriously" or not. The stakes of battles are less real than a pipe.
—Letter from René Magritte to André Bosmans, undated, 1958

We rejoice at the Israeli Army's success, but without liking the military any better, despite its being, as one says, "a necessary evil."
—Letter from René Magritte to Harry Torczyner, June 11, 1967

43 Qu'est-ce que l'Allemagne? C'est la France (What is Germany? It's France). 1940. Pen sketch. Private collection, Belgium

44 Face à l'ennemi (Here's to the Enemy). December 11, 1939. Pen sketch, 6¾ x 8⅛" (17 x 20.5 cm). Collection M. and Mme. Louis Scutenaire, Brussels, Belgium

45 Le survivant (The Survivor). 1950. Oil on canvas, 31⅛ x 23⅝" (79 x 60 cm). Collection William N. Copley, New York, New York

46 Le drapeau noir II (The Black Flag II). 1937. Gouache, 13 x 19" (33 x 48.3 cm). Fischer Fine Art Gallery, London, England

Hôtel du Park et Regina
MONTECATINI TERME Italie (Pistoïa)

PRIMA CATEGORIA
UNICO CON INGRESSO DIRETTO AGLI
STABILIMENTI PRINCIPALI DI CURA TETTUCCIO REGINA
Grande Garage a Box

PROPR. DIR. CAV. UFF. ACHILLE GIACOMELLI & FAMIGLIA

MONTECATINI TERME, le 5 juin 1967
TELEF. 32.32 - 32.33 - 32.34

Cher Harry,

Je vous renvoie le document Harpers Bazaar, signé et daté. (La date avec une rature : je me croyais encore au mois de mai). Donc, c'est que nous sommes bien arrivés à la destination prévue. Il est prévu que nous irons avec Iolas à Vérone vers le 10 juin, mais je ne peux vous en assurer car il est parfois peu ponctuel dans ses rendez-vous. Je vous tiendrai au courant du développement des projets sculpturaux — s'ils se développent ...

La situation internationale est toujours inquiétante, le microbe de la guerre, d'endémique semble vouloir être une bonne fois épidémique — J'avoue ne plus très bien distinguer ce qui se passe réellement : ce ne sont pas les idées de démocraties ou de dictatures, celles de racisme et d'anti racisme qui permettent d'y voir clair. Au lieu d'essayer de raisonner, voilà qu'en ce moment vers 16 h 40, le directeur de l'Hôtel m'annonce que la guerre a commencé entre Israël et l'Égypte! (nous n'avions que des nouvelles de journaux français vieux de 3 jours et ce directeur en a des italiennes toutes fraîches).

Les vautours triomphent donc des colombes. Cela donne raison à mon pessimisme sans que j'en sois satisfait le moins du monde. Je me demande s'il ne serait pas prudent de rentrer à Bruxelles au plus tôt ? En 40, j'ai fait l'expérience des difficultés et ennuis pour rejoindre Georgette dont j'étais exilé à Carcassonne — A présent, avec elle et Loulou s'il y a des difficultés, elles seraient encore plus grandes !)

Je ne peux qu'espérer que les dégâts seront limités ?
Si mon retour se précise, je vous en aviserai aussitôt.
Mille amitiés pour vous, et Marcella,
René Magritte

47 Letter from René Magritte to Harry Torczyner, June 5, 1967.
See Appendix for translation

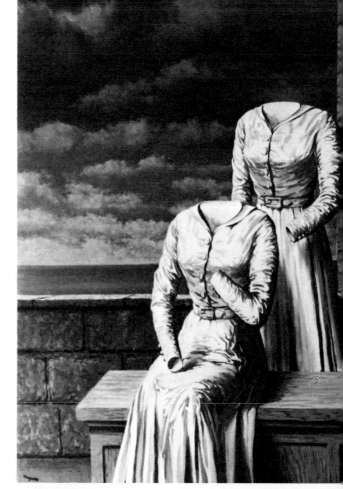

48 *Les cornes du désir (The Horns of Desire)*. 1960. Oil on canvas, 45¼ x 35″ (115 x 89 cm). Collection Tazzoli, Turin, Italy

Fashions

Here, in any event, there are avant-garde curés who go out wearing dufflecoats over their cottas. They are not very respectful of the papal vestimentary edicts.
——*Letter from René Magritte (Avignon) to Louis Scutenaire, July 5, 1958*

The "Surrealist" woman was as stupid an invention as the "pinup girl" who is now replacing her.
——*Letter from René Magritte to Mirabelle Dors and Maurice Rapin, August 22, 1956*

. . . for the first time I saw women in men's trousers without feeling nauseated.* What a difference there is between the apparel of this working girl, full of nobility, and that of a young girl in trousers.
——*Letter from René Magritte to Louis Scutenaire, undated*

*Magritte is referring to the film *Point du Jour*.

I detest these attempts at "graphic art" offered us by luxury magazines that don't succeed in arousing the slightest interest. Like my painting, which would be "behind the times" by comparison, the typography of popular art publications is also too simple and "elementary" in the eyes of distinguished decorators, for example, or of people with "taste." Obviously there is a "taste" that doesn't depend on the decree of some specialist, a dressmaker, perfume manufacturer, or filmmaker. For example, some young people find my lack of taste odd. Thus, they wish the figures I paint were dressed in zoot suits (I'm already behind the times, am I not? Is the zoot-suiter ancient history?).
——*Letter from René Magritte to Maurice Rapin, January 15, 1958*

It seems sometimes that, as in fashion designing, it was suddenly decided that today the sack dress or sack-idea is what the world needs. And right away, if you are unable to appreciate these "fads," you are considered a backward peasant. I must have seemed one to Rachel Baes* who came to see me and, doubtless in my honor, had put on a kind of night dress of a vomitous pastel color. She also supported this sack-idea: the time had come for the authorities to recognize my "artistic worth" by making me a baron! If I should lose my powers of self-defense, I'd end up on the canvas.
——*Letter from René Magritte to Maurice Rapin, February 11, 1958*

*A Belgian painter with Surrealist leanings.

The time-honored forms of objects do not call their forms into question, whereas a strange or new style calls into question nothing but a formal preoccupation, not mystery, which has no form.
——*Letter from René Magritte to André Bosmans, August 18, 1959*

I have a great deal of admiration for admirable things, but I detest this tendency to change the forms of admirable things. If those who create fashion could change the shape of the human body (perhaps they will one day!), we would see a pretty woman with a hunchback, for example. It would be the fashion! On this question of forms, *I have nothing to say* that isn't negative: there are enough admirable forms already for the random search for new forms to be desirable. . . . I would go so far as to say that a new style is not worth knowing—no more so than an old style.
——*Letter from René Magritte to André Bosmans, August 22, 1959*

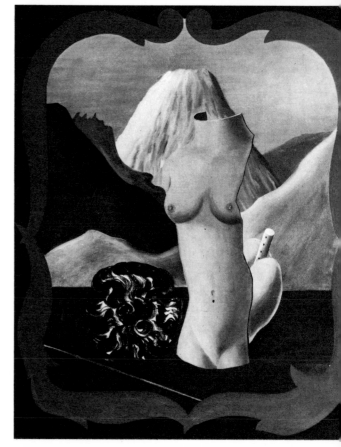

49 *Souvenir de voyage (Memory of a Voyage)*. 1926. Oil on canvas, 29½ x 25⅝″ (75 x 65 cm). Collection M. and Mme. Berger-Hoyez, Brussels, Belgium

Illnesses

Bruxelles le 6 Février 1962

Bien cher ami,

J'ai reçu votre lettre, celle de Suzi avec sa traduction, et la visite de Peter de Mared aujourd'hui.

15e jour de crise hépatique. Le médecin décide que dans 15 jours je pourrais être guéri, mais que d'autre part cela pourrait bien durer encore 6 mois ?....

Mon régime est très strict - je ne peux manger ni boire aucune chose agréable telle que café, tomates, frites, etc -

Il faut que je dorme presque toute la journée, ne pas sortir: le froid me ferait très mal paraît-il.

J'ai reçu la visite de Iolas Dimanche dernier (4 février), Il va repartir pour New York incessamment et attendra mes tableaux et les catalogues pour ouvrir l'exposition décidée il y a quelque temps déjà.

Pour le Collage avec la pipe et l'oiseau, le titre " Moments musicaux,, me semble convenir, Le titre s'applique à plusieurs œuvres (comme certains titres tels que - L'Art de la Conversation, Stimulation objective, etc..)

Bonne chance à Treetown !

Bien cordialement vôtre

René Magritte

50 Letter from René Magritte to Harry Torczyner, February 6, 1962. *See Appendix for translation*

RENÉ MAGRITTE
97, RUE DES MIMOSAS, BRUXELLES 5
TÉLÉPHONE 15.97.30

le 18 Mai 1965

Cher ami,

Je vous remercie de votre lettre et de l'annexe n° 2 qui l'accompagne.

Je retiens les intentions de M. Seitz qui sont à mon goût: "l'histoire n'est pas mon fort", aussi me semble plus intelligent d'envisager une exposition orientée ou choix (judicieux de préférence) des œuvres à exposer plutôt qu'à une chronologie qui ne demande guère de bon sens.

Est-ce la cure qui montre ses effets ou les médicaments prescrits par mon médecin qui ne me donnent pas trop de douleurs pour le moment ? Quoi qu'il en soit, mon état sanitaire est assez satisfaisant, mise à part une fatigue (peut-être congénitale.)

Mais, il y a une autre perspective moins drôle: les analyses révèlent une anémie dont il faudrait connaître la cause. Si bien, ou plutôt si mal, que dans quelques jours on va m'ouvrir le ventre (un peu, mais ouvrir tout de même) afin de l'explorer avec un instrument lumineux par lequel on peut regarder. Cette anémie peut signifier toutes sortes de choses, même celle qu'il ne faudrait pas trouver: la leucémie par exemple.

Je vous dirai ce qu'il en est aussitôt que possible. En attendant de savoir, mon optimisme habituel, étant déjà très modeste, n'a aucune raison d'être plus décidé pour le moment.

Bien affectueusement à vous et à Marcelle.

RM

51 Letter from René Magritte to Harry Torczyner, May 18, 1965. *See Appendix for translation*

RENÉ MAGRITTE
97, RUE DES MIMOSAS, BRUXELLES 3
TÉLÉPHONE 15.97.30

2075-i

le 30 mai 1965

Cher Ami,

[handwritten letter in French, largely illegible]

Bien affectueusement à vous,
RM.

52 Letter from René Magritte to Harry Torczyner, May 30, 1965. *See* Appendix *for translation*

It's never too late to grow old, you will tell me, but it's difficult to find oneself in a state of belated youth, or the old age one was able to cope with when young. . . . Our platform is nothingness, plus our friendship.

René Magritte, *Artiste-peintre*
——Letter from René Magritte to Gerard Van Bruaene, April 9, 1954

Dear Friends,
 Happy New Year. Better than the one that's ending. As for me, I hope to be in better form. I was abnormally tired in 1956. . . .
——Letter from René Magritte to Mirabelle Dors and Maurice Rapin, December 1956

I've delayed a bit in answering you, "not being very well." A liver attack came upon me only a week ago. I'm beginning to "get over it"—too slowly for my taste, but I hope that soon I'll be getting around as I did before this somatic incident.
——Letter from René Magritte to André Bosmans, January 31, 1962

In the meantime I can say I'm not suffering, that only fatigue at the slightest effort warns me that I must be prudent. Another signal is that I'm no longer smoking and I don't feel the least desire to do so.
——Letter from René Magritte to André Bosmans, February 14, 1962

I have continual pain in my head, muscles, nerves, liver. Fortunately, there are moments without great awareness of "having a body." Perhaps it would be better if I didn't smoke? But it's hard to stop and very unpleasant. Furthermore, the outcome of such asceticism is very unpredictable.
 "As for feelings" (to use my theoretical language), the world presents itself most of the time as a painful feeling (not, luckily, to the point of being unbearable).
——Letter from René Magritte to Suzi Gablik, October 15, 1963

On the subject of miracles, I think that if there is a miracle of spontaneous cure, there is a comparable one of the onset of an illness. It's not a question of calling upon the "powers that be" to make people ill, it's the very emergence of the disease or cure that is involved. This is how the notion of "miracle" loses its magic, of which we were not very aware in the first place.
——*Letter from René Magritte to André Bosmans, April 3, 1964*

. . . aside from these stubborn rheumatisms that are fairly bothersome and painful, albeit bearable, I consider, taking everything into consideration, that my health is "good" for my age—I can do what I choose, paint for two or three hours a day, take "moderate" walks, and breathe like everyone else, which is quite enough for living.
——*Letter from René Magritte to André Bosmans, March 4, 1966*

53 *La tempête (The Storm).* 1927. Pencil drawing, 7⅛ x 9¼" (18 x 23.5 cm). Private collection, United States

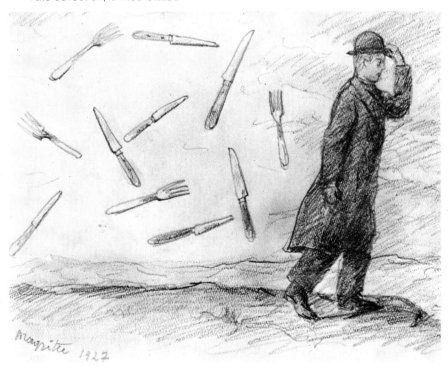

54 Letter from René Magritte to Harry Torczyner, January 17, 1967. *See* Appendix *for translation*

54 Letter from René Magritte to Harry Torczyner, January 17, 1967. *See* Appendix *for translation*

RENÉ MAGRITTE
97, RUE DES MIMOSAS
BRUXELLES 3

le 17 janvier 1967

Cher Harry,

Nous voici rentrés de Paris où mon exposition "bat son plein". Je n'ai pas eu la force mentale et physique d'écrire des contes illustrés, c'est-à-dire que la fatigue a atteint un point voisin du coma.

Il y a eu la foule des vernissages, des "interview" et ce que cela comporte de facile à imaginer. Les critiques dans les journaux sont plus importantes qu'il y a deux ans, à Paris. Elles sont plus attentives aussi et chose curieuse j'y prête moins d'attention.

Je commence à me réveiller de ce cauchemar et je retrouve le plaisir de vous envoyer des nouvelles et surtout de reprendre notre commerce épistolaire. et amical.

A bientôt sans doute? Affectueusement à vous et à Marcelle,

René Magritte

P. S. - J'espère que vous recevez le catalogue que la Galerie Iolas doit vous envoyer.

DE GUSTIBUS ET COLORIBUS

Books were essential for Magritte's sustenance. Tempted by the role of author as a very young man, he wrote detective novels under the pseudonym Renghis, a combination of two of his given names, René and Ghislain. Later on, he was to sketch out "literary images," such as his *Théâtre en plein coeur de la vie (Theater in the Heart of Life)*.

His curiosity drew him to the most diverse areas of literature. He admired Simenon as much as Conrad or Stevenson. He passed effortlessly from the world of Souvestre and Allain and their *Fantômas,* which had delighted his youth, to the philosophical garden in which he encountered Spinoza, Hegel, Nietzsche, Marx, Bergson, Heidegger, and Foucault. Foremost among his favorite poets were Edgar Allan Poe, Lautréamont, Apollinaire, and Éluard.

The brother of a composer and husband of a fine pianist, Magritte was an eclectic music lover. His tastes ranged from Bach to Schoenberg, whom he defended as early as 1929, and he was particularly fond of the music of Erik Satie.

His favorite diversions were chess and movies. He was a fervent fan of the films of Laurel and Hardy, westerns, suspense movies—the real "cinema," without pretentions or messages. An amateur filmmaker himself, he made comic or naïvely erotic films with his friends. From time to time, he made documentaries, which he showed at home, such as his last film, made in June 1967, concerning the foundry in Verona where his bronze sculptures were cast.

Chess served him as a sort of mental gymnastics. He liked to move the men around, intrigued by their shapes.

Of course, he liked to walk, or to swim during vacations, but he was not attracted to sports, and although he admired acrobats, he did not think much of athletes.

In his youth he had gone to the races, and he retained in his memory those images of jockeys and horses that we find in his pictures.

After turning sixty, he tried to become an expert driver. He bought a bright red Lancia, but after two accidents in less than one week he gave up this ambition.

Homebody though he was, he sometimes allowed himself to be enticed into traveling, without ever being at heart a tourist. What he disliked most were the preparations, vaccinations, and boring consultations of complicated timetables. In August 1929, during one of his first foreign trips with Georgette, he went to Spain with his friends Camille Goemans, and Paul and Gala Éluard. At Cadaquès, where they met Salvador Dali, they witnessed the adventure that became the soap opera of the art world: the love affair between Dali and Gala, and her leaving Éluard. In 1937, at 35 Wimpole Street, an address as literary as it is elegant, Magritte painted at the home of his host Edward James and discovered the charms of the English language. Toward the end of his life, he traveled to Texas and Israel where his fame had preceded him, and he was impressed by these new lands and customs. Still, the familiar landscapes from the Ardennes to the North Sea remained his favorites. For Magritte, the voyage he most enjoyed was the voyage around his own room.

55 Photograph of several of René Magritte's friends, Sénart Forest, Paris, France, 1929

56 *La colère des dieux (The Wrath of the Gods).* 1960. Oil on canvas, 24 x 19⅝" (61 x 50 cm). Collection Tazzoli, Turin, Italy

55

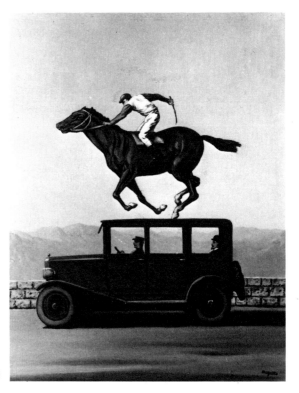

Automobile

The next picture I am going to paint will be called *La colère des dieux (The Wrath of the Gods).* . . . This is not in response to the (not yet posed) question of the automobile, in that although the image of an automobile fits here (and the jockey fits, too), both automobile and jockey came to me spontaneously through inspiration. As a problem posed, the automobile would prompt quite a different response, one that inspiration would give me after lengthy research.
—*Letter from René Magritte to André Bosmans, July 19, 1960*

I don't know if I'll tackle the "automobile problem," but I think I'll paint the first image I found during my research for the solution to the violin problem.
—*Letter from René Magritte to André Bosmans, July 20, 1960*

I imagined an automobile whose steering wheel is made out of a piece of bacon.
—*Letter from René Magritte to André Bosmans, October 16, 1961*

56

RENÉ MAGRITTE
97. RUE DES MIMOSAS. BRUXELLES 3
TÉL. 15.97.30

57 Letter from René Magritte to Harry Torczyner, July 23, 1962. *See* Appendix *for translation*

58 *Hommage à Von Stroheim (Homage to Von Stroheim)*. Sketch included in letter from René Magritte to Paul Colinet, 1957. *See* Appendix *for translation*

Cinema

Saw *The Woman in the Window* [Fritz Lang]— both not bad and terrible. It is worth seeing, but from the beginning and not to the end, which is stupid and ruins the whole film (like so many films, it is based on the hassles one character has to go through).
——*Letter from René Magritte to Paul Nougé, September 26, 1946*

In a film by Clouzot that starred [Louis] Jouvet and introduced the actress Suzy Delair, Magritte remembered only the latter because she reminded him of those Parisian women who eat nothing but cold cuts.
——*Remark about René Magritte related by Marcel Mariën, undated*

I recently thought of making some attempts at home movies. In the end, it is tiring and not very rewarding: a lot of direction for ephemeral and questionable results.
——*Letter from René Magritte to Mirabelle Dors and Maurice Rapin, November 8, 1956*

For at least a week I will be subject to the cinematographic demands of Luc de Heusch . . . who is beginning a film using me and my pictures as principal actors.* I think it will be good (a talkie, in color, made with the latest technical equipment). It will be shown in "cinema clubs" around the end of this year. . . .
——*Letter from René Magritte to André Bosmans, July 2, 1960*

**Magritte, ou La Leçon des Choses (Magritte, or the Lesson of Objects) premier April 7 1960.*

Professional cinema is very tiring. There has been about a week of commotion—which will begin again at the end of the month. The film could be very good. Luc de Heusch and his collaborators have the best of intentions. The "profit" I have derived is not inconsiderable. Several times, De Heusch remarked, "That's good," "That's ridiculous," or "That's stupid" (although he spared no pains in devoting himself to and getting excited about the "stupid" thing itself: for example, apples on a table surrounded by a picture frame I was supposed to arrange in front of the camera). Upon thinking about it afterward (I have a slow mind), this led me to realize that an error acquires common acceptance because of a whole literature that confuses reverie, dreaming, and the absurd, on the one hand, and their opposites on the other.
——*Letter from René Magritte to André Bosmans, July 1960*

Q: Do you think Luc de Heusch's film about your work will help the public understand it better?

A: I don't believe Luc de Heusch's film betrayed me, but it has betrayed the cinema. Cinema is the art of movement, while the reproductions of my pictures we see on the screen are by their very nature static. Furthermore, I do not believe this film has assisted those who already know my work to understand it better. Its role has been merely to initiate outsiders into Surrealism and into my work.
——*Interview by Jacques de Decker with René Magritte, "René Magritte et le Cinéma."* Entracte *(Brussels), no. 1, October 1960*

MAGRITTE, or, the Lesson of Objects*

Images	Commentary	Images	Commentary
Magritte in cemetery	In my childhood, I liked playing with a little girl in the old, abandoned cemetery of a small country town. We visited those underground vaults whose heavy iron doors we could lift and we reascended into the light, where an artist from the capital was painting in one of the picturesque paths.	Paintings: *Les vacances de Hegel (Hegel's Holiday) L'ami intime (The Intimate Friend) La force des choses (The Power of Things) Les valeurs personnelles (Personal Values) La chambre d'écoute (The Listening Room)*	In acquainting ourselves with these images, we recognize the precision and charm that are lacking in the so-called real world, where they appear to us.
Pan to images	At that moment, the art of painting seemed somehow magical, and the painter endowed with superior powers.		
Traveling back from the picture *La Vengeance (The Revenge)* Pan to Magritte finishing a meal	Later, when I began to paint, I also became uncertain of the depth of the countryside, unconvinced of the remoteness of the light blue of the horizon; direct experience simply placed it at eye level. I was in the same innocent state as the child in his cradle who believes he can catch the bird flying in the sky. Even in motion, the world had lost all consistency.	Magritte bites into an apple and walks toward window	Let's take any window. Let's suppose that the glass were to break and that the landscape we see through it were also to break.
Magritte drinks	Then I dreamed that objects themselves should eloquently reveal their existence, and I researched how I might make what is called reality manifest. Reality....Many people confidently speak of it as if they knew it.	Substitution of picture for real window and traveling broken pieces	If that were to happen some day, which is always possible, I'd like a philosopher or a poet—my friend Marcel Lecomte, for example—to explain to me what these broken pieces of reality are....
Magritte picks up a plate of ham, in the middle of which is a glass eye	For me, it's a word as devoid of meaning as, for example, the words *God* or *matter*.	Dialogue, Marcel Lecomte and Magritte	Direct sound.
Magritte lifts glass cover on cheese dish	Have some cheese, some Brie. If I painted it, can we still say "This is a piece of cheese?"	Painting: *La condition humaine (The Human Condition)*	The window poses a serious problem, the problem of the human condition. The tree represented in this picture is hiding the tree behind it, outside the room. This tree is both inside the room, in the picture, and outside, in the real landscape. This is how we see the world; we see it as something outside ourselves and yet we have only a representation within us.
Substitute picture representing cheese for real cheese	Try to eat some to see!		
Magritte arranges apples in frame laid flat on the table	So there is no necessary connection between a thing, an object, or even its name....	Painting: *La voix du sang (The Call of Blood)*	When the picture has been painted—it is still not completed—a title must be found for it. The title is not an explanation. Image and word have the same poetic value. The title must be chosen in such a way as to prevent the picture from being situated in too familiar a context.
Painting: *Le bon sens (The Good Sense)*	Let's consider a still life....What we call apples, pears, a glass, an egg....These things are not so attached to their names that we cannot find another one that might suit them better.		
Magritte picks up empty frame, sets it on easel	The habit of using speech for life's immediate needs imposes on words that designate objects a limited meaning. Let's try some false denominations of objects.	Discussion among Magritte and his friends about the most recent painting	Direct sound.
Detail of *La clé des songes (The Key of Dreams)* Full view of *La clé des songes* Pan to *L'orage (The Storm)*	Objects can change their names. We can also place them where they are never found, upset the usual order. It seems evident that the evocation of mystery consists of images of familiar objects joined or transformed in such a way as to destroy their harmony with our naïve or sophisticated notions.	Sequence of pictures	Statement of titles. **The End**

**A Luc de Heusch film, 1960, with René Magritte*

Yesterday I saw a film by Hichkoc [sic], *The Paradine Case*. Very good as cinema. But what fake thinking! As if believing anything good enough for the public—a poisoner (of her blind husband) has a fight with her husband (before she poisons him) for love of a servant (faithful to

the husband), and demands that he dismiss the servant, but the husband' relies upon the faithful servant's services. Upon learning of the servant's suicide, she confesses her crime; nothing matters any longer, her life is shattered by the servant's death! . . .
——*Letter from René Magritte to André Bosmans, July 23, 1960*

Hichkok [sic] is a highly talented imbecile: his latest film, *Psycho,* proves it. His talent is immense, because when seeing the film we experience two or three extraordinary seconds. The imbecility is revealed by a scene at the beginning of the film that cannot be justified by anything connected with the "subject": it showed an almost naked man on a bed with a scantily attired woman, and it has no purpose other than to present this lifeless image. It complicates the subject—"crime movie"—by bringing insanity to the fore. Here the crime movie is confused with a so-called scientific movie. The essential thing in any crime film is the criminal (stupid, violent, etc.) and not some inmate in an insane asylum. It is obvious that to "put it over" Hichkok [sic] has pandered to the taste of the "serious" public, which demands from cinema a caricature that it, the public, can take as an expression of profound thinking. This public shrugs its shoulders when it goes to see Chaplin (the early films) or at *Fantômas*. It thinks it participates in intellectual life when it listens to speeches by cinematic scholars.
——*Letter from René Magritte to André Bosmans, November 25, 1960*

My sister-in-law Leontine tells me that someone who has "come back" from America heard that some film actors like my painting very much, and that one of them, John Wayne, is a particular fan and reportedly said wonderful things about me to reporters. That makes me happy, because as a matter of fact Wayne is an actor I like a lot. I've seen *Stagecoach* many times, and I even rented the film to show at home.
——*Letter from René Magritte to Harry Torczyner, May 6, 1961*

I can't believe there's real interest in *Les 400 coups;** it's a movie that isn't a movie, but is instead amply provided with an edifying theme that doesn't really edify, since such a movie will delight delinquent youth. The praises of the cinema "intelligentsia" had made me rightly fear I'd only be bored by this "moral" film, and, given the tastes of this intelligentsia, I was indeed bored. "Moral" (or instructive or aesthetic) films always lack movie morality, which consists merely in making movies to amuse or arouse us. "Moral" cinema is not cinema: it's a boring caricature of a boring lecture in ethics. Like boring lectures, it has no morality.
I consider true cinema to be films such as *Coup dur chez les mous,** Madame et son auto,*** Babette s'en va-t-en guerre.**** They are "true" because they make no pretense except to amuse us, and therefore have not been robbed of their indispensable morality.
——*Letter from René Magritte to André Bosmans, September 30, 1959*

*Film by François Truffaut. 1959
**Film by Robert Vernay. 1959
***Film by Christian Jacques. starring Brigitte Bardot. 1958

"Cinema for intellectuals" never amuses me, and I expect nothing from movies but amusement—useless, if you like, but which few films manage to provide.
——*Letter from René Magritte to André Bosmans, March 20, 1960*

Saw an unbearable film, *L'oeil du monocle.** The director has looked for "how" to tell a story—supposedly startling photographic effects, cutting—without attaching the slightest importance to what must be shown.
——*Letter from René Magritte to André Bosmans, December 14, 1962*

*Film by Georges Lautner. 1962

59 *Cinéma bleu (Blue Movie).* 1925. Oil on canvas, 25⅝ x 21¼" (65 x 54 cm). Davlyn Gallery, New York, New York. The title of the painting is the name of a movie theater in Charleroi, Belgium, frequented by René Magritte

Beware of the movie *Les quatre vérités,** which is unbearable (except for one bearable act where Aznavour plays the part of a framer, and a brief moment in the first act where a band followed by a hearse plays a short piece that ends with some nice music). . . .
The "fashionable" directors are all decidedly stupid, each and every one.
——*Letter from René Magritte to André Bosmans, April 26, 1963*

*Each section of the film was made by a different director. The section Magritte refers to is by René Clair

. . . *Symphonie pour un massacre.** The French are no good at "serious" gangster films. They think that creating a "typical" atmosphere is enough (using slang, for example). On the other hand, they're very good at comic gangster films: *A toi de faire mignonne,** Coup dur chez les mous,* and others have given me a good laugh.
——*Letter from René Magritte to André Bosmans, September 10, 1963*

*Film by Jacques Deray
**Film by Bernard Borderie

Horses

Le jockey perdu (The Lost Jockey) is the first canvas I really painted with the feeling I had found my way, if one can use that term.
——*Remarks by René Magritte reported by E. C. Goossen, January 28, 1966*

60 *Le coeur du monde (The Heart of the World)*. 1956. Oil on canvas, 26 x 20⅛″ (66 x 51 cm). Museum of Art, Carnegie Institute, Pittsburgh, Pennsylvania. Gift of Mr. and Mrs. George L. Craig, Jr.

61 *Le secret d'état (The State Secret)*. 1952. Oil on canvas, 18⅛ x 15″ (46 x 38 cm). Private collection, Brussels, Belgium

60

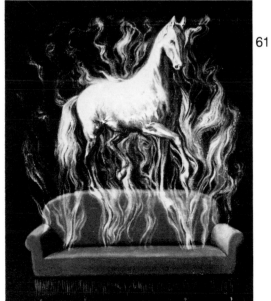

61

62 *Le jockey perdu (The Lost Jockey)*. 1926. Collage and gouache, 15½ x 23⅝″ (39.5 x 60 cm). Collection Harry Torczyner, New York, New York

63 *Le jockey perdu (The Lost Jockey)*. 1940. Oil on canvas, 23⅝ x 28½″ (60 x 72.5 cm). Collection William N. Copley, New York, New York

64 *L'enfance d'Icare (The Childhood of Icarus)*. 1960. Oil on canvas, 38⅝ x 51⅜″ (98 x 130.5 cm). Location unknown

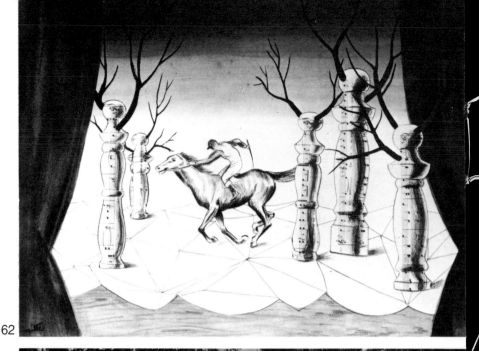

62

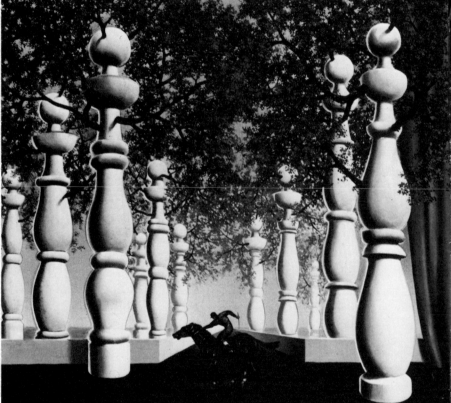

63

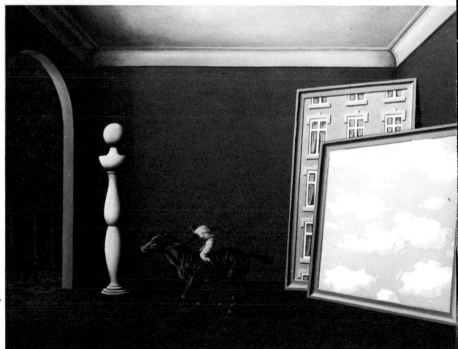

64

Chess

A very difficult chess problem is only beautiful so long as it is a problem. Once it has been solved, you're no better off than before.
——*Letter from René Magritte to G. Puel, May 22, 1955*

Thank you for the photograph of Marcel Duchamp, whom I had the pleasure of seeing last year when a trip brought him to Brussels. While showing him some paintings, I said (in a disillusioned tone), "What do you want? They're works of art." To which he replied, "One must do what one is able." I concluded with his motto "C'est la vie" (Rose Célavy [sic]).

 I took him to the chess club and he had a game with a player worthy of him. (There was no real question of my taking him on.)
——*Letter from René Magritte to André Bosmans, September 1959*

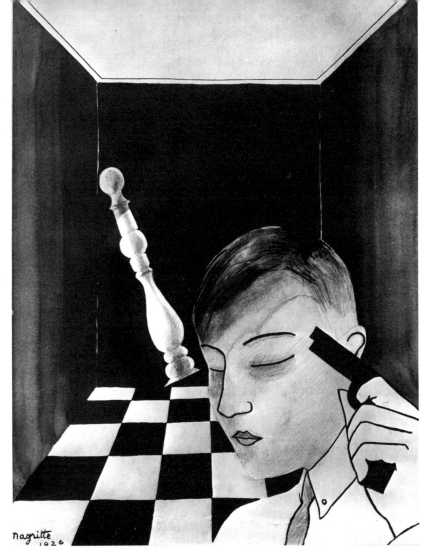

65 *Echec et mat (Check and Mate).* 1926. Gouache, 15⅜ x 11⅜″ (39 x 29 cm). Private collection, Brussels, Belgium

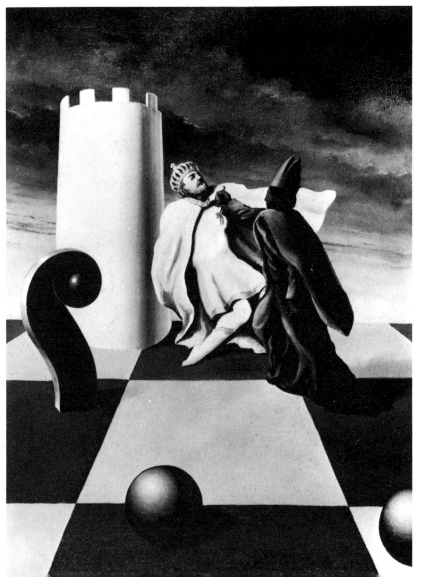

66 *Le mat (The Checkmate).* 1936. Oil on canvas, 28⅜ x 20⅞″ (72 x 53 cm). Collection Mr. and Mrs. Daniel Mattis, Scarsdale, New York

Football

I had planned to call the painting of the football
players *La fête continuelle (The Endless Holiday)*.
———*Letter from René Magritte to André Bosmans, August 28, 1961*

67 *La représentation (The Representation)*.
1962. Oil on canvas, 31⅞ x 39⅜" (81 x 100
cm). Collection Ertegun, New York, New York

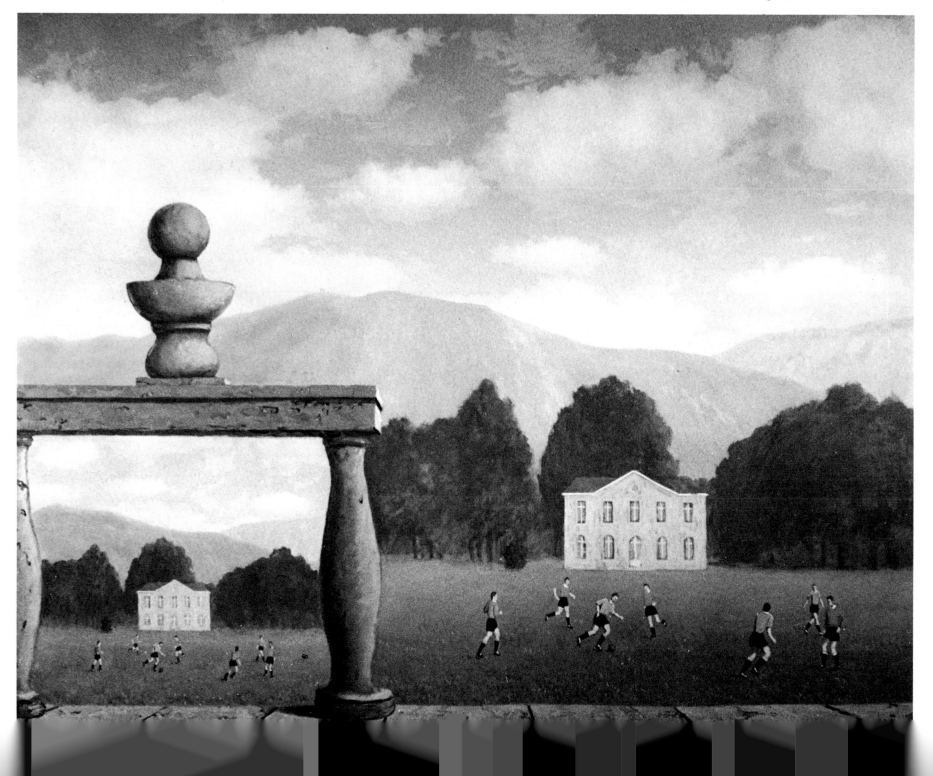

Literature

List of Magritte's favorite authors, compiled by Georgette Magritte: Alain - Alberès - Allais - Alquie - Andersen - Apollinaire - Aragon - Aymé - Balzac - Barbey d'Aurevilly - Barrès - Bataille - Baudelaire - Bealu - Beauvoir - Benda - Benoit - Berdyaev - Bergson - Bernard - Bertrand - Biran - Bloy - Bochensky - Borges - Borne - Borrel - Bossuet - Bourges - Bréhier - Breton - Brisjarrain - Buchan - Camus - Carco - Caron and Hutin - Carrouges - Castex - Cauvain - Céline - Cervantes - Champfleury - Chateaubriand - Châtelet - Chesterton - Chirico - Claudel - Cocteau - Collection, *Que sais-je?* - Conrad - Constant - Cooper - Corneille - Courteline - Crofts - Dard - Debussy - Defoe - De Quincey - Dervalhens - Descartes - Dickens - Diderot - Diogenes - Dostoevsky - Doyle - Duhamel - Dumas - Dupuis - Duranty - Eckhoud - Ewers - Faure - Fénelon - Fichte - Flaubert - Fontaine - Foucault - France - Fromentin - Gautier - Gengenbach - Gerbaud - Gide - Gobineau - Gourmont - Gracq - Grasset - Grimm - Guzman - Hammett - Hamp - Hardy - Harte - Hegel - Heidegger - Hello - Helmut - Hicks - Hoffmann - Homer - Hugo - Huttin - Huysmans - Hyppolyte - Ibsen - Irish - Jacob - James - Jammes - Jankelevitch - Jerome - Jouhandeau - Jouve - Jünger - Kahn - Kafka - La Bruyère - Laclos - La Fontaine - Laforgue - Lautréamont - Lavelle - Léautaud - Lebel - Leroux - Lesenne - Louÿs - Mac Orlan - Maeterlinck - Mallarmé - Malebranche - Mann - Maritain - Mauclair - Maùpassant - Mauriac - Mauron - Mehl - Merimée - Michelet - Molder - Molière - Montesquieu - Munier - Nabokov - Nerval - Novalis - O'Henry - Page - Pascal - Pater - Paulhan - Penent - Perelman - Peret - Pergaud - Plato - Poe - Proust - Queneau - Racine - Radcliffe - Raitt - Renan - Renard - Renouvier - Restif de la Bretonne - Reverdy - Rilke - Rimbaud - Rivière - Romains - Rosner - Rousseau - Roussel - Saint-Martin - Saint-Simon - Sainte-Croix - Salmon - Sartre - Scheller - Schwob - Scott - Scutenaire - Ségur - Sévigné - Sherriff - Sophocles - Souvestre and Allain - Spinoza - Stendhal - Stevenson - Stout - Thomas - Tolstoi - Tzara - Valéry - Van Loon - Verlaine - Verne - Vialatoux - Vigny - Villiers de l'Isle-Adam - Vilmorin - Wahl - Waldberg - Weil - West - Whitehead - Wilde - Wilder - Zweig

68 Photograph of René Magritte in his library at 97 rue des Mimosas, Brussels, Belgium, 1965

The passages that *always* leave me indifferent (and this is strange) are those in which some actions (not unlike other actions) occur as dreams, hallucinations, or daydreams. This is probably because in real life I place an equal value on things that happen to me asleep or awake; what I see when I read occurs on a level that should remain as it is and not be split up, as happens when the writer gives me a dream text. I stress the "pure pleasure" reading can give. For reading can produce other effects, and then it's no longer a question of pleasure, but something else: for example, laborious study when reading a manual on the art of lacemaking, instructive study in reading Freud, annoyance when reading one's tax return, etc. . . .
——*Letter from René Magritte to Malet, February 28, 1948*

I'm reading *Au Pays de la Magie* and it's a revelation to me. I think it's one of the most beautiful books.
——*Letter from René Magritte to Louis Scutenaire, undated*

Like you, I am sensitive to certain beautiful things —Debussy's music, for example, Futurism, good stories *(Carmen,* Conrad's *Typhoon,* etc.)—but they do not call into question my conception (if I may use the word), my feeling of what we are. Any activity (painting, writing pamphlets or poems) that does not involve us fundamentally seems to me worthless and depressing in advance.
——*Letter from René Magritte to Maurice Rapin, March 22, 1958*

I've read something beautiful:
 "When a work is really *absolute,* divine, nothing corporeal is ever mingled with it, never. The corporeal, *physical meaning* of the work must always be lacking either in the work or in the artist when this *meaning* seems rationally necessary in order for art to emerge and express itself."
 ——*Reliques,* Villiers de l'Isle-Adam, 1954
——*Letter from René Magritte to André Bosmans, March 20, 1960*

This morning I received *L'Art Magique**—a big book for rich people—eccentric and annoying typography—two reproductions of old paintings of mine (as though I'd stopped painting since) and my response to the questionnaire—no "abstract" painters (although the author has shown no distaste for these vacuities . . .).

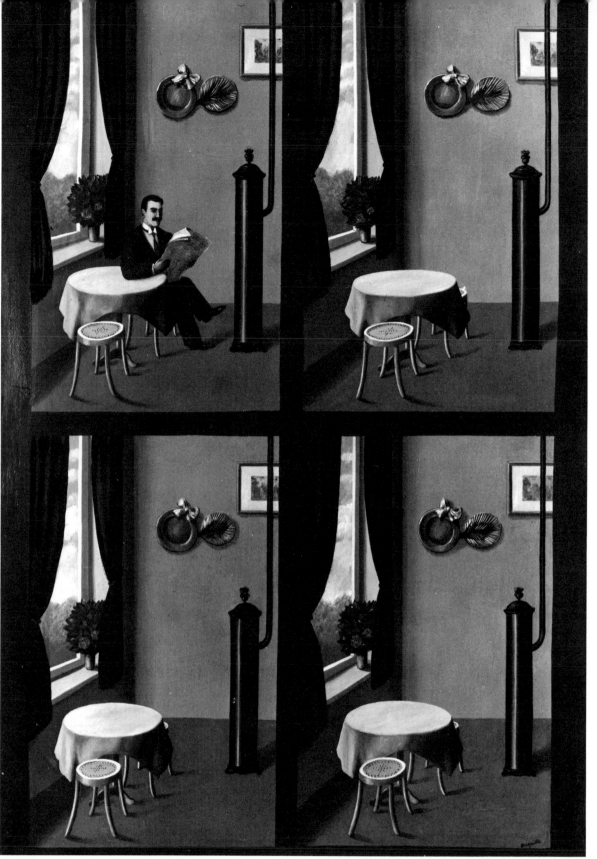

69 *L'homme au journal (Man with Newspaper).* 1927. Oil on canvas, 45⅝ x 31⅞" (116 x 81 cm). The Tate Gallery, London, England

 This book disgusts me, probably because I'm more sensitive than Breton. He's not disgusted, I can easily imagine him being "above" such annoyance.
——*Letter from René Magritte to Paul Colinet, September 1957*

*An anthology published under the aegis of R. Gaffe

Alain-Fournier

I was delighted by a sentence in your letter: "When I was a child, I thought newspapers were only for the erudite." A story that began like this and then went on with the same felicity would be the most beautiful thing one could read.
 Le Grand Meaulnes, as I recall, is a novel that at certain moments gave this kind of reading pleasure.
——*Letter from René Magritte to André Bosmans, May 4, 1959*

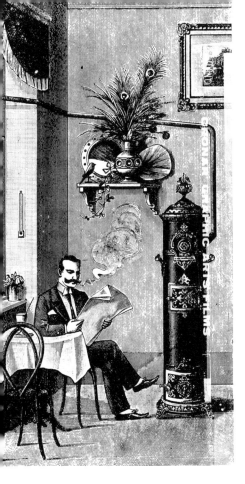

70 Untitled illustration in *La Nouvelle Médication Naturelle* by F. E. Bilz (edition translated from German), 1899, vol. 2, p. 1445, fig. 392. Archives Pierre Alechinsky, Bougival, France

I found the drawing of *L'homme au journal (Man with Newspaper)* in an old medical book by Dr. Bilz. I can show you this book.
——*Letter from René Magritte to André Bosmans, December 6, 1960*

Alphonse Allais

I happen to be rereading Allais, and you mention him: what a terrific guy! Do you know (probably yes) the little masterpiece *Le Bon Amant?* and *Nature Morte* (Volume: "A l'Oeil"—Flammarion)? For that matter, one ought to list all the rest—they're magnificent. *Nature Morte* contains some remarkable insights into painting.
——*Letter from René Magritte to Maurice Rapin, February 28, 1958*

When the joke reaches the pitch to which Alphonse Allais, for example, brings it, it's obvious that then this joke becomes frightening or loses its charm in those circles that are [interested in] being amused. Thus Allais is not a littérateur who really belongs to the literary world.
——*Letter from René Magritte to Maurice Rapin, March 15, 1958*

Guillaume Apollinaire

I'm reading a marvelous book—Apollinaire's *Le Flâneur des Deux Rives*. It has to do solely with *reality,* but a charming reality with occasional touches of the surreal. During my reading, which is still in progress, I haven't come across one ill-chosen word, if there indeed are any in this book (aside from the dedication to one of his friends "dead on the field of honor"!—which is a pity, both for the friend and for the poet Apollinaire). It's fine for Apollinaire to be distraught. But to be made distraught by patriotism is incomprehensible to me. It supposes a defect (which can be serious, especially in someone who can write such beautiful things).
——*Letter from René Magritte to André Bosmans, July 1959*

Gaston Bachelard

I cannot like Bachelard's thinking. He "represents" (for me, to the extent that I cling to the sacred) one of the foremost accountants of those pestilential evacuations of the scientific-poetic brain. One of the effects of this infectious disease is precisely demonstrated by the shape now being established for the earth (elliptical). A painter who draws the earth this way (there are many of them nowadays, when novels dealing with the future are being called "science" fiction) is giving proof of his satisfied innocence, which we must hope will not be permanent.
——*Letter from René Magritte to André Bosmans, December 6, 1960*

Georges Bernanos

I am trying to read Bernanos' *La Joie.* Is that stupid of me? I understand hardly any of it (I might understand it and not like it). Still, it is possible for a book like this to be interesting—it obviously has a real power over those who feel obliged to measure their own mediocrity against Bernanos' "lofty" sentiments.
——*Letter from René Magritte to Mirabelle Dors and Maurice Rapin, September 6, 1956*

Jorge Luis Borges

Last night and today I have been reading some Borges that Georgette gave me. My first impression hasn't changed: it's a kind of mind I don't like. I admit he "mixes up" a lot of ideas I don't "get" at all. (He "mixes" like loquacious and ineffectual speakers—who aren't totally ineffectual, since they produce unbearable boredom.) I don't mind his creating illusion, his bluffing, or his posing as an "honest man," but in spite of all the sham brilliance of his discourse, I consider Borges to be an educated *prick*. . . .
——*Letter from René Magritte to Paul Colinet, June 1957*

I went on reading Borges for lack of anything better; he continues to disgust me despite some curious notions I've come across. These curious notions (to me) are:
——The fear that horsemen have of the city. (This is curious, but it would be ridiculous to believe it.)
——That a certain disorder in a work of art must be controlled by some secret order. (This is curious but doesn't mean much—no more than the notion that a secret disorder enriches the apparent order of a work of art.)

——That Mark Twain's statement—that nothing could be worse than a human being—is "wise."
One of Borges' notions that seems *true and pleasant* is that if the number of possible books is indeed limited by the possible combinations of the letters of the alphabet, the manner or the *spirit* in which we read them is *limitless.* (Here I feel we are getting at something.)
——*Letter from René Magritte to Paul Colinet, July 1957*

André Breton

Like you, I find Breton depressing. He is no longer seeking the "philosopher's stone" (did he ever?). His current activity seems to me to be set once and for all, and *very serious* it is. I had already noticed this "seriousness": one day around noon he went to visit Éluard, who made excuses for not inviting him in. Éluard was very busy with an "orgy" at home. Breton thought that that sort of thing should take place in the evening, [and] that it illustrated lack of "order" or what-have-you on Éluard's part.
——*Letter from René Magritte to G. Puel, March 8, 1955*

. . . Breton seems to have succumbed to senility. If he was formerly the spokesman for a movement we all valued very highly, could it be because he got away with saying things by giving them disputatious meaning? God only knows what he was trying to say with "Freedom colors man". . . .
——*Letter from René Magritte to Mirabelle Dors and Maurice Rapin, March 7, 1956*

We have also heard that Breton just died, more than sad news: one is deeply affected by the disappearance of a truly irreplaceable person.
——*Letter from René Magritte to Harry Torczyner, October 30, 1966*

E. M. Cioran

Your *Précis de Décomposition* is precious due to reading pleasure it so abundantly affords. Yet when you deal with illusion, you seem to find it necessary to deduce that Bach and Shakespeare, for example, would have been incapable of attaining a certain perfection—which is not illusory—without pessimism or optimism, although neither has ever bestowed genius on anyone.
One can state without illusion that perfection can be achieved in every field, since the terms *perfection* and *illusion* are unrelated. Perhaps, then, neither rejoicing nor despair are called for.
——*Copy of a letter to E. M. Cioran by René Magritte forwarded to André Bosmans, July 14, 1963*

Cioran's ideas are indeed "interesting" if often very debatable. If we want to verify such ideas, we have no alternative but the pleasure of debate. In the final analysis, the author seems to be "in good health" but feels the need to appear "sick."
——*Letter from René Magritte to André Bosmans, August 11, 1963*

Paul Claudel

I read *Le Soulier de Satin* as you suggested, and do you know what it made me think of? It's that Claudel speaks like a woman when he is writing dialogue for a female character, and afterward he feels obliged to put himself in a soldier's shoes. This is the phenomenon that struck me above all.
——*Letter from René Magritte to Paul Nougé, May 1930*

René Descartes

Descartes' work, fascinating though it must have been when it first appeared, today is only useful as an outdated scheme of references for academic philosophers and is hardly more than an elegant example of the art of writing. However, Descartes dared to attempt to rid the human mind of the false notions that acted as prohibitions on the use of the intellect. In giving examples of intellectual meditations, Descartes made use of the "material" of his time—that is, God and the real existence of the physical world. Although the exercise of the intelligence was a valuable example to follow, the disappointing material Descartes had to work with could only yield poor results, such as the logical proof of the real existence of the physical world.
——*René Magritte, La Lutte des Cerveaux, 1950*

Paul Éluard

Dans les plus sombres yeux se ferment les plus clairs/The darkest eyes enclose the lightest.
——*A line of Éluard that Magritte often quoted*

André Gide

André Gide may have swelled the clientele of the criminal courts, but I doubt it, since that clientele is hardly literary. For that matter, a writer has no more power than anyone else to change the order of the world in any way whatsoever.
——*Remarks by René Magritte reported by Georges Amphoux, "Conversation avec un Surréaliste: Les Idées de Magritte," Cahiers des Arts, February 1958*

Joseph-Arthur Gobineau

. . . Gobineau is very good. But I'm afraid you'll be disappointed if you expect anything more than unique reading pleasure. This pleasure is already something—it's even quite rare—but in my opinion Gobineau never wrote an idea that was not self-satisfied.
——*Letter from René Magritte to André Bosmans, February 19, 1959*

René Guénon

. . . *La Crise du Monde Actuel* by Guénon. This book contains some very interesting ideas, among them the following: it is a mistake to believe in "progress," because the world is going downhill (scientific "progress," for example, is actually the sign of an increasing lack of spirituality).

Guénon accepts as a certainty that there was a perfect knowledge of truth in ancient (prehistoric) times, and that all that remains of [this understanding] is to be found in Tradition (not a "human" tradition, such as one usually assumes). This is an interesting notion, but it flatters our "piggish" instincts that must have "everything" to be satisfied. This piggishness doesn't deserve support despite its fleeting interest.
——*Letter from René Magritte to Paul Colinet, 1957*

Martin Heidegger

Since I'm interested in the story and not style, I don't have anything to read. I just received some books I ordered from La Proue, and they're all pretty dull: Paul Morand's *Fin de Siècle*, Gobineau's *Lettres Persanes* (I thought they were short stories), Heideger's [sic] *What is Philosophy?*—which I read first, but without pleasure. Heidegger reminds me of Gide's remark that "good literature is not made up of fine sentiments." However, Heidegger reveals the astonishment of a true philosopher as a precondition for proper thought. Gide did not, certainly, disdain such feelings as attention and need when he wrote, did he? These "great minds" are sometimes really pretty small.
——*Letter from René Magritte to Paul Colinet, 1957*

. . . Heidegger evokes mystery when he poses the question, "Why, in sum, is there something rather than nothing?"; Éluard does when he says, "The darkest eyes enclose the lightest"; Breton: "It's me, open up!"; Nougé: "We are responsible for the universe."

There are plenty of examples, all evocative without being more "effective" for this reason. Only practical things are effective—"poetry" only works for people who like (who have a preference for) unusual emotions; it is useful, like morphine.
. . .

Mystery, however, cannot be evoked—it is "sterile," "empty," "without content," "incapable of changing anything for better or worse." It is miserably and ridiculously reduced to being the absolute and necessary principle by which reality can exist, by which the most absurd things and the most sublime things can be made manifest. . . .

In order to evoke mystery, one must always say something new and different. If what you are going to write or what I am going to paint were not unknown to us at this time, we would spend the future studiously imitating, like priests do, what has already been manifested.
——*Letter from René Magritte to André Bosmans, August 26, 1959*

Stéphane Mallarmé

Rereading Mallarmé, I see that it involves a game very much like chess. The game is not worth the effort.
——*Letter from René Magritte to Paul Nougé, August 14, 1946*

Mallarmé's death is the end of a human era in which poets could give the word *poetry* the meaning of an inspired expression. Mallarmé, also concerned with *what is expressed*, gave it an

71 *Paul Éluard.* 1936. Drawing, 17¾ x 23⅝" (45 x 60 cm). Collection Domen, Antwerp, Belgium

impact that has not been surpassed; his book was intended to be the supreme manifestation of the Universe. . . .

The word *poetry* enjoys a reputation that suffices for hard-to-discourage authors to settle for fairly undistinguished writings that they call poems. At present, it adds only confusion to the knowledge we have of the effects of research into certain feelings and certain almost commonplace ideas. (Examples: the sympathy one can feel for a stone; the idea of creation without a creator.) No attempt should be made to reduce these effects to any meaning, even a poetic one. They have no meaning, they *are* a meaning.
——René Magritte, "Quel sens donnez-vous au mot 'poesie'?", La Carte d'Après Nature, January 1954, special issue

Raïssa Maritain

I read Raïssa Maritain's book *almost* as I would read an adventure story by Ponson de Terrail. It's funny, this family of intellectuals praying with all their might. It's almost as picturesque as the circles frequented by Rocambol. Also curious is the state of mind that characterizes Guérin's "unhappy life" as something remarkably exceptional. . . . I'm an ungrateful reader, and that bothers me, since I appear to be picky.
——Letter from René Magritte to Paul Colinet, 1957

Maurice Merleau-Ponty

Merleau-Ponty's very brilliant thesis is very pleasant to read, but it hardly makes one think of painting—which he nevertheless appears to be dealing with. I should even say that . . . the way he talks about painting is like discussing a philosophical work by studying the author's penholder and paper. (On page 225, he talks about "painters of matter" as though "matter" aroused new interest, had some new existence by virtue of being manipulated by a painter!) Descartes dealt with drawing, but thought primarily of copperplate engraving. He had a hard time seeing the drawing through the copperplate engraving, which is actually a process and not the drawing.

I think Merleau-Ponty's essay would be more illuminating if it were limited to the "question" of the visible world and man. Painting is not inseparable from this "question," of course, but it is not interesting unless it is conceived as an evocation of mystery. The only kind of painting M-P deals with is a variety of serious but futile divertissement, of value only to well-intentioned humbugs. The only painting worth looking at has the same raison d'être as the raison d'être of the world—mystery.
——Letter from René Magritte to De Waelhens, April 28, 1962

72

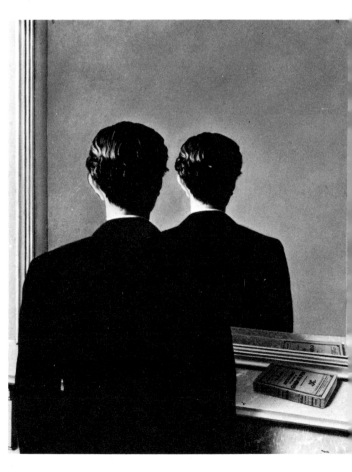

74

72 *Schéhérazade (Sheherazade)*. 1947. Gouache, 6⅞ x 4¾" (17.6 x 12.2 cm). Collection Robert Rauschenberg, New York, New York

73 *Le manteau de Pascal (Pascal's Coat)*. 1954. Oil on canvas, 23½ x 19⅝" (59.7 x 49.8 cm). Private collection, United States

74 *La reproduction interdite (Not To Be Reproduced)*. 1937–1939. Oil on canvas, 32 x 25⅝" (81.3 x 65 cm). Collection Edward James Foundation, Chichester, England

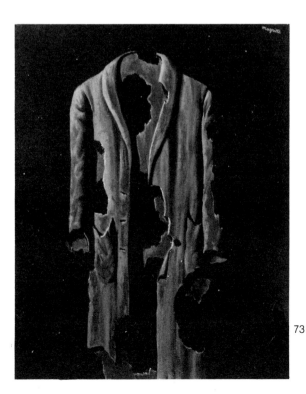

73

Poetry

Mesens: What does the word *poetry* mean to you?
Magritte: I know the poems of Baudelaire, Mallarmé, Nerval, and some other poets. Like everyone else, I have poetic *memories,* and they *intervene* at certain moments in life. Thus, when I gaze at a starry night I find among the other aspects of this spectacle a "poetry" of the stars (poetic memories of written things). Thus I consider that now poetry *is given,* like the other elements in a spectacle or another moment in life. The poetry of a Flouquet or a Goffin clumsily conveys what is *given,* which is to say that these authors are both useless and easy to please.

If we consider the *effects* we are seeking—in real life, when we find the means for bringing them about with available resources . . . in pictures, in *writings* (not *poems,* a word appropriate to Goffin or Flouquet's endeavors)—it becomes apparent that if poetry is discussed with regard to these effects, confusion sets in, and anyone who thinks "poetry" thereby proves that these effects escape him.

I feel this point is important; I believe it justifies the question I posed. Scut [enaire] and Colinet are replying in the same sense as I. Nougé and Mariën in *almost* the same sense. As for the other replies, they all confuse "given poetry" with *creative or expressive poetry,* as Baudelaire, Poe, and others who create poetry justifiably declared.
——*Letter from René Magritte to E. L. T. Mesens, November 5, 1963, in response to a questionnaire on the definition of poetry suggested by Magritte*

Maybe the "right" kind of reader likes all of Racine, Hölderlin, Baudelaire, Verlaine, or Rimbaud. Not me: only a few isolated lines strike me as being brilliant. . . . I always wish a poet (or painter) would only call upon or illustrate that which cannot be "thought."

I only know Hölderlin through the excerpts Heidegger comments on in his *Essence of Poetry.* It's obvious he likes Hölderlin, but (I feel) his comments are unfortunate. He addresses himself to the philosophical meaning of the poems, and the "essence of poetry" he seeks to define deals with a different kind of knowledge from poetic knowledge, which cannot be defined. He loves Hölderlin (and Van Gogh), but he has a strange way of writing about the object of his affections. To love and to analyze (even masterfully) his love is an odd practice, an odd preoccupation.
——*Letter from René Magritte to André Bosmans, January 20, 1959*

I *never* experience this reading pleasure with poems. Reading for the sake of reading cannot take place when I am getting to know a so-called poetic text. At times something is not in the text and seems to be telling me what I am missing.
——*Letter from René Magritte to André Bosmans, February 19, 1959*

I define poetry as the *description* of absolute thought—thought that cannot be modified by either interpretation or symbols. (Symbols are foreign to what is being symbolized.)

A writer's thought seems to be described by these two lines, for example:

> *It's me, open up!*
> ——André Breton

> *The darkest eyes enclose the lightest.*
> ——Paul Éluard

Rimbaud, too:

> *I saw a living room at the bottom of a lake. . . .*

On this subject, it seems remarkable to me that Rimbaud and the poets I most like never imagine anything "imaginary." Their thinking is imaginative: it is absolutely *that which is thought.* This thinking is real.
——*René Magritte, unpublished notes written at the Sheraton-Gladstone Hotel, New York, New York, December 16, 1965*

Raymond Queneau

My thanks also for the book on Queneau. Queneau is wrong to try to change the French language. It's fine as it is and quite adequate for writing beautiful things. Besides, it's the uninteresting people who turn to slang—or worse. [Queneau] can write properly and very pleasantly. "A rude winter," for example, would not find favor with Academicians (not by those who call themselves nonconformists).

His line: "I'm in a fairly ridiculous situation" reflects respectable French usage. All this is fine, except for old and young idiots who don't know how to respect anything.
——*Letter from René Magritte to André Blavier, September 19, 1961*

Arthur Rimbaud

When Rimbaud stated his fondness for idiotic naïve paintings, he was right in standing up to an official, petrified art. But at the time he was the only one who spoke in this way. Now that everyone shares that taste, it is no longer possible to tolerate such affectation with regard to painting.
——*René Magritte, La Lutte des Cerveaux, 1950*

John Ruskin

One must love Ruskin, that passionate devotee of art, for his freedom when he writes: "Let every work of art perish rather than the birds that sing in the trees."
——*René Magritte, La Pensée et les Images, exhibition catalogue, Brussels, May 1954*

Jean-Paul Sartre

I have reread Sartre's *Baudelaire,* which I first read a long time ago. I soon put it down, because it irritated me. Sartre is incapable of thinking that Baudelaire could have liked Poe's stories simply because they are admirable; he explains Baudelaire's interest in Poe by the motives psychoanalysts are so fond of. He doesn't even merit the distinction of having discovered this kind of explanation himself.
——*Letter from René Magritte to André Bosmans, March 2, 1964*

Being and Nothingness . . . is excellent as an exercise, I believe. I don't know it well enough to be able to discuss it with "authority." Sartre's technical language is barely accessible to the "uninitiated." He has been chosen by the jury for the Nobel Prize. I don't think this jury does anything haphazardly: Sartre's thought doesn't disturb them, but Sartre doesn't seem flattered that this "honorific" distinction was bestowed by a *jury composed of "honorable men."* He deserved it one way or another, and it is my opinion that he "deserved" it despite whatever unpleasantness it may imply for us. . . . His *Nausea* . . . was interesting enough. However, what he says elsewhere about art and about poetry is not.
——*Letter from René Magritte to André Bosmans, October 29, 1964*

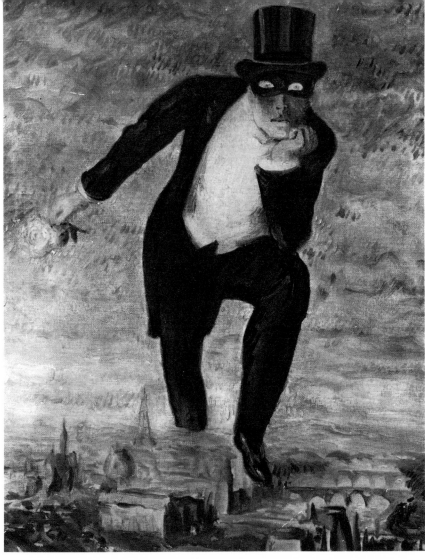

75 *Le retour de flamme (The Backfire)*. 1943. Oil on canvas, 25⅝ x 19⅝″ (65 x 50 cm). Collection M. and Mme. Émile Langui, Brussels, Belgium

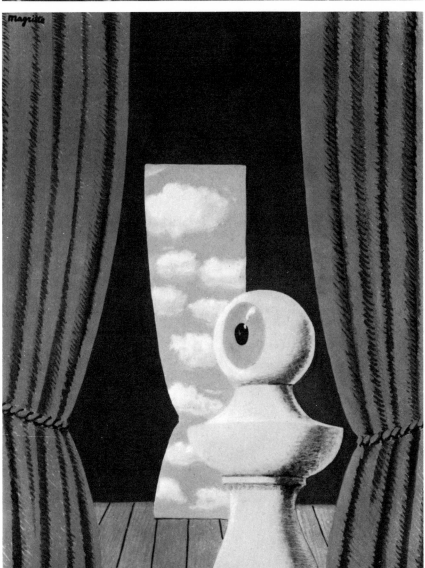

76 *Hommage à Shakespeare (Homage to Shakespeare)*. 1963. Gouache, 13⅝ x 10¼″ (34.5 x 26 cm). Collection Evelyn Musher, New York, New York

André Schwarz-Bart

A book [I] read passionately (to about half the way through) is *The Last of the Just*.
——*Letter from René Magritte to André Bosmans, December 26, 1959*

Shakespeare

HOMAGE TO SHAKESPEARE

Brutus: No, Cassius: for the eye sees not itself
But by reflection, by some other things.
——*Julius Caesar,* Act I, Scene 2

——*Quotation written by Magritte on the back of the gouache*

Souvestre and Allain

Your reading *Fantômas* reminds me of those moments of "innocent youth" when I followed the adventures of the King of Horror with utter trust in his genius.
——*Letter from René Magritte to André Bosmans, February 19, 1966*

Theater

I received your letter about stage design. I have been asked to imagine some, but I don't believe imagination should play a part in the painting of scenery. The imagination of the playwright should suffice to arouse us.

Scenery need only have the appearance of landscapes or interiors in the real world. It need not "express" the spirit of a play, since the author has done this himself by writing it.

In my opinion, scenery must have the appearance of reality, but only the appearance—just as the actors should only appear to be the characters they portray. (This is why, for example, a real doctor would act the role of a doctor badly.)

I know that I am unwilling to accept an "avant-garde" conception of theater and that I may seem old-fashioned. I am convinced that the preoccupation with new methods testifies to an overall confusion and to a puerile imagination. The value of the imagination consists in discovering what one must think, what is important to us.
——*Letter from René Magritte to Serge Creuz, April 18, 1967, in* Beaux Arts *(Brussels), no. 1166, May 6, 1967*

A Thousand Nights and One Night
——*French translation by A. Galland, 1646–1715*

I'm starting to reread *A Thousand Nights and One Night* with pleasure—will it continue?
——*Letter from René Magritte to Paul Nougé, August 19, 1946*

le _____ octobre 1958

Cher ami,

j'attends toujours le signe De Maerel pour que je porte à la Sabena le beau petit paquet. Je patiente pour vous et je suis impatient de savoir ce que vous penserez de mes efforts particulièrement attentifs à ne pas nous décevoir — (pour ma part, je suis satisfait de votre portrait, de la Tour de Pise au soleil couchant et de la "country" au reverbère allumé sous un ciel clair du Midi —)

En résumé, tout est prêt, il n'y a plus que De Maerel à s'apprêter —

Reçu la photo de Rex Stout qui a un curieux visage orné d'une barbe peu abondante de poils-cheveux blancs — S'il vous arrive de lire des romans policiers, je vous conseille cet auteur (inégal sans doute, mais très amusant) —

à bientôt de vos nouvelles j'espère et bien à vous Rue Magr—

77 Letter from René Magritte to Harry Torczyner, October 2, 1958. *See* Appendix *for translation*

Paul Verlaine

I'm sorry I can't go along with you about Verlaine's *Oeuvres Libres.* This kind of poetry bores me. I'm returning the manuscript to you in the hope you won't follow up on your intention to translate and publish it. There are already too many "specialists" in the world involved in this kind of work.
——*Letter from René Magritte to Volker Kahmen, September 8, 1966*

Jean Wahl

I read your *Survey of French Philosophy* a long time ago, and more recently I read your *Treatise* with another kind of interest, because I found in it the idea—astonishing for a philosopher—that one must look for a richer vision of reality elsewhere than among the great thinkers (whose tradition somewhat overlooks the essential aspects of human nature).

With only an academic interest (which does not exclude passion) for the "great problems," one can (this is true for me and I suspect for you, too) "deal" with them and devote oneself to them without either hope or despair. This is how I "deal" with painting, to *evoke* with the unknown images of the known the absolute mystery of the visible and the invisible.
——*Letter from René Magritte to Jean Wahl, February 3, 1967*

Oscar Wilde

. . . that old Oscar Wilde, in the Preface to *Dorian Gray,* said something very apt. I'm quoting from memory: "Those who create something useful have no excuse for admiring what they have made." "Those who create useless art cannot admire it too much."*

Oscar Wilde, by the way, was too much the artist for me to admire him. He amuses me sometimes, no more.
——*Letter from René Magritte to André Bosmans, August 26, 1959*

*The correct quotations from the Preface to *The Portrait of Dorian Gray* (1891) are:
"We can forgive a man for making a useful thing as long as he does not admire it."
"The only excuse for making a useless thing is that one admires it intensely."

Zen

Like everyone else, I've read books about Zen, and I haven't been disappointed, for although my curiosity was satisfied I never expected to experience any revelation that would overwhelm me once and for all and thereby give me the comfort of believing in some metaphysical religion. Despite reference to the development of ideas fit for Brahmins or fakirs, and the temptation to bring out tendencies presupposed in Zen texts. . . .

In fact, it would be too easy to discuss my painting from the point of view in which Zen (or even aesthetics) is introduced to please lovers of classical esoterism. Remember that I like "the conveniences," including those that provide sordid comfort. But to confuse this need with the kind of whims that immobilize us is taking a big step.
——*Letter from René Magritte to G. Puel, May 19, 1955*

Émile Zola

In the duel between Zola and Malarmé [sic], Zola wins: all things are equal (despite some being less rare than others). Zola is merely uttering a platitude, in the sense that it is obvious that all things are equal. Thus, he is "right," but is nonetheless wrong to utter a platitude.

What Mallarmé should have replied is that one may *prefer* some things to others. (To prefer them because they are rarer is a motive worthy of a businessman.)
——*Letter from René Magritte to Suzi Gablik, January 28, 1963*

Lourdes is a good novel *of its type,* [but] contains less information than I had thought.
——*Letter from René Magritte to André Bosmans, April 8, 1964*

Music

List of some of Magritte's favorite composers, compiled by Georgette Magritte: Albeniz - Albinoni - Bach - Beethoven - Brahms - Chabrier - Chausson - Chopin - Cimarosa - François Couperin - Debussy - Duparc - Dvořák - Falla - Fauré - Franck - Gershwin - Granados - Grieg - Handel - Haydn - Hindemith - Lully - Mahler - Mendelssohn - Mozart - Pergolesi - Poulenc - Puccini - Purcell - Rachmaninoff - Rameau - Ravel - Respighi - Rimsky-Korsakov - Saint-Saëns - Satie - Scarlatti - Schoenberg - Schubert - Schumann - Smetana - Stravinsky - Tchaikovsky - Turina - Vivaldi - Wagner

79 Cover of sheet music for "Norine Blues" (music by Paul Magritte). Collection Mme. René Magritte, Brussels, Belgium

78 *Moments musicaux (Musical Moments)*. 1961. Collage and gouache, 16⅜ x 11⅝" (41.5 x 29.5 cm). Private collection, Lake Mohegan, New York

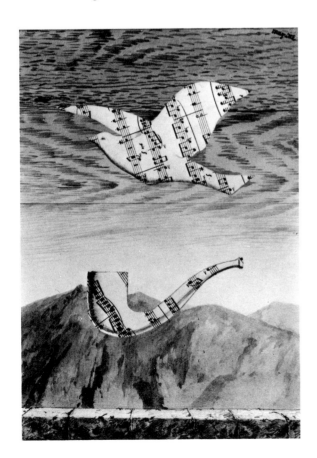

. . . about 1923, I sold my first canvas to Evélyne Brélia, a singer who later married Fernand Quinet and who was murdered. . . . But that's another story. I sold that canvas for 100 francs. Evélyne Brélia liked my painting very much. She also adored music: Debussy, Ravel.
——*Remarks by René Magritte reported by Goris, 1962*

80 *Evélyne [Bourland] Brélia.* 1924. Oil on canvas, 18 x 11⅞" (45.6 x 30.1 cm). Collection de Sutter, Brussels, Belgium

I think the title *Moments musicaux (Musical Moments)* fits the collage with the pipe and the bird. This title could be applied to several works (like certain other titles such as *L'art de la conversation, Stimulation objective [Objective Stimulation]*, etc.). . . .
——*Letter from René Magritte to Harry Torczyner, February 6, 1962*

Must we believe that music can "express" ideas, which in my opinion cannot really be described other than with words?

I am convinced that the term *expression* is only rhetorical when understood as "expressing feelings, sensations, or ideas." For me, *expression* implies only a language that describes what one thinks.

That that one thinks and that is associated with words cannot be described by music, painting, cold cuts, woodworking, or any other "discipline" except that of words.

So? Do you really believe that Berg's or anyone else's music contains any meaning other than the one it manifests? And if this were true, wouldn't the other "hidden" meanings necessarily be immaterial? (For when they are "revealed" by an author or critic, they are always ridiculous as ideas, feelings, or sensations "to be expressed," worth the trouble of being communicated by artistic means.)
——*Letter from René Magritte to André Souris, December 5, 1963*

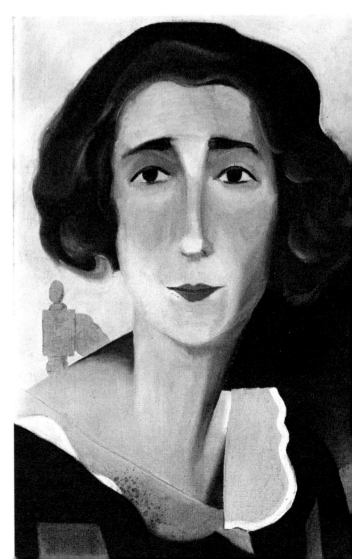

Memories of Travels

Paris is a beautiful city without any raison d'être; aside from great vistas, it's a vacuum.
——*Letter from René Magritte (Paris) to Paul Nougé, May 13, 1948*

The few days I spent in Paris gave me the impression of a ghost town, where medieval mysticism has merely been transformed into a commercial, political, industrial, scientific mysticism . . . or artistic! (Paris is not an isolated case—it's the same everywhere.)
——*Letter from René Magritte to Mirabelle Dors and Maurice Rapin, January 23, 1956*

82

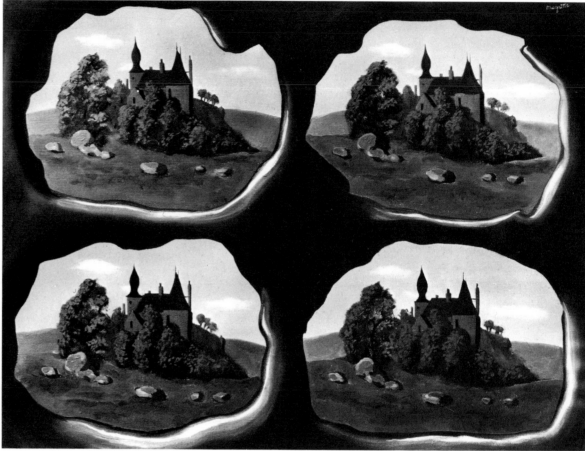

81

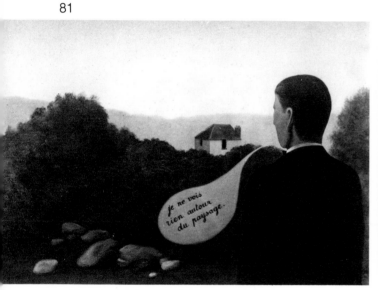

I saw some mountains on the way back through Switzerland (that boring country). As one nears Switzerland, France becomes Swiss and makes escape that much easier. You can't wait to get rid of the chalets and cheeses. Mountains quickly bring on indigestion (contrary to what I just read in *Le Rapport d'Uriel* by Benda,* for whom mountains command respect due to their impressive immobility). I recommend Benda to you; he's very amusing reading: he's nearly always angry and never stops attacking so-called reasonable doctors.
——*Letter from René Magritte to Mirabelle Dors and Maurice Rapin, July 23, 1956*

*Julien Benda (1867–1956) was a French philosopher and littérateur known for his antipathy toward Bergson and others who had turned from intellectual discipline toward a more mystical interpretation of the world

I am spending my vacation at home. During the first half of June I'll probably go to Zoute (Belgian coast resort). That will depend on the temperature, which isn't very high here: mornings and evenings one gladly wears a coat.
——*Letter from René Magritte to Harry Torczyner, May 25, 1957*

My vacation is being spent at home—I only see the disagreeable side of travel plans. I am completely devoid of the kind of imagination one needs to "set off" on a trip.
——*Letter from René Magritte to André Bosmans, May 26, 1958*

83

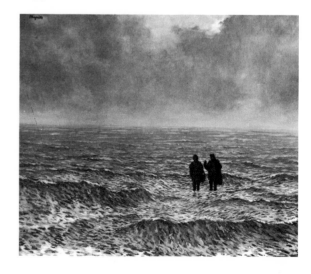

Adresse complète :

La Madonnina Hôtel
Casamicciola Terme
ISCHIA (Via NAPOLI.)
ITALY

CASAMICCIOLA TERME (NAPOLI)

le 22 ~~Août~~ Avril 1965

Bien cher ami,

Je reçois votre lettre du 17 Avril avec grand plaisir : c'est le premier signe pour nous de l'existence d'un centre control que cette île étrangère. Jusqu'à présent, il a fait un froid de canard, ici, « au pays du soleil ». Je ne sais si les bienfaits de la cure ne seront pas compromis par la température peu satisfaisante qui règne ici (L'Hôtel n'a pas de chauffage). Au point de vue gastronomique, il s'agit de "surprises" étonnamment « en contraire » : Poulet filandreux accompagné d'un emplâtre vert épinard. Potage « crème de légumes », difficilement à distinguer d'une frappe de tapisserie. Nous sommes dans, paraît-il, le meilleur hôtel de Casamicciola. Je pense que nous sommes venus trop tôt : la bonne saison (si elle n'est pas un mythe) se montrera après notre retour à Bruxelles.

Quant à la cure, elle dure une bonne heure : 1° bain de boue 2° bain d'eau de la montagne 3° repos 4° massage. Cela se passe vers 8 h du matin, à jeun. Pas d'amélioration déjà du statu quo sanitaire à Bruxelles. Je dois faire un effort pour écrire, pour m'asseoir, me coucher, etc.

Je ne sais que vous conseiller pour satisfaire les demandes d'expositions. Kansas City, par exemple, il faudra peut-être y renoncer si le musée de N.Y. a fixé une date qui ne permet pas d'organiser plusieurs expositions ?

Georgette et moi, nous avons été très contents d'avoir de vos nouvelles. Nos meilleures amitiés pour vous et pour Marcel.

R.M.

(Je vous ai adressé le 16 une carte via air mail, ainsi qu'à Suzi).

84 Letter from René Magritte to Harry Torczyner, April 22, 1965. *See* Appendix *for translation*
85 *La nuit de Pise (Night in Pisa).* 1958. Oil on canvas, 15 x 11⅜" (38 x 29 cm). Collection Mrs. Jack Wolgin, Philadelphia, Pennsylvania

85

The Tower of Pisa is called *Souvenir de voyage (Memory of a Voyage)*. With its feather, it is "upright," as in the first picture in which it appeared. The "recumbent" position . . . is unnecessary, I feel, for it to express what is necessary. Thus, rigid moralists are bound to find it inadequate.
——*Letter from René Magritte to Harry Torczyner, October 20, 1958*

I got back from London tired out from the opening. There are too many people to talk to. I've come away with an unpleasant feeling about airplane trips: the reduction in distance is paid for by a loss of tranquillity; I do not have total confidence in machinery. Still, London seems to have a "power" that Paris, for example, seems to lack. . . .

Finally, I had a fine idea for a painting the night I spent in London: in the middle of a large city, a candle towers very high and lights up the night. You will probably see this image when you come at the beginning of next month. I hope to be able to start painting it very soon.
——*Letter from René Magritte to André Bosmans, October 1, 1961*

We may go to America, but the decision has not been made completely. We would rather go by boat than by airplane—we don't have enough confidence where the heavier-than-air is concerned; heavier-than-water seems less dangerous.
——*Letter from René Magritte to Suzi Gablik, September 29, 1964*

Here we are at Ischia—Georgette, Loulou, and I. We feel secure in a certain way because there are *carabinieri* here (as referred to by the accompanying sketch). I brought few books: Mallarmé's *Divagations, Stello,* and Edgard Poë [sic] are all I packed. We are going to see Vesuvius and Herculanum [sic] as tourist custom demands.
——*Letter from René Magritte (Ischia) to Marcel Lecomte, April 17, 1965*

Here, my good friends, you know you are on Italian soil. Everywhere on the island (which is rainy, cold, and damp) we are forever seeing the word *Italia: Cinema Italia, Ristorante Italia, Pensione Italia, Tabacchi Italia,* etc. Handsome specimens of the race Italia are practically nonexistent. There is one pretty young man who gave me a massage (he replaced Pepito, who is more experienced and nice, but so-so. He frequently bursts out laughing, saying "Capito." We say to him things like "cannelloni, spagetti [sic], macaroni," etc.). Georgette has Ramina as masseuse and Carmenina as bath attendant. They're nice, but would never win any beauty contest. The doctor who administers the "cure" smokes his 30 cigarettes a day. At the moment, it's thundering (thunder Italia).
——*Letter from René Magritte (Ischia) to Louis Scutenaire, April 26, 1965*

Sheraton-Gladstone Hotel
114 East 52nd Street
New York, N. Y. 10022
Room 703 Phone: Plaza 3–4300
(Please write the number seven
like this: 7, because written
like this: 7, the Yankes [sic]
don't understand what number it is.

December 10, 1965.

Dear Irène and Scut, New York isn't bad. For example, a moving (to us) reminder of *Uncle Tom's Cabin*—our chambermaid is black. (Actually, this black is more brown, but you wouldn't notice that.) Upon arrival (after eight long hours on the plane and around thirty kilometers by car) we saw New York by night (at 5 p.m., or midnight Brussels time), and it was magical. By the way I am just now telling Georgette, who has just got dressed, "You're looking very pretty"—so everything is going well, and will get even better. (This "better" does not include the many invitations we are getting: various cocktail parties, etc.)

During the day we stroll around the streets, which oddly enough seem quieter than the Rue Neuve in Brussels. This seven million population seems to live slowly. The tempo of New York life is not much different from that of Braine d'Alleu or Olignie.

Harry Torczyner has a very comfortable office, two secretaries (a white woman and a black woman—another reminder of Uncle Tom), and finally a normal assistant.

Georgette fed nuts to the tame squirrels in the park. Suzi [Gablik] took us there. She is going to have a show soon and curses you because of your deliberate absence from her city. She has shown me her paintings (which are actually "photomontages" she has colored and retouched). They are nice, but, strangely enough, although she has found beautiful titles for me *(La Joconde* [*La Gioconda*], *L'arc de triomphe* [*The Arch of Triumph*]),* hers is, for example, *Hermaphrodite Landscape,* and she is sticking to it, despite my suggestion to change it to *The New York Poet* (or *New York 1000 Years Ago,* for example).

I will end by sending you our affectionate greetings.

Mag. Georgette
——*Letter from René Magritte (New York) to Louis Scutenaire and Irène Hamoir, December 10, 1965*

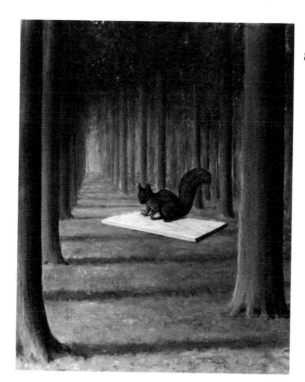

86

We are spending two whole days in Houston, "Western" country. At St. Thomas University, I was pleasantly surprised to find a large collection of my paintings (notably *La lunette d'approche* [*The Field Glass*]). I am delighted by the Texans' interest in my painting: it appears to be considerable. We are being royally entertained by Mr. and Mrs. de Menil.
——*Letter from René Magritte (Houston) to André Bosmans, December 19, 1965*

87

While Georgette is praying in a *Catholic* church in Houston (Texas), I am manipulating my ballpoint to tell you that fact and to prepare you for seeing me wearing a real cowboy hat and a shirt with metal buttons when we meet again among the mimosas.
——*Letter from René Magritte (Houston) to Louis Scutenaire, December 20, 1965*

86 *Le chef d'orchestre (The Orchestra Conductor).* 1954. Oil on canvas, 23⅝ x 19⅝" (60 x 50 cm). Private collection, Belgium

87 *L'étoile du matin (The Morning Star).* 1938. Oil on canvas, 19⅝ x 24" (50 x 61 cm). Marlborough Fine Art (London) Ltd., England

88 René Magritte at a rodeo in Symington, Texas, December 1965. Photograph by Adelaide de Menil

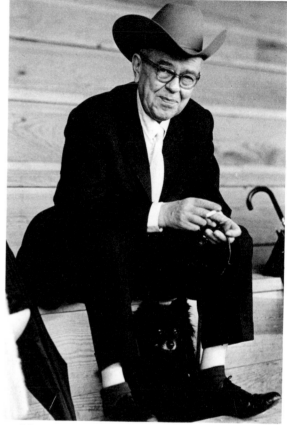

88

The trip to the "holy places" has not given me any religious feeling. But the country is very beautiful and one feels very much at home, even in the desert. Of course, we have been living here only under the best conditions.
——*Letter from René Magritte (Jerusalem) to André Bosmans, April 24, 1966*

Here we are, back from Israel since Friday evening. It was a fine trip: we visited the country north and south—it is very beautiful, and reminds me of a more primitive and more historic Côte d'Azur. We were given the best reception possible, like New York for that matter; despite being tired, we were enchanted, and hope to go back to Jerusalem under calmer conditions. That city's museum has some real treasures—the Dead Sea Scrolls and a beautiful Picasso exhibit. I have two pictures in the museum's (permanent) collection.

I'm starting to recover from the trip, which means that very soon I will be thinking about taking up paints and brushes again.
——*Letter from René Magritte to Harry Torczyner, April 25, 1966*

I don't travel in kilometers—I'm not a traveling salesman. Wherever I go, I say to myself: "It's just like I imagined it would be. I thought so."
—*Remarks by René Magritte reported by Guy Mertens,* Pourquoi Pas, *April 26, 1966*

It has stopped being as hot as a furnace. I wear dark glasses since the light is too brilliant and is therefore tiring. At the risk of shocking you, I will be glad to get back to the Northern mists, the Josephat Park, and the "Deux Magots" at the Porte Louise and the # 65 bus.
—*Letter from René Magritte (Cannes) to Louis Scutenaire, June 27, 1966*

90 Photograph of Edgar Allan Poe's chair and desk in his home in the Bronx (New York), New York

91 Photograph of (left to right) Alexandre Iolas, Marcelle Torczyner, and René Magritte at the opening of the exhibition *René Magritte* at the Museum of Modern Art, New York, New York, 1965. On the wall hangs *Le faux miroir (The False Mirror)*

PERSONAL VALUES

René Magritte considered it almost a duty to ignore the contemporary art scene, with the exception of those painters with whom he felt natural affinities—which he hastened to elevate to the rank of elective affinities—such as De Chirico, Max Ernst, and, much later, Klapheck. Of course, he also paid homage to Picasso and Braque, but only as Cubists. He had a certain regard for such women painters as Rachel Baes, Jane Graverol, and Leonor Fini, a regard due above all to his inherent gallantry.

Criticism's evil eye watched constantly over Magritte. He was called an illustrator, postcard manufacturer, a painter of no pictorial value whatsoever; his work was said to be an insult to intelligence! The benevolent gaze of friendly criticism, even more cruel, took pains to explain Magritte. Alchemy, the cabala, tarot, the art of mime, dreams, and fantasy were all called upon. Between the enmity of one group and the incomprehension of the other, Magritte sat back and accepted the inevitable.

As one once believed in the good savage, he would believe for a long time in the "good" revolutionary, be he Surrealist, communist, or both. Life for him was a threepenny opera with a new cast of characters: Violette Nozières, who poisoned her incestuous father, earned his homage; Dominici, the peasant patriarch who murdered an English lord, his wife, and daughter, inspired him to write a ballad. Although he discoursed, wrote, published manifestos, and took part in all the ritual demonstrations, Magritte knew deep down that his sole and real calling toward changing the world was to paint his images.

Magritte did not want to listen to talk about psychoanalysis. Mad ideas are proper, madness is not. Fantasies are suitable, the fantastic reprehensible. He affirmed the presence of the spirit and denied the influence of dreams. Obstinately he shut doors and windows to the evil spirits.

This extremely inquisitive man was not curious about scientific discoveries. Paradoxically, he considered the sciences a discipline devoid of interest because they applied themselves to the world of the possible. If scientists restricted themselves to mental speculations, they earned his respect, but the concrete goals they set for themselves diminished them in his eyes. Pure research and its uncertainties escaped Magritte.

The awareness, as he told me, that he would never be able to fathom the reason for existence on this earth preoccupied him unceasingly. None of the other questions that life poses seemed to have the same importance. Death, nothingness, of which he spoke dispassionately, did not worry him. He was obsessed with the "why" of the world.

Art

If we were to bother about an artistic hierarchy . . . André Lhote* would have little place in it, and could be left out with no great loss. On the other hand, Ingres and Picasso would have "prominent" positions. If an aesthete or art historian has any commonsense, he must agree with this. (Picasso, of course, as a Cubist, is a great figure in art history. The Picasso who followed in Lautrec's footsteps was superfluous.)
——*Letter from René Magritte to Maurice Rapin, March 15, 1958*

*André Lhote (1885–) is a French painter who has written and taught extensively about art. He was originally affiliated with the Cubists.

Unfortunately, we have to admit that many "artists" restrict their "messages" to information about the "importance" of the "material" they employ.
——*Letter from René Magritte to André Bosmans, July 10, 1963*

Abstract Art

. . . the current attempt to promote "abstract" painting on a popular level with a lot of help from artistic drill sargeants may be worthy of your assessment. In any case, one must either be for or against the stupidity that is trying to pass itself off as intelligence. Unfortunately . . . although Sacha Guitry* passes as being intelligent with those admirers who were moved by his [portrayal of] Napoleon, the Sacha Guitrys without theaters easily come to guide the consciences of "intellectuals" who think they are smarter than their grocers. In addition, the "battle" of ideas, lively though it may be, cannot at its present level excite anyone but narrow-minded people. The battle would probably be more amusing and less boring if it were not just hot air. I think that, to begin with, we must refuse to play a kind of game (the "Parisian" game, despite the "prestige" it enjoys, makes judgments on the players without the right of appeal) whose complexity is taken for profundity. The word "reaction" could signify the decision to do away with all the idiocies with which we are so busy.
——*Letter from René Magritte to N. Arnaud, May 7, 1955*

*Sacha Guitry (1885–1957) was a French writer, actor, and director active in the theater and cinema. One of his best known plays is *Castles in Spain*.

The many varieties of painting are occasionally amusing and fascinating. About 1915 I was passionately interested in Mondrian and the emergence of abstract painting. All the abstract paintings reveal only *abstract painting,* and absolutely nothing else. Painters have been making and remaking the same abstract picture since 1915 (whether red, black, or white, large or small, etc.).

The world and its mystery can never be remade; they are not a model that can just be copied. What is more, I cannot share an interest in what abstract painting is able to say, which was summed up once and for all by the first abstract painting.
——*Letter from René Magritte to André Bosmans, August 1959*

92 Photograph of (left to right) René Magritte, Marcel Duchamp, Max Ernst, and Man Ray, Amsterdam, The Netherlands, October 1966

Age-old stupidity was manifested recently by a claimant that appeared when the art of painting was replaced by a so-called abstract, nonfigurative, or formless art—which consists in depositing the "material" on a surface with varying degrees of fantasy and conviction. However, the act of painting is undertaken so that poetry can emerge, not so the world is reduced to the variety of its material aspects.

Poetry is not oblivious to the world's mystery: it is neither a means of evasion nor a taste for the imaginary, but rather the presence of mind.
——*René Magritte, Rhétorique, no. 9, 1963*

To be curious about the reasons for or against "abstract art" is to play the "abstractionists'" game, the same game. They either have the answers to their questions or are interested in discovering further answers, but never ask themselves effective questions that are astonishing enough to stand up as questions and nothing but questions.

To say "this or that is inexplicable" is undoubtedly easy when it is easy and when one goes on to further verbal exploits with the same contempt (which one unwittingly feels) for what one says or thinks. It's no longer this easy if that which is inexplicable is forceful enough to demand our undivided attention, and thereby forbid our misplaced interest in some would-be explanation.

I hope you are going to write against "abstract art" in view of the inexplicable element that truly concerns us, sufficiently for us not to respond with curiosity or indifference.
——*Letter from René Magritte to Paul Bougoignie, undated*

Baes

I cannot be indifferent to "your world"; it reminded me of Marcel Proust's.
——*Letter from René Magritte to Rachel Baes, 1955*

Bosch

I am often asked if I feel I am the heir to the great Belgian painters. Why specifically Belgian? In my opinion, Belgian painting is only one episode among many in the overall history of art. And Bosch is singled out. . . . Hieronymus Bosch lived

in a world of folklore, of hallucinations. I, by contrast, live in the real world.
——*Remarks by René Magritte reported by Claude Vial, Femmes d'Aujourd'hui, no. 1105, 1965*

Braque

The large Georges Braque exhibition at the Brussels Palais des Beaux-Arts deserves to be brought to our readers' attention. It is of unquestionable historical interest and illustrates an experiment that is important to grasp fully.

Braque is a "Cubist" painter.

In art history, it may be useful to make a summary distinction between two periods, that of classical art and that of modern art.

Modern art began about 1800. Such painters as Courbet, Géricault, and Delacroix created images that no longer had the conventional character of classical compositions. Millet and Manet captured life itself with such a vigor that to the eyes of their contemporaries their painting looked like a provocation, and it drove to fury both art critics and a public devoted to sterile imitations of the past.

With Corot, researches began in which specifically pictorial concerns prevailed over the subject matter, which in turn became no more than a pretext for displaying the forms created by light and shadow.

The importance bestowed upon "appearance" became even more pronounced with the Impressionist painters. They aspired to capture the real colors of the subject at the very moment it was observed; this direct observation of reality enabled them to take notice of the nuances that had either escaped classical painters or had seemed unimportant to them. The "pointillists" were to go even further in their attempt to restore the special vibrations of certain atmospheres through the breakdown of colors.

Nonetheless, these various researches were necessarily limited. At best, they enabled the sensations produced by the external world's *appearance* to be given concrete form.

Cézanne went beyond this stage. In Cézanne, we find a concept of the universe that cannot be realized through this technique. This painter attempted to penetrate the very substance of the world and the essence of space. Cézanne's pictures also departed from the relative stylization of photographic reproduction. They questioned the pictorial representation of reality.

The "Cubists," among whom Georges Braque and Pablo Picasso appear to be the most eminent, responded to this challenge in an original way.

They flatly condemned all painting that purported to be a reflection of the universe.

Cubist pictures are objects with a life of their own, not *representations.* They justify themselves by the *disparity* they bring out between the

le 18 Septembre 1965

Cher ami,

[Handwritten letter in French by René Magritte — see Appendix for translation]

Finally, so as not to break with the customs of criticism, we should note that Braque uses a very limited number of colors, that he is especially devoted to contours and nuances, and that the variety of his grays, whites, and blacks frequently gives rise to surprising effects.

——*René Magritte under the pseudonym Florent Berger, La Voix du Peuple (Belgian Communist Party organ), December 1, 1936*

Dali

The 5000-kilo block of marble [balanced] on a bayonet is well within the style of the traditional artist who sees things "on a grand scale."* A few years ago, I dealt with a related subject without resorting to the *quantity* that impresses the empty headed. The 5000 kilos of rock will impress these idiots and, owing to the nature of their minds, they will comprehend nothing but the weight of the stone.

——*Letter from René Magritte to Mirabelle Dors and Maurice Rapin, May 9, 1956*

*During an interview, Salvador Dali had announced the construction of a sculpture made up of a five-ton block balanced on a bayonet.

Dali is superfluous: his flaming giraffe, for example, is a stupid caricature, an unintelligent bid—because it is facile and useless—to outdo the image I painted showing a piece of paper in flames and a *burning key*, an image I subsequently refined by showing only one flaming object—a trumpet (the title of it is *L'invention de feu* [The Invention of Fire]).

Moreover, Dali has given proof for some time that he really belongs to that vile group of individuals who drop in on the pope and value historical-religious painting without having any religious feelings whatsoever to justify this kind of behavior—which is an indication of the superficiality that is always so rampant everywhere nowadays.

——*Letter from René Magritte to André Bosmans, March 1959*

De Chirico

He is actually the first painter to have thought of making painting speak of something other than painting.

——*Letter from René Magritte to André Bosmans, March 27, 1959*

94

93 Letter from René Magritte to Harry Torczyner, September 18, 1965. *See Appendix for translation*

94 *Le bain de cristal (The Glass Bath).* 1946. Oil on canvas, 19⅝ x 13¾" (50 x 35 cm). Collection M. and Mme. Berger-Hoyez, Brussels, Belgium

95 Letter from René Magritte to Harry Torczyner, January 24, 1959. *See Appendix for translation*

95

le 24 janvier 1959

[Handwritten letter in French by René Magritte — see Appendix for translation]

painted object and the appearance of the real object. This appearance itself is held up to question, and one discovers that the intention of the Cubists was to seek out a new means of knowledge, rather than to induce aesthetic pleasure through new means.

Has their undertaking been a success?

While some doubt may still remain, an exhibition such as the one devoted to Georges Braque deserves to be considered with the greatest attention.

I saw Chirico on television. He . . . made witty replies to the journalist questioning him. (He was probably trying to seem "down to earth" when he explained his paintings' Greek settings.) I noticed . . . the landscape with the men in the "foreground." All the same, I wondered whether Chirico's occasional outbursts of hilarity weren't signs that he was slightly gaga?
——Letter from René Magritte to André Bosmans, April 8, 1964

Delvaux

As for D[elvaux], I don't share your benevolence: he is a thousand percent *artiste-peintre* with the professional eccentricities and self-assurance that go along with it. I know him well enough to know that he's naïve, basically pretentious, respectful of and a believer in the most bourgeois "order." His success is due solely to the quantities of *naked women* he turns out continuously on immense panels. To him, they are "nudes" like those the academy professors tell us were the most sublime subjects of heroic classical painting.
——Letter from René Magritte to Maurice Rapin, February 28, 1958

Dubuffet

. . . it's getting easier to understand Dubuffet: one wrong note after another, his value based exclusively on imbecilic snobbery. He could go even further and exhibit used toilet paper arranged according to his "fancy" under glass; that would make some aesthetes drool.
——Letter from René Magritte to Louis Scutenaire, 1949–1950

Ensor

The reactions prompted by the James Ensor exhibition are extremely interesting in themselves. First, there is the critical reception, which is unanimous in declaring James Ensor to be an artist of the highest rank and of considerable influence. Yet this same body of criticism has given a cool reception to Ensor's early pictures (*Le chou* was condemned for "moral turpitude" in 1880, *L'après-midi d'Ostende* was refused by the Salon de Bruxelles in 1881, and so on). This criticism has, of course, played its habitual role, that of defending vociferously, whenever called upon, the outmoded values prevailing at the time, and the young Ensor treated [these values] with casual disrespect. Nowadays, the general consensus has changed: it seems that Ensor is some kind of summit. Ensor has had to display a certain freedom, of course, in order to seek a new pictorial climate. The French Impressionists pursued the same goals: to limit painting's professed objectives and to plumb them more deeply. Like his French friends, Ensor has achieved pictures in which color has given way to plays of subtlety or violence. The subjects are insignificant, serving as mere pretexts for unsymmetrical compositions and the decorative interplays of a colorist. It is apparent that here, by contrast to the work of Millet, Courbet, or Manet, a new way of understanding the world has not been introduced. An unenlightened euphoria and childish humor have dominated the development of James Ensor's work, and it represents fairly accurately one notion of happiness ascribed to by the bourgeoisie of 1900. A certain inconsequential nostalgia can be extrapolated from the vestiges of his disappearing world, but we must not confuse it with an exalted feeling about life.

A different kind of interest is also being shown on the occasion of this Ensor exhibit: the interest of the art dealers and speculators on the lookout for a "good deal."

The preface of the exhibition catalogue informs us that "doubtful" attributions will soon be eliminated as the result of investigations. Ensor's pictures will thus become solid investments. Poor old James Ensor! They made you a baron, and now the pictures in which you celebrated your youth have become the sorry objects of common speculation.

Finally, the interest of the visitors to the Ensor retrospective must be noted: they wander with great seriousness in front of the vegetables, the vases of flowers, the drunken Christs, and the other subjects Ensor enjoyed painting, without wondering if the seriousness they vaunt isn't somewhat out of place.

Were it possible to forget the gossip and the legend that disfigure James Ensor, a large exhibition of his works such as this one might possibly clear the artistic atmosphere that is still somewhat darkened by the Nazi occupation. However, it appears that we must go on living under this cloud.
——René Magritte, "Homage à James Ensor," Le Drapeau Rouge, *no. 20–21, October 1945*

Ernst

Max Ernst's painting represents the world that exists beyond madness and reason. It has nothing to teach us, but it relates directly to us, and that is why it can surprise and enchant us.

Max Ernst clearly does not resemble the traditional artist for whom "thinking big" or "small" seems to be indispensable to his happiness or suffering. All kinds of interests are evinced for traditional painting: historical, documentary, political, etc.

If we make a distinction between Max Ernst's pictures in which virtuosity commands the professional attention of technicians, and those whose style depends on the diligent imitation of an idea, there is still only one interest that truly applies to both: an interest made up of astonishment and admiration. The odd feeling that Max Ernst's pictures are "well painted" means that we are under their spell, rather than in the presence of a manifestation of respect toward some definition of "fine painting."

Max Ernst possesses the "reality" that is able to awaken—if it be asleep—our trust in the marvelous, which cannot be isolated from the real-life situation in which it appears.
——Letter from René Magritte to Patrick Waldberg, 1958, in Waldberg, Max Ernst, *Paris, 1958*

Fantastic Art

The art of painting, like many things, can give rise to minor or major confusions. This is especially true of so-called Fantastic art, which is sometimes charming, but more often purposefully puerile and sordid. Its false reputation imputes to it a capacity for discovering or imagining a privileged world that is (if one heeds the practitioners of the Fantastic) truer than the world itself.
——René Magritte, acceptance speech upon becoming a member of the Académie Picard, April 5, 1957

Imitation Art

. . . a slice of bread and jam displayed in a painting exhibition can really only fill the role of an "imitation" picture.

Bread and jam shown in an exhibition undoubtedly suggest the opposition "imitation" picture—true picture. But this relies on the usual frivolity of the viewing public, to whom it never occurs that a picture could be an imitation. I have never personally encountered this *explicit* notion of an imitation picture. One often has occasion to speak of bad painting, stupid painting, and so on, but the term "imitation" seems to be freer of ambiguity. It is worth popularizing, whereas formulas such as figurative art, nonfigurative art, etc., are not, given the confusion to which they give rise. "Imitation picture" probably has no chance of succeeding, because in order to be "fashionable" imitation is just what is called for. "Figurative art" is the equivalent of cooking with food, while nonfigurative art is nonfood cooking.
——Letter from René Magritte to André Bosmans, July 20, 1960

Impressionism

Unlike "Sunday painters" or Paris Salon painters, the Impressionists brought to painting a needed and intelligent new form, which was to create a contrast between living ideas and dead ideas. Today, the general public still prefers the dead idea and has not yet really absorbed the living idea of the Impressionists.
——René Magritte, La Lutte des Cerveaux, *1950*

96 Letter from René Magritte (written in London) to Louis Scutenaire and Irène Hamoir, February 18, 1937. *See* Appendix *for translation*

Kandinsky

Le toile vide (The Empty Canvas). Kandinsky's emptiness has nothing to do with the "invisible" painting, as I once called it. To my mind, the "invisible" is the removal of the habitual meaning of the things that are visible in the picture, by means of which our mystery comes to dominate us completely.

Kandinsky's "emptiness" can easily be achieved.

Our mystery dominates us. We can do nothing to make it appear.
——*Letter from René Magritte to Maurice Rapin, March 31, 1958*

Matta

Matta is a young man who comes from South America. I think he has a little Indian blood in his veins. He does paintings which are a thousand times better than those of Miró. He has many ideas. He received a religious education and he lives in a flat in a white house.
——*Letter written in English from René Magritte (London) to Louis Scutenaire, March 12, 1937*

Miró

I don't think I'm very "bright," but I manage. I don't at all envy those who feel or who felt up to defying the whole world. If I happen to come across evidence of this heroic posture (a reproduction of a picture by M—, for example), I am astonished that the involuntarily comic aspect of this venerable champion of "the liberation of Mankind" is still not recognized.
——*Letter from René Magritte to Mirabelle Dors and Maurice Rapin, January 24, 1957*

Picabia

Yes, Picabia's pictures move, they are hands that caress girls for a specific length of time. Picabia's white hair gives an impression of eternal youth. Unbelievable though this may seem. But that gives pleasure to those few of us who love pleasure, *even in painting,* and who are determined to alleviate the boredom of the same old artistic stories.

We must not think, then, when standing before Picabia's paintings, of "revelations" in coffee grounds or of "prophecies" that require too much patience to be verified. Picabia thinks the way one ought to think. In 1946, he is confronting an encroaching past with the movement and flashes of vivid light, by which one looks at life in all its awe-inspiring loneliness.

One summer evening, he carried off a pretty young bride on her wedding day and taught her the impossible. Everything was fine. Every transformation goes very well, for that matter. It is enough to prefer the girl who runs laughing down the street to the gloomy charm of old photographs. It is enough to prefer freshness and the murmur of the forest to the dust of ancient manuscripts. It is enough to want to make pleasure prevail despite the spectacle offered us by a world teeming with ruins and silly anxieties.

Picabia's pictures move; they escape from fixed ideas. They are as superficial as the joyous life of lovers and leave to themselves, one might say, those who miss the "profundities" of the blackout and the music of the cannon. They inaugurate this reign of pleasure that ought to be brought within the limits of our lives.
——*René Magritte, "La Peinture Animée, La Vérole du Pape F.P.," preface for a Picabia exhibition, 1946*

Are you familiar with this picture by Picabia (rejected by the salons)? One needn't describe it, but rather the "manner" in which the picture was created: Picabia "shat" on a white canvas and stuck a calling card in the turd. I think it will be hard for him to outdo himself!
——*Letter from René Magritte to Louis Scutenaire, June 13, 1948*

Picasso

As for Picasso, who discovered a new intelligence of painting, he owes his adoption by the partisans of confusion to his negative aspect, that is, to a completely superficial appearance of intellectual scandal.
——*René Magritte, La Lutte des Cerveaux, 1950*

Pop Art

Pop Art is "inspired" (twenty-five years after the fact) by Dadaism.
——*Letter from René Magritte to R. Giron, September 3, 1964*

The Pop artists are very pleasant, very nice, but . . . I'm sorry, they've taught me nothing new, nothing. It seems to me they lack the intelligence required to achieve the works everyone is waiting for. The regeneration of painting will not come from them!

. . . Yes, I know I'm called the father of Pop Art, Op Art, and all kinds of other "arts" . . . But Pop Art is nothing but another version—an infinitely

97 *Un Picasso de derrière les fagots (A Picasso from the Finest Vintage).* 1949. Painted bottle, height 12⅜″ (31.5 cm). Private collection, United States

less audacious one—of the good old Dadaism of fifty years ago! Modern painting went through an evolution that ended with Picasso. Everything touted today as novelties is only a variation on what was already done many years ago.

How will painting evolve from here on? Well . . . any way it can!

. . . And Pop! Let's just say that it's not very serious, and that it's probably not even art? Or perhaps [it is] poster art, advertising art, a very temporary fashionable art. It is effective enough in the streets, I admit, on young girls' dresses.
——*Remarks by René Magritte reported by Claude Vial, Femmes d'Aujourd'hui, no. 1105, 1965*

They [Pop artists] say they like me a lot. But they are of their own time—neon, posters, technology. . . . Me, I feel I am into truth. . . . Then I feel that that should have been said. . . . I no longer feel either hope or despair. . . . There's nothing to be done.
——*Remarks by René Magritte reported by Jacques Miche, Le Monde, January 13, 1967*

They are into Neon, I am into Truth.
——*Remark by René Magritte reported by Maurice Rapin, Aporismes, 1970, p. 20*

Rauschenberg

To clear up a few misconceptions, I confess I know X and Z of the New York School only very slightly: I now know generally what Rausenberg [sic] "represents," thanks to a pile of rags hanging on Suzi's [Gablik] wall. Before this encounter he was a name along with one or two others that for me represented only the charmless confusion of the "avant-garde's" artistic mind.
——*Letter from René Magritte to Louis Scutenaire, December 24, 1965*

Rousseau

An example of the aberrations into which we are led by the snobbism of dead movements is provided by the fate reserved for the Douanier Rousseau.
——*René Magritte, La Lutte des Cerveaux, 1950*

Surrealism

. . . unlike the Surrealism of 1930, extramentalism is not a "fringe" activity, but seems able to "contain" everything friendly, inimical, etc. Perhaps political activity should be reconsidered?

I willingly gave up the word "extramentalism," not so much as a result of your arguments, but because of my own lack of political sense and because of confidence in your political judgment, which I believe to be good. The arguments have not stood up under further examination:

1. The anticipated schism was not an obstacle for the Surrealists at the time of their rupture with Dadaism.

2. Surrealism always meant Breton, and we never did anything to make the public connect us with the word. (In the Charleroi Conference the word is not even mentioned.) When Breton lectures in Brussels, we let him go ahead without interfering, etc. Perhaps it is too late for us to get this venerable term back and make use of it, and

we will probably have to work hard if we want the public to understand the term differently. Wouldn't it be simpler to use a new word and direct our energy elsewhere? New ideas call for a new vocabulary, and a new name would avoid confusion.

I have laid Surrealism to rest—my own for some time now, and Breton's with even greater reason.
——*Letter from René Magritte to Paul Nougé, September 1946*

You probably know that "for one reason or another" I'm no longer a Surrealist, my basic reason being the minimal pleasure I get from the kind of old wife's magic good Surrealists believe in.
——*Letter from René Magritte to Malet, January 31, 1948*

When we deliberately chose pleasure as life's supreme goal, we had already had the experience of twenty years of Surrealism, which at first produced startling objects effective enough to escape Dadaism's sterile confusion. Following a reactionary development, Surrealism now stands for the practice of ineffective magic, the cult of so-called exotic or esoteric mysteries, and the establishment of a myth extracted from the same cask used to distill holy beverages. The area available for the revelation of pleasure grew so confining that we could no longer allow ourselves to be destroyed in the Surrealist way.

Present-day Surrealists can conceive their activity only in terms of being for or against the Communist Party. Reactionary Surrealists choose idealism, revolutionary Surrealists prefer materialism. We, on the other hand, believe such preoccupations would paralyze the specificity of our activity. It is obvious to us that both the economic-political struggle being waged according to the tenets of dialectical materialism and our own activity and experiences are necessary, but that they are parallel, so it is ridiculous to confuse them and to want to see one suppressed or one impose its own method on the other.

We have neither the time nor the inclination to play at Surrealist art. We have an enormous task before us and must think up bewitching subjects that will arouse what remains of our instinct for pleasure. We should avoid ambiguity and distinguish ourselves from the Surrealists. For this reason, we are adopting the qualifying term "Amentalist," which we believe will have the advantage of constantly reminding us that the era of philosophical fanatics is breathing its last.
——*René Magritte, Manifeste d'Amentalisme, 1946, Le Fait Accompli, nos. 51–53, July-August 1971*

I feel the same disinterest for the "Surrealist" attitude, whose defect is apparent: faith in human pride, which is quite incapable (due to the stupidity it implies) of making good any of its promises. What some Surrealists have actually managed to do well *is not Surrealist*. . . .

A "Surrealist" treats painting in a "lordly" way; he "dominates" the situation without ever doubting that he is himself *part of the situation* without free will, whatever it may seem.
——*Letter from René Magritte to Maurice Rapin, August 6, 1956*

"Surrealism" (like "Fantastic art") has only a very vague meaning, which is false if it is given a mean-

ing other than the very limited one it has: Surrealist is what suits Breton, what he says is valid. (This doesn't mean he really thinks it is.) So I am not very "Surrealist." For me, the word also signifies propaganda (a dirty word), with all the idiocies necessary to propaganda's success.

I may be "in practice" considered a "Surrealist," but this is part of a stupid "game." I have shows with "Surrealists," such as Labisse, Couteau, etc. . . . It goes without saying that I do not participate in, nor am I a part of, this artistic-cultural Ballets Russes movement.
——*Letter from René Magritte to Maurice Rapin, July 3, 1957*

Some Romantics are admirable, and some Surrealists are nothingness incarnate. There is a mediocre way of thinking, not necessarily Romantic, which can be classical or Surrealist. This is the one that is impossible to destroy: it has no force, it is the value that has been given it.
——*Letter from René Magritte to Harry Torczyner, 1959*

If the word *chance* exists, its meaning is in effect the same as that of the word *order*. It can be demonstrated that chance obeys a certain order, that it is the order of order, that order is due to chance, that this is so by chance, etc. . . . The Surrealists have talked a lot of nonsense, and I fear that despite their genius they are not made of the stuff to realize it. "Automatic" writing naïvely encourages this banal pretension to devise a methodical way of "forcing thought to speak"—as if thought were a machine, as if the interesting quality in writing or painting weren't *always unpredictable*.
——*Letter from René Magritte to André Bosmans, January 13, 1959*

. . . there are no Belgian Surrealists, aside from Delvaux (if even!) and myself. The Belgian artists who pass for Surrealists have only vague or false notions about it—in other words, none at all.
——*Letter from René Magritte to Harry Torczyner, January 25, 1964*

The term *Surrealism* gives rise to confusion, and the term *Realism* is not suitable for the direct apprehension of reality. Surrealism is the direct knowledge of reality: reality is absolute, and unrelated to the various ways of "interpreting" it. Breton says that Surrealism is the point at which the mind ceases to imagine nothingness, not the contrary. That's fine, but if I repeat this definition I'm no more than a parrot. One must come up with an equivalent, such as: Surrealism is the knowledge of absolute thought.
——*Notes written by René Magritte at the Gladstone Hotel, New York, New York, December 16, 1965*

Tachisme/Action Painting*

Nothing very exciting is achieved by "action painting" [*tachisme*] or "automatic writing." "Detachment" is also easy to understand. These methods of painting or writing make short work of all the problems that arise when one is looking for something truly different. We are talking about "technique," a word that in itself suggests a way of "cutting" a Gordian knot, because technique, conscious thought, and unconscious thought are

all ways of thinking that are mistaken for thought itself.

Of immediate concern to us is a painted or written language that does not leave us indifferent, not the knowledge that it is conscious or unconscious, spontaneous or deliberate. The level on which such opposites become meaningful may be as scientific as you like, but I can't accept that. To follow Boileau or the *Surrealist Manifesto* is to affirm that hope may be ridiculous and easily satisfied. There are things done spontaneously that have no grace, and carefully thought out things that do. This doesn't depend on the chance that always seems to come along when one believes in it.
——*Letter from René Magritte to Maurice Rapin, March 7, 1958*

*Action painting, the more gestural manifestation of Abstract Expressionism, was known in France and Belgium as "art tachiste." This name was derived from the "taches"—paint stains, spots, or splashes—that were characteristic of such paintings. Magritte here plays on the double meaning of the term "art tachiste," which is largely lost in translation.

Tanguy

The idea of showing Tanguy's paintings along with mine isn't bad . . . it's fine of itself, but it takes a museum curator's mentality to have thought it up, since such an exhibition would point up the clash (almost total) between Tanguy's ideas and my own. It is apparent to everyone (except a curator) that Tanguy always stuck to redoing the same painting. The modifications [apparent in] the countless versions are negligible. The curator's idea is good because it will demonstrate the opposite of what he believes. As far as he is concerned, there can be no question in his mind of either nuances or incompatible differences.
——*Letter from René Magritte to Harry Torczyner, September 30, 1961*

As for painters like Tanguy [or] Miró, I think they behave like priests: they always use the same recipe for invoking the God of the Catholics. Both of them have renounced (or are unaware of) the distinction between imaginary and imagined, and have settled on the imaginary, which never varies.
——*Letter from René Magritte to André Bosmans, November 13, 1965*

Trompe l'Oeil

"Trompe l'oeil" (it does indeed exist) does not belong to the realm of painting. It is rather a "playful physics"?
——*Letter from René Magritte to De Walhens, April 17, 1963*

Van Gogh

I don't really respond to Van Gogh's paintings. I mention this because I've been asked to write something about this painter; I don't know if I'll manage to do it [since] I'm not very "enthused." There is, of course, the story of the ear, cut off and cleaned up, put in an envelope, and given as a gift to prostitutes. If I do write something, I'll try to convey what happened as being more important than the actual pictures that elicit the obligatory admiration of intellectuals.
——*Letter from René Magritte to G. Puel, March 8, 1955*

Criticism

I read what you wrote in *Arts* with unusual pleasure, since I am little used to seeing signs of intelligence in critics.
——*Letter from René Magritte to Alain Jouffroy, December 30, 1955*

Most aesthetes have an equivocal affection for art; in fact, they share the "scientific" viewpoint that explains art by insanity, the conscious by the unconscious, etc. We might be interested in these people who never allow themselves "to be taken in" if once in a while they would be different from what they think, do, or feel. Although they never allow themselves to be taken in, they are naïve and unshakable believers in thoroughly vapid theories. Despite precautions about "hypotheses," scientific disciplines are rigorously followed only by the believers who never doubt their faith. Does a psychiatrist ever judge his own problems, for example, to be "fantasies," although this quality is relegated to other people's problems?

I don't believe in the meager influence of my painting. The real interest that you and a few unusual individuals in the world show in it is enough to keep me from bemoaning the ignorance the contemporary art scene shows toward me. The "successes" of this kind I have had are too ridiculous for me to feel deprived or hungry for publicity. Thank God we have no taste for the complicated pleasures that Cocteau, for example, experiences when he sees his photograph in *France-Soir*. This never ceases to astonish me. What we truly love can easily get along without exterior consecration or justification.
——*Letter from René Magritte to Mirabelle Dors and Maurice Rapin, February 3, 1957*

Questions such as "What does this picture mean, what does it represent?" are possible only if one is incapable of *seeing* a picture in all its truth, only if one automatically understands that a very precise image does not show precisely what it is. It's like believing that the implied meaning (if there is one?) is worth more than the overt meaning. There is no implied meaning in my paintings, despite the confusion that attributes symbolic meaning to my painting.

How can anyone enjoy interpreting symbols? They are "substitutes" that are only useful to a mind that is incapable of knowing the things themselves. A devotee of interpretation cannot see a bird; he only sees it as a symbol. Although this manner of knowing the "world" may be useful in treating mental illnesses, it would be silly to confuse it with a mind that can be applied to any kind of thinking at all.
——*Letter from René Magritte to A. Chavée, September 30, 1960*

This morning in the butcher shop a woman asked for two "good" kidneys. I was tempted to ask for two "naughty" kidneys. Someone else asked for saucisson. "With or without garlic?" asked the butcher's wife. "A *little* garlic," was the reply. This "little" did not alter the existing proportions, so the clients don't seem contemptuous of the virtues of speech. Nor are critics, in their own fashion. Their illusions are shared by newspaper readers. Thus, they believe one can "escape" through painting "dream" pictures, unaware that what happens is precisely the opposite: no dream, no escape. Good kidneys, a little garlic, must be what the

98 Untitled drawing. 1948. Pen and ink, 7¼ x 6¼" (18.5 x 16 cm). Private collection, United States

critics are thinking of when they discuss my painting.
——*Letter from René Magritte to André Bosmans, April 1959*

I'm back from Paris, where my show* was fairly successful, if I go by the guest book signed by the many visitors, who not only signed but wrote things that were very good for my ego. Vanity! Vanity! etc. . . . And by devoted buyers. . . .
——*Letter from René Magritte to Harry Torczyner, 1960*

*At the Galerie Rive Droite

From the review in *The New York Times* you were kind enough to translate for me, a passage that you didn't translate (concerning Belgian art in general) has been printed in *Le Soir,* the Brussels paper you're familiar with. This passage says something such as: "Belgian art is willing to admit that figurative painting exists!" This resembles the notion that Belgian art is by nature abstract and that furthermore it goes without saying that this is true. With this kind of thinking, one could say that the population of Harlem is willing to admit that there are whites in New York.

In addition, there's no doubt about the critic's goodwill. However, it is a critic's goodwill and that says it all. In one way, of course, it's unimportant, but in another way, if frivolity contents most art critics, why do they insist on feigning interest in works that display an exceptional conscientiousness?
——*Letter from René Magritte to Harry Torczyner, 1960*

Yesterday, I attended the opening of the exhibition at the Palais des Beaux-Arts of the government's purchases in 1963. My picture for the Brussels museum was there, along with a fairly large number of the daubs so highly esteemed by officials. (For once these are the "revolutionaries," and I look like some diehard conservative.)
——*Letter from René Magritte to Harry Torczyner, January 4, 1964*

The Parisian newspapers are talking about "the object" with regard to my exhibition. . . .*

I mean to evoke the "object," but it must be made clear that this term is a general one—to the point where it has almost no meaning. "Object" has so many different meanings that it doesn't designate the visible appearance of an apple or a star, for example. How are we to distinguish in what the world offers us of the visible between what is an "object" and what is not? On the other hand, how are we to separate the "subject" from what is called "object," since without being united neither would exist?
——*Letter from René Magritte to Marcel Lecomte, November 25, 1964*

*René Magritte: Le Sens Propre, Alexandre Iolas, November 12-December 7, 1964

I must inform you however that words such as *unreal, unreality, imaginary,* seem unsuited to a discussion of my painting. I am not in the least curious about the "imaginary," nor about the "unreal." For me, it's not a matter of painting "reality" as though it were readily accessible to me and to others, but of depicting the most ordinary reality in such a way that this immediate reality loses its tame or terrifying character and finally presents itself with its mystery. Understood in this way, that reality has nothing "unreal" or "imaginary" about it.
——*Letter from René Magritte to Volker Kahmen, August 13, 1964*

What you tell me about the unexpected descriptions of my paintings indicates a state of mind quite alien to what I believe to be correct. The errors are due to many people's inability to *see with the mind* what their eyes are looking at. Their eyes look and their minds don't see; they substitute "ideas" they find "interesting" for what they look at. These individuals cannot have a thought without ideas—that is, a *thought that sees*—and thus are not familiar with the mystery such a thought conveys.
——*Letter from René Magritté to André Bosmans, March 4, 1966*

Journalists still interview me for no reason. Here as well as in New York—if *Times* [sic] and *Newsweek* are any indication—they pay no attention to what I tell them and transform it in an unintelligent manner. Art criticism is really no more than the expression of the public's opinions, whereas it should propose as its raison d'être [first] that thought free itself from its submission to habits inhibiting proper appreciation of artistic things and, in addition, [thought] be less self-assured and a bit more precise when it comes to other matters.
——*Letter from René Magritte to Harry Torczyner, January 17, 1966*

I have a great idea (not earth-shattering) about the naïve question, "What does this picture represent?" My idea is that the questioner sees what it represents, but he wonders *what represents the picture,* and faced with the difficulty of figuring it out from this direction, he finds it easier and more fitting to ask what the picture "represents."

What represents the picture are our ideas and feelings—in short, whoever is looking at the picture is representing what he sees.

This idea is not, some say, within the realm of knowledge, so it won't help me protect myself when the occasion arises.
——*Letter from René Magritte to Paul Colinet, 1957*

Philosophy

If society weren't ignorant of what we are like, don't you think it would find us suspicious? Society plays its role. We're surrounded by jokers who have forgotten what they're about. Yet we have to take society into account. It uses poor judgment, but it is isolated. Otherwise. . . .
——*Letter from René Magritte to Marcel Lecomte, September 1928*

There is an established "beauty" that is like a self-satisfied person with a solid income; there's another kind of beauty that sears our souls. I love this beauty that has no protection or strength except its own force and charm. For me, thought and language cannot be reduced to their function (as alleged by sociologists), which would involve the social structure and bring about changes in it. Thought and language clearly possess this function as far as orthodox sociologists and philologists are concerned. I don't feel obliged to think as they do, nor have I any desire to do so!
——*Remarks by René Magritte quoted by Maurice Rapin, Aporismes, 1970*

It's as though we were in a cave without ventilation.
——*Remark by René Magritte reported by Louis Scutenaire, René Magritte, 1942, p. 36*

99 *Les vacances de Hegel (Hegel's Holiday).* 1958. Oil on canvas, 23⅝ x 19⅝" (60 x 50 cm). Galerie Isy Brachot, Brussels, Belgium

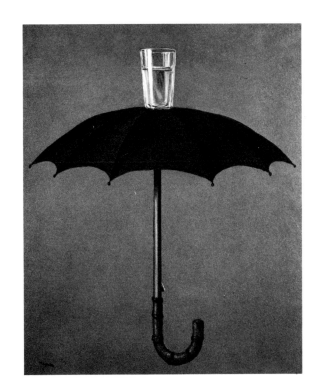

Varieties of Sadness

Life is supposed to be better appreciated through displeasure, uncertainty, pain, terror. We find "completely natural" the unceasing efforts that continue to be made to turn the world into a torture chamber. We don't protest because the mind has been twisted into thinking as follows: we believe that tragic lighting is better suited to reveal life, and that this is how we come into contact with the mystery of existence. Sometimes we even believe that we are successful, thanks to this illumination, this objectivity. This objectivity becomes greater as the terror becomes more vivid.
——*René Magritte, notes written to Marcel Mariën regarding the Manifeste de L'extramentalisme, 1946*

We mustn't fear daylight just because it almost always illuminates a miserable world.
——*René Magritte, Le Surréalisme en Plein Soleil, October 1946*

When we consider philosophy, it's like considering painting or writing. We aren't thinking of what the professional philosophers, painters, or writers mean. Whence the danger of using the words *philosophy, painting,* etc.
 Beauty is a promise of happiness (happiness for twentieth-century Westerners).
——*Letter from René Magritte to Paul Nougé, October-November 1946*

I consider valid the linguistic attempt to say that my pictures were conceived as material signs of freedom of thought.
——*René Magritte, La Pensée et les Images, catalogue of the Magritte exhibition, Brussels, May 1954*

A pictorial (or other) language impresses the yokels insofar as it is *dull.* Let me explain: the artist paints dull pictures so that they seem to mean something important. If the picture were to state clearly what the artist thought, we would recognize it as an open secret, as a banal idea or feeling. Thanks to obscurity, however, the untutored believes the picture to have some wonderful meaning.
 What I paint is addressed to those who *"live" in the present,* or rather, *for* it. . . . An artist who paints for posterity has an intention that I do not have. In my opinion, he is doing something idiots understand very well—those who do not concern "living" men. The man who seems to be alive, whom one refers to as "alive," is an enigmatic reality that need not be lent a meaning that would *interpret* that reality as one that is concerned with posterity. We *see* that after a time reality abandons what we perceive in it, that it abandons its form and means of communication (death no longer speaks our language, since if it speaks we cannot hear it). I think of my pictures as being truly in touch with the living, but there is no reason for expecting these pictures to outlive the living, when the latter do not have a parallel ambition or [entertain] such facile notions.
——*Letter from René Magritte to Louis Scutenaire, February 24, 1955*

This business of the [art] public might also be clarified. (Van Gogh showed his pictures without saying anything to the "respectable" people who barely glanced at them. Now, everyone is more "sensitive" than those "respectable" folk, and everyone recognizes Van Gogh's greatness now that he is dead.) In this regard, I think that my painting has real interest only for those who are alive now. In the future, it will have nothing but some historical value (if it still has any value at all). Why do we care about creating works that will last, when man doesn't have similar ambitions for himself? This surrogate survival through one's work is nonsense.
——*Letter from René Magritte to G. Puel, March 8, 1955*

The criterion that Valéry condemns doesn't yet exist, as far as I know. There is this need I mentioned to you in which an interest in the most difficult things and the passion for research are replaced by an interest or desire for the result.
——*Letter from René Magritte to G. Puel, May 22, 1955*

VARIETIES OF SADNESS*

I

On Sundays, foreigners fill those places where one can see museums of interesting objects, historic buildings, etc. Every care has been taken to satisfy the pressing needs of the visiting crowds. Those who can wait to relieve themselves patiently wait their turn. There are signs telling them they are not forgotten, and that provisions have been made to handle them during the week.

This preamble is justified if, having noted this careful solicitude for physical needs, one noted a bit less the lack of attention given to other human needs. These can be satisfied, one might respond, by the movie theaters, insane asylums, cemeteries, and a great number of schools specifically designated for this purpose. However, a touch of nausea warns us not to overestimate these doubtful expressions of the mystery of human life. In addition, maybe there are people in the shadows preparing shocking suprises for us?

Retired from business, having an active participation in the 1914–1918 campaign to his credit, trained in the school of hard knocks (but broadminded enough to take an interest in the phenomenon of the soul in his spare time), the mayor of a tourist locale seems to have wholeheartedly undertaken the study of a delicate problem.

After clearing the terrain and posing the late Marshal Foch's well-known retort "What's it all about?", the mayor chose for his working hypothesis the affective state of the average visitor—laborer or intellectual—at the moment he left the town. His analysis revealed that the visitor was sated but tired, and that he was thus liable to confuse his need for sleep with the undefinable desire for something else. A good night's rest would dissipate this fleeting feeling. Meanwhile, the visitor's face looked sad, his judgment was shaky, and this risked giving his memories of the locality a somber cast. To remedy this unfortunate tendency, the mayor concluded that he should station himself along with other members of the local council on a flower-decked platform, in order to give a friendly greeting to the visitors who had had *enough* of the place. This thoughtful gesture, coming from an official body, ought logically to distract the visitors from their useless sadness. In this way, they would realize that the *brain* of the town functioned for their benefit and accompanied them.

101 Letter from René Magritte to Paul Colinet, 1957. *See* Appendix *for translation*

102 *Variante de la tristesse (Variation of Sadness).* 1955. Oil on canvas, 19⅞ x 23⅜" (50.5 x 59.5 cm). Private collection, Chicago, Illinois

II

Dinos: But doesn't the All High know all things?
Agathos: And it is the *only thing* (since he is the All Highest) that should remain unknown to Himself.
——*Edgard* [sic] *Poe*

Freedom is the possibility to be, and not the obligation to be.

The sad heart can beat, it can cease to beat; it makes acquaintance with freedom. Sadness knows freedom; it imposes nothing.

Freedom is an "old acquaintance" that we bear as badly as sadness and being. The will intervenes to control or stop palpitations. All the feelings that judge, serve, represent, deny, or utilize freedom *are not distracted by sadness,* are not led astray as to the extent of their ignorance of freedom.

Ignorance is surely not total save in [a state of] absolute nothingness.

In a world that puts a price tag on usefulness, we tolerate freedom, sadness, and being, which are duly motivated by their obedience to the laws of chance, necessity, or experience. We respect sadness, but want to alleviate it: "Travel is an effective diversion for moral afflictions," said Larousse, whose gargantuan labors were indicative of a normal insanity, a tenacious will to "banish dark thoughts." There are many ways to "alleviate sadness": learned discoveries teach us, among other things, that love is hate, that sadness stems from a childhood complex, etc. However energetic the search for error or truth, the entertaining outcome outweighs all other aspects.

Caricatures of sadness command respect. . . . The knowledge of freedom prescribes nothing useful. Rather, it distinguishes with some difficulty between the useful and the useless.

Respect turns into suffering when certain faces express arrogance, brutality, cruelty, or the other emotions that would impose their wills, no matter the abjectness that may result. This spontaneous or methodical will is stupid insofar as it is unfamiliar with freedom and lacks sadness.

Like love, honest emotions can be distracted by sadness. They counter the knowledge of freedom with no disinterested or passionate motives. They are happy, they can suffer the most acute unhappiness.

"Unmotivated and inconsequential" emotions such as nostalgia, congeniality, pity, boredom, charm, and humor are variations of unedifying sadness.

Edgard [sic] Poe wrote "The Genesis of a Poem." He tells us that one kind of logical method decides on the treatment to be inflicted on a "theme" chosen for its *utility:* NEVERMORE! Obviously, *no one* believes the utility of NEVERMORE! to be more than marginal, more than a negligible quantity. NEVERMORE! is only suitable for assisting in something such as, for example, the conception of a poem. Poe humorously brings his discourse into line with the truth in popular opinion, which attributes to sadness the power of leading the will down solemn or merry paths. Truth does not contradict the truth of the heart or mind.

"The Raven" and "The Genesis of a Poem" express the sadness that has never abandoned poets of freedom.
——*René Magritte, 1955*

*An earlier, shorter version, *Two Variations of Sadness*, was contained in a letter to Louis Scutenaire, 1955

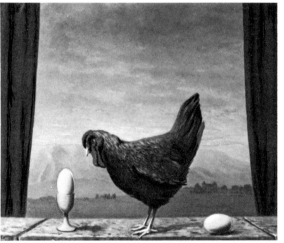

102

I am planning to paint a picture on the idea of the chicken with a boiled egg. (I'm wondering if the egg should be decapitated or intact?) Nocturnal and sunlit variations are a possibility.
——*Letter from René Magritte to Paul Colinet, 1957*

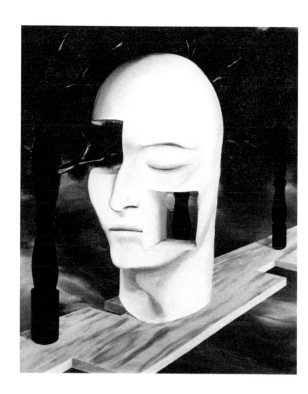

103 *Le visage du génie (The Genius' Face)*. 1927. Oil on canvas, 29½ x 25⅝" (75 x 65 cm). Collection Max Janlet, Brussels, Belgium

When our eyes are opened a little, we have to admit that all our actions, emotions, sensations, and ideas never escape banality.

In becoming known, unknown things become common, even if the "common" is composed of only one person. What all knowledge—intelligent or stupid, rare or widespread, beneficent or maleficent, unusual or familiar, large or small, etc.—has in common is its banality.

Love of the unknown is synonymous with love of banality: to know is to find knowledge banal; to act is to discover the banality of feelings and sensations.

No association among things ever reveals what it is that unites different things. No one thing ever reveals what makes it appear in the mind.

The banality common to all things is a mystery.

The mind would assume the responsibility of a machine if the world is understood to be a language of mystery. This responsibility corresponds to no moral or physical code that might be extrapolated from it. Since this responsibility, like everything else, is mysterious, it cannot be defined with any conventional meaning since it is de facto mysterious. . . . Human responsibility is no less mysterious than that of a machine, a stone, or anything else. It is in strict compliance with convention to claim to know what we must do or think about the mystery of the past, present, or future. The responsibility we assume is mysterious de jure, although we believe knowledge can enlighten ignorance without ever shedding light on mystery.

Mystery is what enlightens knowledge.
——*René Magritte, Bizarre, no. III, December 1955, p. 44*

Being the "master of one's fate" can't be accomplished without automatic recourse to the faculty of comparing oneself to a master of fate or maintaining a privileged relationship with fate. To believe in fate, one has to compare future time with past time, and believe in both past and future.
——*Letter from René Magritte to Mirabelle Dors and Maurice Rapin, March 13, 1956*

I think a lot about . . . the impossibility of perceiving anything other than ideas, feelings, or sensations. What we imagine to be *links* between these things are in turn only an idea or feeling, and to my knowledge nothing can be seriously considered a *link, relationship, cause* or *effect*.

In rereading Nietzsche, I find exactly the same idea, but expressed with a word that revolts me—*atomism:* "Our conscience (as we call it) is composed of atomic phenomena," meaning separate, autonomous, isolated, indivisible things. He also stresses what I already thought: we can predict nothing; everything that happens is an "effect" whose "cause" is beyond what happens to us, beyond our horizon. He goes on at great length about our civilization, its decadence. He isn't very attractive here. But his disciples seem to have misunderstood him precisely to the extent they were "concerned" with social questions. The Nazis "were fond of" Nietzsche, Beethoven, Wagner, as though, had they been alive, they wouldn't have gone straight to the gas chamber.
——*Letter from René Magritte to Mirabelle Dors and Maurice Rapin, June 19, 1956*

The fact of living is of great importance for everyone, but the life of someone else doesn't have the same importance. . . .

Since death is absolute nothingness, it will be an absolute comfort to us mortals. The moral question will not come up in the absolute absence of "point of view" (lack of "conscience"). Since it is absolute nothingness, then, death would be a program of absolute comfort that is attained no matter what means are employed to achieve it. The idea that death is absolute nothingness is not contradicted by the idea that we live in mystery. Mystery is not penetrated by this supposition. On the contrary, it appears to respect the idea of mystery, and thus should be respectfully considered.
——*Letter from René Magritte to Paul Colinet, 1957*

It's "normal" to think sometimes of putting an end to what we call life. It would be possible, like other possibilities we occasionally think about without "following through."

All the same, there is something so uninteresting about blowing one's brains out that such a project couldn't hold our interest for long, and once you've given it up you're impervious (as I am, I think) to things that may appear sensational but that are in the end more or less nothing.
——*Letter from René Magritte to Maurice Rapin, February 18, 1958*

104 *La statue volante (The Flying Statue)*. 1927. Oil on canvas, 23⅝ x 19⅝" (60 x 50 cm). Private collection, Belgium

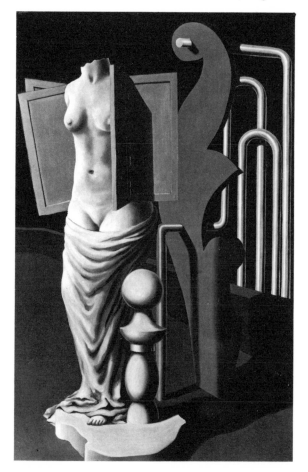

105 *L'usage de la parole (The Use of Words)*. 1932. Oil on canvas, 19⅝ x 29½" (50 x 75 cm). Collection M. and Mme. Louis Scutenaire, Brussels, Belgium

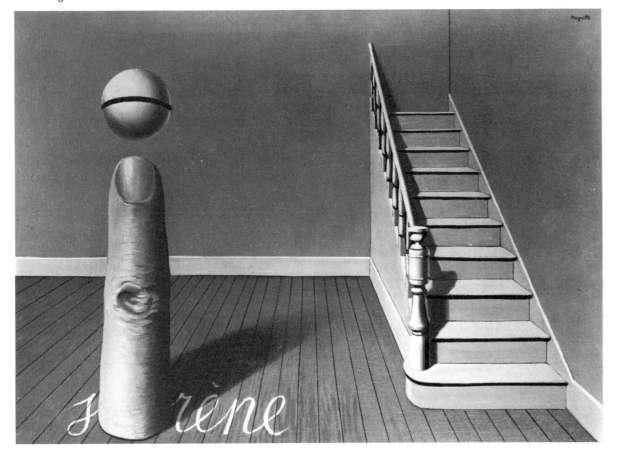

Words have all kinds of meanings. Take the word *serious,* for example: "serious" people such as scientists, businessmen, strategists, etc. A French biologist (Rostand) states with the scientist's solemnity: "Once past childhood, we should know that nothing is serious." This superiority, which does not lack serious irony, illustrates the seriousness of "serious" people, and is a prime example of the stupidity of specialists who try to "deal with everything." Poets can reclaim this word *serious* by giving it a *truly* serious meaning. Poetry is a more serious "business" than science, strategy, finance, or another supposedly serious thing.

The poet can seriously judge what is not poetic. The scholar, the man of war, the empire builder, cannot seriously judge poetry.

The meaning of the word *logic* has never to my mind followed the scholastic rules of reasoning when it designates that which should join images together so that a poem can be what we have the right to expect of it. I don't put any more stock in the word *logic* than in any other. Poetic "meaning," "rigor," "enlightenment," or "logic" are all the same. The important thing is the poem, in which nothing is unimportant, and which is able to give the feeling of something truly "serious."
——*Letter from René Magritte to André Bosmans, May 1959*

. . . I *jokingly* said that clever people would reproach the "heaviness" of what I might write to elucidate an idea. . . . It's what one says that counts above all; the way one says it is important only if it is suited to saying exactly what must be said.
——*Letter from René Magritte to André Bosmans, July 20, 1960*

After a discussion about my text *La Voix du Mystère (The Voice of Mystery),* I'm afraid that the mystery I'm talking about may be confused with the one priests propagandize. Someone told me that they would be able to convince me that I'm a "believer" as they understood the term. . . .

Is it perhaps a question of distinguishing between Nothingness and the Nirvana touted by Eastern priests? But this is a difficult matter. In "distinguishing" Nothingness, we already define it and give it a form it couldn't possibly, as Nothingness, have.

I believe that what we don't yet know about Nothingness is necessary.
——*Letter from René Magritte to André Bosmans, September 25, 1961*

If someone likes you for your good qualities, it's only your good qualities they like.
——*Letter from René Magritte to André Bosmans, March 1962*

I chose "idea" to differentiate between thought composed of words (speech) and thought composed of another language (music, painting, mathematics, etc.).

What is appealing about ideas is that they are so often questionable. It seems that the sum is not greater than the part ad infinitum, which accounts for that immediate effectiveness [of ideas] that suffices for our happiness.
——*Letter from René Magritte to André Souris, December 7, 1963*

The first feeling I remember is when I was in a cradle, and the first thing I saw was a chest next to my cradle. . . . The world presented itself to me in the guise of a chest.
——*Remarks by René Magritte, reported by Jean Neyens, January 1965*

I don't know the reason (if there is one) for living or dying.
——*Letter from René Magritte to Chaim Perelman, March 22, 1967*

"We never see but one side of things," Victor Hugo said, I believe. . . . It's precisely this "other side" that I'm trying to express. . . .
——*René Magritte, 1967, quoted in* Lectures pour Tous, *Pierre Cabane, Paris, no. 167, November 1967*

Politics

MODERN ORNAMENT DOES NOT EXIST: it no longer belongs to our time; it forces the laborer and the machine to prostitute their energy and leads to a criminal waste of essential materials. Before disappearing, the diamond industry will count the Kaffirs and the Zulus among its last clients. . . .

We are on the threshold of a classical age: THE AGE OF POLISHED STEEL. Only those who are AWARE realize this. . . . We hold that a work of art must be an autonomous work that can be reproduced by the millions thanks to improvements in color photoengraving. . . .

More exhibitions, the lending of works of art so that exhibitions are visited like movie houses. In the evenings in large, cosmopolitan cities, [there will be] illuminated signs: THE PAINTER X . . . IS HAVING AN EXHIBIT.
——*René Magritte and Victor Servranckx, unpublished manuscript, L'Art Pur: Défense de l'Esthétique, 1922*

Man's will is being enlisted to engage in the accomplishment of a utopian task.

The consent of the workers is obtained by employing threats and words that seem to point out indispensable realities.

The world is blinded by this blackmail, and yet it manifests a legitimate concern—quickly allayed, to be sure, by the vague hope that its desires will somehow be fulfilled.

As long as we have the means to do so, we Surrealists cannot discontinue the activity that puts us in direct opposition to the myths, ideas, feelings, and behavior of this ambiguous world.
——*Letter from René Magritte to Louis Scutenaire, December 12, 1932*

The Communist point of view is my own. My art is valid only insofar as it opposed the bourgeois ideal in whose name life is being extinguished.
——*René Magritte, Les Beaux Arts (Brussels), no. 164, May 17, 1935, p. 15*

I distrust this folk art the Fascists have chosen to promote. Art-for-the-people is spurious because it is based on a superficial point of view. I too am part of the people. What a painter must do is to see mankind in workman's overalls. This is what Courbet did when he painted *Les Casseurs de Pierre (The Stone Breakers),* which caused a scandal among gallery-goers because its subject was new. For that matter, I have often met with greater understanding from the working class than from the most refined aesthetes. As for the snobs, they have wildly applauded Surrealist projects because they have to be "with it." Today, they are being lulled by the deplorable singsong of Existentialism, and tomorrow. . . .
——*René Magritte, Clarté, December 16, 1945*

. . . just between us, I'm afraid the Party underestimates the struggle we are engaged in, and yet the cleanup job we alone are attempting in order to offset the propaganda is the same kind that Marx undertook, for example.
——*Letter from René Magritte to A. Chavée, December 25, 1945*

At present artists cannot survive unless they allow their works to be exploited. A painter who turns down a contract with a dealer or who refuses to sell his pictures to collectors on the pretext that he has the right to greater returns has no way of acquiring those greater returns; he lacks that effective means available to other professions—the strike. A strike by professional painters or poets would create hardship for no one.

The only way poets and painters have of struggling against the bourgeois economic system is to give their works a content that rejects the bourgeois ideological values that underlie the bourgeois economic system.

In actuality, the only writers and painters working toward this goal in Belgium (along with scientists in their respective field) are the signatories of this letter, and their public adherence to the Communist cause is being met with real hostility and mistrust on the part of the Communist Party. Indeed, their efforts are never discussed when the Communist press takes up cultural problems (not a word in *Le Drapeau Rouge* about the works that have been submitted to it by Nougé, Scutenaire, Mariën, and Magritte; on the other hand, the bourgeois press exhibits its perspicacity in doing them the honor of considering them enemies), but rather it seems to be the rule that only representatives of bourgeois thought are given much consideration.

The articles in *Le Drapeau Rouge* devoted to contemporary art exhibits mention:
1) Ensor (who showed in Germany during the Occupation) and other "stars" established by the bourgeoisie.
2) Dead artists, the fact of their death having aroused some "rather belated" interest, and apparently being sufficient to confer exceptional value on their works.
3) An anarchical group of experiments by "young" [painters], from which nothing can be extrapolated at this juncture.

* * * *

The Party refused, it says, to take a stand on these questions: in fact, if the Party has no confidence in the content of these works, it is because that content is nonexistent as a force of opposition to bourgeois thought. Nevertheless, the Party wants to get some use out of artists who are *incapable of inventing new emotions,* and requires them to engage in political agitation. Yet since artists cannot go on strike, the absurdity of artists' political agitation is only too obvious.

The only *correct* attitude the Party can take with regard to the aesthetic question, *and which it is refusing to take,* is that of requiring an artist to give his works a revolutionary content. This is our conviction, and it prevents us from attending the meetings at Antwerp, which will be held with the absurd notion of seeking ways for artists to engage in political agitation.
——*René Magritte et al.,Lettre au Parti Communiste de Belgique, 1946*

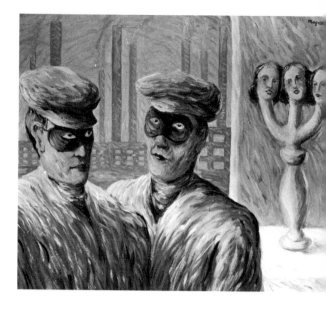

I got back from Paree yesterday. Belle Ville [sic] was up in arms. As usual, without planning to, I found myself in the midst of a riot: some young pricks were having a counterdemonstration against the one improvised by the workers, who began their march right after work. This sea of men in blue overalls was truly magnificent; you're really on their side, poor shits being driven crazy by a bunch of toughs. Still, one must keep busy with other things, cling to this raft of the *Medusa,* which is leaking from every crack.
——*Letter from René Magritte to G. Puel, June 23, 1946*

Have I discovered something? I thought that the idea *progress doesn't exist* was dangerous to our health, since it prevents a greater contact with reality: good and bad things (for us as well as others, for the dead and the yet unborn) that continually happen, struggle, are replaced, and so on.

The notion of progress facilitates cerebral suppurations such as: "The dunce cap is an advance over the tricorn," "The revolver is an advance in the art of killing," "Death and suffering in an ultramodern hospital is an advance," etc.

The idea of progress is linked to the belief that we are coming closer to absolute good, which permits a lot of today's evil to emerge.
——*Letter from René Magritte to Paul Nougé, August 14, 1946*

If the Party finds it useful to "control" the domain of the arts in order to keep its hands on lukewarm supporters, we doubt the pressure artists can bring to bear on bourgeois governments and on the tactic of slow reforms likewise advocated by the Socialist Party. Only through revolution are a Communist policy and administration of the fine arts possible. (The current ministry has promised to beautify factories, and is carrying on a crusade with this in mind.) The Marshall Plan too is trying to make life in the capitalist world more agreeable. I cannot recruit new supporters from among those who are already "friendly," and no one needs to "hold my hand"; my convictions remain proof against adopting the role of poor relation and my chances of exploiting my activity in the capitalist manner.
——*Letter from René Magritte to Bob Claessens, October 1947*

All my latest pictures are leading me to the simplified painting I have sought for so long. In short, it is the increasingly rigorous research into what is, to me, the essential in art: a purity, a precise image of mystery that, having abandoned all extraneous conjecture, is decisive. . . . It seems that in this way I express what was overwhelming about *Le viol (The Rape)* with forms identical to those in nature. The reading of it becomes internalized.
——*Letter from René Magritte to Claude Spaak, undated*

. . . painting is not only a studio task, but it is also a financial task. This is probably a result of the democratization of the arts (which, curiously enough, makes aristocrats out of artists). A democratization evidenced by the current spectacle of painting's invasion by sordid subjects (relatively sordid and viewed as such by advocates of historical painting or portrait painting of great men such as Louis XIV).
——*Letter from René Magritte to Irène Hamoir, May 24, 1943*

On the other hand, in order to attract the interest of the artistic, political, and literary population, this title was chosen because of the "sensitivity" to current events that makes these cultivated individuals so impressionable. Having thus gained the attention of this group for the few moments it is capable of maintaining a semblance of thought, one notices that on their level—the level of unskilled art—folk objects are the equivalent of the so-called secrets of alchemy in another area.

Just as propaganda for alchemy could only be made with an ignorance of today's scientific knowledge, so the arguments for folk art can only be explained by the reprehensible ignorance of spiritual things shared by the cultural specialists who are responsible for or support this shameful enterprise.

Whereas the least objective of minds would readily judge the call for a return to alchemy to be an attempt to destroy scientific progress and a desire to return to the adoration of icons or to the fear of forbidden fetishes in the hope of rediscovering a so-called age of gold, a parallel and large-scale endeavor in favor of folk art is now underway and is being supported by both those who are for reaction and those who seek change in the world economic system.

The agreement these opponents have reached on the benefits of folklore is unusual and significant enough to merit examination.

The fact that the Catholic and revolutionary newspapers are united in this affair leads one to believe that what divides them exists on another level than that of cultural matters, and that there is nothing to keep them from agreeing on "minor questions."

In short, these political foes give little importance to the feelings a man has about life and the enhancement of those feelings by artistic means. What divides them makes them alike. These foes are made of the same stuff: second-rate stuff that has nothing to do with either the noble spirit of the alchemists or with the enthusiasm of unknown folk artists. Alas! This stuff is the stuff of inertia, an inertia made monstrous by its permanence and its extent!

There are some men here on earth who know

108 *Le viol (The Rape)*. 1945. Oil on canvas, 25⅝ x 19⅝" (65 x 50 cm). Collection Mme. René Magritte, Brussels, Belgium

107

Le viol (The Rape). This painting was part of a 1947 show organized by Communist intellectuals and sympathizers at *Le Drapeau Rouge* offices, rue des Casernes, Brussels, and was lost subsequent to the exhibition. It was found by Pierre Alechinsky, who returned it to Madame Magritte after Magritte's death.

108

what true intellectual honesty is and who want no part of this inertia nor expect any help from it. The countless others are indifferent, passive, clumsy calculators, or dishonest. Their number is not enough to make them right.

In the artistic sphere in 1949, we are called upon to dismiss the case involving the fraudulent attempts to revive feudal obscurantism based on folk material. Also, to refuse to respect the myriad selfish hopes one could place on this kind of undertaking.

Simple honesty demands that such attempts—doomed, in any case, to failure—be called by their rightful name: the sign of contemptibility.
——*René Magritte, Nous N'Avons Pas Choisi Le Folklore, 1949*

NOTE FOR THE COMMUNIST PARTY

The workers have been exposed to paintings under poor conditions as a result of initial confusion in regard to artistic activity and political action. While the political struggle must, under present circumstances, concentrate on the demand for our rights to, for example, adequate nourishment and minimum comforts, the battle being waged by revolutionary artists can now be understood as a response to a maximum need: the conquest of the mind's wealth, a conquest that must never be abandoned.

In their encounter with artists, the workers were only permitted to contemplate those pictures strictly limited to the plastic expression of political ideas or sentiments; and the architects of the Party's cultural policy are making the error of leading the workers to believe that this is the only kind of painting for which they are suited.

Although the pictorial translation of political ideas is useful for illustrating Party posters, it does not automatically follow that the artist's only valid role is to paint pictures that in more or less lyric terms express the social struggle, and that the workers must forgo the pleasure of looking at pictures that can enrich their minds without teaching them class consciousness.

Class consciousness is as necessary as bread; but that does not mean that workers must be condemned to bread and water and that wanting chicken and champagne would be harmful. If they are Communists, it is precisely because they hope to attain a better life, worthy of man.

For the Communist painter, the justification of artistic activity is to create pictures that can represent mental luxury, a luxury for Communist society quite different from the useless, ostentatious, tasteless luxury of the existing exploiting classes.

To want systematically to exclude this luxury from the socialist world is to condone a sordid and culpable establishment of mediocrity, at least insofar as the mind is concerned.

A better life cannot be conceived without some real luxury. It cannot be achieved without political struggle and the difficult struggle waged by revolutionary artists, those who do not limit their efforts solely to the expression of political ideas or to the representation of familiar scenes in the life of the working class for the purpose of edification.
——*René Magritte, Note Pour Le Parti Communiste, April 24, 1950*

Revolt is a response of active man that need not be legitimized by more or less comprehensible motives.

Revolt against the world of today signifies the refusal to participate willingly in activities dominated by hoodlums and imbeciles. It likewise signifies the will to act against this world and to seek ways of changing it.
——*René Magritte, "La Révolte en Question," Le Soleil Noir (Paris), no. 1, February-March 1952, p. 68*

LA PAIX DU SOIR*

Etant patriarche et moyen propriétaire
Chez moi, je ne veux pas de présence étrangère
Qui foule sans vergogne et sans autorisation
Le sol arable dont j'assure la fonction.
Un beau soir après le repas pris en famille,
On me dit qu'un Anglais, son épouse et sa fille
Vont dormir au grand air sur ma propriété
Sans m'avoir averti ni m'avoir consulté.
C'est d'abord le tableau d'une femme en chemise
Laissant entrevoir un doux poil qui se frise
Que j'ai aperçu dans mon imagination,
Et puis l'idée de l'observer d'un buisson.

De ce qui s'est passé, vous connaissez la suite:
Ma rude main de vieux travailleur a ensuite,
Avec mon fusil de guerre, tiré, cogné
En justesse sur les endroits bien exposés.
J'ai laissé mes douilles vides dans la rosée,
Mon fils éduqué dit les avoir ramassées
Et avoir modifié la posture des corps
Pendant que dans mon lit je dormais sans efforts.
Grâce à l'astuce et aussi l'expérience,
Des gendarmes j'ai bien rigolé de la science
Jusqu'au moment où dans la reconstitution
Je n'ai plus su garder ma dissimulation.
—René Magritte, 1952

*Written at the time of the Dominici affair, to be sung to the tune of "Le Chant du Départ"

PEACEFUL EVENING

As a patriarch and small landowner
I don't like strangers
who shamelessly and without permission trample
the arable soil which I work with my hands.
One fine evening after the family meal,
I was told that an Englishman, his wife, and
daughter
were camping on my property
without having advised or consulted me.
At first it was the vision of a slip-clad woman,
allowing a glimpse of soft curly hair,
that arose in my imagination,
and then the idea of spying on her from behind a
bush.

You already know what happened next:
my rough laborer's hand
took my carbine, fired, and hit her
with great accuracy on her exposed parts.
I left my empty shells lying in the dew;
my educated son says he collected them
and changed the position of the bodies
while I slept peacefully in my bed.
Thanks to my cleverness and experience,
I had a good laugh on the police
until the moment during the reenactment [of the
crime],
when I was no longer able to maintain my
cover-up.

109 *L'impromptu de Versailles (Versailles Impromptu).* Illustration for *Violette Nozières,* Brussels: Edition Nicolas Flamel, 1933

L'impromptu de Versailles (Versailles Impromptu): Homage to Violette Nozières, who poisoned her incestuous father
—René Magritte, in *Violette Nozières, Brussels: Éditions Nicolas Flamel, 1933*

Progressive atheists and Fascist Catholics are not very interesting. While on the way to Antwerp yesterday, I passed near the camp at Breendonc [sic] (the Belgian Buchenwald), and the memories this camp brought back are far from being able to provide any rationale for the universe. As for the progressive atheists you mention, who dream of horsewhipping the whole world, they are obviously incapable of making anything but trouble. We don't have to do anything about such "engagés" so long as they leave us more or less in peace. However, when "culture" is at stake, their titles—Catholics, Fascists, atheists, progressives, etc.—are reason enough for one to be disgusted at the prospect of collaborating with them. For them, it's not enough to take a "quick turn round the floor with a modicum of elegance." They wouldn't hesitate to stop you if it were necessary.
—Letter from René Magritte to G. Puel, May 22, 1955

One idea that's occurred to me—I don't know what it's "worth." What we call a "work of art" is usually "defended" with the same tenacity with which one would defend—to cite the same example—the subway if it came under attack. Painters are born, live, and die "for painting" (preferably abstract) as they would "for France." The idea occurred to me that what is to be defended can-

not be defined as easily as can old or fashionable "pictorial values." It seems to me that it is the vision of the world that must be defended, *because it cannot be separated from the viewer.*
—Letter from René Magritte to Mirabelle Dors and Maurice Rapin, January 23, 1956

Apropos current events, I couldn't state better than yourself what we ought to make of them: "My legs feel as though they were sawed off, [but] luckily we don't think with our lower members." I received the dark red pamphlet, *Hungary: The Rising Sun,* in which one sentence made me wince: "It is the Fascists who fire against the people." Here we have a general rule that initiates a sudden respect for abstract generalities in Surrealist tracts. Such language might have been comforting coming from Ubu,* but great men have been boring for some time. The bets are all placed, as they say, and I add: So much the better! A title for the kind of magazine I would enjoy (which is something I intend to stick to from now on) might be: THE POLITICS OF THE OSTRICH.

A lot of inanities about Austria-Hungary, for example, could easily be avoided. Nor is ancient or current history *the organ of thought.* We have horrible feelings, and that's enough! The belief that history is to blame is very convenient for "great men," who know well how to take advantage of the indignation [expressed by] fanatics of every hue.

Let us respect our own occasional fanaticism! Let us not attribute it to a "cause" that is taken for granted.
—Letter from René Magritte to Mirabelle Dors and Maurice Rapin, November 1956

*The principal character in Alfred Jarry's drama *Ubu Roi* (1896), whose rabid unconventionality became an inspiration to the Surrealists and Dadaists.

My conception of the art of painting consists, first and foremost, of an attempt to paint pictures like apparitions, yet in which we recognize people, objects, trees, rocks, skies. In my opinion, these paintings must reveal the mystery of the present, and thereby allow us to participate in the life of the spirit!

Valid art works are necessary. They fulfill an inner need. But they are not indispensable to society. As soon as art becomes "social," it obeys external circumstances—however complex —which guide the artist by depriving him of freedom in the possibilities of his art.
——*René Magritte's replies to an inquiry by La Gauche (Brussels), on "Belgian Artists vis-à-vis Art and Life," October 26, 1957*

I'd be curious to see the Neo-Fascist pamphlet* you mention. Couldn't you sent it to me? I'll return it right away. I wouldn't like you to use what I wrote in *Le Savoir Vivre*: it was about the publication of a letter to an organization that had asked me to have a show in the Belgian Congo. That letter (or a passage from it) and *Le bouquet tout fait (Ready-Made Bouquet)* have no direct relation to the current Algerian situation. The colonial oppressors are clearly contemptible. But the patriotic chord, in all its variations (including the desire for social independence), doesn't reverberate for me strongly enough to take ineffective steps.
——*Letter from René Magritte to Mirabelle and Maurice Rapin, April 22, 1958*

*L'avant-garde réactionnaire, pamphlet published by Simon Hantaï after his expulsion from the André Breton circle.

With all that, you won't see the Brussels World's Fair? Upon arriving here a lot of Americans dash off to the . . . American Pavilion. It seems to me you see America better from where you are, and if you're really interested in it, you aren't missing anything by not visiting the U.S. Pavilion. I'm avoiding this fair, where each participating country proudly displays what it is known for: dishes, carpets, liquors, dances by downtrodden peasants, etc. . . . There's also some painting, as though suddenly it were important to the populace (thanks to this fair). Much ado for an ephemeral and ridiculous result.
——*Letter from René Magritte to Harry Torczyner, September 1958*

Lenin's writings (which I am familiar with in part) play a tune that bores me quite as much as the droning of a board of directors' meeting. Although I admire his practical intelligence of social questions, I'm deaf to the "meaning" they have for him. I don't like to think the world really has the meaning Lenin ascribes to it, a "meaning" that can only come from a scientific mind. . . .

While we're on the subject of Lenin, there is an excerpt from something he wrote in a book I have, *Panorama of Contemporary Ideas*, which truly "says nothing to me." The words *state, power, classes, capital*, etc., that recur on every line are the same as *love, always, in my arms* that always appear in bad songs.
——*Letter from René Magritte to André Bosmans, June 1959*

My own less virulent "fanaticism" prevents me from sympathizing with fanatics on either Left or Right. If I had to choose, I wouldn't hesitate—*it goes without saying*—to hate those on the Right more.
——*Letter from René Magritte to André Bosmans, July 22, 1959*

I leave social questions to the experts (as in medical questions, one has little choice, despite the hopeless trust one must sometimes have in doctors). These questions make us in part accede, you say, to the will to wipe out opposing ideas. . . . A whole gamut of heroic actions can, alas, result from this. . . . But the hero can only attack or defend reality without its mystery.

The "outsider" hero is an extraordinary, sensational figure. He can be on the Right as easily as on the Left. Also, I consider the state of being an outsider to be no more than a psychological possibility. . . . As for the mystery of reality, no hero and no event (war, revolution, etc.) can evoke it. The hero evokes only his own acts, and events [evoke] only a possibility of reality—humble or pleasant, known or unknown, etc.
——*Letter from René Magritte to André Bosmans, August 1959*

I am convinced that the world is an enigma (not an enigma that can be solved by any "discipline"). This conviction resembles what the world offers us. I would therefore say that problems pose themselves to us, and not that we can pose problems. If we do pose them, we have the illusion of freedom by making the world resemble what we want it to, whereas freedom is [the act of] resembling the world. The most stupid activities are possible thanks to the so-called freedom that "decides" how the world ought to be: for example, the military world.
——*Letter from René Magritte to André Bosmans, January 26, 1961*

Last evening I listened to De Gaulle talk for an hour and say nothing. It's stupefying and "admirable," in the sense of a "tour de force" of which I am totally incapable.
——*Letter from René Magritte to André Bosmans, April 12, 1961*

My trip to Paris got stalled at the planning stage. The strikes that have been announced in France have prompted me to put it off. The railroad workers are right in considering that what they earn is far from enough (the railroad prices are raised an enormous percentage while the workers are granted an insignificant raise). It's all right to prevent or interfere with travel no matter how annoyed the travelers get—if it's necessary for justice to be done.
——*Letter from René Magritte to André Bosmans, October 19, 1961*

There's a pamphlet to publish about what is going on in the Congo. I heard Tsombé [sic] on the television. He thinks he's addressing himself to simple Negroes, and perhaps he's right in believing the whites are as stupid as the blacks. He thinks they will go along when he says things such as "Communists are directing U.S. policy since that policy is allowing the Congo to be delivered over to Communist influence." One has to be stupid oneself to use this kind of "reason" just to create an opinion favorable to Katangan secession. The "moral" of the story of Congolese independence consists in noting 1) the triumph of stupidity, 2) the defeat of intelligence: Lumumba's assassination. A tract of this sort could be signed by people who are not necessarily "Leftists." It shouldn't be written from a political viewpoint (this is only possible with facts that even the specialists don't have), but from the viewpoint of simple honesty and criticism of stupidity (such as praises for the blessings of colonialism, in light of Lumumba's criticism of it during the Congolese independence celebrations).
——*Letter from René Magritte to André Bosmans, December 8, 1961*

Yesterday on television I heard something delightful about the current "work" going on at the Vatican; the Italian Communists say they are abandoning "sterile anticlericalism." Isn't that charming?
——*Letter from René Magritte to André Bosmans, September 16, 1964*

In politics, on the other hand, I am a stout revolutionary. Man belongs to the world, the world doesn't belong to man. Power, force, conquest, are meaningless terms. [They have] no more meaning for me than the word *subconscious*.
——*Remarks reported by Claude Vial, Femmes d'Aujourd'hui, no. 1105, 1965*

I'm not a militant. I am not armed with either the ability or the energy for political struggle. However, I agree with what you say I am—that I am still *for* "socialism" . . . that is, for a system that will abolish inequality of wealth, constraints, wars. In what form? By what means? I don't know, but that's the side I'm on, despite setbacks and disappointments.
——*Remarks reported by Patrick Waldberg, René Magritte, 1956, pp. 210–211*

Someone has suggested showing me the United Nations Building. Can you imagine? They want to take me on a tour of the offices!
——*Remarks to Louis Scutenaire, January 1966*

I joined the Communist Party in 1945, and I believed that after making contacts I could convince them that art shouldn't be the way the Communists understood it—an art for propaganda—but I failed, as did the Surrealists in France.
——*Remarks reported by E. C. Goossen, January 28, 1966*

I can't make any pronouncement on the notion that anarchy and Communism make a very good combination. That would require a knowledge and practical science of politics and sociology that I do not possess. . . .
——*Letter from René Magritte to André Bosmans, January 6, 1967*

Psychoanalysis

110 *Le modèle rouge (The Red Model).* c. 1935. Pencil drawing, 12⅜ x 9" (31.5 x 23 cm). Collection Melvin Jacobs, New York, New York

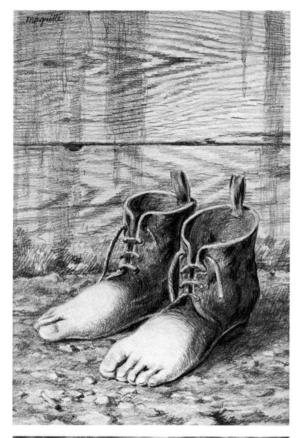

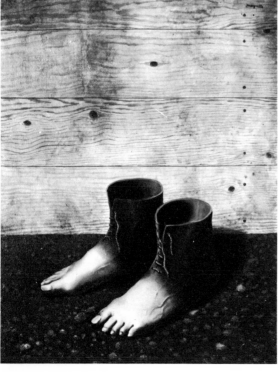

111 *Le modèle rouge (The Red Model).* 1935. Oil on canvas, 22 x 18" (55.9 x 45.8 cm). Musée National d'Art Moderne, Centre National d'Art et Culture Georges Pompidou, Paris, France

Dear Friends,

I am, at the moment, seated before my coffee, and Mrs. Paige is in front of me, and in front of Mrs. Paige is a typewriter. Before commencing the letter, we have verified the date on the calendar. At last, speaking of serious things, yesterday the young Matta brought me to the home of two psychoanalysts but let us not speak too quickly, it is necessary to put things clearly.

First, Matta is a young man who comes from South America. I think he has a little Indian blood in his veins. He does paintings which are a thousand times better than those of Miro. He has many ideas. He received a religious education and he lives in a flat in a white house. That for Matta!

Second, Dr. Matté is also a young South American. At first he was a surgeon, but then he became interested in the work of our friend, Freud. He also lives in a flat, only it is in a street where all the doctors live. At the moment he treats young boys of five years and his treatment consists in painting with these young boys. It seems that the brushes represent the sexes (masculine) for the boys. This young doctor is very much interested evidently (that goes without saying) by sur-realism.

Third, Dr. Vits is a man of about 50 years of age, and he has no hair. He finds Brussels very erotic but London not the least so (according to Mrs. Paige New York is in this respect like London). He left Germany for the reason that Hitler is making thought impossible in Germany. Obviously, he is a doctor who treats fatal diseases. On the whole, he is sympathetic.

Now you know with whom I passed yesterday evening. They questioned me on the subject of my painting and they now understand the interpretations of my paintings. Thus, they think my picture, "The Red Model" is a case of castration. You will see from this how it is all becoming very simple. Also, after several interpretations of this kind, I made them a real psychoanalytical drawing (you know what I mean): 'canon bibital' etc. Of course, they analyzed these pictures with the same coldness. Just between ourselves, its terrifying to see what one is exposed to in making an innocent picture.

I received the account of your journey. It seemed to me a little complicated, but as I am a good boy, I do not mind.

I want you to do whatever you can to make my absence less distressing to my wife, I thank you in advance and I send you my regards 'bibitals'.

Magritte

112 Letter from René Magritte (written in London) to Louis Scutenaire and Irène Hamoir, March 12, 1937

The problem of shoes demonstrates how the most frightening things can, through inattention, become completely innocuous. Thanks to *Le modèle rouge (The Red Model)*, we realize that the union of a human foot and a shoe is actually a monstrous custom.
——*René Magritte, La Ligne de Vie, lecture, November 20, 1938*

113 Study for *La durée poignardée (Time Transfixed)*. 1935. Pencil drawing, 11¾ x 9⅞" (30 x 25 cm). Private collection, Brussels, Belgium

114 *La durée poignardée (Time Transfixed)*. 1939. Oil on canvas, 57½ x 38¾" (146 x 98.5 cm). The Art Institute of Chicago, Chicago, Illinois

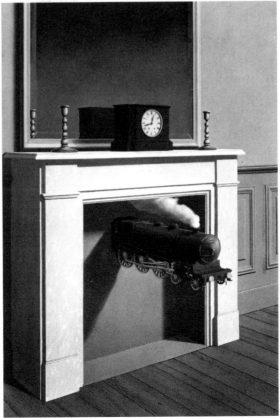

I apologize for the delay in answering your letter of April 25th, although it wasn't my fault. I had to wait for a translation of what you wrote in English.

The question you ask concerning the conception of the painting *La durée poignardée (Time Transfixed* doesn't seem to be a very accurate translation) can be given an exact answer insofar as *what I was thinking of*. As for trying to explain *why* I thought of painting the image of a locomotive and *why* I was convinced this painting should be executed, I cannot know nor do I wish to know. Even the most ingenious psychological explanations would have validity only with regard to a "possible" interest in an understanding of an intellectual activity that posits relationships between what is thought and what has nothing to do with thought. Thus, I decided to paint the image of a locomotive. Starting from that possibility, the problem presented itself as follows: how to paint this image so that it would evoke mystery—that is, the mystery to which we are forbidden to give a meaning, lest we utter naïve or scientific absurdities; mystery *that has no meaning* but that must not be confused with the "non-sense" that madmen who are trying hard to be funny find so gratifying.

The image of a locomotive is *immediately* familiar; its mystery is not perceived.

In order for its mystery to be evoked, another *immediately* familiar image without mystery—the image of a dining room fireplace—was joined with the image of the locomotive (thus I did not join a familiar image with a so-called mysterious image such as a Martian, an angel, a dragon, or some other creature erroneously thought of as "mysterious." In fact, there are neither *mysterious* nor unmysterious creatures. The power of thought is demonstrated by unveiling or evoking the mystery in creatures that seem familiar to us [out of error or habit]).

I thought of joining the locomotive image with the image of a dining room fireplace in a moment of "presence of mind." By that I mean the moment of lucidity *that no method can bring forth*. Only the power of thought manifests itself at this time. We can be proud of this power, feel proud or excited that it exists. Nonetheless, we do not count for anything, but are limited to witnessing the manifestation of thought. When I say "I thought of joining, etc., . . ." exactitude demands that I say "presence of mind exerted itself and showed me how the image of a locomotive should be shown so that this presence of mind would be apparent." Archimedes' "Eureka!" is an example of the mind's unpredictable presence.

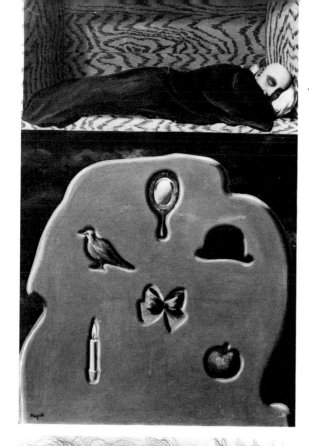

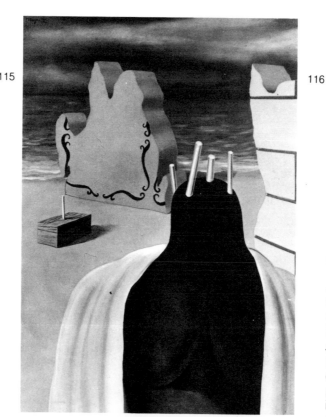

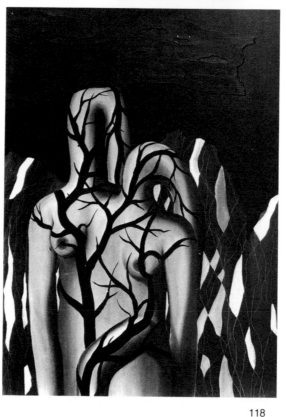

115
116
117
118

115 *Le dormeur téméraire (The Reckless Sleeper)*. 1927. Oil on canvas, 43¼ x 33½" (110 x 85 cm). The Tate Gallery, London, England

116 *Le supplice de la vestale (The Vestal's Agony)*. 1926. Oil on canvas, 37⅜ x 28¾" (95 x 73 cm). Galerie Isy Brachot, Brussels, Belgium

117 *Le secret d'état (The State Secret)*. 1950. Gouache, 7⅛ x 6¼" (18 x 16 cm). Galerie Isy Brachot, Brussels, Belgium

118 *Paysage (Landscape)*. 1926. Oil on canvas, 39⅜ x 28⅜" (100 x 72 cm). Private collection, Brussels, Belgium

The word *idea* is not the most *precise* designation for what I thought when I united a locomotive and a fireplace. *I didn't have an idea; I only* thought of an *image*.

The power of thought or "presence of mind" manifests itself in different ways:

—For the painter, thought becomes manifest in *images* (for the exacting painter, and not the painter who has "ideas" or who "expresses" his "sublime" emotions).

—For Bergson, thought manifests itself in *ideas*.

—For Proust, it manifests itself in *words*.

I am very exacting, and in conceiving a painting

I avoid "ideas" or "expressing emotions." Only an image can satisfy these demands.

La durée poignardée is only an image. Because of that it testifies to the power of thought—to a certain extent. While looking at this painting, you think of Bergson and Proust. That does me honor and demonstrates that an image *limited strictly to its character as an image* proves the power of thought just as much as Bergson's *ideas* or Proust's *words*. *After* the image has been painted, we can think of the relation it may bear to ideas or words. This is not improper, since images, ideas, and words are *different* interpretations of the *same* thing: thought.

However, in order to state what is *truly necessary* about an image, one must refer exclusively to that image.

This is what I have tried to write to you—clumsily, and in French, which I fear will be much less clear than if I had been able to put it into English for you.

In any case, I hope you will not doubt my goodwill to answer you as well as possible.

Very cordially,
René Magritte

P.S.—The title *La durée poignardée* is itself an image (in words) joined to a painted image.

The word *durée* was chosen for its poetic truth—a truth gained from the union of this word with the painted image—and not for a generalized philosophical sense or a Bergsonian sense in particular.

NOTE:

I think the following points should be clear:

1. Psychological theories "explain" nothing. They are possible *thanks to thought*. They give expression to thought—*but they do not make thought possible*. Thought exists without psychology. It is thought that illuminates what it sees: ideas, images, emotions, sensations, and psychology!—not vice versa.

2. "Presence of mind" (or the power of manifest thought) can be found in Bergson, in Proust, in other men.

Hegel, for one, experienced this presence of mind. But, in his old age, when he found the sight of the starry sky banal, *which is true* (along with the sight of a locomotive), he overlooked as a philosopher the fact that the starry sky imitated in an image would no longer be banal if this image were to evoke mystery, thanks to the lucidity of a painter who could paint the banal image of the starry sky in such a way that it appeared in all its evocative force.

Hegel saw only a "given" image, without the intervention of thought. I believe Hegel only gave

validity to the manifestation of thought *through ideas*. He might perhaps have allowed himself to be distracted while looking at images; it might have been a kind of vacation for him. Would my picture entitled *Les vacances de Hegel (Hegel's Holiday)* have amused Hegel? Would another, older picture, *Le travail caché (The Hidden Work),* perhaps have "taught" him that images are as valid as ideas? This painting actually shows the trite spectacle of a starry sky . . . (The stars spell out the word *DESIRE*.)

Philosophers attempt to concern themselves with art. But so far as I know, none of them tell us about what is *inside* art.

When will the philosopher construct a system that powerfully conveys mystery? (Although philosophers make brilliant *attempts* at theories about mystery.)
——*Letter from René Magritte to Hornik, May 8, 1959, in André Bosmans archive*

[Here's] something pretty amusing: On a television program, a doctor was telling how the art of lunatics differed from that of the Surrealists. He commented on a patient's drawing and later regretted his words. He was interpreting it (according to the sacrosanct habit of seeing everything as a symbol), and in his scientific ardor he forgot scientific discretion to such an extent that he said, "And this is a symbol of the female sex organ, *with all its disgusting attributes.*" He realized after it was too late that he had expressed his own opinion rather than that of the author of the drawing, and that maybe he would be mistaken for a homosexual. Even if one could have corrected the tape, the imprudent psychiatrist must have been made keenly aware of the dangers inherent in interpretation.
——*Letter from René Magritte to Harry Torczyner, August 18, 1961*

Psychoanalysis only allows interpretation of that which lends itself to interpretation. Fantastic Art and Symbolic Art present it with numerous occasions for intervention. With respect to these Arts, there is often the question of more or less apparent delirium.

Art, as I conceive it, is resistant to psychoanalysis. It evokes the mystery without which the world would not exist, that is, the mystery one should not mistake for some sort of a problem, however difficult.

I see to it that I paint only images that evoke the world's mystery. To make this possible, I have to be wide-awake, which means I have to cease to identify myself completely with ideas, sentiments, and sensations. (Dreams and madness, on the contrary, are propitious to absolute identification.)

Nobody in his right mind believes that psychoanalysis could elucidate the mystery of the universe. The very nature of the mystery annihilates curiosity. Nor has psychoanalysis anything to say about works of art that evoke the mystery of the universe. Perhaps psychoanalysis is the best subject to be treated by psychoanalysis.
——*Statement by René Magritte (Brussels), May 21, 1962, in* The Vision of René Magritte, *exhibition catalogue, Walker Art Center, Minneapolis, Minnesota, September 16–October 14, 1962.*

. . . the Surrealists' taste for dream narratives is of no interest to me. Maybe the judgment that "my paintings are dreams" contributes to my indifference. I never put any stock in this judgment. I don't mean to say that dreams aren't interesting to doctors; that is their business (like penicillin).
——*Letter from René Magritte to André Bosmans, May 8, 1962*

The title is *Gradiva* (even if I mistakenly put *Gravida*, as you spell it). *Gradiva* is a novel by . . . ! forget the name, with an analysis by Freud. I'd also forgotten I had given the drawing a title. Maybe that would be significant to a Freudian specialist.*
——*Letter from René Magritte to Harry Torczyner, October 29, 1965*

*Magritte is referring to *Gradiva* (a pregnant woman), as distinguished from *Gravida*, the title of a story by Wilhelm Jensen, which was the subject of Freud's first psychoanalytic study of a literary work, *Illusions and Dreams in Jensen's "Gravida."*

119 *Personnage méditant sur la folie (Person Meditating on Madness).* 1928. Oil on canvas, 21¼ x 28¾" (54 x 73 cm). Collection M. and Mme. Louis Scutenaire, Brussels, Belgium

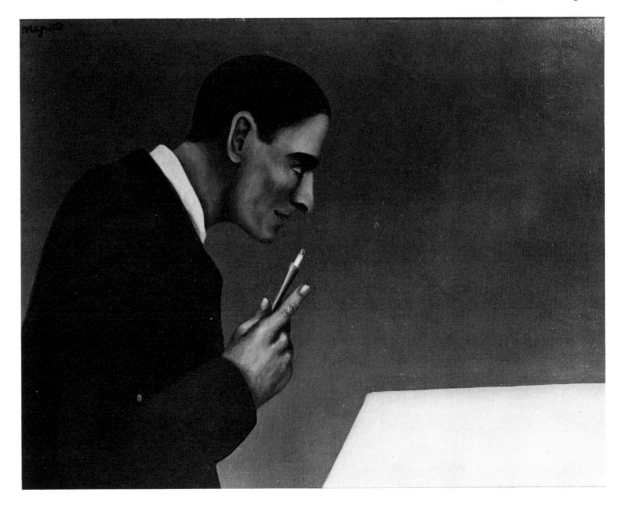

Sciences

Poets were able to enjoy Jules Verne's *Journey to the Moon,* and they will pay no attention to such a voyage as is presently being planned by serious people, generals, journalists, financiers, etc. . . .
——*Letter from René Magritte to André Bosmans, January 10, 1958*

I am, of course, unable to appreciate science, not being a scientist. That doesn't imply contempt for it, merely lack of interest. It seems to me that skepticism consists not only in withholding judgments, but above all in avoiding error and consequently in thinking of truth as something inaccessible (which is already an infidelity to skepticism, since truth is what is being judged).

It happens that scientific conquests and the more or less precise goals of scientific endeavor don't interest me at all. As for the value of science and its capabilities, I am maintaining a spontaneous "scientific" discretion, which may be uninformed, but which is nevertheless final.

I believe everything is always possible, but there is only mediocrity in anything one might desire of the possible. For example, it's possible that one day we may see a squared circle or live centaurs. In what way can hope for a particular possibility force us to esteem some science that may enable us to realize those possibilities?
——*Letter from René Magritte to Maurice Rapin, May 7, 1958*

The "illustration" of the themes of science, scientific research, mankind can to my mind be nothing more than a joke (albeit an innocent one). I painted an image entitled *La présence d'esprit (Presence of Mind),* which exactly *fit* (without "illustrating") the ideas and emotions relevant to the varied possibilities of the theme. Thus, the painting *La présence d'esprit* shows the sky, earth, a bird, a man, and a fish—in other words, all aspects of the world with which science is concerned (it researches what they are, at least for the science-minded). This image, *La présence d'esprit,* does not prejudge what they represent for the scientifically inclined, nor for those subject to any discipline whatsoever: commercial, political, military, or anything else. It shows aspects of the world with which all kinds of people are concerned, including scientists, in their own way. If we accept this [proposition], I believe we can hold that these aspects of the world interest mankind in general. . . .

The "idea" of mankind . . . can in turn be "presented" in the painting due to the fact that a man depicted in it "symbolizes" the "unity of man." Furthermore, the picture is called *La présence d'esprit*—that which is absolutely indispensable to any program that is to encompass "science, scientific research, and mankind."
——*Letter from René Magritte to Harry Torczyner, July 1960*

120 Study for *La présence d'esprit (Presence of Mind).* 1960. Drawing, 5⅞ x 4½" (15 x 11.5 cm). Private collection, New York, New York

121 *La présence d'esprit (Presence of Mind).* 1960. Oil on canvas, 45⅝ x 35" (116 x 89 cm). Collection Pirlet, Cologne, Germany

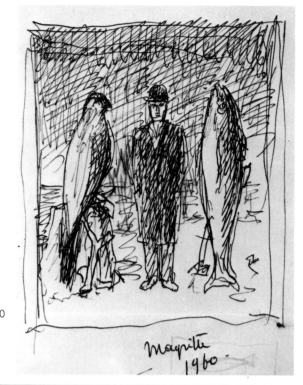

120

121

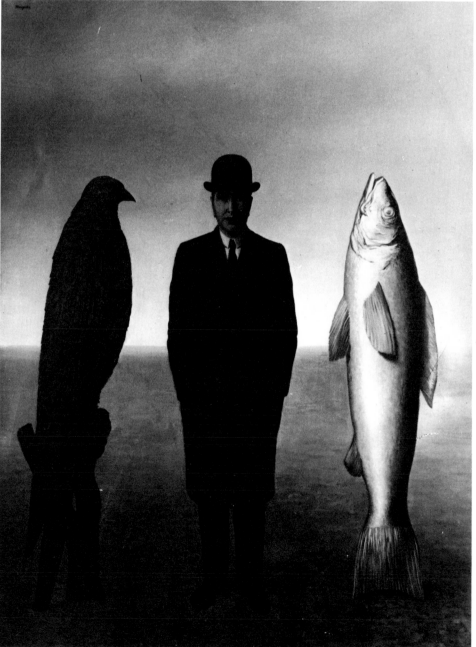

BY MYSTERY POSSESSED

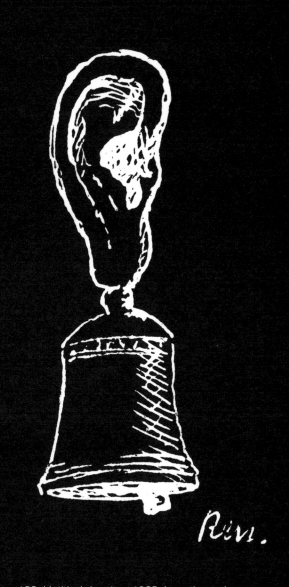

122. Untitled drawing. 1965. Location unknown

"The visible presented by the world is rich enough to constitute a language evocative of mystery," Magritte told us. The division of the painting; the painting within the painting; the dismemberment of the image; the use of words; the juxtaposition of unrelated objects set in the sky, on the ocean, or on earth—all these inventions of his mind had no purpose other than to mark out and to make remarked this empire, possessed by mystery. It is this ultimate confrontation with mystery that Magritte's work forces upon us, whence its power and its spell.

He was concerned with the problems of similarity and of resemblance; finding for them a simple and perfect solution gave him intellectual pleasure. "Peas share a relationship of similarity . . . only thought has resemblance," he wrote to Michel Foucault. In fact, analogy and *rapprochement* are mental operations. In his variations on one of his best known themes, *L'empire des lumières (The Empire of Lights),* Magritte gives us a precious example of these inspired games. From the time he discovered his path and adopted his particular gait, he never again deviated from his pictorial style. One can say that his other modes of expression—Cubist, Impressionist, and Fauvist (which lasted only for a moment, the moment of the exhibition "The Black Period")—are merely interludes in his life as a deliberate magician.

Magritte never hesitated to represent the human figure as an object, but he was not attracted by the self-portrait or portrait. He did not like using a mirror to reflect either his person or his personality. Nevertheless, out of friendship he consented to paint a few portraits of friends, thereby giving them the satisfaction of observing themselves in a false mirror.

Mystery—without which no world, no thought, would be possible—corresponds to no doctrine, and does not deal with possibilities. Thus, a question such as "How is mystery possible?" is meaningless because mystery can be evoked only if we know that any possible question is relative only to what is possible.

Some mediocre or absurd things do not really cast doubt on the concept of mystery; nothing beautiful or grandiose can affect it. Judgment as to what is, was, or will be possible does not enter into the concept of mystery. Whatever its manifest nature may be, every object is mysterious: the apparent and the hidden, knowledge and ignorance, life and death, day and night. The attention we give to the mystery in everything is deemed sterile only if we overlook the higher sensibility that accompanies that attention, and if we grant a supreme value to what is possible. This higher sensibility is not possible without freedom from what we call "the laws of the possible."

Freedom of thought alert to mystery is always possible if not actually present, whatever the nature of the possible: atrocious or attractive, mean or marvelous. It has power to evoke mystery with effective force.
——*René Magritte, "La Voix du Mystère,"* Rhétorique, no. 4, January 1962, p. 1

Resemblance—which can be made visible through painting—only deals with figures as they appear in the world: people, curtains, weapons, stars, solids, inscriptions, etc. . . . spontaneously united in the order wherein the familiar and the strange are restored to mystery.

What one must paint is the image of resemblance—if thought is to become visible in the world.
——*René Magritte, catalogue of the Magritte exhibition, Paris, Galerie Rive Droite, 1960*

MAGIC CATALOGUE

123 Notes for an illustrated lecture given by René Magritte at Marlborough Fine Art (London) Ltd., February 1937; published in facsimile in the catalogue of the exhibition *Magritte* held at Marlborough Fine Art (London), October–November 1973, pp. 21–23. *See* Appendix *for translation*

Naming Things

Mesdames et Messieurs,

La démonstration que nous allons faire ensemble tendra à montrer quelques caractères propres aux mots, aux images et aux objets réels.

(1) Un mot peut remplacer une image:

Chapeau HAT.

(2) Une image peut remplacer un mot. Je vais le démontrer en me servant d'un texte d'André Breton où je remplace un mot par une image:

Si seulement IF ONLY THE SUN WOULD SHINE TONIGHT.

[de Jean Scutenaire] On ne peut pas ONE CANNOT GIVE BIRTH TO A FOAL WITHOUT BEING ONE ONESELF.

de Paul Eluard:
Dans les plus sombres yeux se ferment les plus clairs.
THE DARKEST EYES ENCLOSE THE LIGHTEST.

[de Paul Colinet] Il y a THERE IS A SPHERE PLACED ON YOUR SHOULDERS.

de David Gascoigne

[de Mesens] Masque de veuve WIDOW'S MASK FOR THE WALTZ.

de Humfrey Jennings THE FLYING of EDUCATION

- 2 -

(3) Un objet peut remplacer un mot:
Le pain du crime. THE BREAD OF CRIME.

(4) Une forme quelconque peut remplacer l'image d'un objet: un mot
Les naissent THE ARE BORN IN WINTER.

(5) Un mot peut faire l'office d'un objet:
Ce bouquet THIS BOUQUET IS TRANSPARENT

(6) On peut désigner une image ou un objet par un autre nom que le sien:

L'oiseau O THE BIRD
La montagne THE MOUNTAIN
Voici le ciel BEHOLD THE SKY (skaie)
this is de skaye

(7) Il existe une affinité secrète entre certaines images. Elle vaut également pour les objets représentés par ces images. Recherchons ensemble ce qui doit être dit. Nous connaissons l'oiseau dans une cage. L'intérêt est éveillé davantage si l'oiseau est remplacé par un poisson, ou un soulier.

Ces images sont curieuses. Malheureusement elles sont arbitraires et accidentelles.

- 3 -

Il est possible pourtant d'obtenir une image nouvelle qui résistera mieux à l'examen du spectateur. Un grand oeuf dans la cage parait être la solution requise.

Occupons nous maintenant de la porte. La porte peut s'ouvrir sur un paysage vu à l'envers.

Le paysage peut être représenté sur la porte.

Essayons quelque chose de moins arbitraire: à côté de la porte faisons un trou dans le mur qui est un autre porte aussi.

Cette rencontre sera perfectionnée si nous réduisons ces deux objets à un seul. Le trou se place donc tout naturellement dans la porte et par ce trou l'on voit l'obscurité.

Cette image pourrait de nouveau s'enrichir en éclairant si l'on la chose invisible cachée par l'obscurité. Notre regard veut toujours aller plus loin, veut voir enfin l'objet, la raison de notre existence.

Texte de la démonstration faite par René Magritte, à Londres, à la London Gallery, le février 1937.

Un objet ne tient pas tellement à son nom qu'on ne puisse lui en trouver un autre qui lui convienne mieux :

Il y a des objets qui se passent de nom :

Un mot ne sert parfois qu'à se désigner soi-même :

Un objet rencontre son image, un objet rencontre son nom. Il arrive que l'image et le nom de cet objet se rencontrent :

Parfois le nom d'un objet tient lieu d'une image :

Un mot peut prendre la place d'un objet dans la réalité :

Une image peut prendre la place d'un mot dans une proposition :

Un objet fait supposer qu'il y en a d'autres derrière lui :

Tout tend à faire penser qu'il y a peu de relation entre un objet et ce qui le représente :

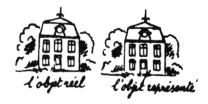

Les mots qui servent à désigner deux objets différents ne montrent pas ce qui peut séparer ces objets l'un de l'autre :

Dans un tableau, les mots sont de la même substance que les images :

On voit autrement les images et les mots dans un tableau :

Une forme quelconque peut remplacer l'image d'un objet :

Un objet ne fait jamais le même office que son nom ou que son image :

Or, les contours visibles des objets, dans la réalité, se touchent comme s'ils formaient une mosaïque :

Les figures vagues ont une signification aussi nécessaire, aussi parfaite que les précises :

Parfois, les noms écrits dans un tableau désignent des choses précises, et les images des choses vagues :

Ou bien le contraire :

René MAGRITTE.

125 *L'appel des choses par leur nom (Naming Things)*. 1929. Oil on canvas, 31⅞ x 45⅝″ (81 x 116 cm). Collection William N. Copley, New York, New York

126 *L'alphabet des révélations (The Alphabet of Revelations)*. 1935. Oil on canvas, 21⅝ x 28¾″ (55 x 73 cm). Private collection, United States

127 *La preuve mystérieuse (The Mysterious Proof)*. 1928–1929. Oil on canvas, 19⅝ x 23⅝″ (50 x 60 cm). Private collection, Zurich, Switzerland

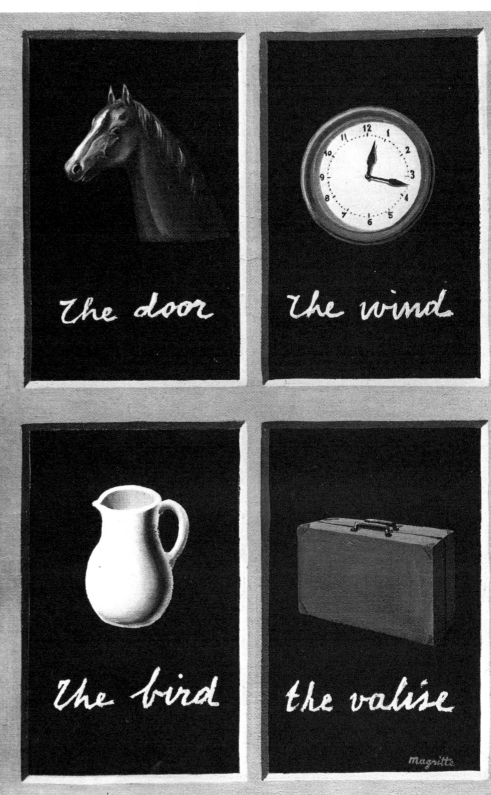

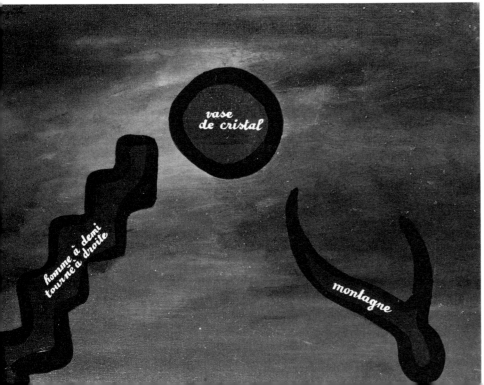

128 *La clé des songes (The Key of Dreams)*. 1932. Oil on canvas, 16⅜ x 11″ (41.5 x 28 cm). Collection Jasper Johns, New York, New York

Rose

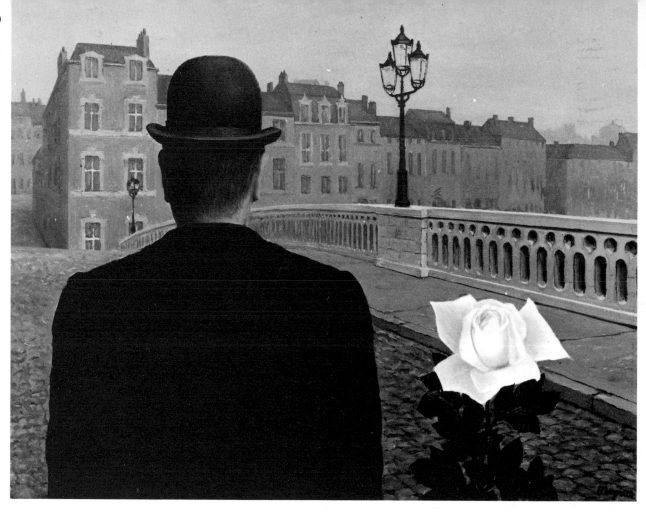

129 *La boîte de Pandore (Pandora's Box)*. 1951. Oil on canvas, 18¼ x 21⅝" (46.5 x 55 cm). Yale University Art Gallery, New Haven, Connecticut

130 Untitled drawing. n.d. Pencil. Collection Robert Rauschenberg, New York, New York

According to the method that I think is exclusively my own, I have been looking for about two months for the solution to what I call "the problem of the rose." At the end of my search, I realize that I have probably known the answer to my question for a long time, but dimly, in the same way as everyone else. This knowledge, which is apparently organic and not conscious, has been there at the beginning of every search I've undertaken. The first sign I instinctively dashed off on paper when I decided to resolve the rose problems is this one:

and that oblique line diverging from the stem of the flower has required long, hard research for me to unravel its meaning. Of the many objects I imagined, I recall these:
the line is the pole of a green flag

the line is a tower of a feudal castle

or an arrow:

finally, I hit on it: it was a dagger, and the rose problem was pictorially solved as follows:

Finally, after the search is concluded, it's easy to "explain" that the rose is perfumed air, but it is also cruelty, and reminds me of your "patricidal rose." I also recall this passage of forbidden images by Nougé: "We perceive the rose's faint perfume by means of a heartrending memory."
And a curious fact—in 1942 or 1943 I made a picture with the cover of the first volume of *Fantômas,* but replacing the murderer's bloody knife with a rose.
——*Letter from René Magritte to Paul Colinet, November 27, 1957*

The presence of the rose next to the stroller signifies that wherever man's destiny leads him he is always protected by an element of beauty. The painter hopes that this man is heading for the most sublime place in his life. The rose's vividness corresponds to its important role (element of beauty). The approach of nightfall suits withdrawal, and the bridge makes us think something will be overcome.
——*Letter from René Magritte to Mr. and Mrs. Barnet Hodes, undated, 1957*

130

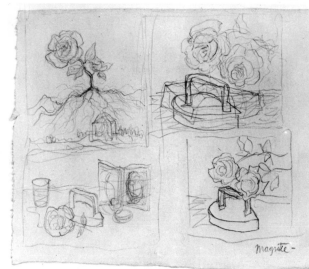

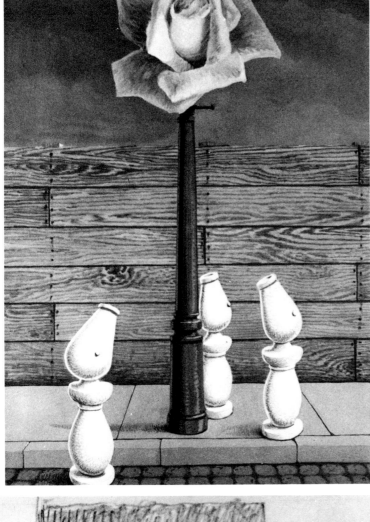

131

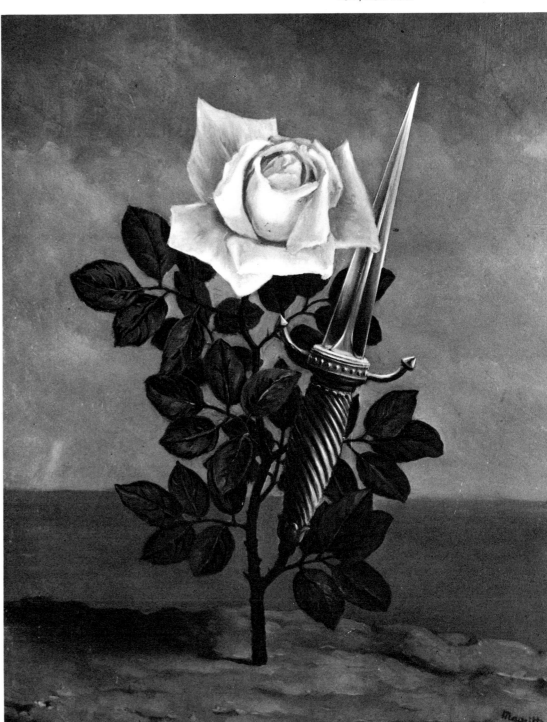

133

132

Le coup au coeur (The Blow to the Heart) shows as answer to the rose a dagger growing out of the rose's stem.

——*René Magritte, La Carte d'Après Nature, no . 1, October 1952*

91

134 *Le voyage des fleurs (The Voyage of the Flowers).* 1928. Oil on canvas, 28¾ x 35⅜″ (73 x 90 cm). Collection Jean-Louis Merckx, Brussels, Belgium

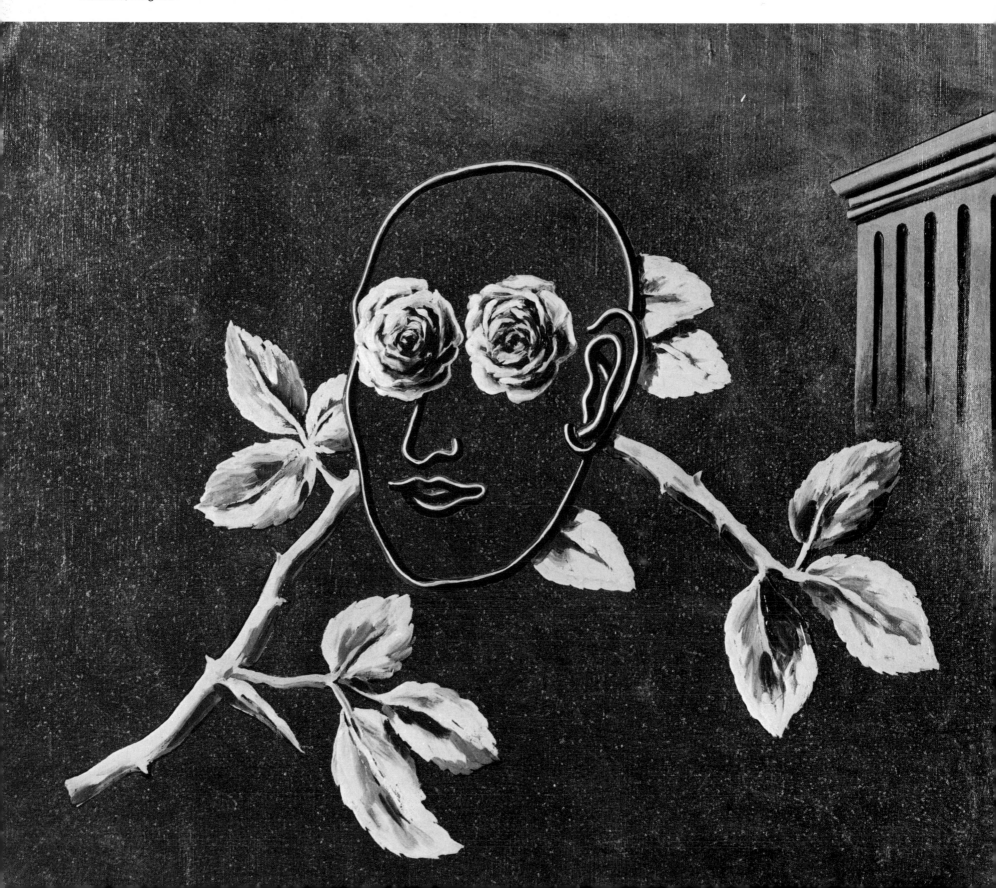

Bell

I'd prefer to believe that the iron bells hanging from our fine horses' necks grew there like poisonous plants on the edge of precipices.
——*René Magritte, "La Ligne de Vie," Combat, vol. 3, no. 105, December 10, 1938*

135

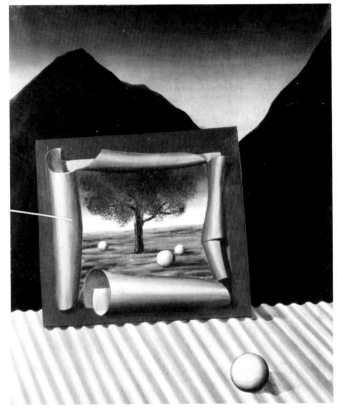

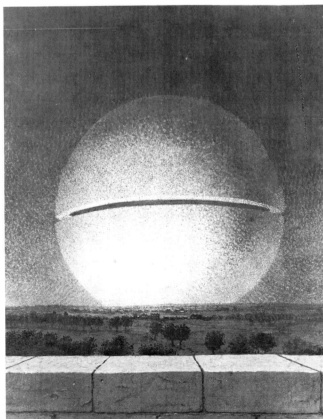

136

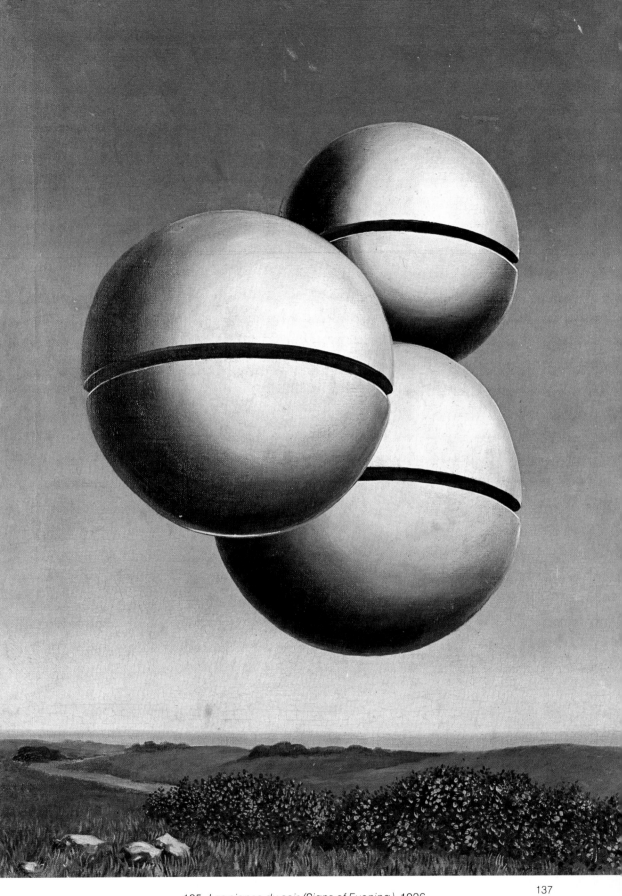

137

135 *Les signes du soir (Signs of Evening).* 1926. Oil on canvas, 29½ x 25¼" (75 x 64 cm). Collection Claude Spaak, Choisel (Seine-et-Oise), France

136 *L'entrée de la Seine (The Entrance of the Seine).* n.d. Oil on canvas, 16⅞ x 14⅛" (43 x 36 cm). Private collection, New York, New York

137 *La voix des vents (The Voice of the Winds).* 1928. Oil on canvas, 25⅝ x 19⅝" (65 x 50 cm). Private collection, United States

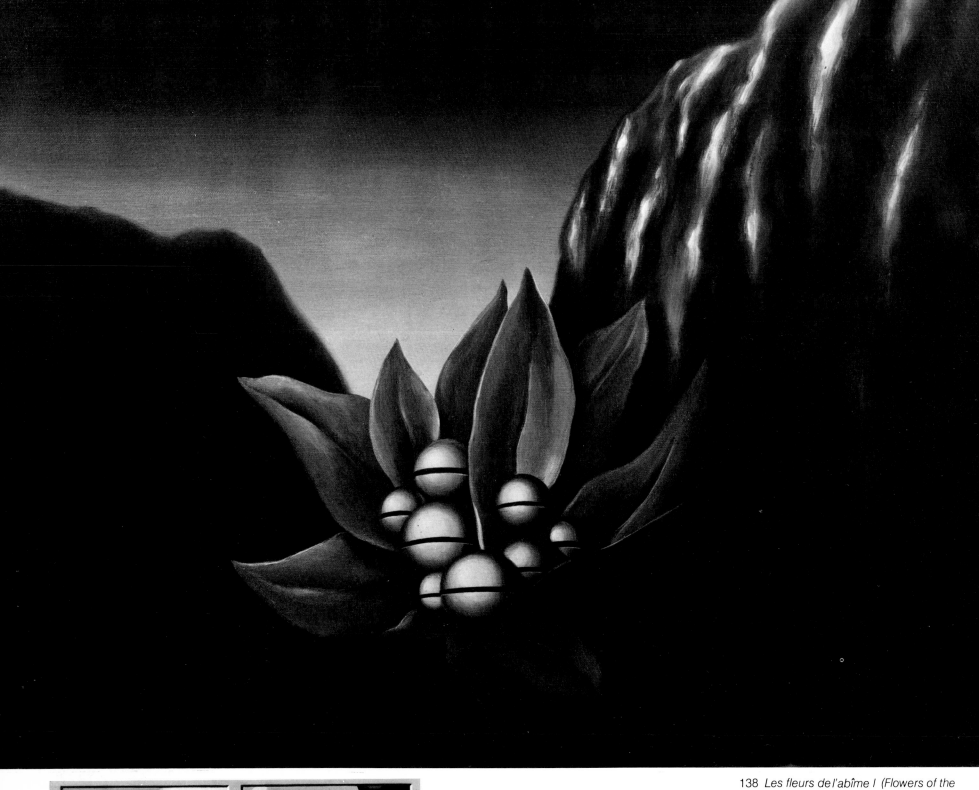

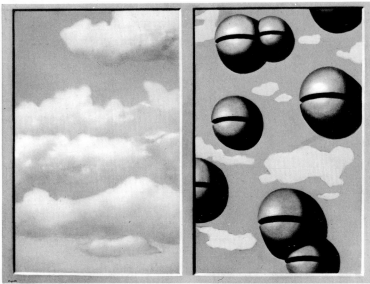

138 *Les fleurs de l'abîme I (Flowers of the Abÿss I)*. 1928. Oil on canvas, 21⅝ x 28¾" (55 x 73 cm). Private collection, New York, New York

139 *Grelots roses, ciels en lambeaux (Pink Bells, Tattered Skies)*. 1930. Oil on canvas, 28¾ x 39⅜" (72 x 100 cm). Collection Baron Joseph-Berthold Urvater, Paris, France

Room

Late-nineteenth-century authors are not devoid of charm: Lorrain's *Mr. de Baugrelon,* for example, is highly to be recommended. Once I called a picture *Le tombeau des lutteurs (The Tomb of the Wrestlers)* in memory of a book by Cladel* I read in my youth and that I've completely forgotten. I felt the title fit the idea of a huge red rose filling the space of a room.
——Letter from René Magritte to André Bosmans, July 23, 1960

*Ompedailles, ou le Tombeau des Lutteurs by Léon-Alpinien Cladel, 1879

I am happy to hear about the welcome you've given *Le tombeau des lutteurs.* The date 1944 shows that during that period the painting I envisaged, though attempting to bring it into harmony with the spirit of Impressionism, wasn't always (in 1954 [sic]) attuned to that spirit. "My usual manner" was sometimes—always, rather—there to testify that I would recover once and for all. The 1944 pictures, such as *Le tombeau des lutteurs,* were, in fact, painted in "my usual manner," which has since come to be the only one that I feel is truly necessary for painting without fantasy or eccentricity those ideas already "sublime" enough that they do not need to be given anything but a precise description. I firmly believe that a beautiful idea is ill-served by being "interestingly" expressed; the interest is in the idea. Those ideas that need rhetoric to be "acceptable," for example, are incapable of making an effect on their own.
——Letter from René Magritte to Harry Torczyner, August 19, 1960

I am requesting . . . that you lend the picture *Le tombeau des lutteurs* to the Guggenheim Museum, and that you inform them of the following.

It seems to me that given the wit (or rather, the lack of wit) prevailing in "professional" circles, this picture may have some chance of being appreciated through a misunderstanding. Indeed, with the help of blindness, it could be taken for an "abstract" painting, "tachiste," or what have you. The importance of the color red will undoubtedly beat interest into the sensibilities of the amateurs of currently fashionable painting, as though they were so many bass drums.
——Letter from René Magritte to Harry Torczyner, August 25, 1963

140 Letter from René Magritte to Harry Torczyner, August 19, 1960. *See* Appendix *for translation*

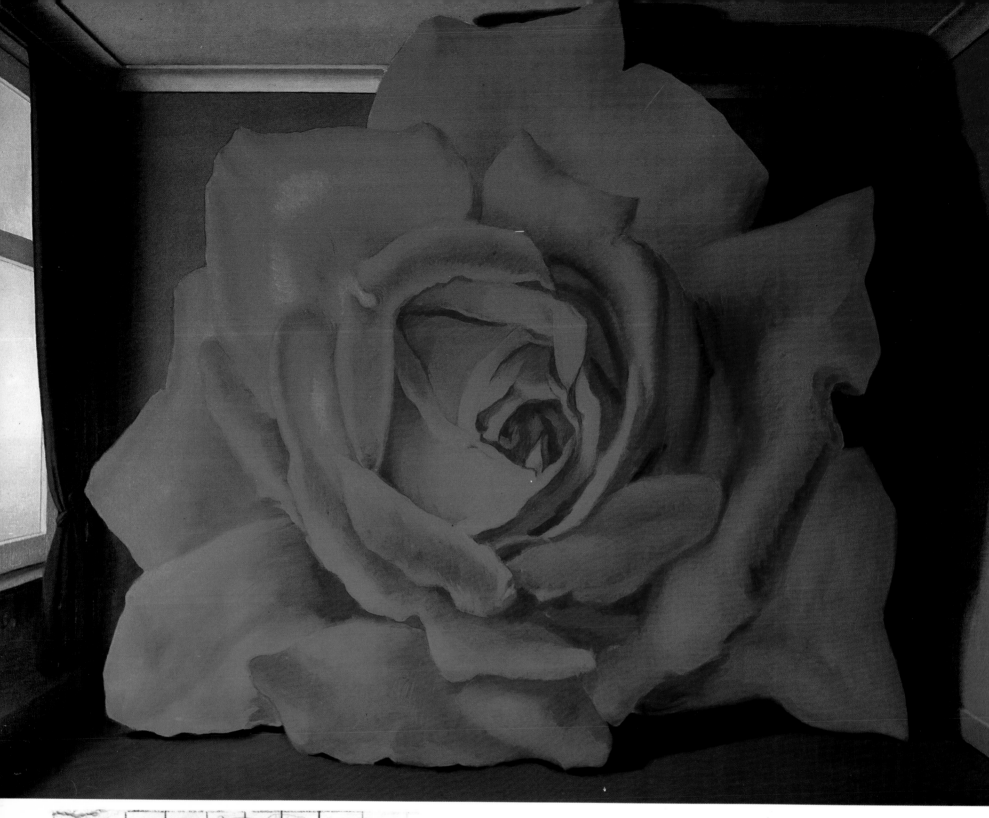

141 *Le tombeau des lutteurs (The Tomb of the Wrestlers)*. 1960. Oil on canvas, 35 x 46⅛″ (89 x 117 cm). Collection Harry Torczyner, New York, New York

142 *Le tombeau des lutteurs (The Tomb of the Wrestlers)*. n.d. Drawing, 3⅞ x 5½″ (10 x 14 cm). Private collection, New York, New York

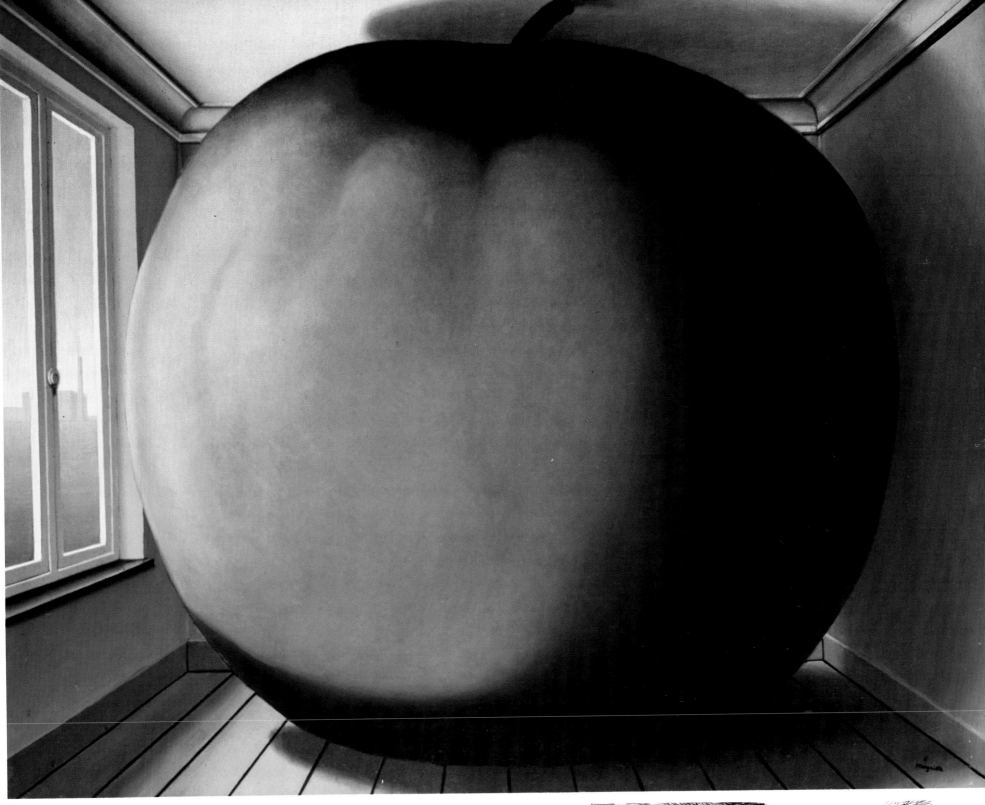

143 *La chambre d'écoute I (The Listening Room I).* 1953. Oil on canvas, 31½ x 39⅜" (80 x 100 cm). Collection William N. Copley, New York, New York

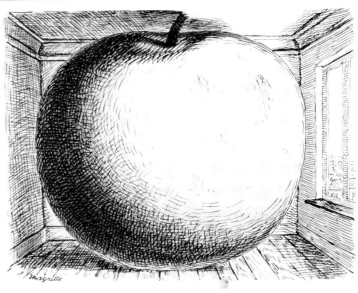

144 *La chambre d'écoute (The Listening Room).* n.d. Drawing. Private collection, United States

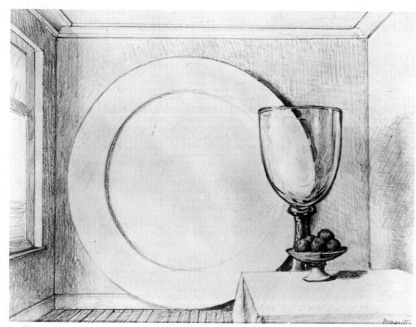

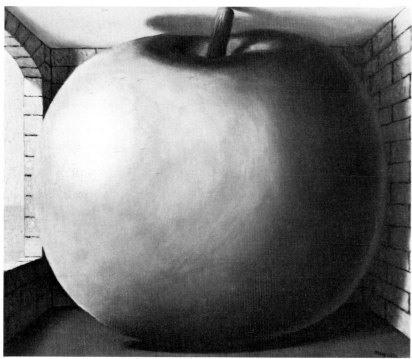

145 *Les valeurs personnelles (Personal Values)*. 1962. Drawing, 7⅞ x 11″ (20 x 28 cm). Private collection, Belgium

146 *La chambre d'écoute II (The Listening Room II)*. 1958. Oil on canvas, 13 x 15″ (33 x 38.2 cm). Collection Mrs. H. Rattner, New York, New York

147 *La chambre de Madame Sundheim (The Room of Madame Sundheim)*. n.d. Oil on canvas, 11 x 14½″ (28 x 36.7 cm). Collection Harry G. Sundheim, Jr., Chicago, Illinois

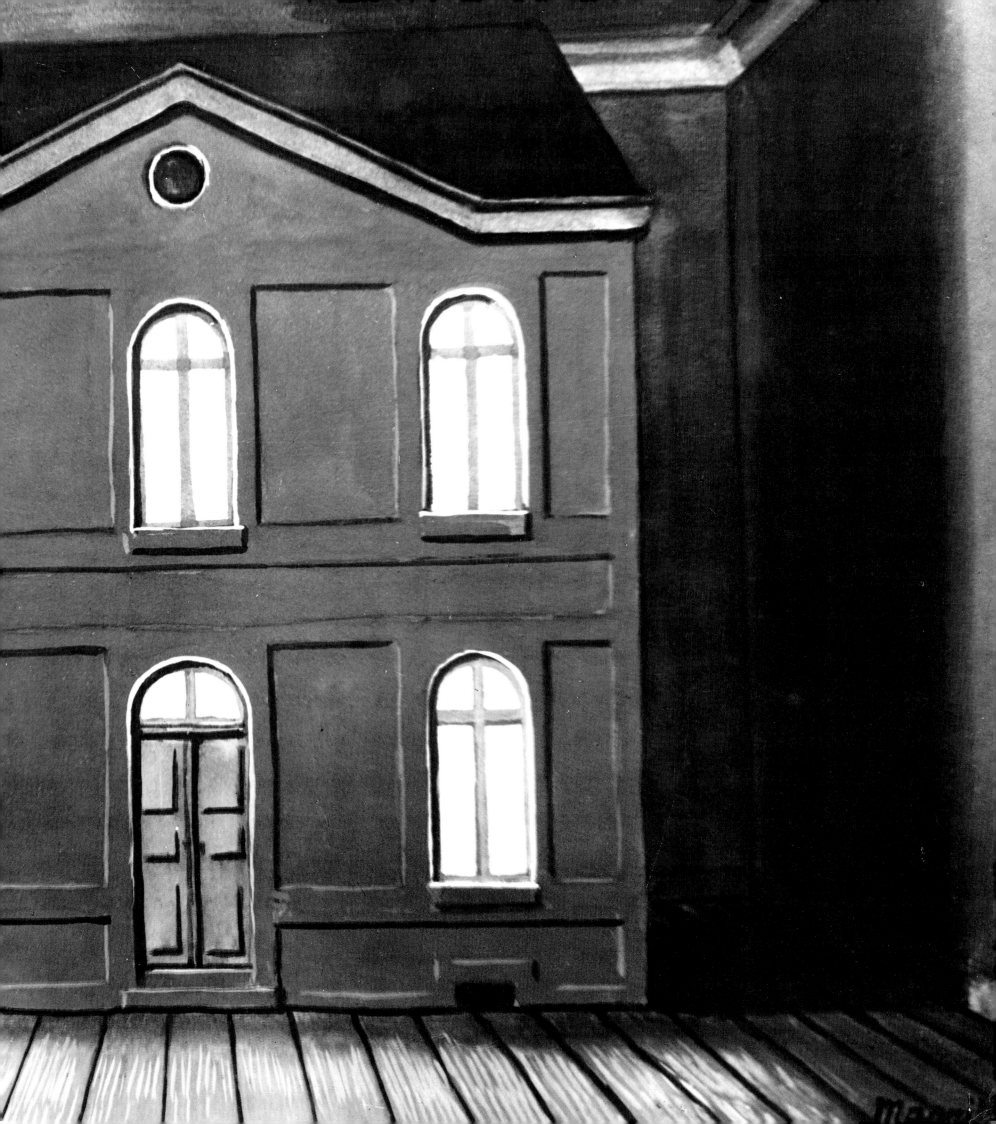

148 *L'anniversaire (The Anniversary).* 1959. Oil
on canvas, 35¼ x 45⅞" (89.5 x 116.5 cm).
Art Gallery of Ontario, Toronto, Canada

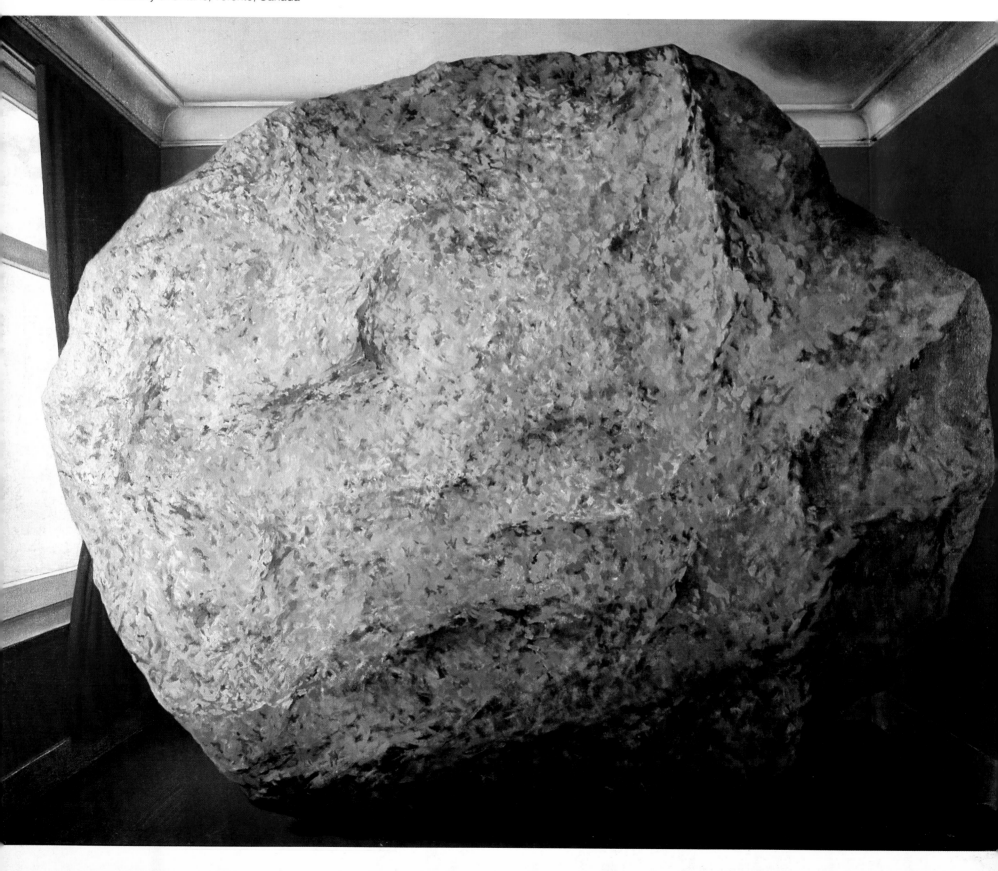

Velocipede

149 *Melmot (Melmot)*. 1959. Oil on canvas, 13¾ x 18¼″ (35 x 46.5 cm). Private collection, United States

150 *L'état de grâce (State of Grace)*. 1959. Gouache, 5¾ x 6¾″ (14.5 x 17 cm). Collection Harry Torczyner, New York, New York

151 Letter from René Magritte to Suzi Gablik, 1959. *See* Appendix *for translation*

151

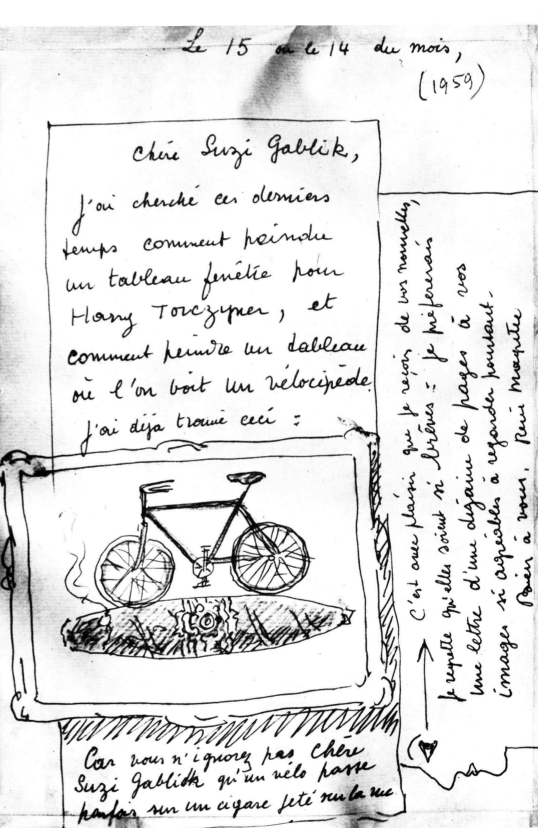

149

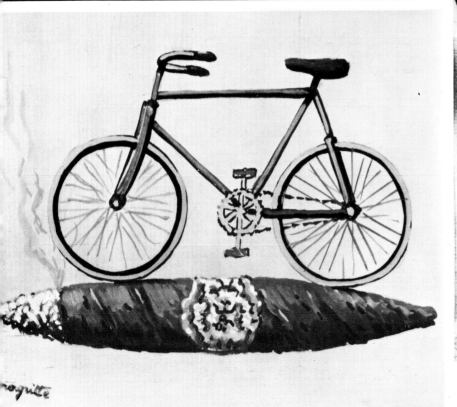

Fish

152

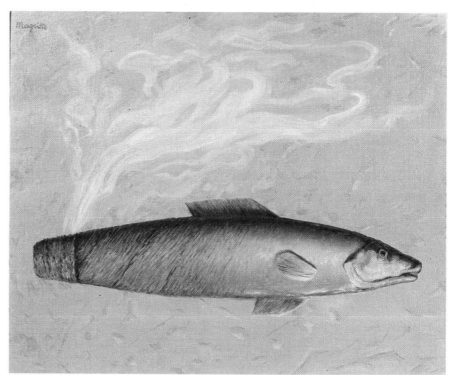

L'invention collective (The Collective Invention) was the answer to the problem of the sea; on the beach I placed a new species of siren, whose head and upper body were those of a fish and whose lower parts, from stomach to legs, those of a woman.

——*René Magritte, La Ligne de Vie, lecture, November 20, 1938*

154

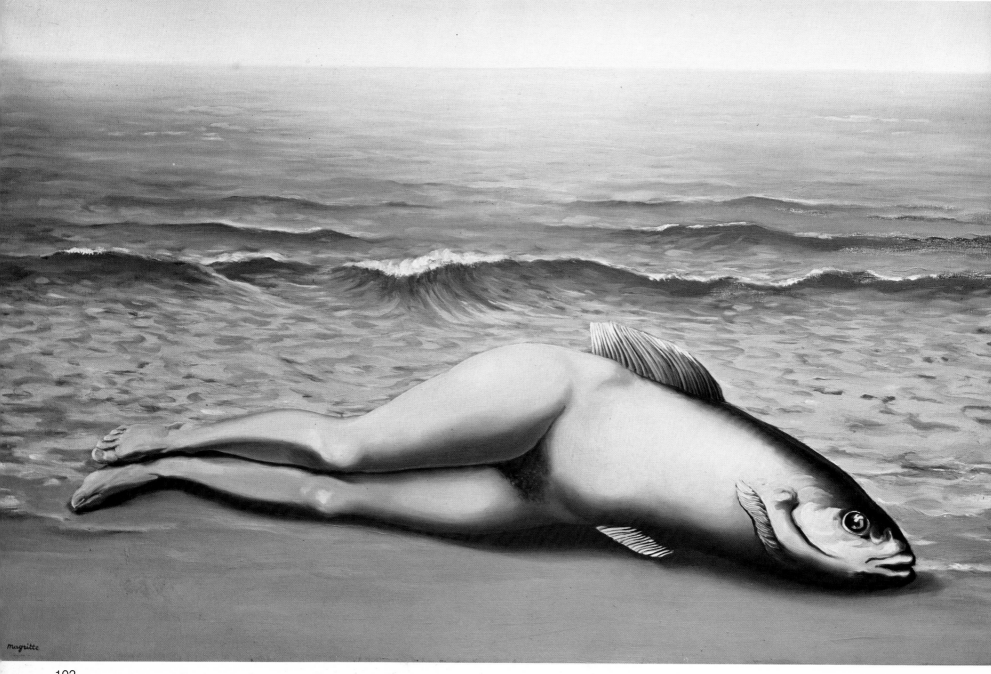

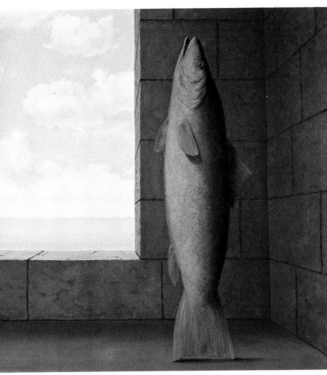

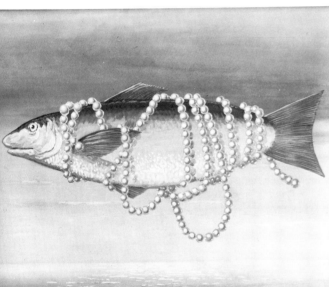

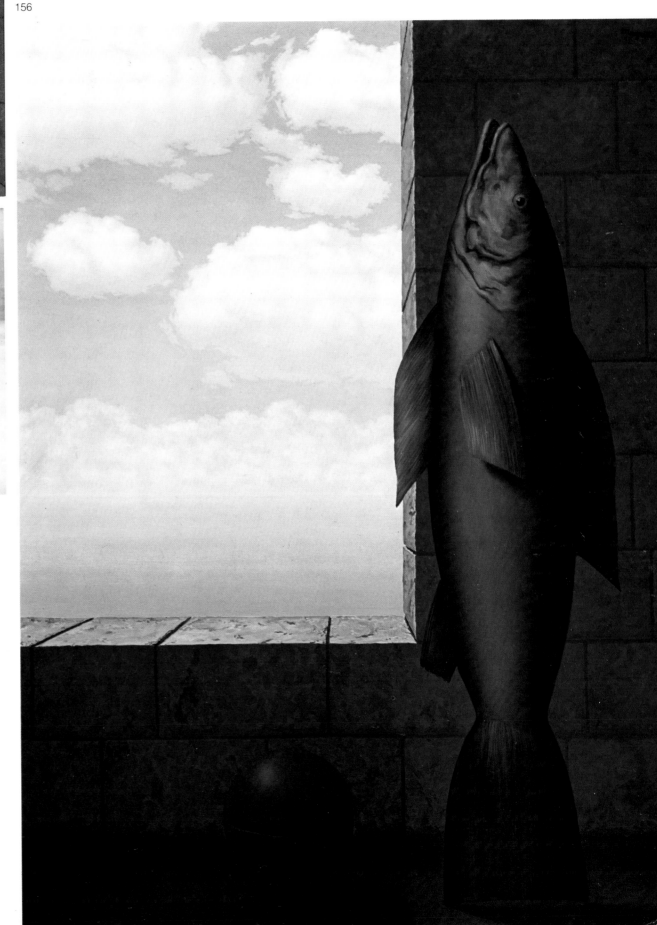

155

152 *L'exception (The Exception).* 1963. Oil on canvas, 13 x 16⅛″ (33 x 41 cm). Galerie Isy Brachot, Brussels, Belgium

153 *La recherche de la vérité (Search for the Truth).* 1963. Oil on canvas, 25¼ x 31½″ (64 x 80 cm). Private collection, Brussels, Belgium

154 *L'invention collective (The Collective Invention).* 1935. Oil on canvas, 29 x 45⅝″ (73.5 x 116 cm). Private collection, Belgium

155 *Hommage à Alphonse Allais (Homage to Alphonse Allais).* n.d. Oil on canvas, 11 x 14⅜″ (28 x 36.5 cm). Collection Harry G. Sundheim, Jr., Chicago, Illinois

156 *La recherche de la vérité (Search for the Truth).* 1966. Oil on canvas, 57½ x 44⅞″ (146 x 114 cm). Musées Royaux des Beaux-Arts de Belgique, Brussels, Belgium

Chair

My current "problem" consists in wondering how to show a chair (as subject) in a painting, and in speaking to you specifically about chairs and mimosas. My question must be answered by discovering the thing, the object destined to be joined with a chair. (For the cage, it's an egg; for an umbrella, a glass of water; for a door, an opening one can pass through, etc.)
——*Letter from René Magritte to André Bosmans, July 23, 1958*

I'm happy with my chair, and with the title, which I feel fits it; it's called *Une simple histoire d'amour (A Simple Love Story)* (just to make it worse in the eyes of the comfortably "installed").
——*Letter from René Magritte to Harry Torczyner, September 20, 1958*

My chair with the tail appears in the film.* Some people comfortably "installed" (in chairs) have understood *Une simple histoire d'amour* in various ways, but they have all burst out laughing (astonishing to think that a chair could get such a rise out of people).
——*Letter from René Magritte to Harry Torczyner, September 1958*

*A motion picture made by Dr. Eugene Lepesckin, Burlington, Vermont.

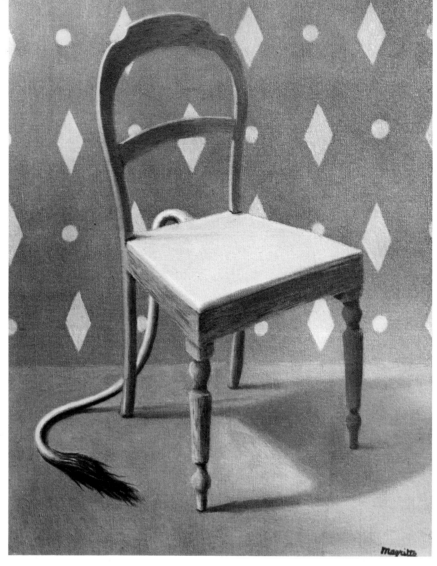

157 *Une simple histoire d'amour (A Simple Love Story).* 1958. Oil on canvas, 15¾ x 11¾" (40 x 30 cm). Galleria La Medusa, Rome, Italy

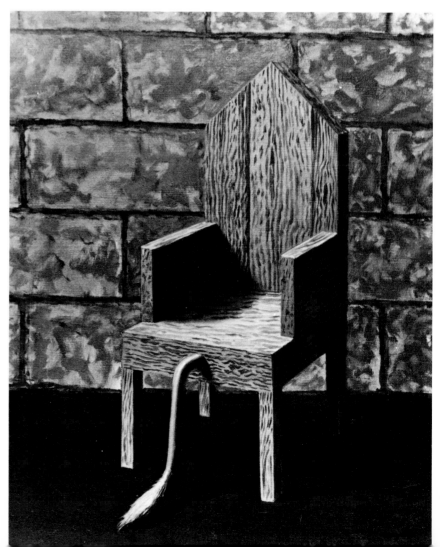

158 *Une simple histoire d'amour (A Simple Love Story).* n.d. Gouache. Private collection, United States

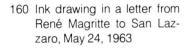

J'attends de vos nouvelles, comme nouvelles je ne vois rien de mieux que de vous faire connaître la solution trouvée à ce problème de peindre un tableau avec une chaise comme sujet. J'ai cherché longtemps avant de savoir que la chaise devait avoir une pierre (qui est plus "parlante" que les timides pattes d'animaux qui servent parfois de pieds aux chaises) je suis très satisfait de cette solution. Qu'en pensez vous?

159 Letter from René Magritte to Harry Torczyner, July 1958. *See* Appendix *for translation*

161 *L'automate (The Automaton).* 1928. Oil on canvas, 39⅜ x 31½" (100 x 80 cm). Moderna Museet, Stockholm, Sweden

160 Ink drawing in a letter from René Magritte to San Lazzaro, May 24, 1963

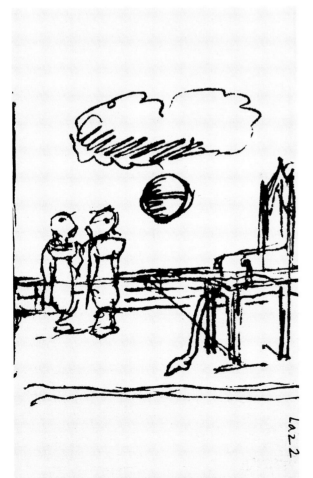

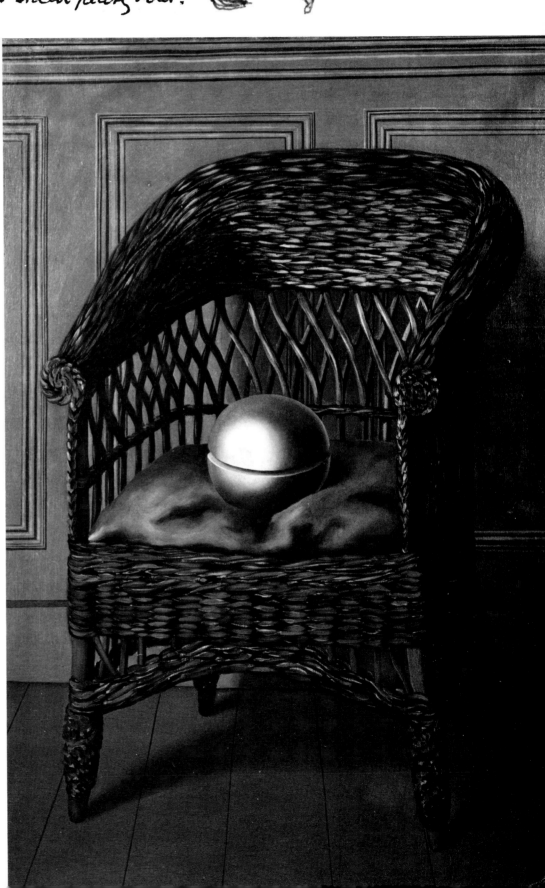

163 *Perspective (Perspective).* 1963.
Pencil drawing, 14⅛ x 10⅝″ (35.9
x 26.9 cm). The Museum of Modern Art, New York, New York. Gift of
Harry Torczyner

162 *La légende des siècles (The
Legend of the Centuries).* 1958.
Ink and pencil drawing, 7⅛ x 3⅞″
(18 x 10 cm). Collection Harry
Torczyner, New York, New York

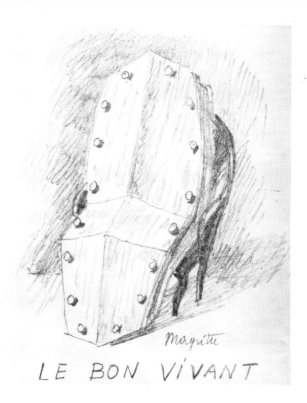

LE BON VIVANT

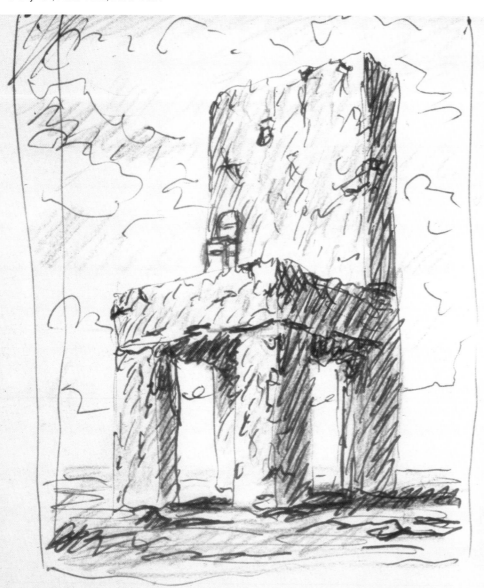

164 *La légende des siècles (The
Legend of the Centuries).* 1950.
Gouache, 9⅞ x 7⅞″ (25 x 20 cm).
Private collection, United States

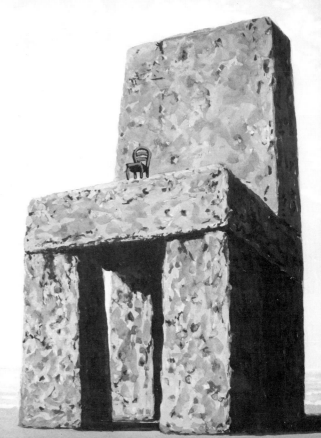

Tree

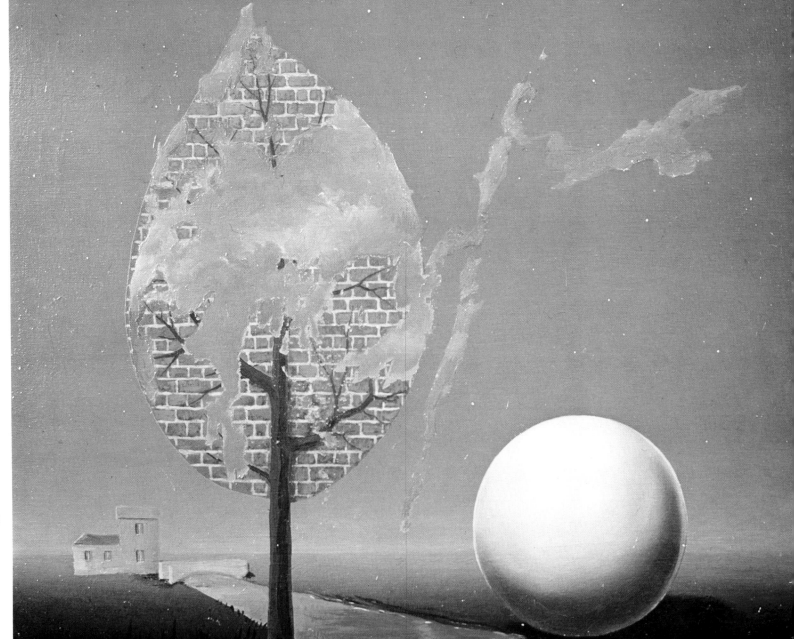

165

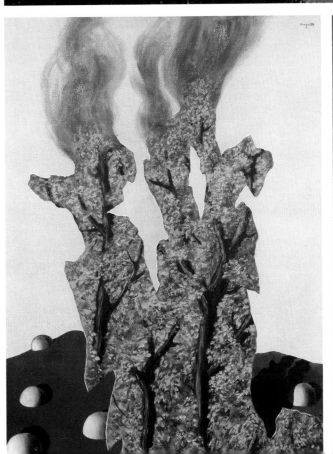

166

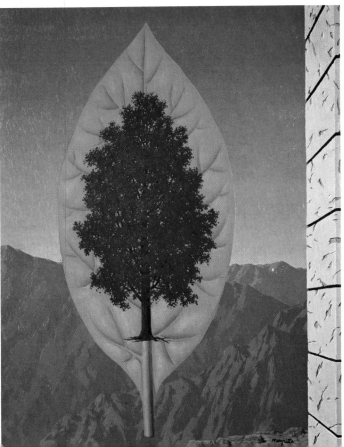

167

165 *Passiflore (Passionflower).* 1936. Oil on canvas, 17¾ x 21⅝″ (45 x 55 cm). Collection M. and Mme. Louis Scutenaire, Brussels, Belgium

166 *Campagne III (Countryside III).* 1927. Oil on canvas, 28⅞ x 21¼″ (73.5 x 54 cm). Galerie Isy Brachot, Brussels, Belgium

167 *Le dernier cri (The Last Scream).* 1967. Oil on canvas, 31½ x 25⅝″ (80 x 65 cm). Collection Dr. Jean Robert, Brussels, Belgium

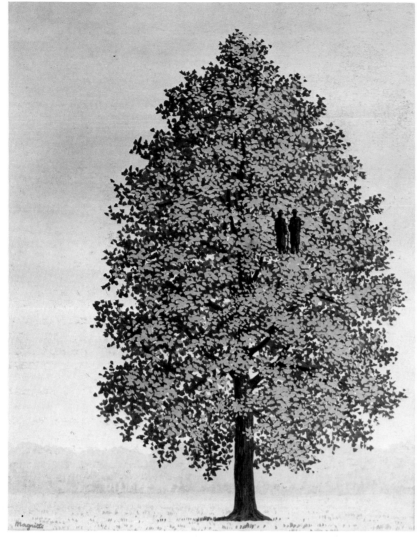

168

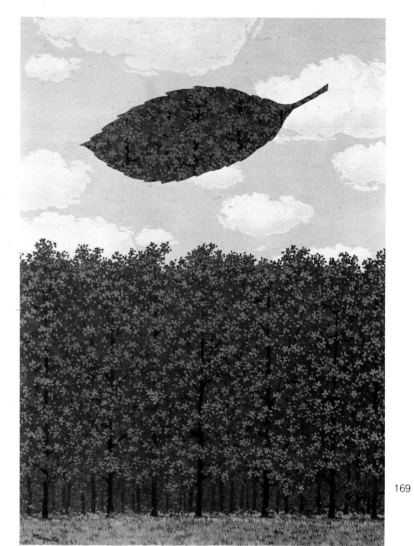

169

168 *La reconnaissance infinie (Infinite Recognition).* 1964. Gouache, 14 x 11″ (35.5 x 28 cm). Collection Harry G. Sundheim, Jr., Chicago, Illinois

169 *Le choeur des sphinges (The Chorus of Sphinxes).* 1964. Gouache, 17¾ x 13¾″ (45 x 35 cm). Collection Mme. Sabine Sonabend-Binder, Brussels, Belgium

170 Untitled. 1944–1945. Oil on canvas, 8⅞ x 12″ (22.5 x 30.5 cm). Collection Mrs. Jack Wolgin, Philadelphia, Pennsylvania

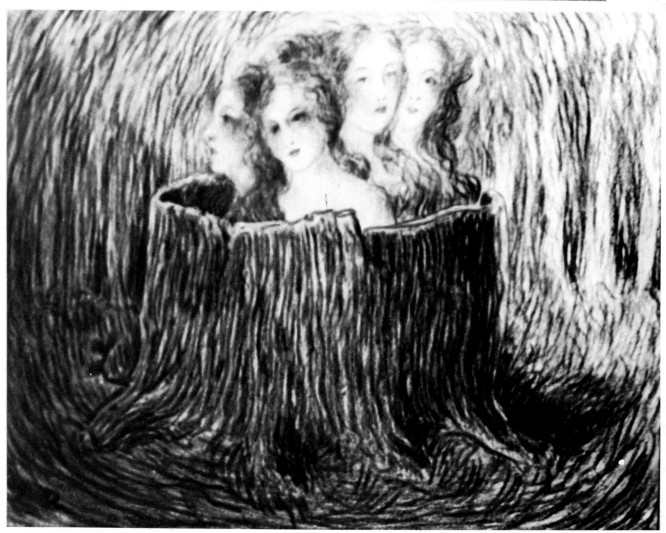

170

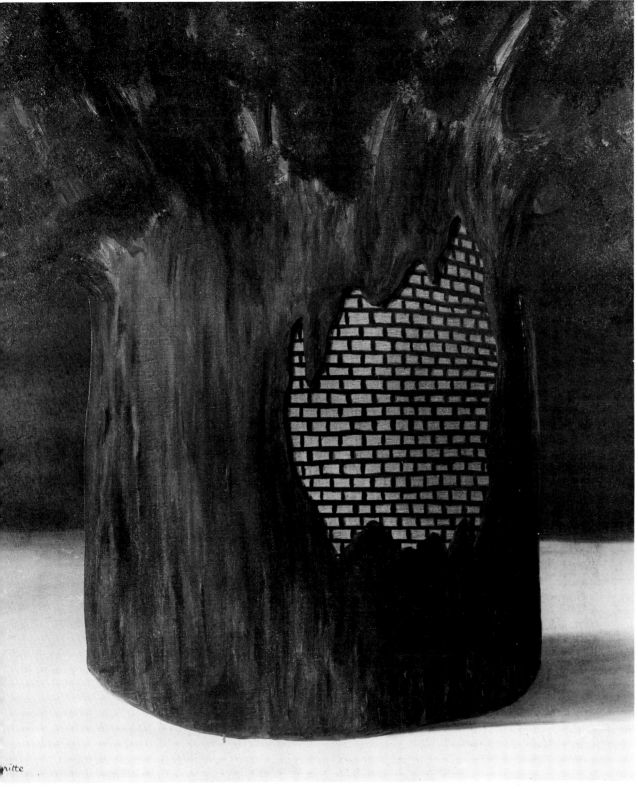

To name the image of a tree "Tree" is an error, a "mistaken identity," since the image of a tree is assuredly not a tree. The image is separate from what it shows.

What we can see that delights us in a painted image becomes uninteresting if what we are shown through the image is encountered in reality; and the contrary, too: what pleases us in reality, we are indifferent to in the image of this pleasing reality—if we don't confuse real and surreal, and surreal with subreal.
—*Letter from René Magritte to André Bosmans, July 1959*

Pushed from the earth toward the sun, a tree is an image of certain happiness. To perceive this image we must be immobile like a tree. When we are moving, it is the tree that becomes the spectator. It is witness, equally, in the shape of chairs, tables, and doors to the more or less agitated spectacle of our life. The tree, having become a coffin, disappears into the earth. And when it is transformed into fire, it vanishes into the air.
—*René Magritte, quoted by Louis Scutenaire, René Magritte, 1947, p. 69*

171 *Le seuil de la forêt (The Threshold of the Forest)*. 1926. Oil on canvas, 29⅛ x 25¼" (74 x 64 cm). Collection Konrad Klapheck, Düsseldorf, Germany

172 *Les travaux d'Alexandre (The Labors of Alexander)*. 1967. Charcoal drawing, 25⅝ x 31½" (65 x 80 cm). Collection Harry G. Sundheim, Jr., Chicago, Illinois

173 *Les travaux d'Alexandre (The Labors of Alexander)*. 1967. Bronze, height 24" (61 cm). Collection Mme. René Magritte, Brussels, Belgium

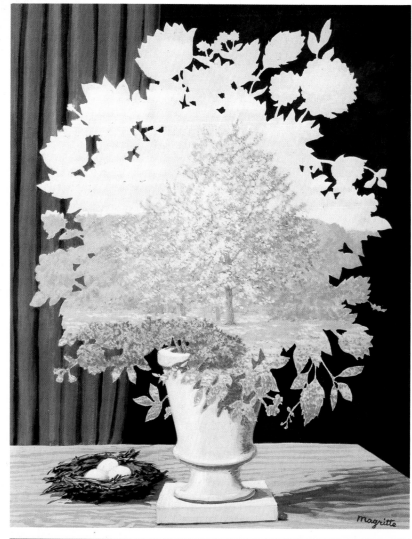

174

176

The sphere and the house suggest enigmatic measurements to the tree. The curtain conceals the useless.

——René Magritte, 1950, Le Fait Accompli, no. 76, December 1972

175

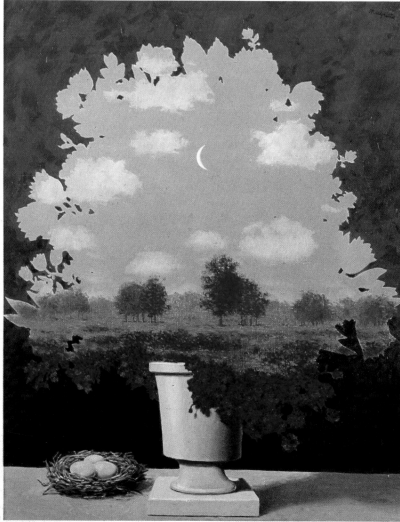

174 *Le plagiat (Plagiarism).* 1960. Gouache, 12⅝ x 9⅞" (32 x 25 cm). Private collection, New York, New York

175 *Le pays des miracles (The Country of Marvels).* c. 1960. Oil on canvas, 21⅝ x 18⅛" (55 x 46 cm). Private collection, Brussels, Belgium

176 *La voix du sang (The Call of Blood).* 1961. Oil on canvas, 35⅜ x 39⅜" (90 x 110 cm). Private collection, Brussels, Belgium

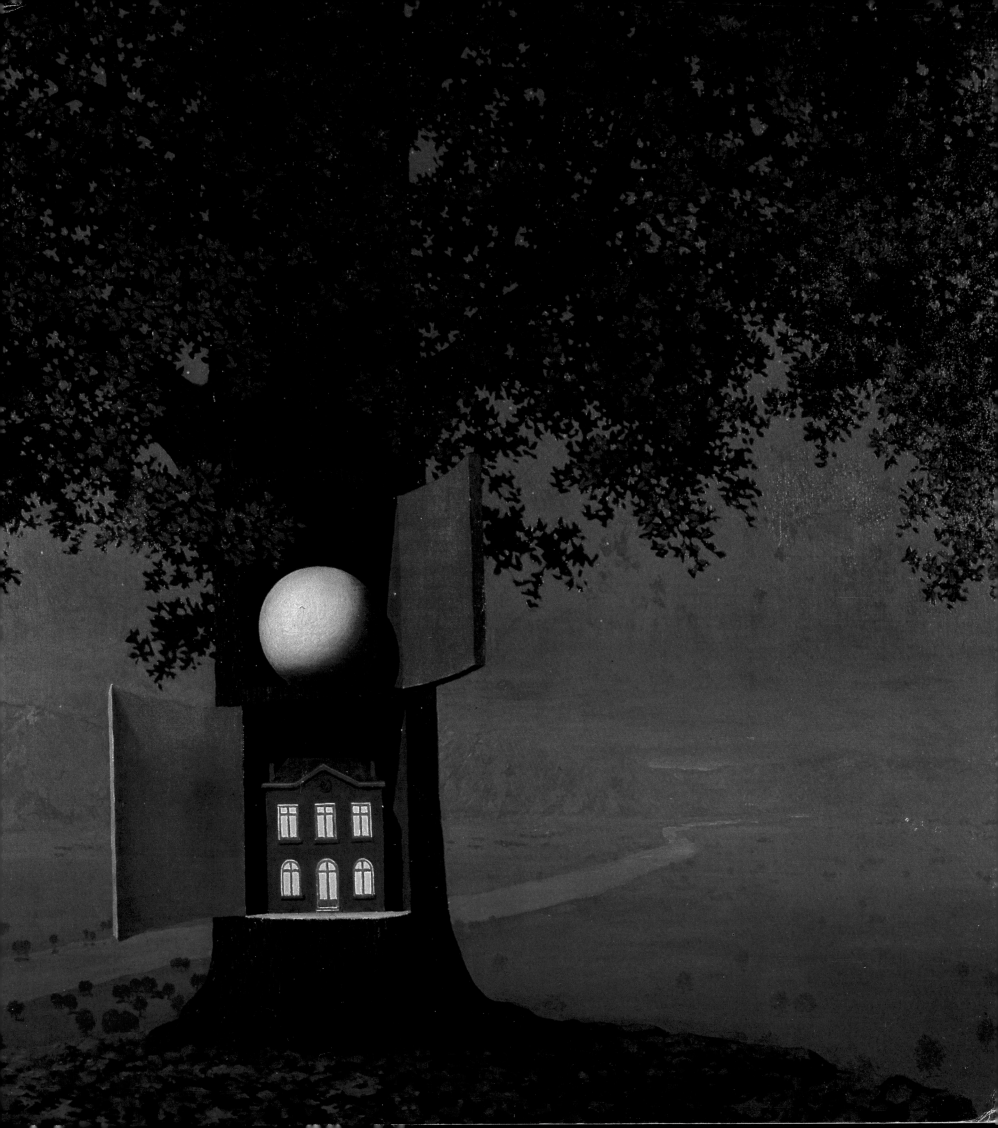

Tree/Leaf

177

La recherche de l'absolu

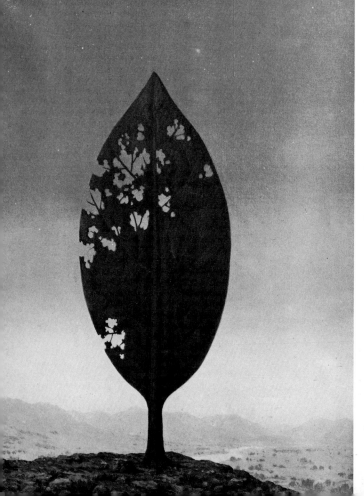

178

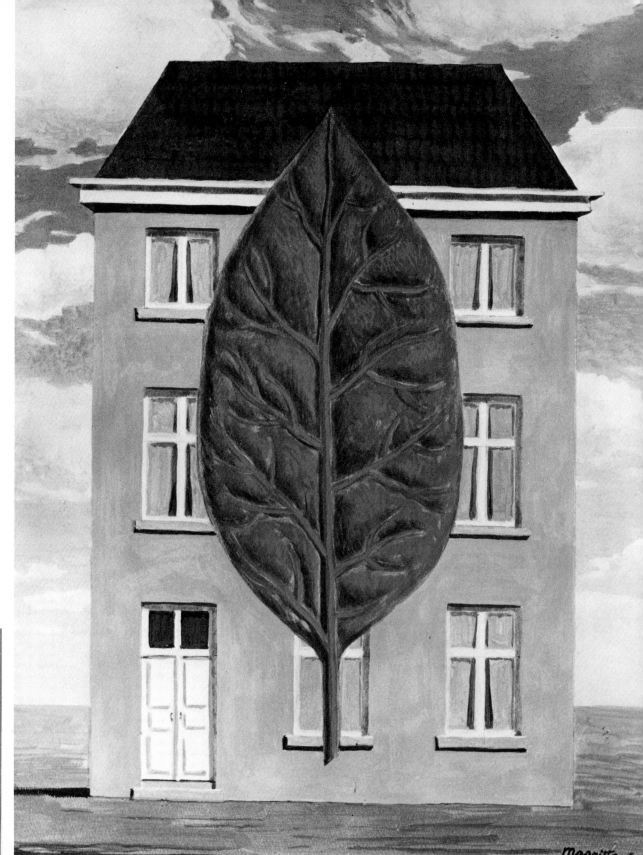

179

177 *La recherche de l'absolu (The Search for the Absolute).* n.d. Drawing. Location unknown
178 Untitled. n.d. Oil on canvas, 25 x 19½″ (63.5 x 49.5 cm). Private collection, New York, New York
179 *Jour de fête (Holiday).* 1954. Gouache, 13 x 11″ (33 x 28 cm). Collection Mrs. Denise Elisabeth Wiseman, New York, New York

180 *Les barricades mystérieuses (The Mysterious Barricades).* 1961. Oil on canvas, 31½ x 50″ (80 x 127 cm). Collection Arnold Weissberger, New York, New York
181 *La recherche de l'absolu (The Search for the Absolute).* n.d. Drawing, 7⅞ x 10¼″ (20 x 26 cm). Private collection, New York, New York
182 Mural decoration in the Palais des Congrès, Brussels, Belgium

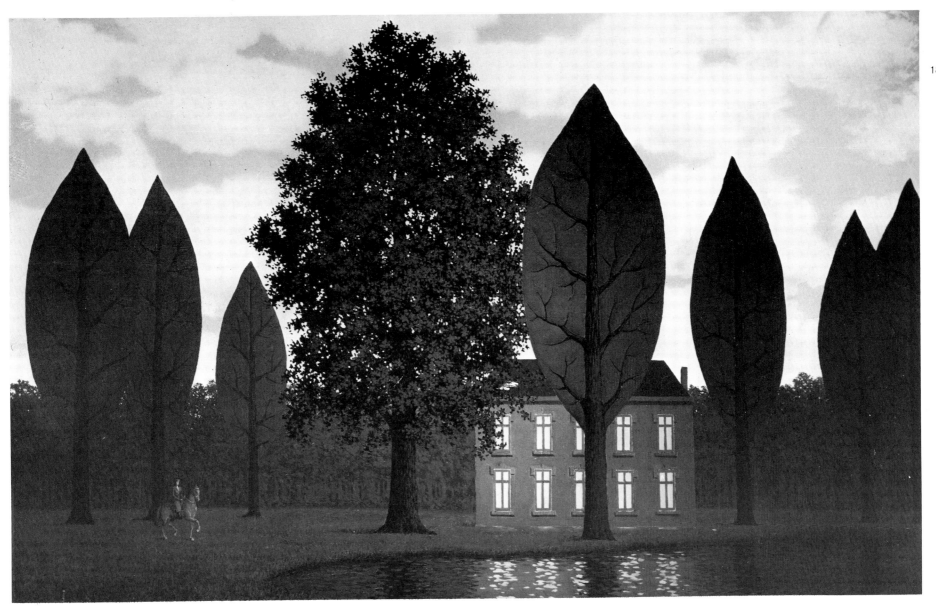

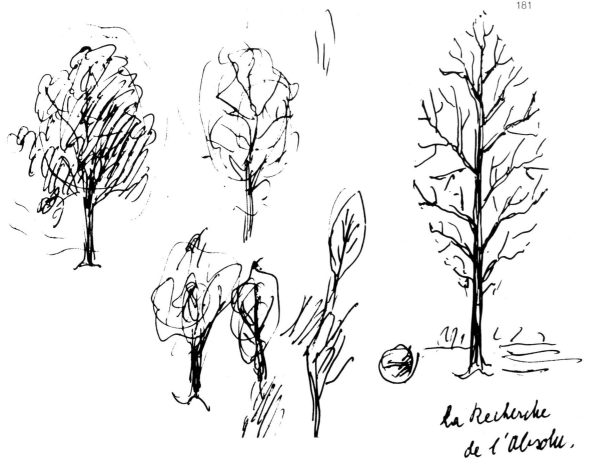

la Recherche
de l'Absolu.

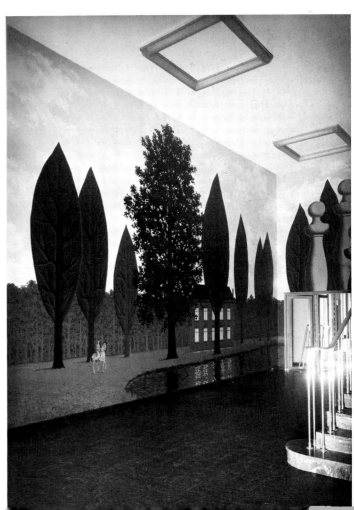

Cloud

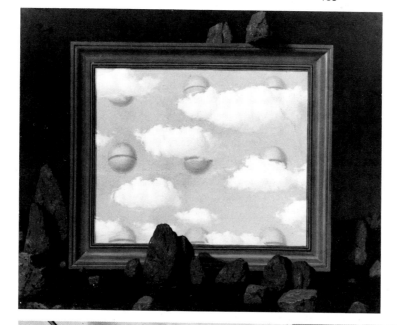

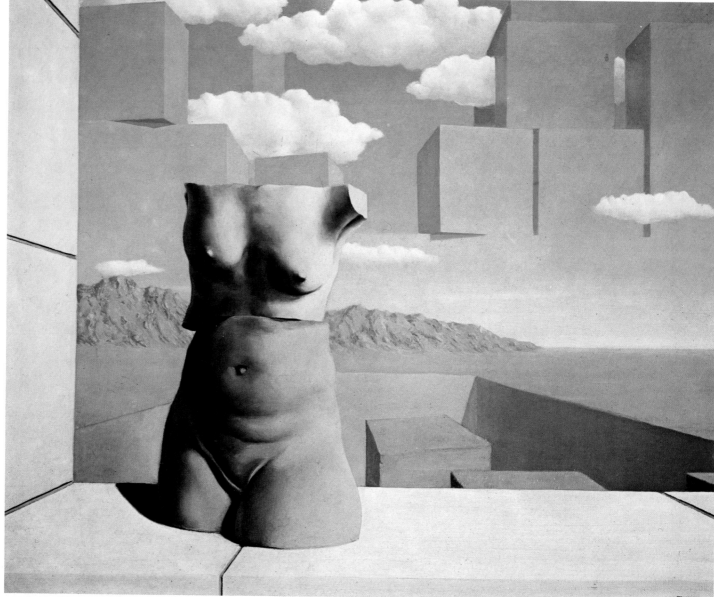

183 *La grande marée (The High Tide).* 1951. Oil on canvas, 25¼ x 31½″ (64 x 80 cm). Private collection, Brussels, Belgium

184 Untitled. 1964–1965. Engraving for *Aube à l'Antipode* by Alain Jouffroy, Édition Soleil Noir, 1966

185 *Les marches de l'été (The Progress of Summer).* 1938. Oil on canvas, 23⅝ x 28¾″ (60 x 73 cm). Private collection, Paris, France

186 *La leçon des choses (The Object Lesson).* 1947. Oil on canvas, 27⅜ x 22″ (69.5 x 56 cm). Collection Mr. and Mrs. Harry G. Sundheim, Jr., Chicago, Illinois

187 *Le souvenir déterminant (The Deciding Memory).* 1942. Oil on canvas, 25⅜ x 19⅞″ (64.5 x 50.5 cm). Private collection, New York, New York

188 *La grande famille (The Large Family).* 1947. Oil on canvas, 39⅜ x 31⅞″ (100 x 81 cm). Collection Nellens, Knokke-Le Zoute, Belgium

186

187

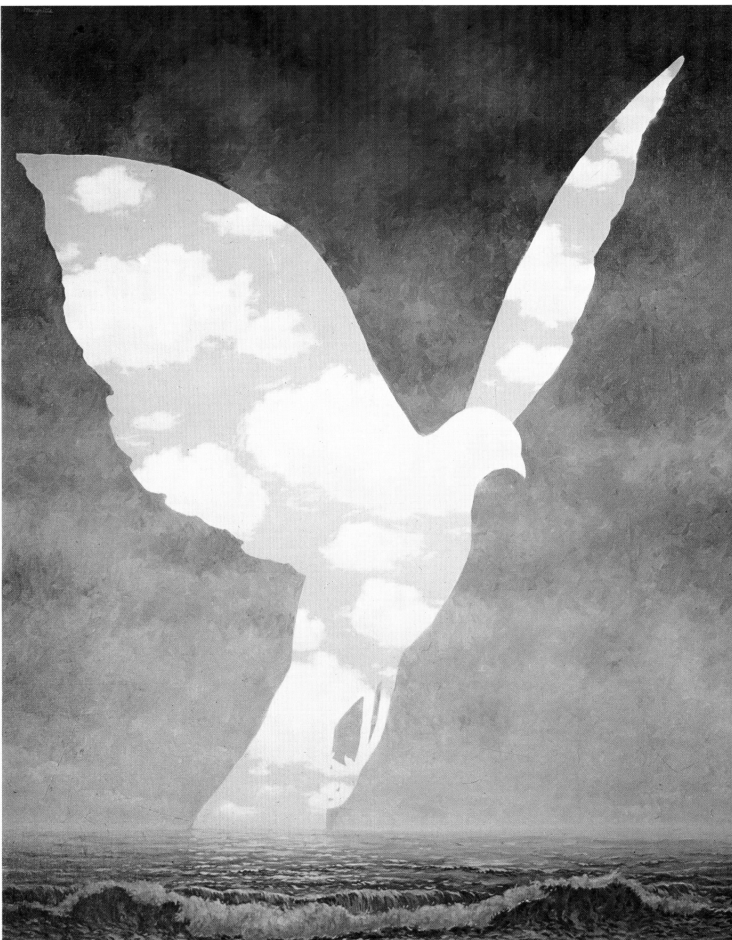

188

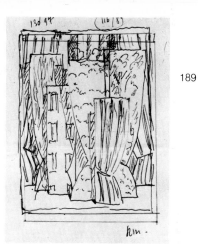

189

191

Curtain

189 *Les goûts et les couleurs (Tastes and Colors).* n.d.
Drawing, 6⅞ x 5⅛" (17.5 x 13 cm). Private collection, New York, New York

190 *La Joconde (La Gioconda).* 1960. Oil on canvas, 27⅝ x 19⅝" (70 x 50 cm). Collection André Mourgues, Paris, France

191 *Les goûts et les couleurs (Tastes and Colors).* n.d.
Drawing, 7⅛ x 7¼" (18 x 18.5 cm). Private collection, New York, New York

192 *La cour d'amour (The Court of Love).* 1960. Oil on canvas, 31½ x 39⅜" (80 x 100 cm). Location unknown

193 *Les orgues de la soirée (The Organs of Evening).*
1965. Oil on canvas, 17¾ x 21" (45 x 53.5 cm).
Private collection, United States

190

192

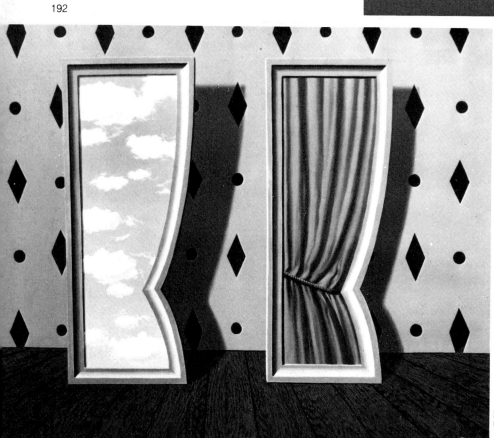

193

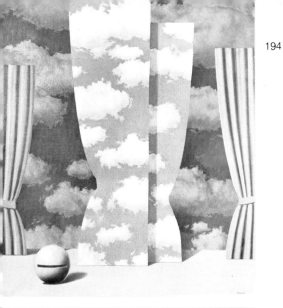

194

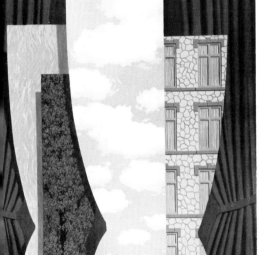

195

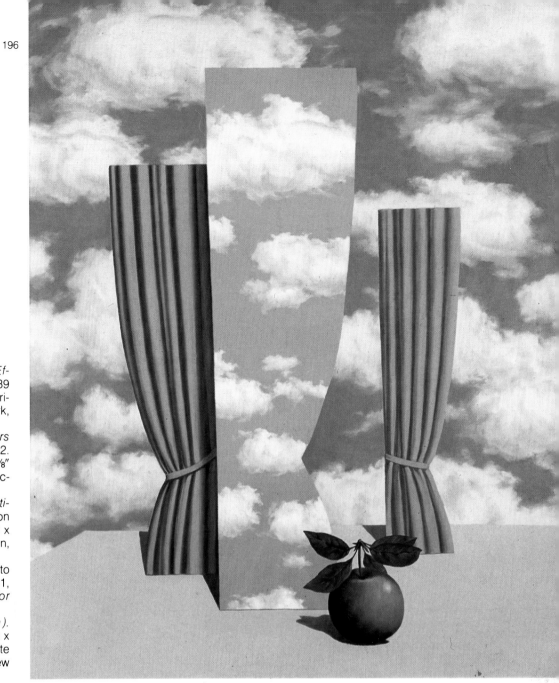

196

194 *La peine perdue (Wasted Effort)*. 1962. Oil on canvas, 39 x 31¼" (99 x 79.5 cm). Private collection, New York, New York

195 *Les goûts et les couleurs (Tastes and Colors)*. 1962. Oil on canvas, 51⅛ x 38⅛" (130 x 97 cm). Private collection, Milan, Italy

196 *Le beau monde (The Beautiful World)*. c. 1960. Oil on canvas, 39⅜ x 31⅞" (100 x 81 cm). Private collection, Brussels, Belgium

197 Letter from René Magritte to André Bosmans, April 21, 1962. *See* Appendix *for translation*

198 *L'ovation (The Ovation)*. 1962. Oil on canvas, 34⅝ x 45¼" (88 x 115 cm). Private collection, New York, New York

197

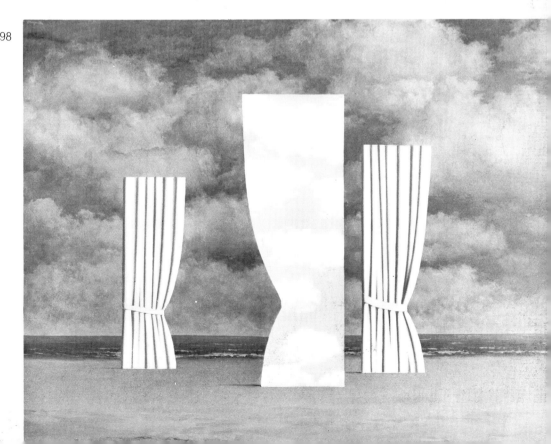

198

Pipe

"The famous pipe. How people reproached me for it! And yet, could you stuff my pipe? No, it's just a representation, is it not? So if I had written on my picture 'This is a pipe,' I'd have been lying!"
——*René Magritte, remarks reported by Claude Vial, "Ceci n'est pas René Magritte,"* Femmes d'Aujourd'hui, *July 6, 1966, pp. 22–24*

201

Fig. 289.

199

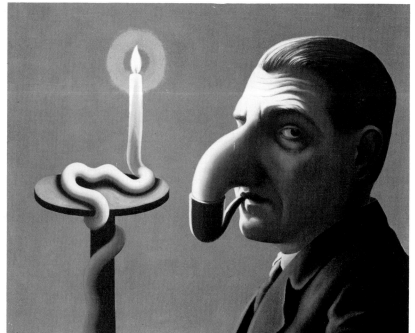

202

200

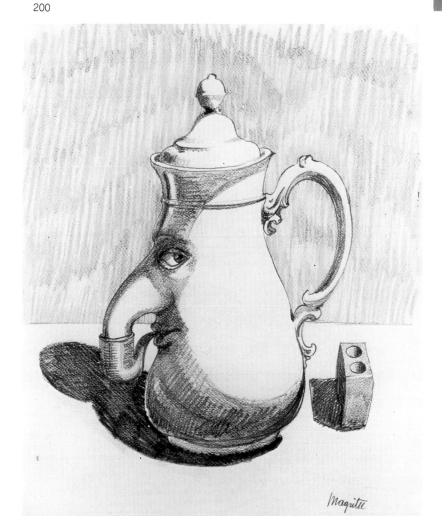

Magritte

203

199 Untitled drawing. 1948. Private collection, Brussels, Belgium
200 Untitled drawing. 1935. 12 x 9⅝" (30.5 x 24.5 cm). Private collection, Brussels, Belgium
201 *Suggestion: Ce n'est pas un enfant mais un rat (Suggestion: This Is Not a Child, But a Rat).* Illustration in *La Nouvelle Médication Naturelle* by F. E. Bilz (edition translated from German), 1899, fig. 289
202 *La lampe philosophique (The Philosopher's Lamp).* 1935. Oil on canvas, 23⅝ x 19⅝" (60 x 50 cm). Private collection, Brussels, Belgium
203 Untitled drawing (Pipe/Dining Room). n.d. Location unknown. [The plan of the pipe/dining room (left to right) is as follows—closure, dining room, hallway, nervous system, billiard room, distilled water, faucet, safety valve.]

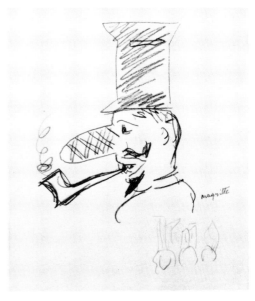

Ceci n'est pas une pipe.

204 *Les ombres (The Shadows)*. 1966. Pen and ink drawing, 6¼ x 10″ (17 x 25.5 cm). Collection Harry Torczyner, New York, New York

205 Untitled drawing. n.d. Private collection, Brussels, Belgium

206 *Ceci n'est pas une pipe (This is Not a Pipe)*. 1928–1929. Oil on canvas, 23¼ x 31½″ (59 x 80 cm). Collection William N. Copley, New York, New York

Table

207

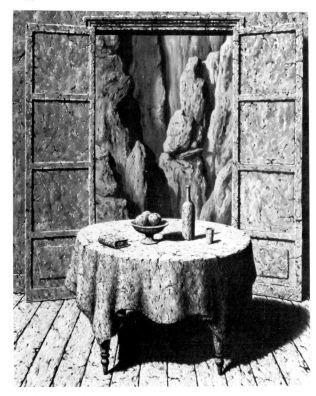

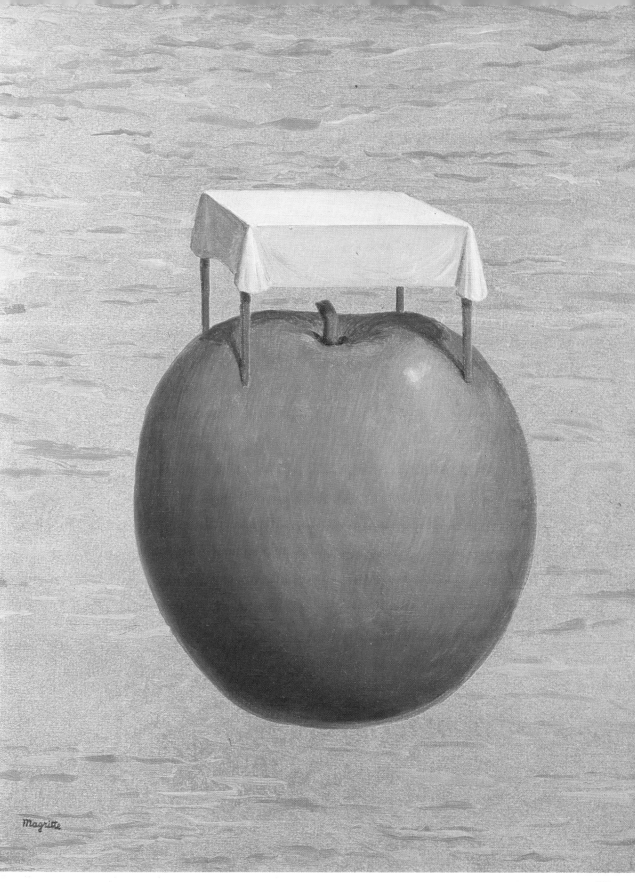

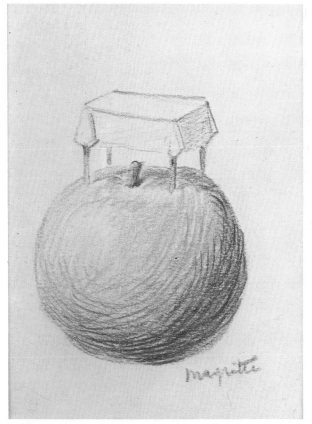

208

210

209

207 *Souvenir de Voyage III (Memory of a Voyage III)*.
1951. Oil on canvas, 33⅛ x 25⅝" (84 x 65 cm).
Collection Adelaide de Menil, New York, New York
208 *Les belles réalités (The Beautiful Realities)*. 1963.
Colored pencil drawing, 5⅞ x 4⅜" (15 x 11 cm).
Collection Harry Torczyner, New York, New York
209 *Les belles réalités (The Beautiful Realities)*. 1964.
Oil on canvas, 19⅝ x 15¾" (50 x 40 cm). Galerie
Isy Brachot, Brussels, Belgium
210 *Problème de la table (The Problem of the Table)*.
n.d. Drawing, 10⅝ x 13¾" (27 x 35 cm). Collection
M. and Mme. Pierre Scheidweiler, Brussels, Bel-
gium

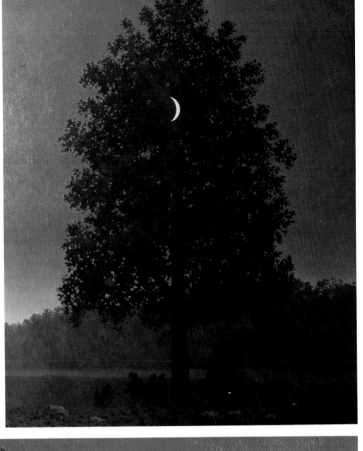

Je viens de peindre la lune sur un arbre dans les couleurs gris-bleu du soir. Scutenaire a trouvé un très beau titre: "Le seize septembre». Je crois que « c'est bien », donc qu'à partir du "16 Septembre" il n'y a rien à fonder.

211 Letter from René Magritte to Mirabelle Dors and Maurice Rapin, August 6, 1956. *See Appendix for translation*

Sun/Moon

212 *Le seize septembre (September Sixteenth).* 1957. Oil on canvas, 63⅝ x 51⅛" (161.5 x 130 cm). Collection Menil Foundation, Houston, Texas

213 *Le banquet (The Banquet).* 1957. Oil on canvas, 19⅝ x 23⅝" (50 x 60 cm). Collection William Alexander, New York, New York

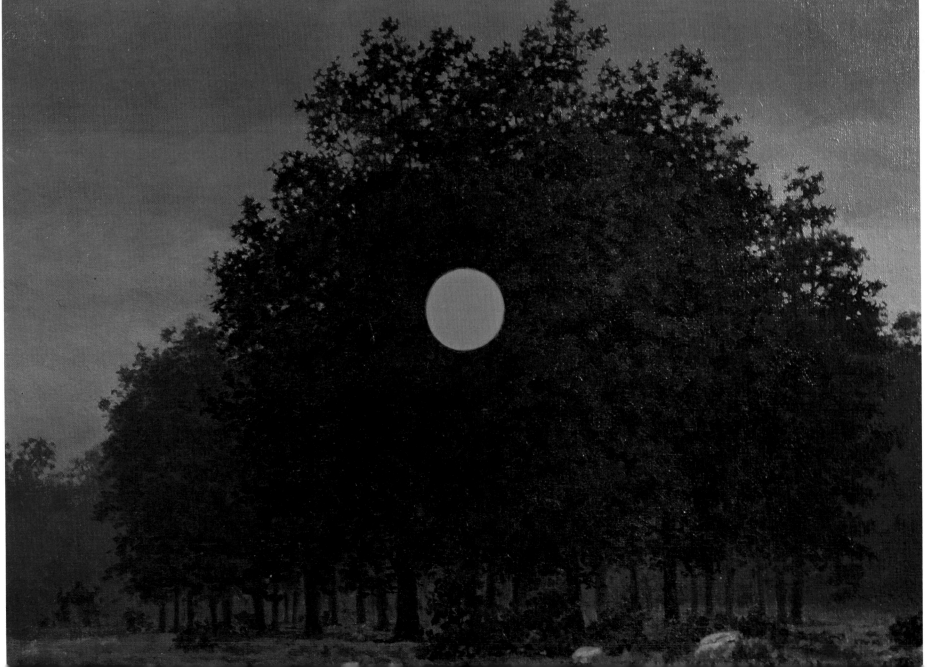

216

arbres noirs *soleil rouge* *ciel rouge*

"Le Banquet"

214

215

In answer to the sun, I have come up with: a tomb. There's a gravestone on the ground, and the sun lights the sky, earth, and tomb. This is today's answer and will perhaps be inadequate in the future. Actually, by taking the sun as the point of departure for the voyage we are making, by taking the sun as our origin, it isn't yet possible for us to envisage any ending for this voyage beyond death. This is a present certainty, and the picture's title, *L'au-delà (The Beyond)*, recreates an affective content for the term.
——*From a lecture by René Magritte, 1939*

The subject that you asked about on Sunday, as to whether or not it had already attracted my attention, has become uppermost in researching the problem of the sun. It was death, indeed, so that it is not possible for fruitless doubts to arise. In passing, I point out to you that the truism "The sun shines for all" is coincidentally illustrated here.
——*Letter from René Magritte to Paul Colinet, Friday the 13th, 1957*

After *La fée ignorante (The Ignorant Fairy)*, I've painted a picture in which one sees the moon hidden by a tree at night. Here in Brussels, they are felling trees on the boulevards and avenues (not forgetting to fell a lot of old houses that are now being replaced by horrid constructions). "Progress" has not yet "improved" Wilfingen, I believe; you're lucky!
——*Letter from René Magritte to E. Junger, June 5, 1956*

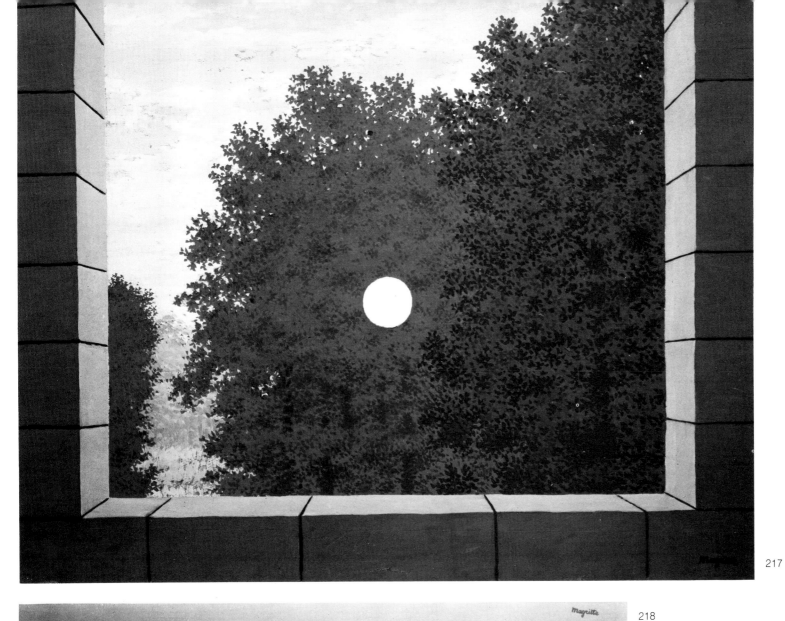

217

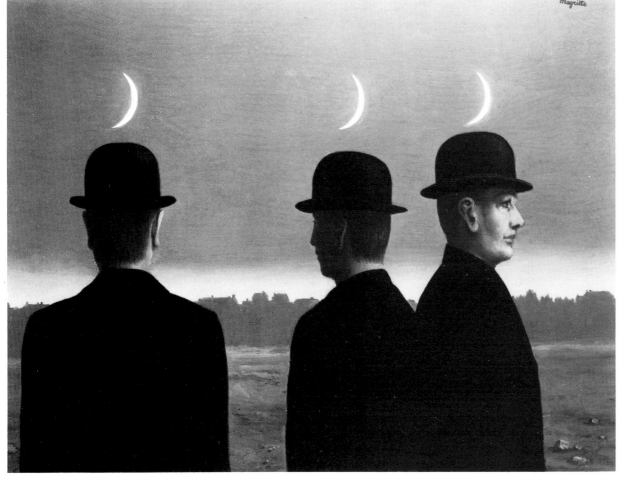

218

214 *L'au-delà (The Beyond)*. 1938. Oil on canvas, 28⅜ x 19⅝″ (72 x 50 cm). Private collection, Brussels, Belgium

215 *La voie royale (The Royal Road)*. 1944. Oil on canvas, 29½ x 18⅛″ (75 x 46 cm). Private collection, Zurich Switzerland

216 Study for *Le banquet (The Banquet)*. 7⅞ x 10¼″ (20 x 26 cm). Collection Harry Torczyner, New York, New York

217 *Le banquet (The Banquet)*. 1956. Gouache, 14⅛ x 18½″ (36 x 47 cm). Private collection, United States

218 *Le chef d'oeuvre ou les mystères de l'horizon (The Masterpiece or The Mysteries of the Horizon)*. 1955. Oil on canvas, 19½ x 25⅝″ (49.5 x 65 cm). Collection Arnold Weissberger, New York, New York

Bottle

222

219

220

221

223

124

224

224 Letter from René Magritte to Harry Torczyner, June 12, 1961. *See* Appendix *for translation*

225 Painted bottles. 1960. Height 11¾″ (30 cm). Collection William N. Copley, New York, New York

226 *La bouteille (The Bottle).* n.d. Gouache, 24 x 21⅛″ (61 x 53.5 cm). Collection Dr. Joseph Moldaver, New York, New York

227 *L'explication (The Explanation).* 1954. Oil on canvas, 31½ x 23⅝″ (80 x 60 cm). Private collection, New York, New York

225

226

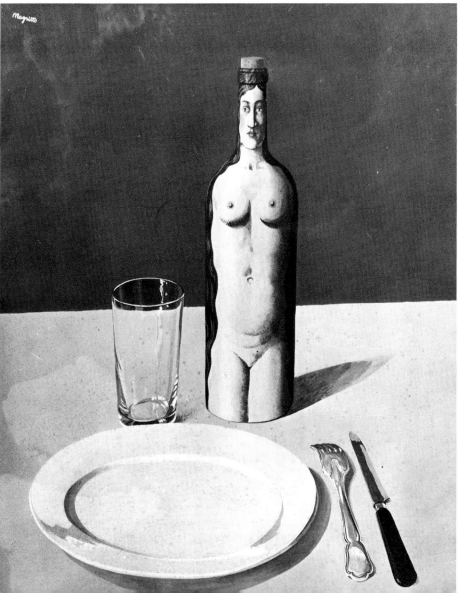

227

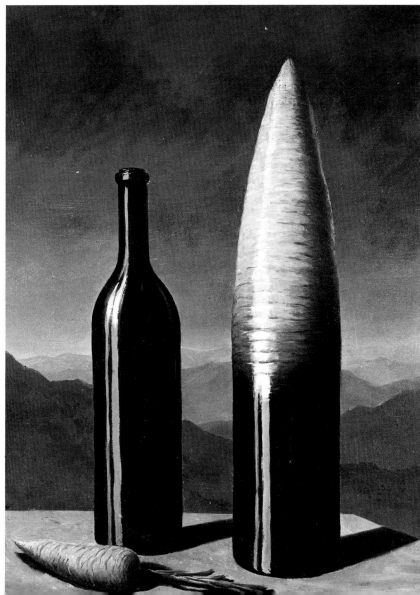

Door

The problem of the door called for an opening one could pass through. In *La réponse imprévue (The Unexpected Answer)*, I showed a closed door in a room; in the door an irregular-shaped opening revealed the night.
——René Magritte, *La Ligne de Vie, lecture, November 20, 1938*

This *closed* door is nevertheless open; an opening admits passing through it as in the opening of an open door. What we see through this opening is a tree in the shape of a leaf. Just as the door corresponds to an opening, the tree corresponds to the leaf. And these correspondences are joined in a *single* object—door-opening or tree-leaf—instead of being separate—a door *and* an opening, or a tree *and* leaves. The house that is next to the tree-leaf suggests the scale of this tree-leaf and prevents it from being mistaken for merely a leaf. On the roof of the house is a bell (such as one fastens to a horse's collar). This bell's presence, on a roof, makes it lose its usual innocence; indeed, it becomes mysterious again, making one wonder why it is there. The answers we might give are without interest: for example, we might explain that a bellmaker lives in the house and he has put this large bell on his roof as an advertisement. A psychiatrist might answer that it's a madman who has put this bell on the roof, etc. . . . These kinds of answers would dissipate the mystery, which is precisely what I've tried to protect and evoke. The difficulty with my thinking when I hope to find a new picture is in fact that of obtaining an image that resists any explication and that simultaneously resists indifference.
——*Letter from René Magritte to Mr. and Mrs. Barnet Hodes, undated, 1957*

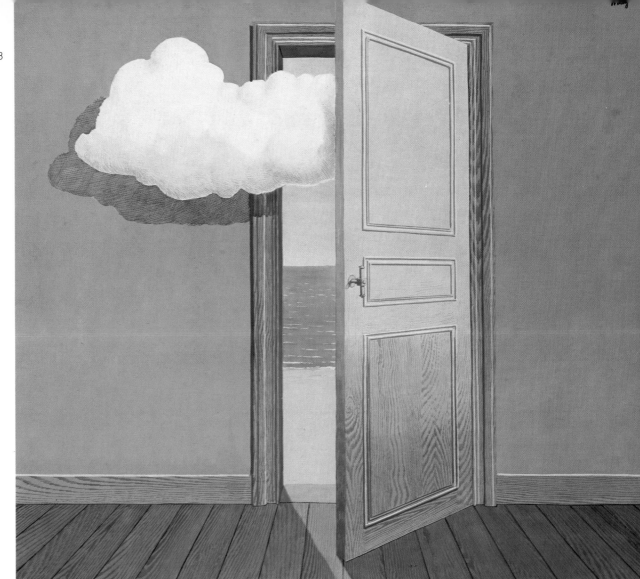

228 *Le poison (Poison)*. 1939. Gouache, 13¾ x 15¾" (35 x 40 cm). Collection Edward James Foundation, Chichester, England
229 Letter from René Magritte to Volker Kahmen, November 23, 1965, with ink drawing for a 1965 version of *Le sourire du diable (The Devil's Smile)*. *See* Appendix *for translation*
230 *Le sourire du diable (The Devil's Smile)*. 1966. Colored pencil drawing, 13¾ x 10⅜" (35 x 26.5 cm). Private collection, New York, New York

229

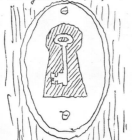

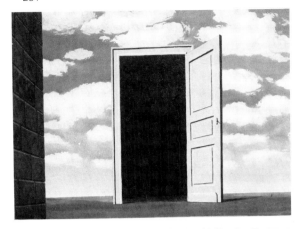

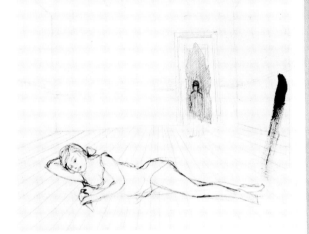

231 *L'enfant retrouvé (The Refound Child)*. 1966. Oil on canvas, 11¾ x 15¾" (30 x 40 cm). Private collection, Belgium

232 Untitled drawing. n.d. 6¼ x 7⅞" (16 x 20 cm). Collection M. and Mme. Marcel Mabille, Rhode-St.-Genèse, Belgium

233 *La perspective amoureuse (Amorous Perspective)*. 1935. Oil on canvas, 45⅝ x 31⅞" (116 x 81 cm). Private collection, Brussels, Belgium

There's neither a door under the radiators nor objects more properly named than usual scattered about under the roof tiles. However, a door with a hole in it is always possible, and some objects with renewed names are also worth attention, in case the need should arise without undue urgency. Two things: *La réponse imprévue (The Unexpected Answer)* solved the problem posited by the door by showing what it is—an opening. The other thing is a part of that series of pictures called *Le sens propre (The Proper Meaning)*, *L'usage de la parole (The Use of Words)*, *L'alphabet des révélations (The Alphabet of Revelations)*, etc. . . . which was begun with a picture that you probably remember—*Ceci n'est pas une pipe (This is Not A Pipe)*.
——*Letter from René Magritte to Harry Torczyner, November 17, 1958*

If a simple image is willfully complicated, it is more the result of a concern for fantasy than of a freedom attentive to a real and irreducible complexity. Thus, a door with an opening hollowed out to allow one to go in and out is at once simple and complex. It's out of the question to complicate this image with an overburden of unimportant events merely for the sake of fulfilling some puerile fantasy: by suspending it from an airplane, for example, or from the ceiling of a room.
——*Letter from René Magritte to André Bosmans, January 2, 1964*

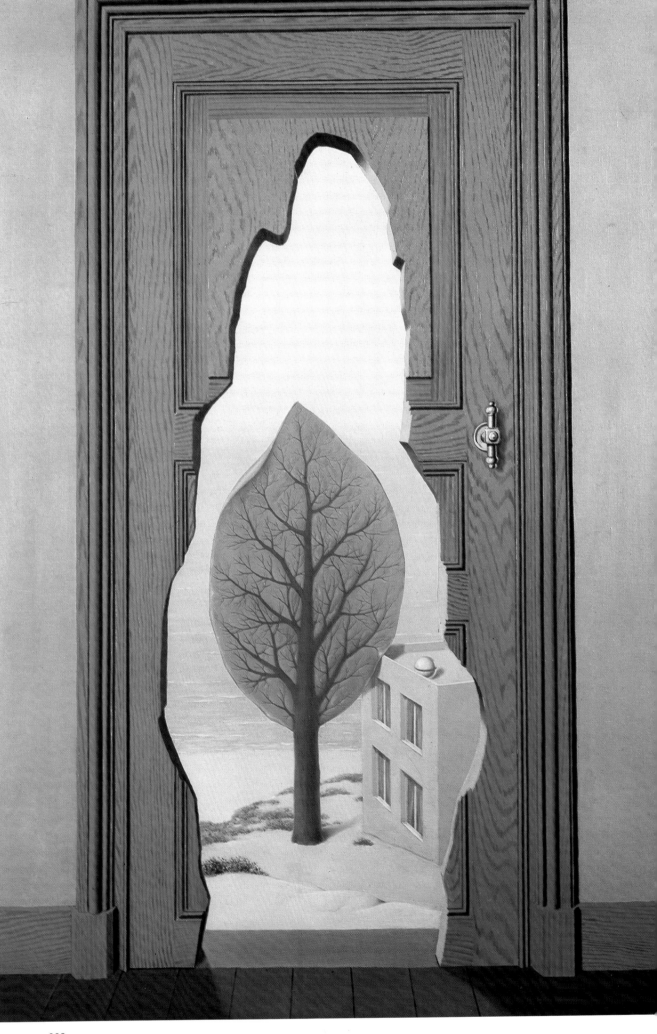

233

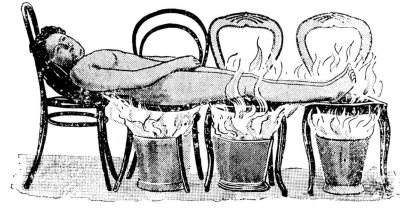

Bain de vapeur en chaise nattée couché.

234

Fig. 523.

Flaming Object

235

La découverte du feu (The Discovery of Fire) allowed me the privilege of experiencing the same feeling that was felt by the first men who created flame by striking together two pieces of stone.

In turn, I imagined setting fire to a piece of paper, an egg, and a key.

———René Magritte, La Ligne de Vie, *lecture, November 20, 1938*

234 *Bain de vapeur en chaise nattée couché (Steam Bath Using Caned Chairs).* Illustration in *La Nouvelle Médication Naturelle* by F. E. Bilz (edition translated from German), 1899, vol. 2, p. 1777, fig. 523. Archives Pierre Alechinsky, Bougival, France

235 *Les fanatiques (The Fanatics).* 1945. Oil on canvas, 23⅝ x 19⅝″ (60 x 50 cm). Collection Nellens, Knokke-Le Zoute, Belgium

236 *L'échelle de feu (The Ladder of Fire).* 1939. Gouache, 10⅝ x 13⅜″ (27 x 34 cm). Collection Edward James Foundation, Chichester, England

237 *L'échelle de feu (The Ladder of Fire).* 1933. Oil on canvas, 21¼ x 28⅞″ (54 x 73.5 cm). Private collection, England

238 Untitled drawing. n.d. 5⅞ x 6¼″ (15 x 16 cm). Collection M. and Mme. Marcel Mabille, Rhode-St.-Genèse, Belgium

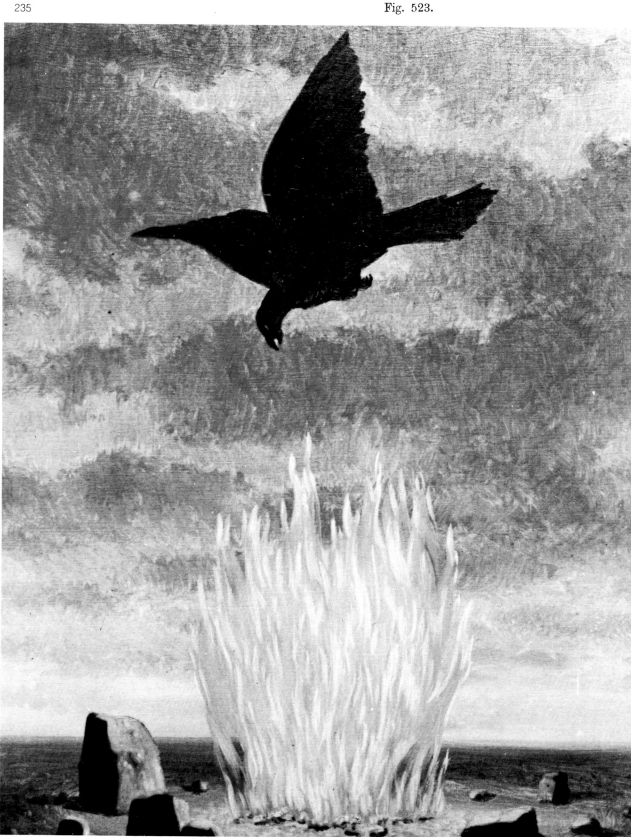

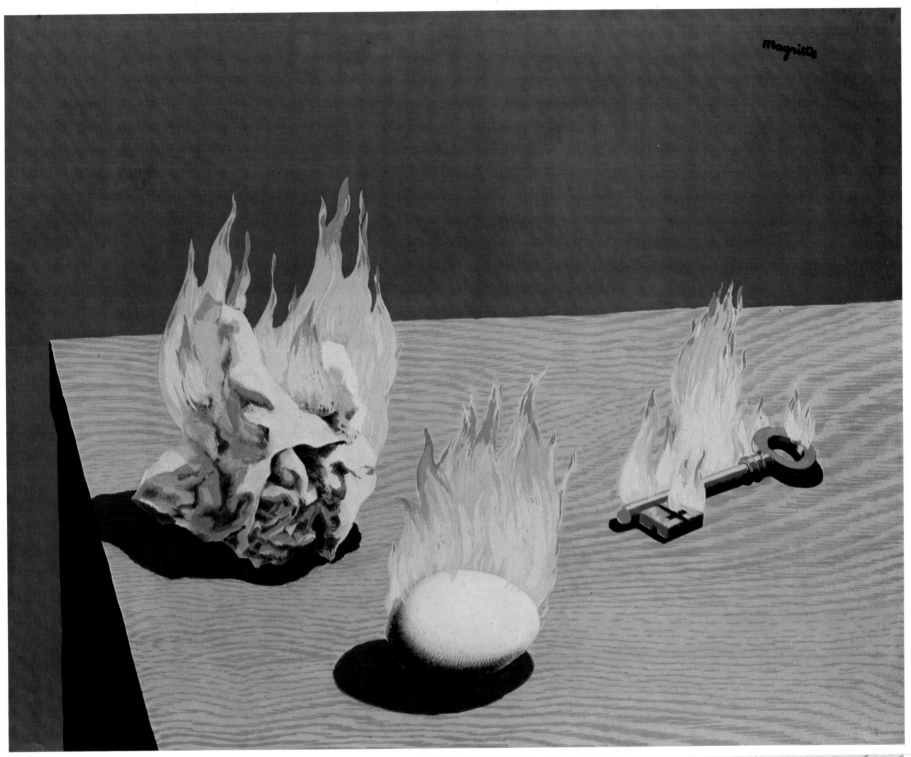

236

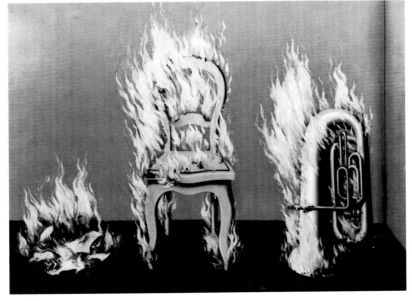

237

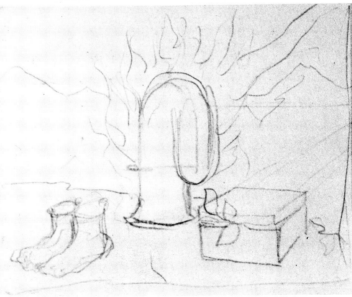

238

Weapon

239 Untitled drawing. 1965. Ink, 7⅛ x 5⅜″ (18 x 13.5 cm). Private collection, New York, New York

240 *Les chasseurs au bord de la nuit (The Hunters at the Edge of Night)*. 1928. Oil on canvas, 31½ x 45⅝″ (80 x 116 cm). Collection William N. Copley, New York, New York

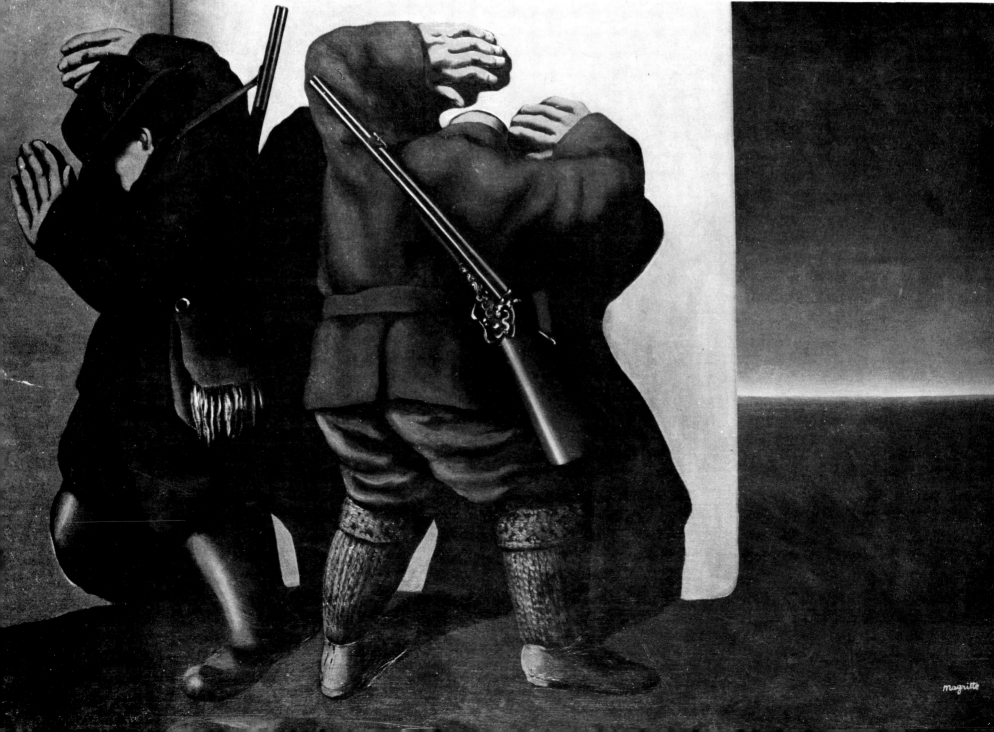

241

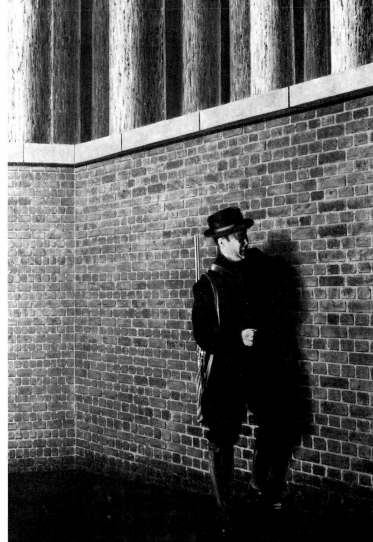

242

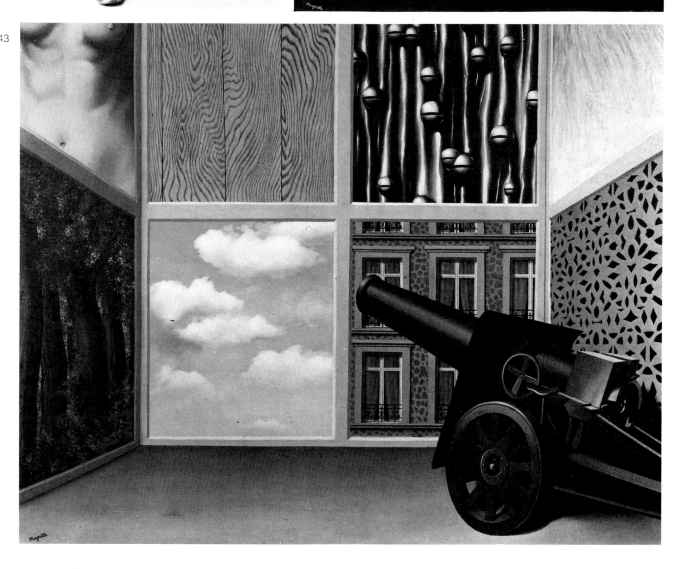

243

Today I made a cannon of a fairly respectable size. I think it will make quite an impression.
——Letter from René Magritte to André Souris, January 1930, reproduced in Lettres Surréalistes, *127–129, November 1974, no. 179*

241 *Le déstructeur (The Destructor).* Photograph of Louis Scutenaire, Brussels, Belgium, Summer 1943. Study for *La gravitation universelle (Universal Gravitation)*

242 *La gravitation universelle (Universal Gravitation).* 1943. Oil on canvas, 39⅜ x 28¾" (100 x 73 cm). Private collection, Paris, France

243 *Au seuil de la liberté (On the Threshold of Liberty).* 1929. Oil on canvas, 45⅛ x 57⅝" (114.5 x 146.5 cm). Museum Boymans-van Beuningen, Rotterdam, The Netherlands

House

. . . nothing prevents me from making sculptures as large as dirigible hangars and that one could enter.
——*Victor Servranckx and René Magritte*, L'Art Pur: Défense de l'Esthétique, *unpublished manuscript, 1922*

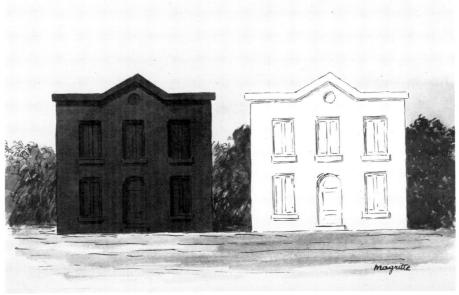

244

245

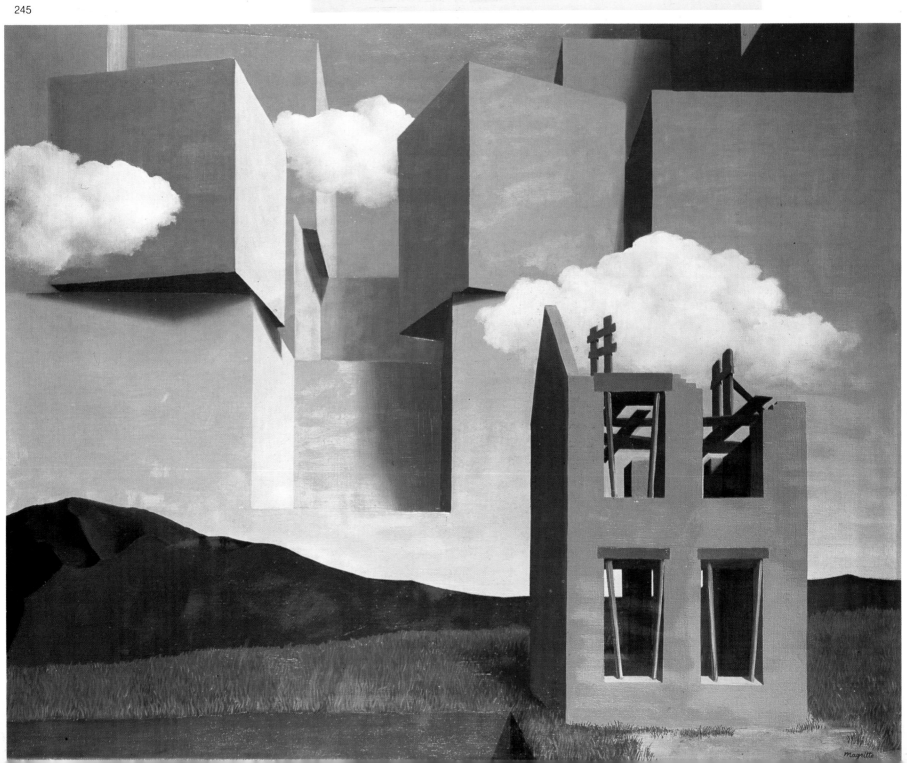

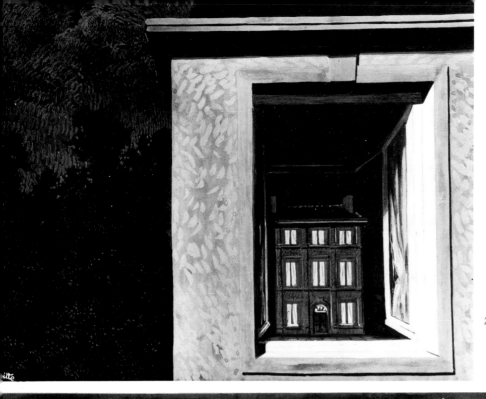

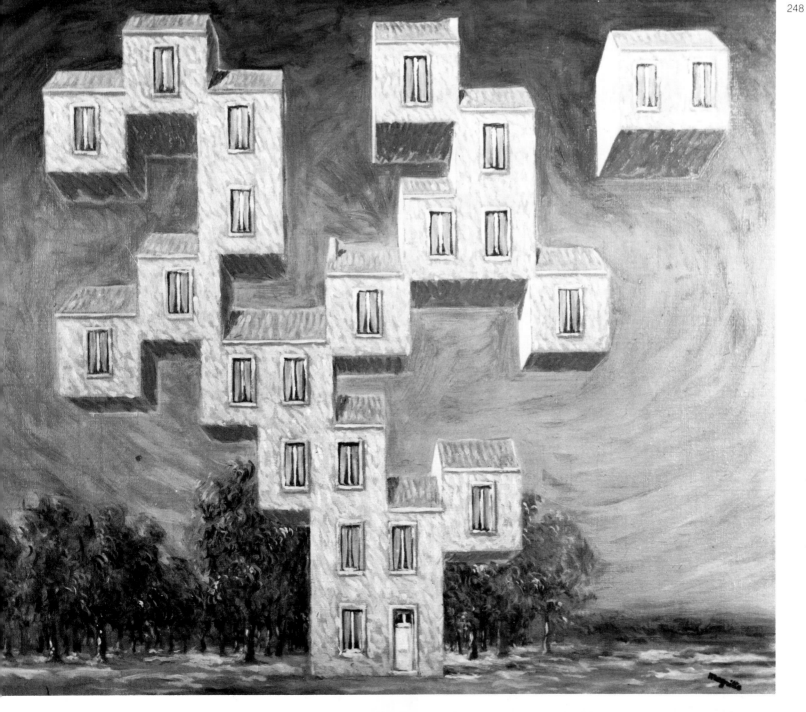

244 *Maison noire – maison blanche (Black House –White House).* n.d. Ink drawing, 7⅛ x 9½″ (18 x 24 cm). Private collection, United States

245 *L'univers démasqué (The Unmasked Universe).* n.d. Oil on canvas, 29½ x 35⅞″ (75 x 91 cm). Collection Mme. Crik, Brussels, Belgium

246 *L'éloge de la dialectique (In Praise of Dialectic).* 1948. Gouache, 14⅛ x 17⅞″ (36 x 45.5 cm). Collection Mrs. Melvin Jacobs, Florida

247 Photograph of Habitat (Moshe Safdie, architect), built for EXPO 67, Montreal, Canada, 1967

248 *Le regard mental (The Mental Gaze).* 1946. Oil on canvas. Collection Boffa, Milan, Italy

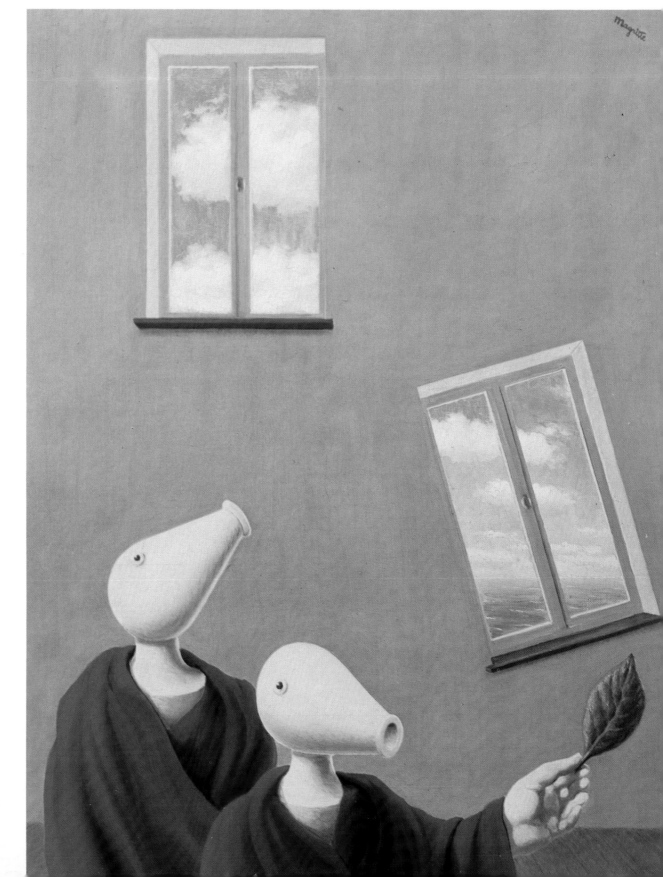

An aesthetically proportioned window fulfills its function a bit less badly than a fake window. We don't want to suffocate in a room that is poorly ventilated by a too-small window, made small to "match" the facade. . . .

The ideal form of a drinking glass or a pencil is the result of chemical and mathematical experiment, not aesthetic choice; as with architecture, when we add on an aesthetic purpose, the glass is swollen and unsteady; it is not quite a glass and not quite sculpture. It is logical to repudiate the "almost" when one can achieve the "most". . . .

Up to now, the architect has coped with both the nature of aesthetics and the nature of the house; away with this fencesitter, let him make way for the construction engineer, and the aesthetic problem will be rid of an irrelevant consideration. In architectural constructions, we will then attain the (maximum current) perfection that mechanics already possesses and that our man-conceived human body will attain (elimination of birth defects, spare parts). . . .

Standardization is necessary for perfection; we should be satisfied only with the latest model house. There is nothing wrong with monotony: the present-day standardization of the light bulb is not monotonous; furthermore, the many specialized buildings (factories, banks, cinemas, schools, apartment houses, private homes, etc.) will offer different appearances, various climates will demand different solutions.
——*Victor Servranckx and René Magritte,* L'Art Pur: Défense de l'Esthétique, *unpublished manuscript, 1922*

Stupefaction: The house is a hard dish to swallow (first one hangs oneself, then vomits from each window, then one puts all of it on his head like a chamber pot). It can also be prepared in the family vault as a shitty side dish.
——*Letter from René Magritte to Louis Scutenaire, October, 1936*

That window! How it bores me! So—so rectangular! One would have thought that whoever built the house, having come to the last window, would have built it another way, on the bias, for example. Someday, maybe I should do this for myself.
——*René Magritte, reported by Marguerite Cullman,* Ninety Dozen Glasses, *New York, 1960, pp. 208–213*

250 Letter from René Magritte to Harry Torczyner, November 24, 1963. *See* Appendix *for translation*

251 *La poitrine (The Bosom).* 1961. Oil on canvas, 35⅜ x 43¼" (90 x 110 cm). Private collection, Brussels, Belgium

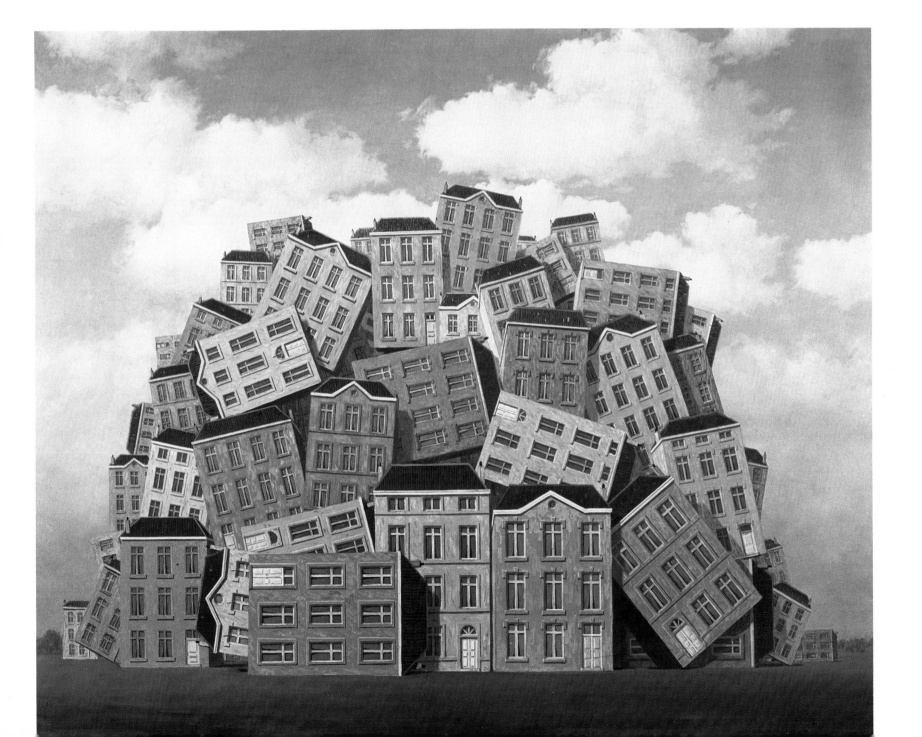

252 Letter from René Magritte to Harry Torczyner, December 24, 1963. *See Appendix for translation*

253 *La ville magique (The Magic Town)*. 1950. Gouache, 11½ x 15″ (29.2 x 38 cm). Collection Mrs. Jack Wolgin, Philadelphia, Pennsylvania

Le nouveau tableau, auquel je pense, contiendrait (s'il en était besoin) que j'évite de rêver et de rêver, même en sachant que je rêve. Il s'agit bien de ce que le monde nous offre, de ce que nous n'ignorons pas si nous sommes attentifs :

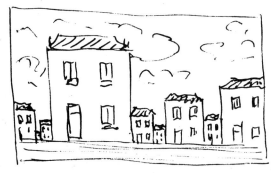

Ce sont des maisons. de différentes grandeurs (Comme le sont les maisons), mais cette différence de grandeurs n'est pas « inaperçue » ici et, pour cette raison « sensible » « insolite ».

Thank you for the little book on Gaudí, whose works I have known for a long time, but whose name I had forgotten. They are truly strange and help to increase one's documentary knowledge of objects. Yet, aside from a passing interest, I put little hope in attempts at new styles for objects: houses, parks, furnishings, household utensils, tools, etc.

A new style can attest only to an interest in new forms, and this accords only with a familiar feeling of mystery.

Should the Gaudí Style become common, then these similarly formed houses might evoke reality in its mystery, and give us, like ordinary houses, an unfamiliar feeling of mystery. If this unfamiliar feeling of mystery is basically of interest to us, Gaudí's works can interest us but little.

The time-honored forms of objects do not call their forms into question, whereas a strange or new style calls into question nothing but a formal preoccupation, not mystery, which has no form.
—*Letter from René Magritte to André Bosmans, August 18, 1959*

254 Untitled drawing. n.d. Private collection, Brussels, Belgium

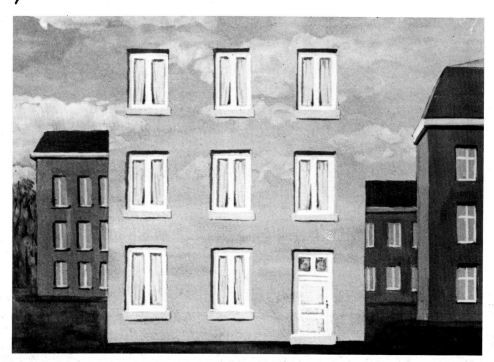

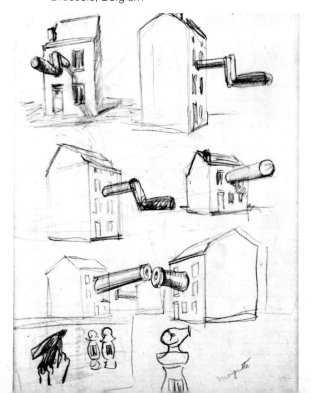

Hair

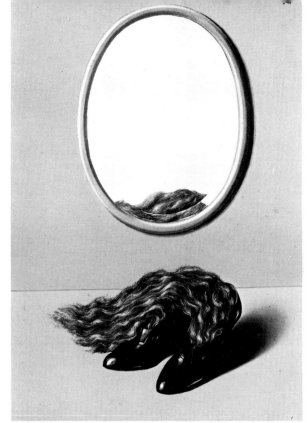

255 Untitled. 1934–1935. Oil on canvas. Location unknown

256 Untitled. 1944–1945. Oil on canvas. Private collection, Italy

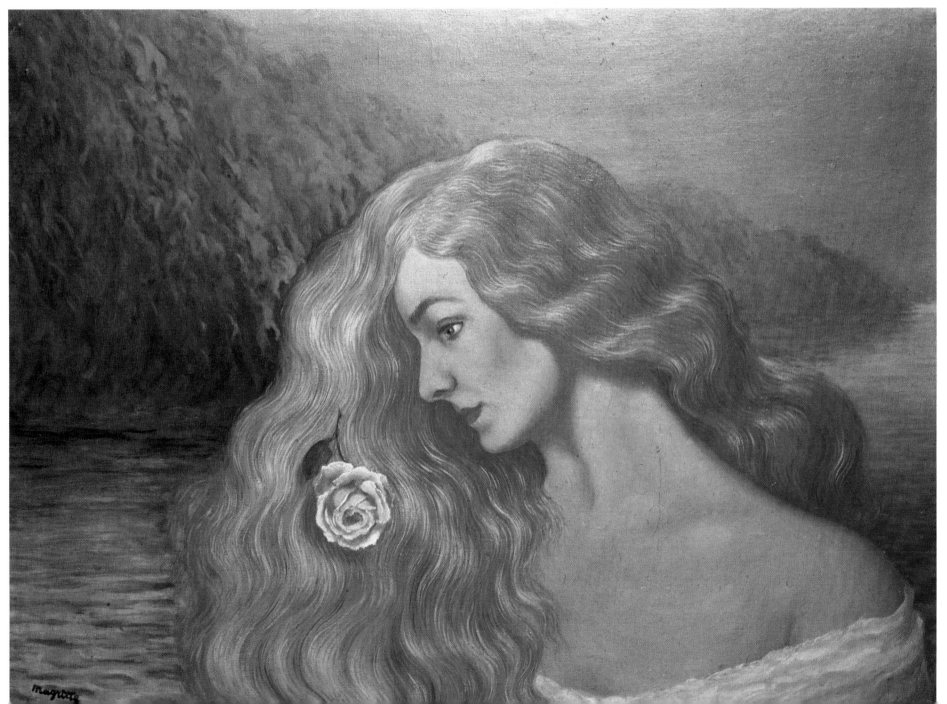

258 Letter from René Magritte to E. L. T. Mesens with sketch of *La robe du soir (The Evening Dress)*, 1955. See Appendix for translation

257 Untitled drawing. c. 1945. 8½ x 5⅜" (21.5 x 13.5 cm). Private collection, New York, New York

LA ROBE DU SOIR

260 *Le pan de nuit (The Patch of Night).* c. 1965.
Oil on canvas, 21⅛ x 17″ (53.5 x 43.2 cm).
Collection Robert Elkon, New York, New
York

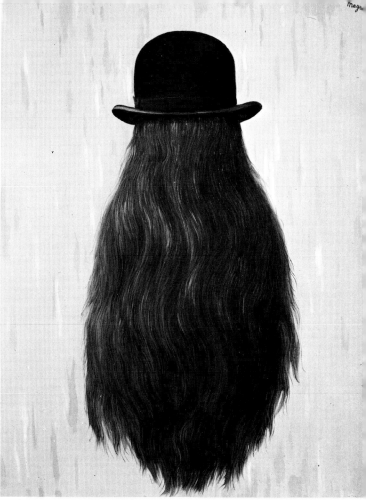

259 *La robe du soir (The Evening Dress).* 1955.
Oil on canvas, 31½ x 23⅝″ (80 x 60 cm).
Private collection, Brussels, Belgium

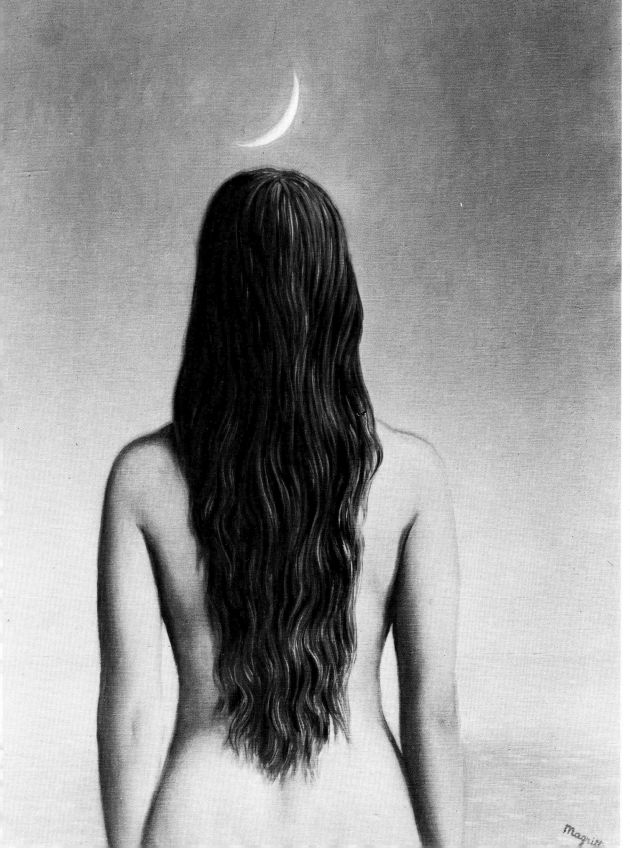

261 Untitled drawing (Young Woman Combing
Her Hair with a Violin Bow). n.d. 7⅞ x 5⅞″
(20 x 15 cm). Collection M. and Mme. Pierre
Scheidweiler, Brussels, Belgium

Balloon

Your letter of the 22nd awakens my dialectical and moral capabilities. In seeing yourself beneath a burning trumpet, you are inviting me to debate a matter of intellectual conscience. I think that if there is too much in a picture, it's as great an error as if there is too little. A flaming trumpet is a precise quantity. The trumpet alone is too little. Trumpet, flames, and a third element are too much, since the third element is already given by the combination of trumpet and flames.

I had first thought of a balloon (mistaken for a syringe, fortuitously, since the syringe led us to the montgolfier balloon), doubtless with your air travels in mind. A montgolfier balloon is more fitting if you are dressed as a Peripatetic. Indeed, an image of Socrates looking at a montgolfier balloon in the sky is a charming one.

The archaic nature of the hot-air balloon (despite its relative youth—around 200 years?) sets it in the past, along with philosophical walks. Socrates looking at a jet airplane would be a vulgarity best avoided.

You are dressed like Socrates, since your activity has an element of the dialectical. You are part of an image wherein one travels by air, as signified by the montgolfier balloon.
——*Letter from René Magritte to Harry Torczyner, July 26, 1958*

262

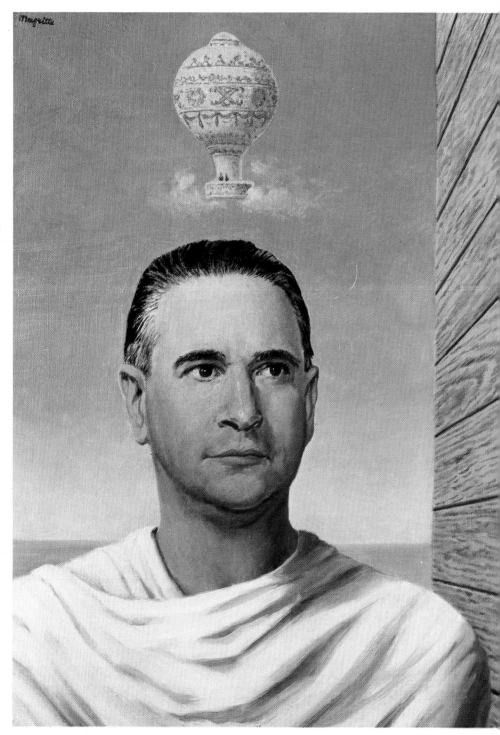

263

264

"Harry Torczyner" as the name of the portrayed I am portraying. However, sometimes a subtitle is found (for example, *La fée ignorante* [*The Ignorant Fairy*], or portrait of Anne-Marie Crowet), and when it is found, that is, when it satisfies the complex requirements of a good subtitle, it is difficult to separate it from the picture. Thus, to me *Justice a été faite (Justice Has Been Done)* is the subtitle that suits your portrait. In giving this verdict, Madame Torczyner has in my opinion completed the title of your portrait in a sibylline and intelligent manner, as you would say, and very aptly, as I would say (justice meaning neither misfortune nor boredom, but the opposite of confusion, stupidity, or bad faith).

——*Letter from René Magritte to Harry Torczyner, October 20, 1958*

265 *La bonne année (The Good Year).* 1945. Gouache, 5⅜ x 4¾″ (13.5 x 12 cm). Collection M. and Mme. Louis Scutenaire, Brussels, Belgium

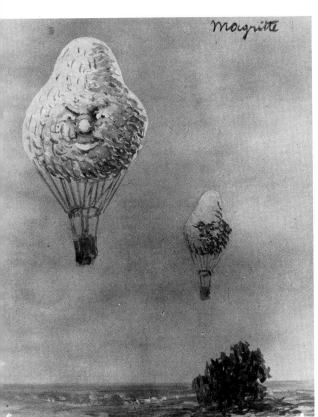

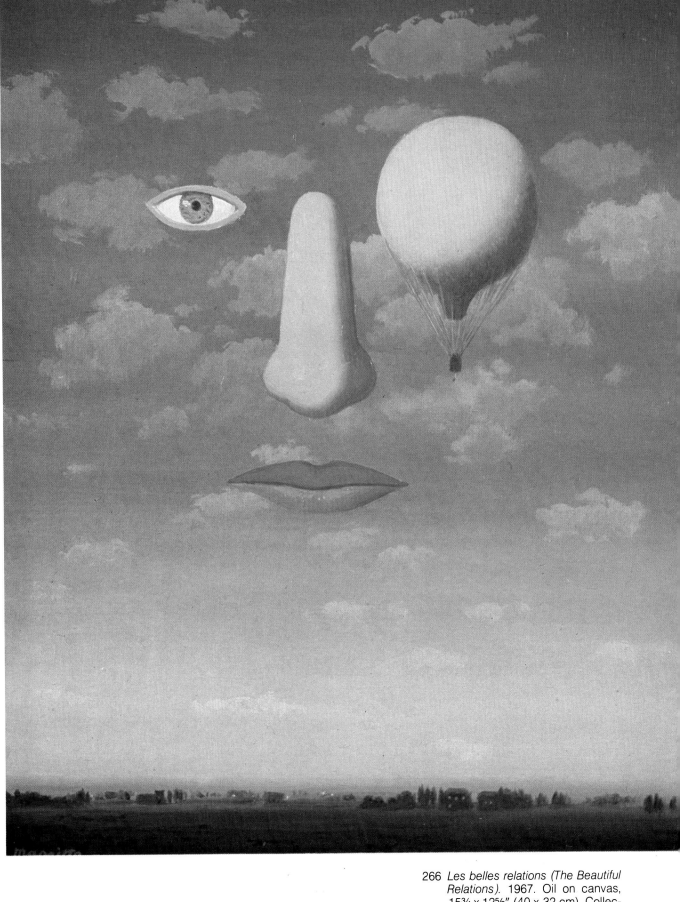

266 *Les belles relations (The Beautiful Relations).* 1967. Oil on canvas, 15¾ x 12⅝″ (40 x 32 cm). Collection M. and Mme. Pierre Scheidweiler, Brussels, Belgium

Word

267 *Le sens propre (The Proper Meaning).* 1928–1929. Oil on canvas, 28¾ x 21¼" (73 x 54 cm). Collection Robert Rauschenberg, New York, New York

268 *Le palais des rideaux (The Palace of Curtains).* 1934. Oil on canvas, 11 x 16½" (28 x 42 cm). Collection Pierre Alechinsky, Bougival, France

269 *Les six eléménts (The Six Elements).* 1928. Oil on canvas, 28⅜ x 39⅜" (72 x 100 cm). Philadelphia Museum of Art, Philadelphia, Pennsylvania. Louise and Walter Arensberg Collection

270 *Les reflets du temps (The Reflections of Time).* 1928. Oil on canvas remounted on cardboard, 22½ x 30¼" (57 x 76.5 cm). Collection Dr. Robert Mathijs, Brussels, Belgium

271 *Le sens propre (The Proper Meaning).* 1963. Gouache, 8¾ x 11¾" (22.2 x 30 cm). Private collection, Lake Mohegan, New York

272 *Le masque vide (The Empty Mask).* 1928. Oil on canvas, 28¾ x 36¼" (73 x 92 cm). Garrick Fine Arts Inc., Philadelphia, Pennsylvania

267

268

270

271

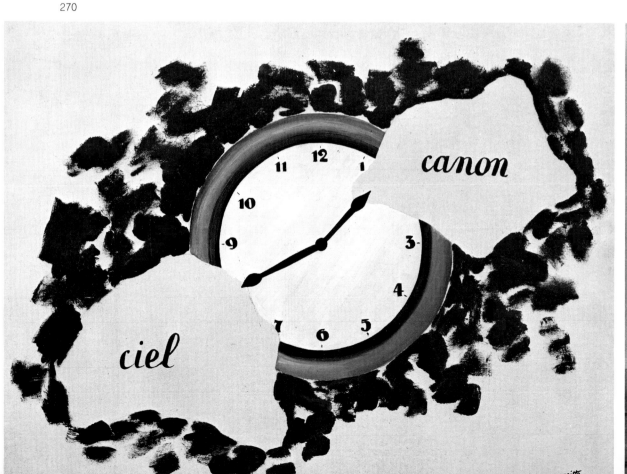

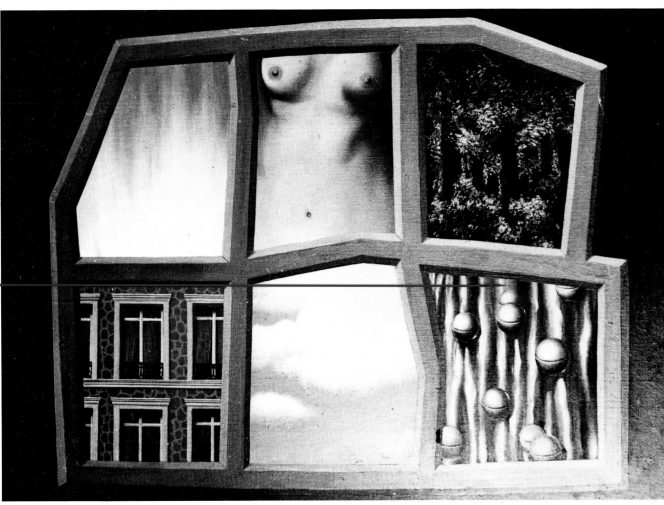

269

272

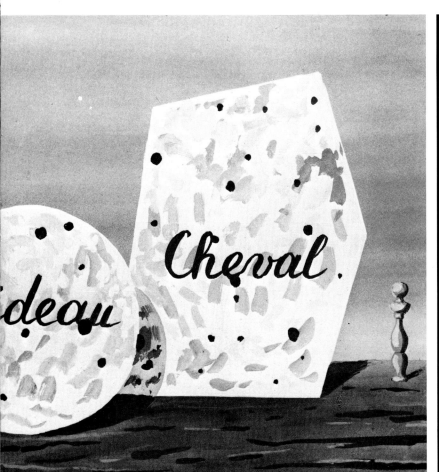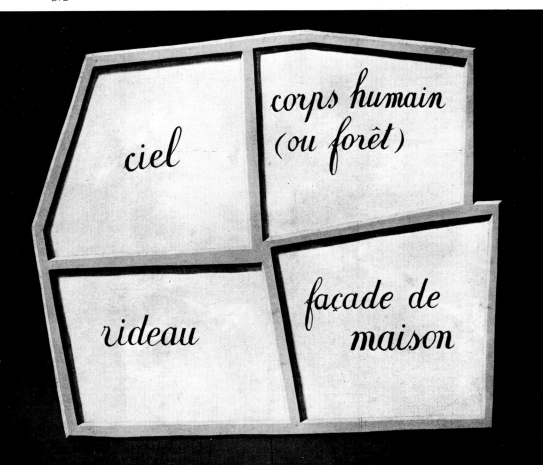

Musical Instrument

The problem I've been dealing with is the problem of the piano. The answer apprised me that the secret object designed to be joined with the piano was an engagement ring. The picture, entitled *La main heureuse (The Happy Hand),* thus represents a black grand piano whose frame goes through a large ring resting on the floor. The size of the ring is like an emanation of some happiness, particularly that of the fingers of a hand playing the piano. In addition, the outline the ring makes, partly concealed by the piano that traverses it. evokes the form of a musical sign, the F Clef.

— *René Magritte,* La Carte d'Après Nature. *no. 1. October 1952*

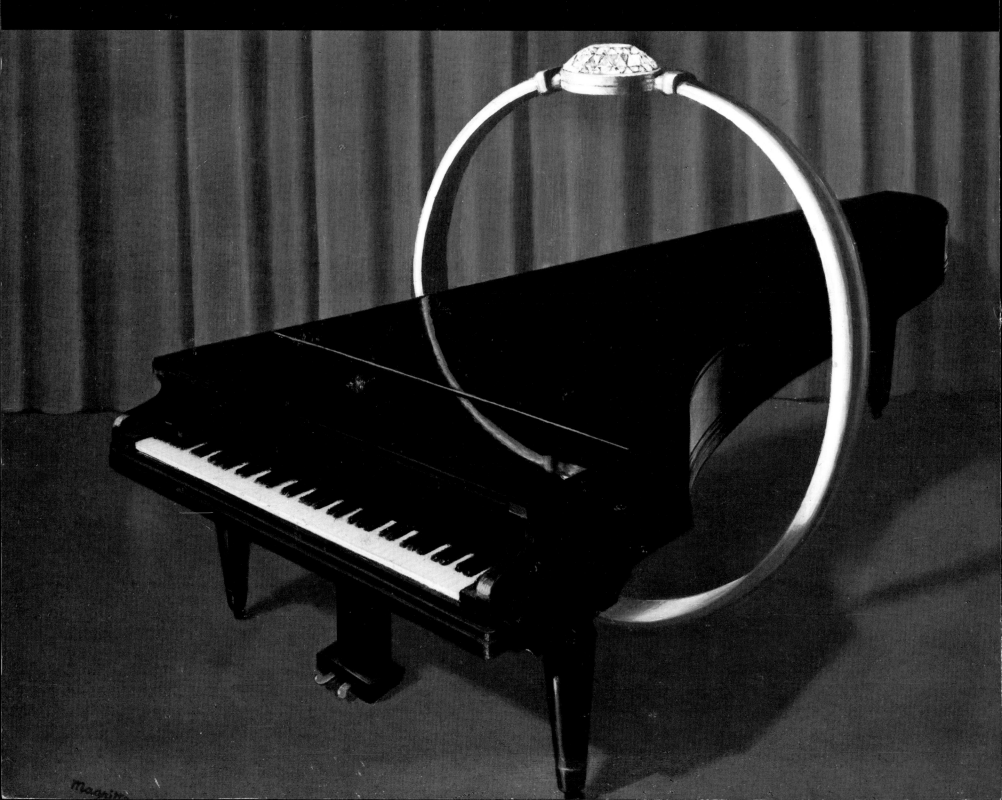

273 *La main heureuse (The Happy Hand).* 1953. Oil on
canvas, 19⅝ x 25⅝″ (50 x 65 cm). Collection
Bosted, United States

274-276 Drawings included in a letter about the prob-
lem of the piano from René Magritte to Marcel
Mariën, 1953. *See Appendix for translation*

274

275

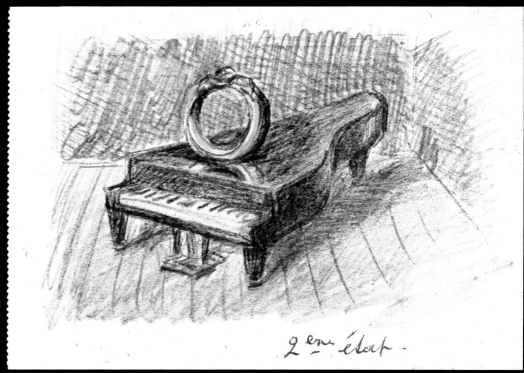

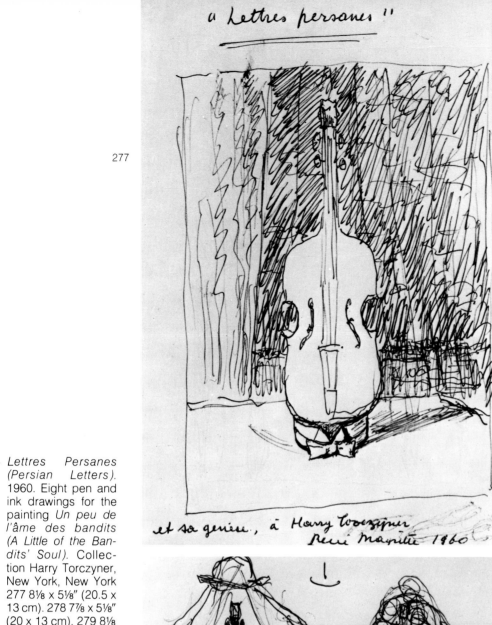

277

"Lettres persanes"

...et sa genèse, à Harry Torczyner
René Magritte 1960

278

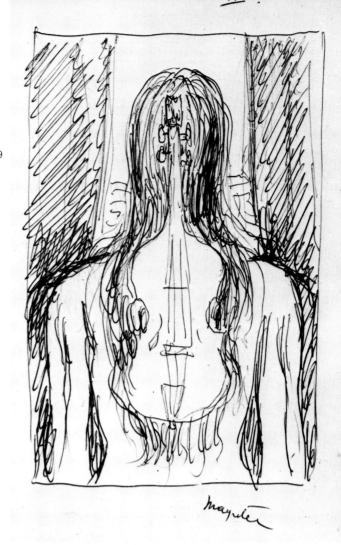

279

Magritte

280

277-284 *Lettres Persanes (Persian Letters).* 1960. Eight pen and ink drawings for the painting *Un peu de l'âme des bandits (A Little of the Bandits' Soul).* Collection Harry Torczyner, New York, New York 277 8⅛ x 5⅛" (20.5 x 13 cm). 278 7⅞ x 5⅛" (20 x 13 cm). 279 8⅛ x 5⅛" (20.5 x 13 cm). 280–284 7⅞ x 5⅛" (20 x 13 cm)

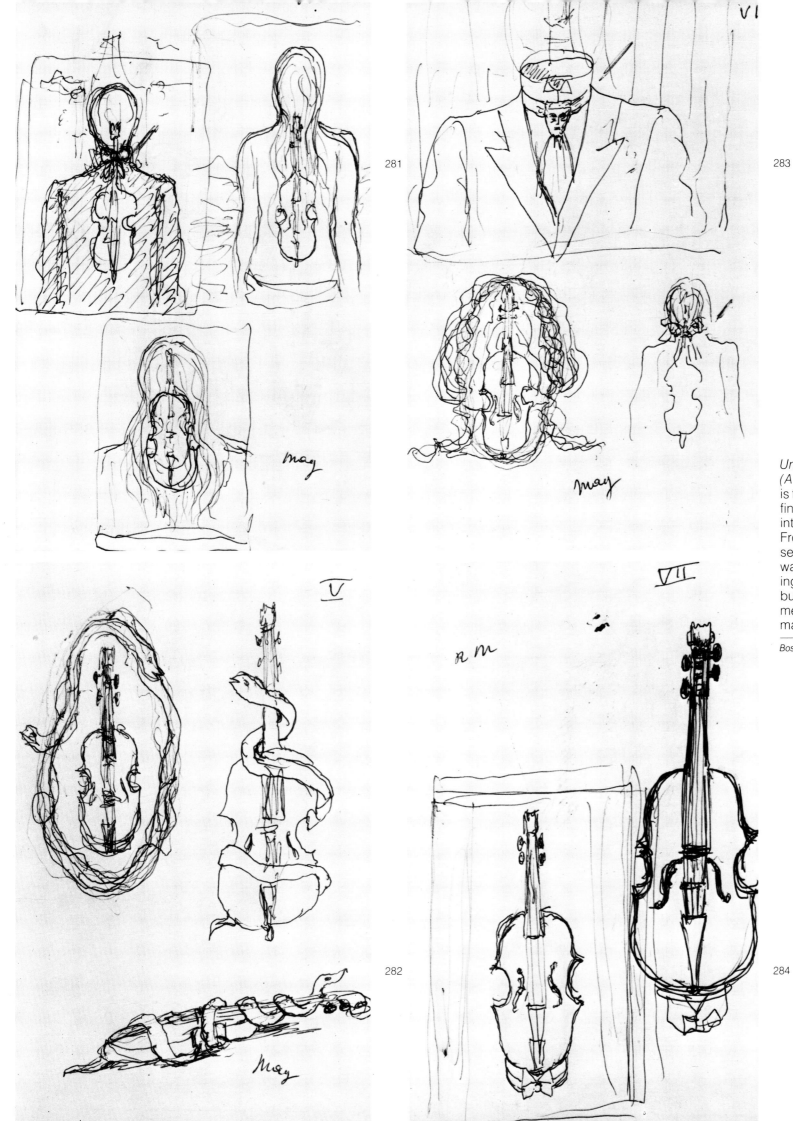

281

283

282

284

Un peu de l'âme des bandits (A Little of the Bandits' Soul) is the result of inspiration that finally came after research into the problem of the violin. From the outset of this research, as ever, the solution was present in the first drawing (which contained a "tie"), but one had to know what it meant: the white tie on a formal collar.
——*Letter from René Magritte to André Bosmans, July 19, 1960*

Apple

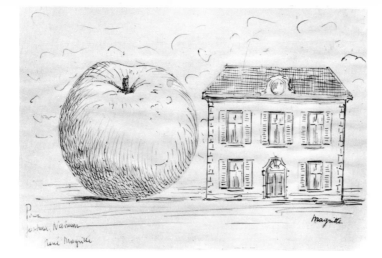

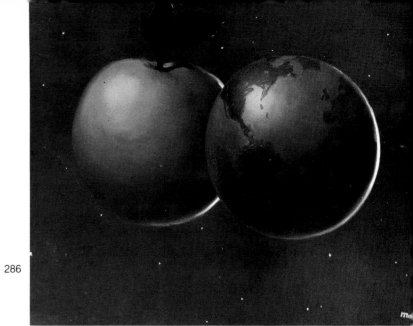

285

286

287

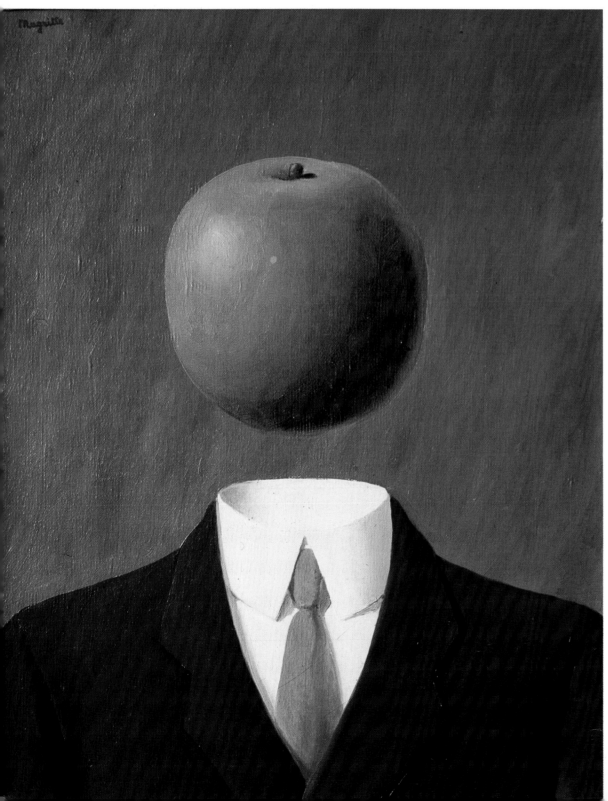

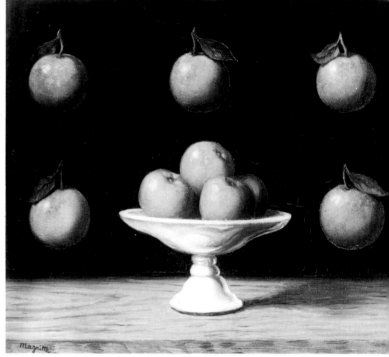

288

289

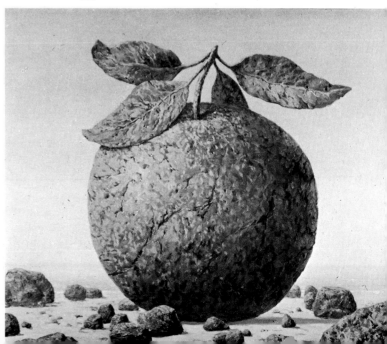

285 Untitled drawing. n.d. 6¾ x 7¼ " (17
x18.5cm). Collection Joshua Nahum
Musher, New York, New York

286 *L'autre son de cloche (The Bell's
Other Chime).* 1951. Oil on canvas,
15⅛ x 17⅞" (35.5 x 45.5 cm). Collec-
tion Mrs. Melvin Jacobs, Florida

287 *L'idée (The Idea).* 1966. Oil on can-
vas, 16⅛ x 13" (41 x 33 cm). Location
unknown

288 *Le principe d'Archimède (Ar-
chimedes' Principle).* 1950. Oil on
canvas, 15⅛ x 18¼" (38.5 x 46.5 cm).
Yale University Art Gallery, New Ha-
ven, Connecticut. Gift of Oliver B.
Jennings

289 *La grande table (The Large Table).*
1959. Oil on canvas, 21⅝ x 25⅝" (55 x
65 cm). Collection Mme. Sabine
Sonabend-Binder, Brussels, Belgium

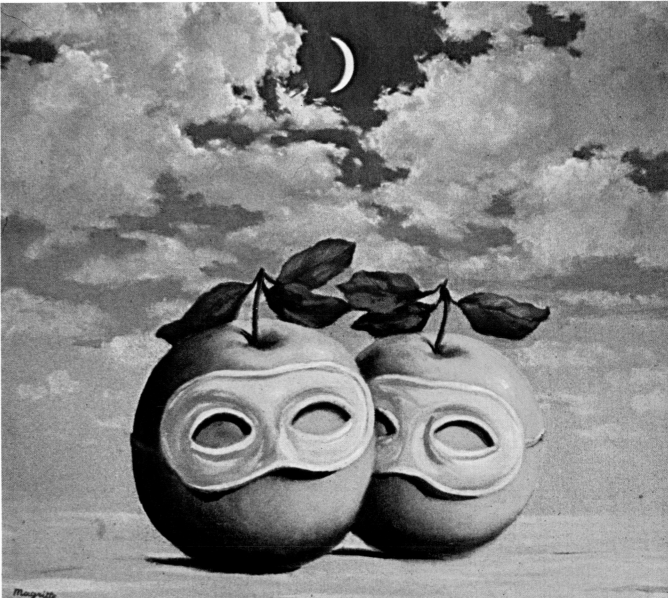

290

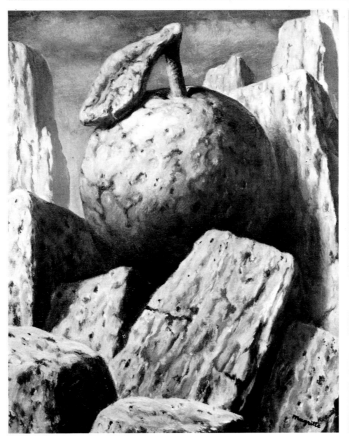

290 *Le prêtre marié (The Married Priest).*
1950. Oil on canvas, 18⅛ x 22⅞" (46 x
58 cm). Collection Mme. René Ma-
gritte, Brussels, Belgium

291 *La parole donnée (The Pledge).* 1950.
Oil on canvas, 23⅝ x 19⅝" (60 x 50
cm). Private collection, New York,
New York

292 *La carte postale (The Postcard).*
1960. Oil on canvas, 27⅝ x 19¾" (70
x 50.2 cm). Private collection, United
States

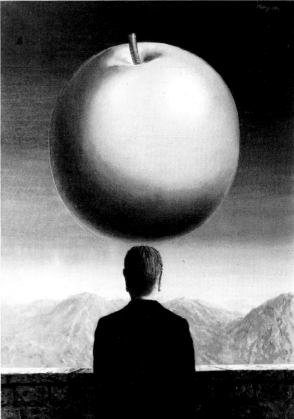

291 292

Bilboquet

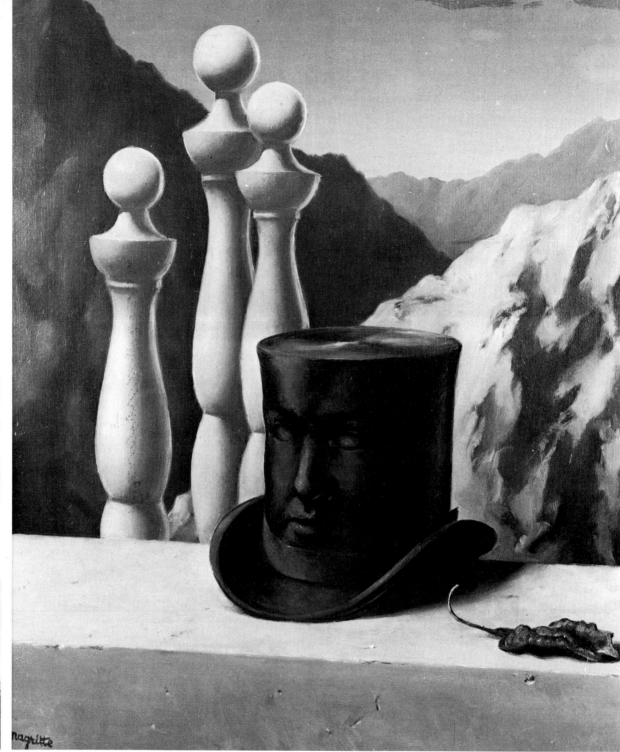

294

293

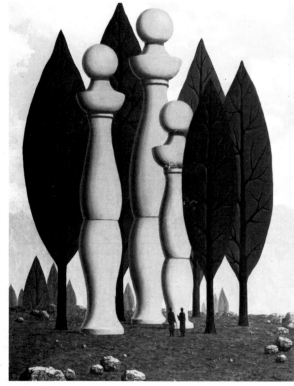

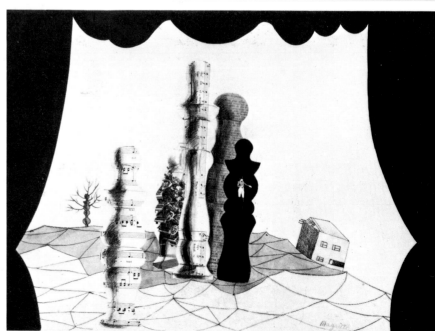

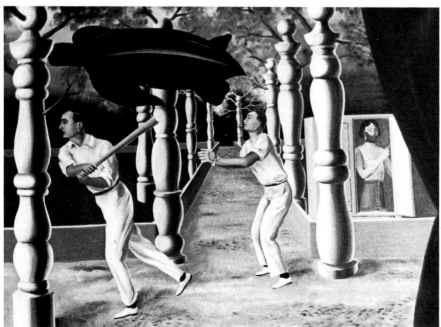

295

296

293 *L'art de la conversation (The Art of Conversation).* 1961. Oil on canvas, 31⅞ x 25¼" (81 x 64 cm). Hanover Gallery, London, England

294 *Le beau ténébreux (Dark and Handsome).* 1950. Oil on canvas, 22⅞ x 18⅞" (58 x 48 cm). The Israel Museum, Jerusalem, Israel.

295 *Le joueur secret (The Secret Player).* 1926. Oil on canvas, 59⅞ x 76¾" (152 x 195 cm). Collection Nellens, Knokke-Le Zoute, Belgium

296 Untitled. 1926. Collage, 15⁴/₅ x 21⅞" (40 x 55.5 cm). Collection Jean-Louis Merckx, Brussels, Belgium

297

298

297 *L'enfant du siècle/Après le bal (Century's Child/After the Ball).* 1926. Gouache, 15⅝ x 21⅝" (39.5 x 55 cm). Private collection, United States

298 *La raison d'être (The Raison d'Être).* 1928. Gouache, 16⅛ x 22" (41 x 56 cm). Private collection, Belgium

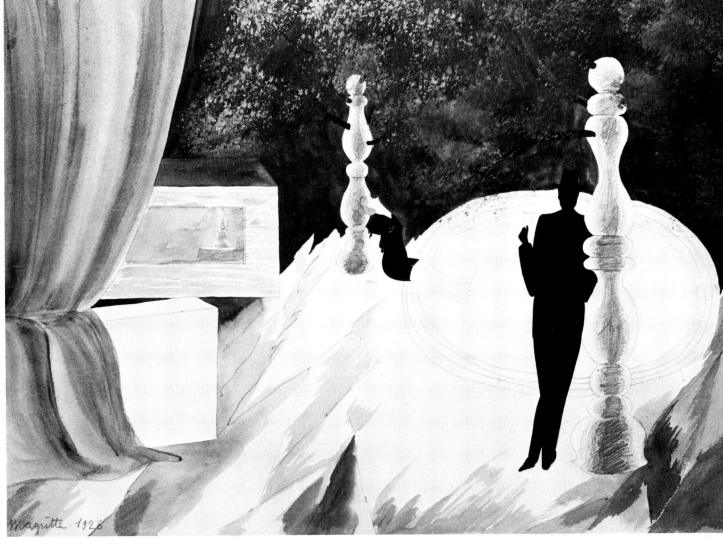

Anthropoid Bilboquet

299 Drawing of *Les droits de l'homme (The Rights of Man)* in a letter from René Magritte to San Lazzaro, June 5, 1963

300 *L'après-midi d'un faune (Afternoon of a Faun)*. 1944. Oil on canvas, 19⅝ x 23⅝" (50 x 60 cm). Collection Komkommer, Brussels, Belgium

301 *Le colloque sentimental/Les Cicérones (The Sentimental Colloquy/The Guides)*. 1937. Red chalk, 14⅛ x 18⅛" (36 x 46 cm). Collection Jean-Louis Merckx, Brussels, Belgium

299

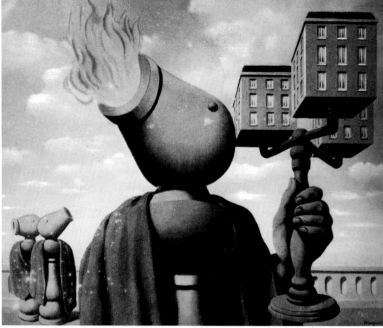

300

301

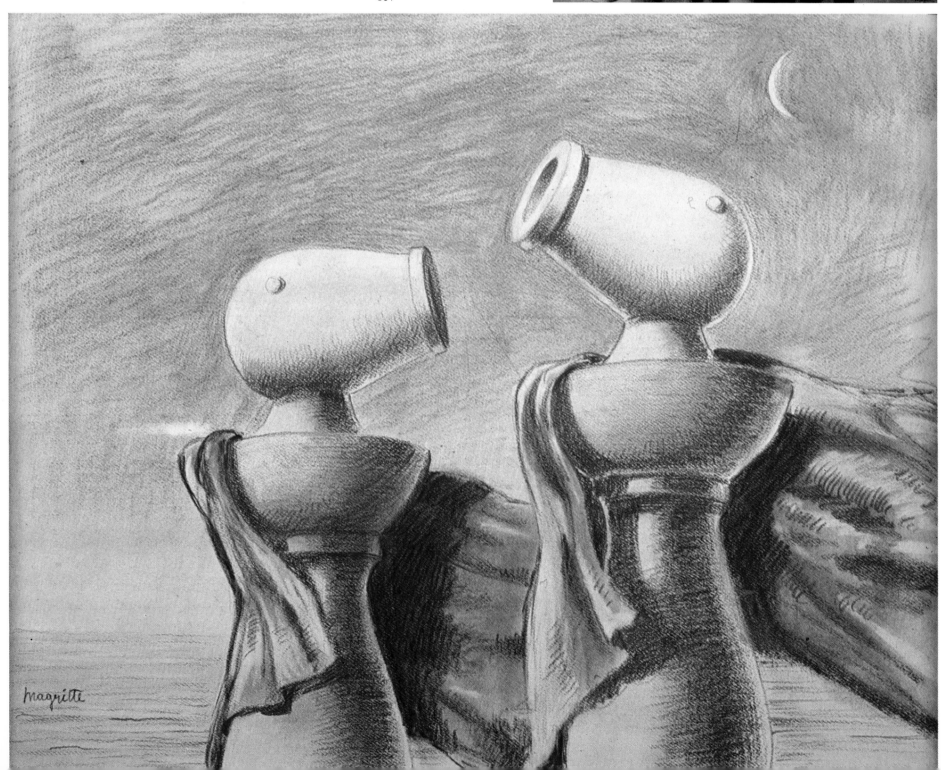

302 *Les droits de l'homme (The Rights of Man)*. 1945. Oil on canvas, 57½ x 44⅞" (146 x 114 cm). Galerie d'Arte del Naviglio, Milan, Italy

303 *Cicérones (The Guide)*. 1948. Oil on canvas, 27⅝ x 19⅝" (70 x 50 cm). Private collection, Brussels, Belgium

304 *La traversée difficile (The Difficult Crossing)*. n.d. Ink and pencil drawing, 5⅛ x 5⅛" (13 x 13 cm). Collection Harry Torczyner, New York, New York. *See* Appendix *for translation*

303
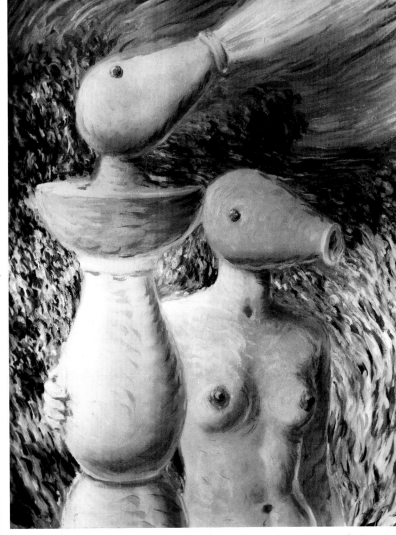

302
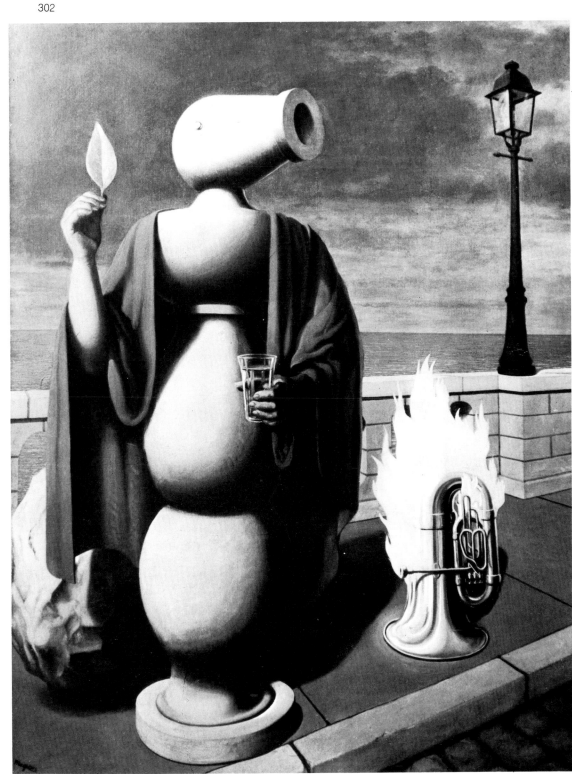

304

A recent experience has made me aware of the gap between intelligences: I have just heard an "explanation" of a picture I painted. I mean *Les droits de l'homme (The Rights of Man)*. It would appear that the fire we see in the picture is Prometheus', but also a symbol of war! The character holding a leaf in his hand is supposed to "repre-sent" peace—the leaf is supposed to be an olive leaf!!! Thus, this picture, etc. . . . I'll stop, because the imagination of amateurs of painting is inexhaustible, but very banal, since such amateurs lack any inspiration whatsoever.
—*Letter from René Magritte to André Bosmans, September 20, 1961*

153

Stone and Rock

Now if, for example, weight can play a part in poetry, it is evoked by a stone (as in *La bataille de l'Argonne* [*The Battle of the Argonne*]). What is evoked is weight, *not its laws;* it is evoked *without physics.* The sensation, feeling, or idea of weight is enough for poetry; *laws would be too much,* and there would be too much as soon as physics intervened. The appearance of the word "physics" asserts a belief in the interest physics has for poetry. Now, interest in physics, while valid for an engineer or a physicist, means that there's no longer any question of poetry. If the physicist grants a greater spiritual importance to physics than to poetry, then the question of truth arises.
——*Letter from René Magritte to André Bosmans, July 24, 1961*

By confronting us with a massive rock in midair*—something we know cannot happen— we are somehow forced to wonder *why* doesn't the rock come plunging down into the sea? We know, of course, that it should. But *why* should it? . . . What fails to happen in the painting reminds us of the mystery of what actually does happen in the real world.

Space, time, and matter are dramatized here in suspended animation. The force of gravity, which we dismiss as commonplace in our daily lives, becomes powerful and awesome here. We can step on an ordinary stone any day without giving it a second thought, but the stone in the painting is compelling. The artist has made it extraordinary. It reminds us that all stones are extraordinary. . . . It is a wonderful picture to remind us that the world of our senses, the world of stones and castles, of oceans, clouds and waves, is the world that we must study before we can comprehend the more subtle world of atoms and molecules, of which the world of our senses is composed. Even more important, perhaps, it has the power to evoke a feeling of wonder. This is the ingredient that can make both a painting and physics exciting.
——*Letter from Albert V. Baez, physicist, to Harry Torczyner, September 8, 1963*

*The author is referring to *Le château des Pyrénées.*

305-309 Unititled drawings. c. 1959. Private collection, New York, New York

310 *Les origines du langage (The Origins of Language).* 1955. Oil on canvas, 45⅞ x 35⅜" (116.5 x 90 cm). Collection University of St. Thomas, Houston, Texas

311 Untitled drawing. c. 1959. 8½ x 5⅜" (20.5 x 13.5 cm). Private collection, New York, New York

305-309

310

311

154

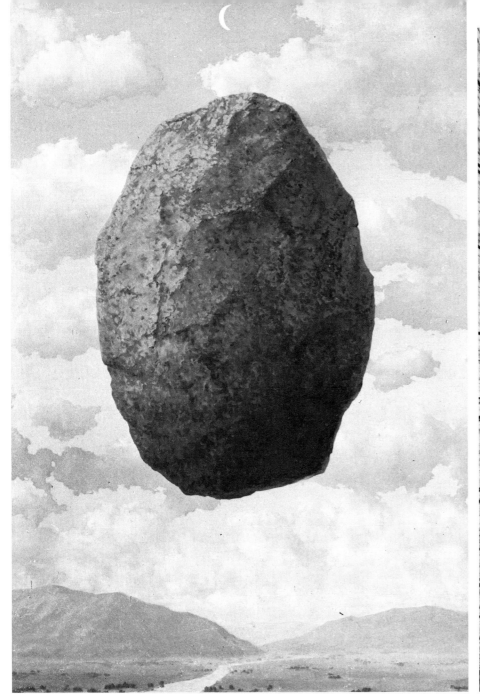

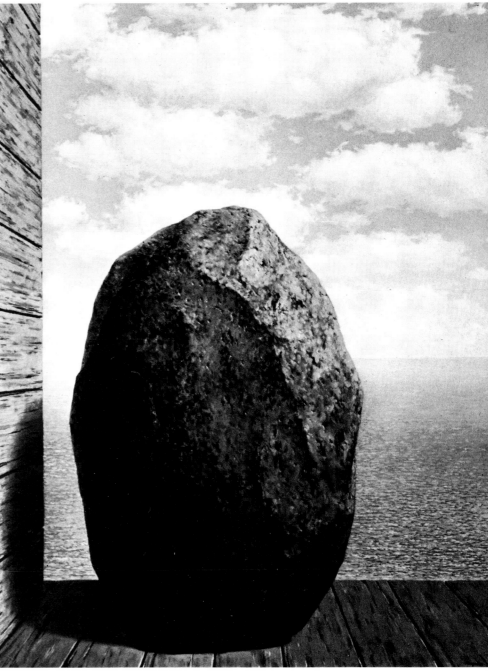

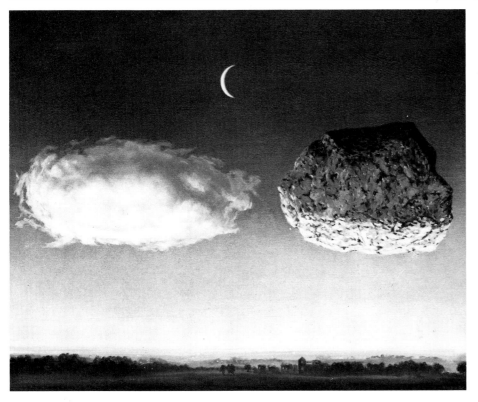

313

312 *Le sens des réalités (The Sense of Reality)*. 1963. Oil on canvas, 68⅞ x 45¼" (175 x 115 cm). Private collection, England

313 *Le trou dans le mur (The Hole in the Wall)*. 1956. Oil on canvas, 39⅜ x 31½" (100 x 80 cm). Collection Hans Neumann, Caracas, Venezuela

314 *La bataille d'Argonne (The Battle of the Argonne)*. 1959. Oil on canvas, 19½ x 24" (49.5 x 61 cm). Collection Tazzoli, Turin, Italy

314

Easel

The problem of the window gave rise to *La condition humaine (The Human Condition)*. In front of a window seen from inside a room, I placed a painting representing exactly that portion of the landscape covered by the painting. Thus, the tree in the picture hid the tree behind it, outside the room. For the spectator, it was both inside the room within the painting and outside in the real landscape. This is how we see the world. We see it outside ourselves, and at the same time we only have a representation of it in ourselves. In the same way, we sometimes situate in the past that which is happening in the present. Time and space thus lose the vulgar meaning that only daily experience takes into account.
——*René Magritte, La Ligne de Vie II, February 1940*

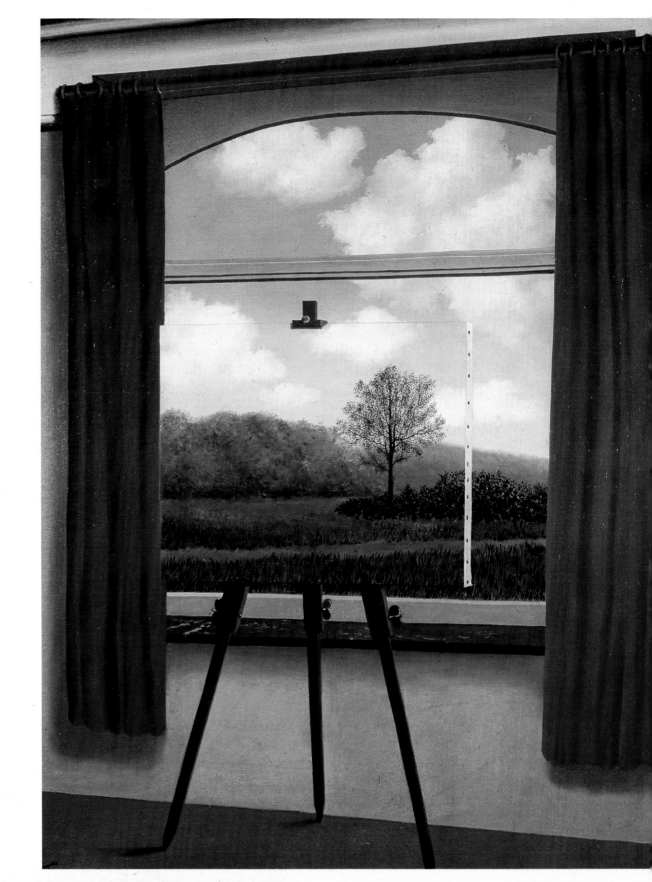

315 *La condition humaine (The Human Condition)*. 1934. Oil on canvas, 39⅜ x 31⅞" (100 x 81 cm). Private collection, Paris, France

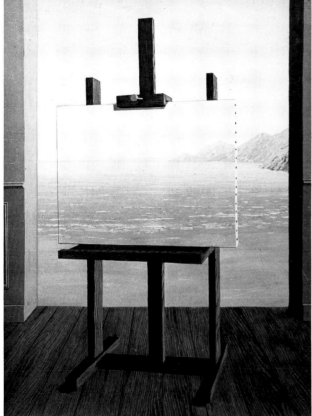

316

317

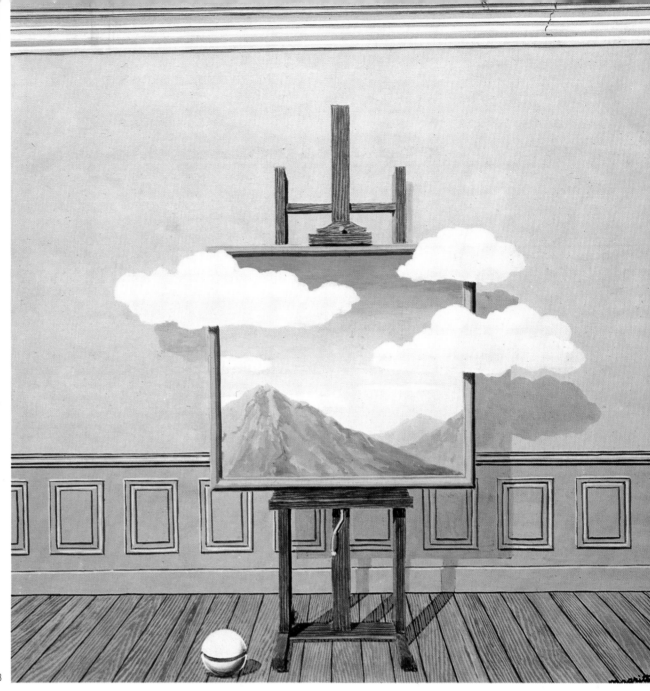

318

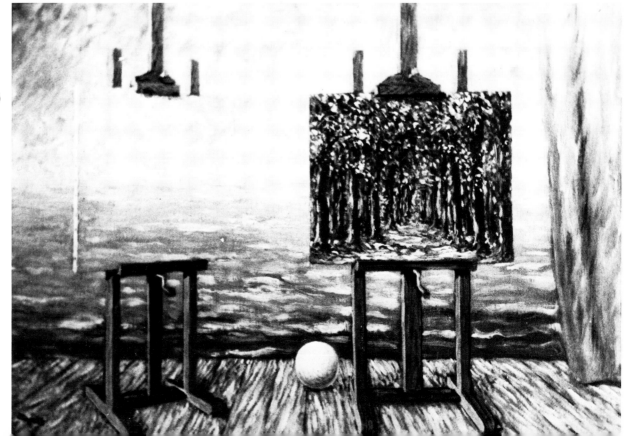

319

316 *La condition humaine (The Human Condition).* n.d. Oil on canvas. Private collection, Belgium

317 Untitled drawing. 1962. Ink, 6 x 4¾″ (15.2 x 12.2 cm). Made for the frontispiece of the catalogue of the Magritte retrospective exhibition at the Walker Art Center, Minneapolis, Minnesota. Private collection, New York, New York

318 *Les nuages (The Clouds).* 1939. Gouache, 13⅛ x 13″ (34 x 33 cm). Private collection, Belgium

319 *La pêche miraculeuse (The Miraculous Draft of Fishes).* 1944. Oil on canvas, 15⅝ x 24″ (39.5 x 61 cm). Collection Mrs. Jack Wolgin, Philadelphia, Pennsylvania

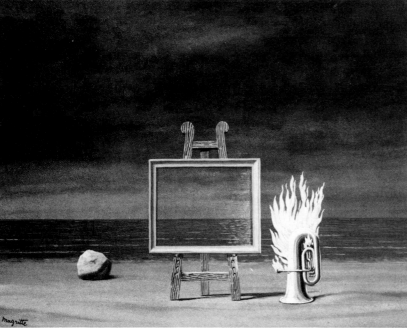

320

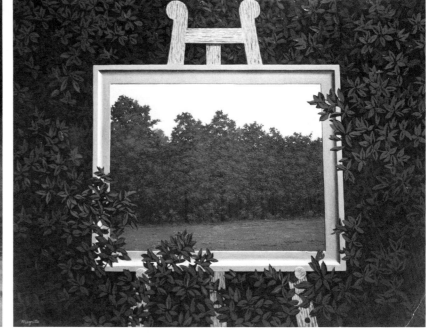

321

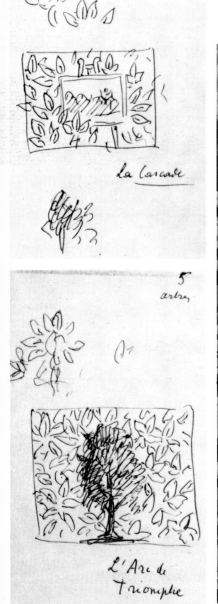

322

320 *La belle captive (The Fair Captive)*. 1949. Gouache, 14 x 17⅞″ (35.5 x 45.5 cm). Private collection, United States

321 *La cascade (The Waterfall)*. 1961. Oil on canvas, 31½ x 39″ (80 x 99 cm). Location unknown

322 Study for *La cascade (The Waterfall)*. 1961. Ink drawing, 18⅞ x 10¼″ (48 x 26 cm). Collection Harry Torczyner, New York, New York

323 Study for *L'arc de triomphe (The Arch of Triumph)*. 1961. Ink drawing, 18⅞ x 10¼″ (48 x 26 cm). Collection Harry Torczyner, New York, New York

324 *La cascade (The Waterfall)*. 1961. Gouache, 14⅝ x 17¾″ (37 x 45 cm). Private collection, Gstaad, Switzerland

324

323

Bird

325
Dieu n'est pas un saint (God Is Not a Saint). 1935. Oil on canvas, 26⅜ x 16⅞" (67 x 43 cm). Collection M. and Mme. Louis Scutenaire, Brussels, Belgium

326
Le principe d'incertitude (The Principle of Uncertainty). 1944. Oil on canvas, 25⅝ x 20⅛" (65 x 51 cm). Private collection, Belgium

327
Le ciel meurtrier (The Murderous Sky). 1930. Oil on canvas, 28¾ x 39⅜" (73 x 100 cm). Collection Nellens, Knokke-Le Zoute, Belgium

328
Le présent (The Present). 1939. Gouache. Private collection, Belgium

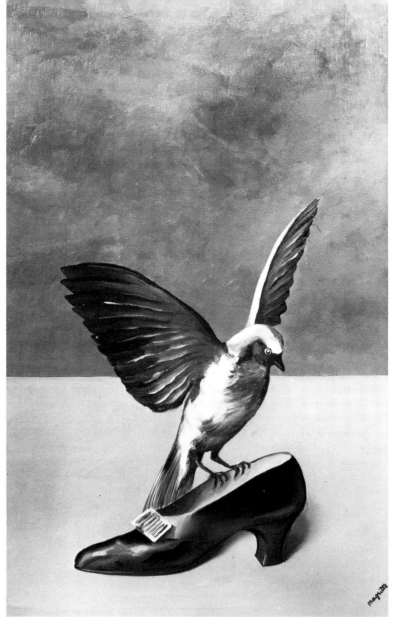

325

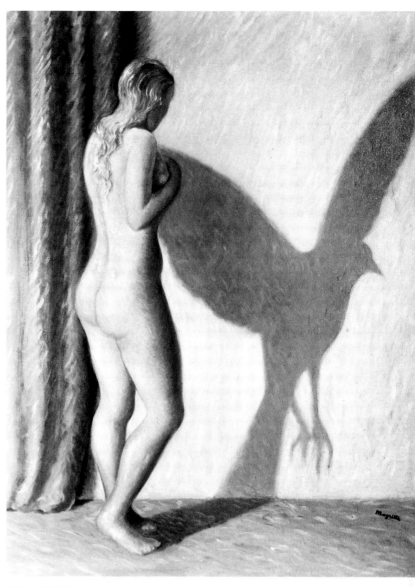

326

A nude woman casts her shadow on the wall in the shape of a bird with its wings spread.
——René Magritte, June 22, 1946, *in* Le Fait Accompli, *nos. 111–113, April 1974*

327

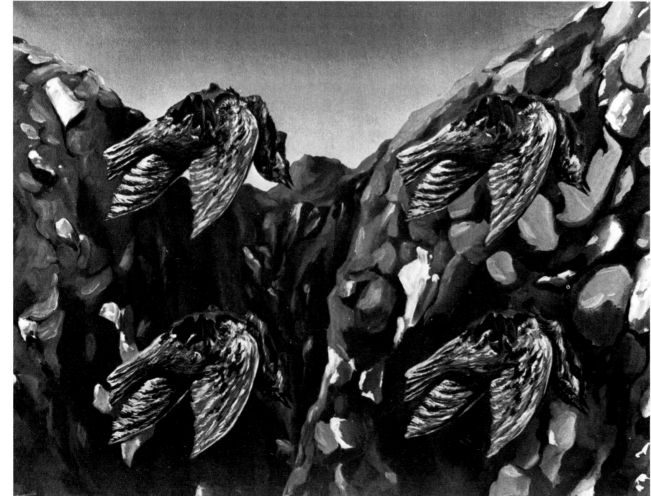

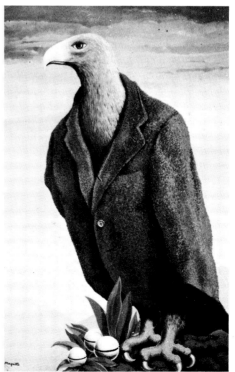

328

Leaf/Bird

329 *Les grâces naturelles (The Natural Graces)*. 1962. Oil on canvas, 15¾ x 11⅝" (40 x 32 cm). Collection Mme. Suzanne Ochinsky, Brussels, Belgium

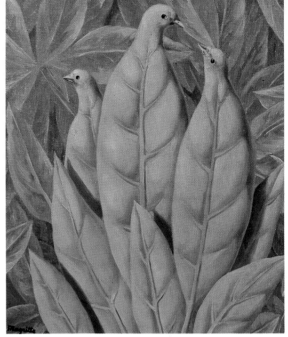

330 *L'île au trésor (Treasure Island)*. 1942. Oil on canvas, 27⅝ x 36⅝" (70 x 93 cm). Collection Mme. René Magritte, Brussels, Belgium

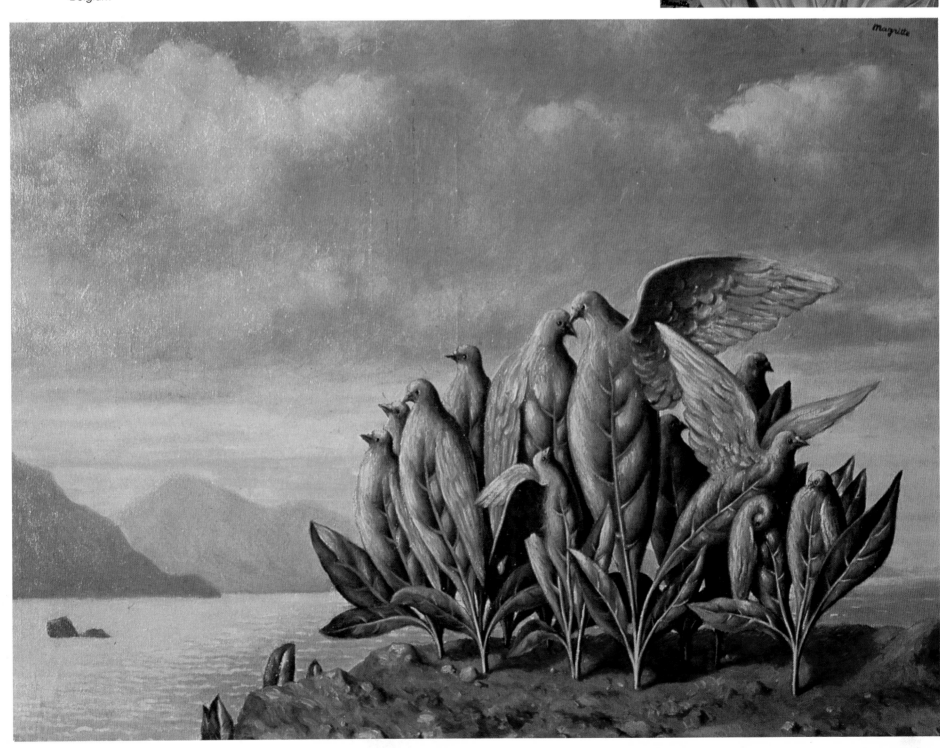

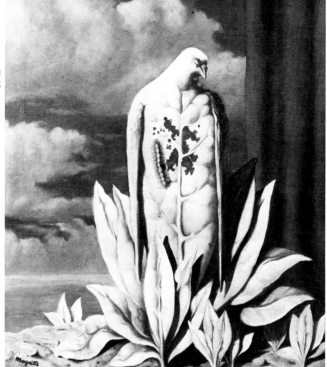

331 *La saveur des larmes (The Flavor of Tears).* 1948. Oil on canvas, 22⅞ x 18⅞″ (58 x 48 cm). Collection Richard S. Zeisler, New York, New York

332 *Les grâces naturelles (The Natural Graces).* 1942. Gouache, 16⅜ x 23⅜″ (41.5 x 59.5 cm). Private collection, Brussels, Belgium

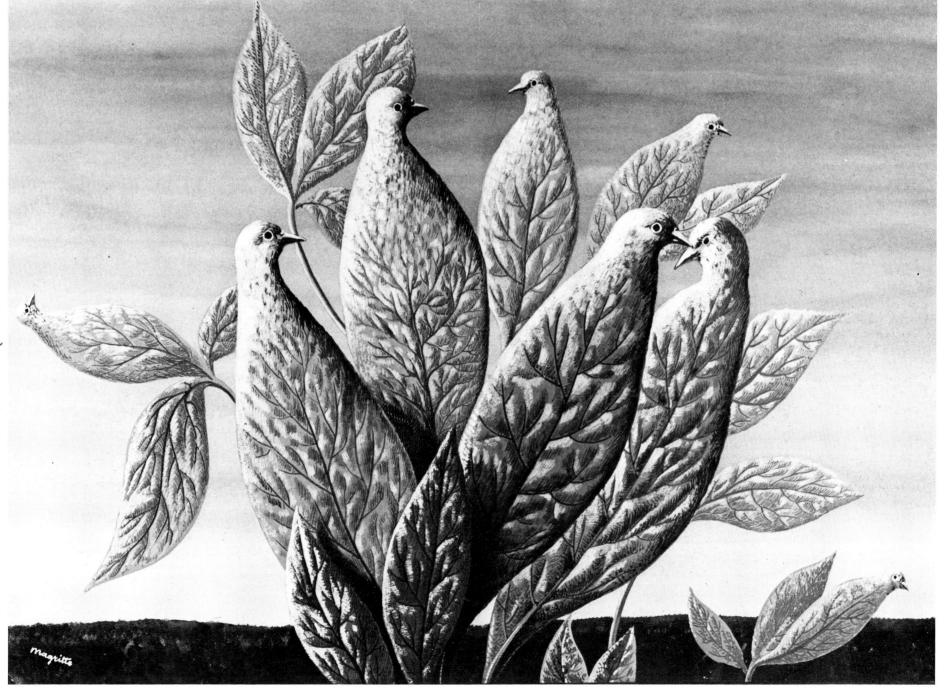

Bird/Leaf

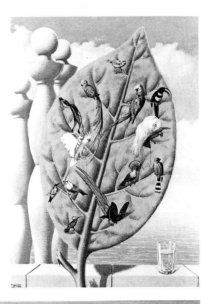

333 *La grande feuille aux oiseaux (Large Leaf with Birds).* c. 1948. Gouache, 18½ x 14⅜" (47 x 36.5 cm). Private collection, Brussels, Belgium

334 *Le regard intérieur (The Inward Gaze).* 1942. Oil on canvas, 23⅝ x 29⅛" (60 x 74 cm). Private collection, Brussels, Belgium

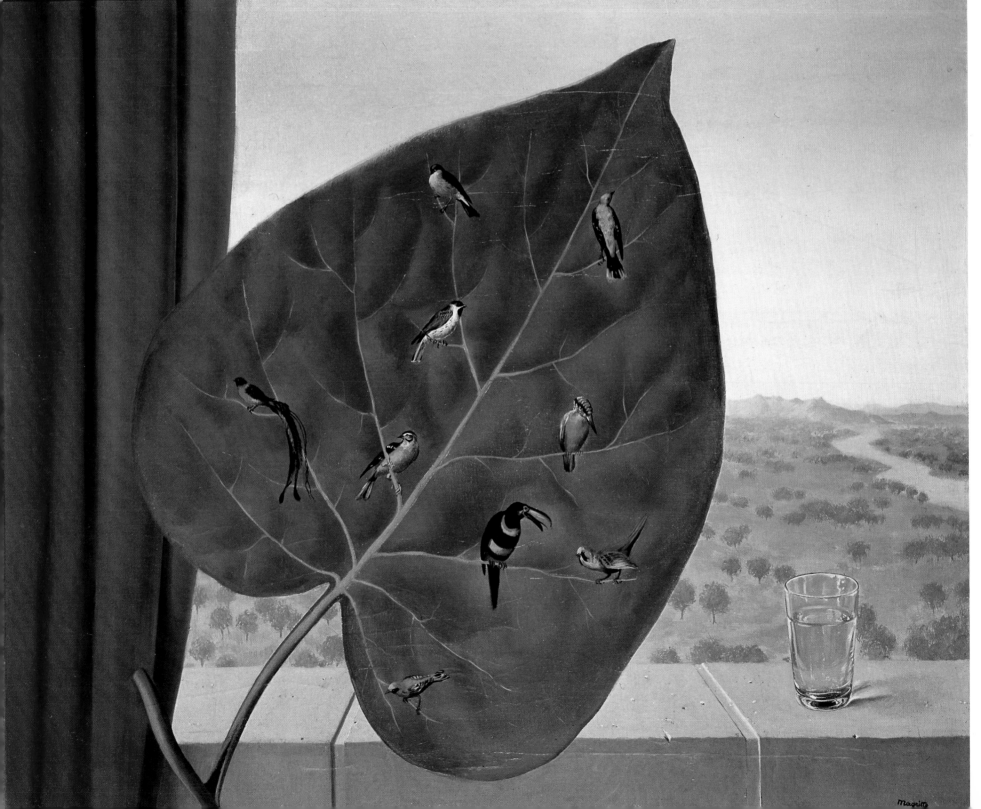

Object

335
Ceci est un morceau de fromage (This is a Piece of Cheese). 1936. Sketch for a painting-object. Location unknown. *See* Appendix *for translation*

336
Fromage sous cloche (Cheese under Bell Glass). n.d. Collection M. and Mme. Marcel Mabille, Rhode-St.-Genèse, Belgium

337
La métamorphose de l'objet (Metamorphosis of the Object). 1933. Study for an ashtray. Gouache, 3⅞ x 3⅞" (10 x 10 cm). Private collection, Brussels, Belgium. *See* Appendix *for translation*

336

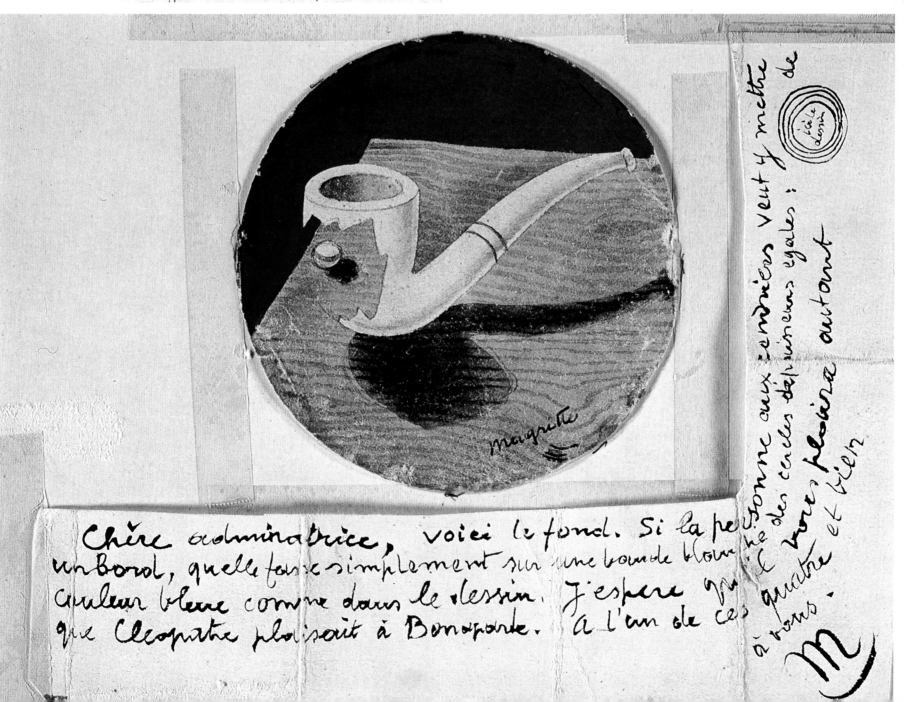

RENÉ MAGRITTE
97, RUE DES MIMOSAS
BRUXELLES 3

le 21 mai 1966

Mon cher Mabille,

Pour ajouter à votre collection d'objets imaginés par moi, je vous propose ceci :

Il s'agit d'un "chapeau boule" sur lequel une étiquette est collée. Si vous désirez cet objet, voici le moyen "d'opérer":

1° vous achetez un "chapeau boulé noir

2° vous faites imprimer une étiquette comme celles qui se trouvent sur les anciens bocaux de pharmaciens; qui est à coller sur le chapeau :

USAGE EXTERNE
magritte

de cette dimension approximativement :

signez l'étiquette ici

en papier doré, lettres "bloc" en noir et encadrement en noir.

L'objet s'appelle : "Le bouchon d'épouvante"

Entre autres moyens de "présenter" cet objet, il me semble qu'une sorte de boîte en verre – comme un aquarium carré – conviendrait ? Le chapeau posé sur un bloc, à l'intérieur de la boîte.

A un de ces jours, et très cordialement à vous,

René Magritte

339 *Le bouchon d'épouvante (The Fearsome Bottle Cap)*. 1966. Collection M. and Mme. Marcel Mabille, Rhode-St.-Genèse, Belgium

Decoupage

The phrase "papier masqué" comes up in a text. This is the poetic expression one of my friends uses to designate the paper figures—regularly pierced with various geometric forms—that appear in certain of my pictures.

——*Letter from René Magritte to Volker Kahmen, July 8, 1965*

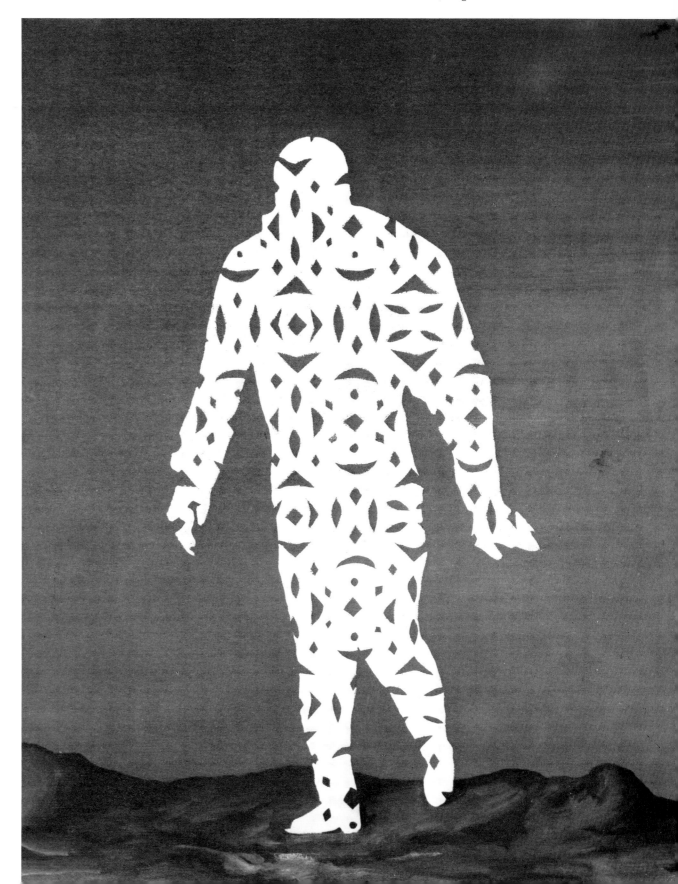

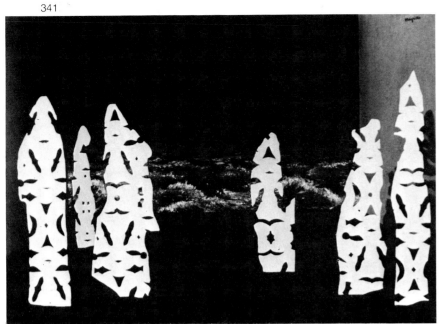

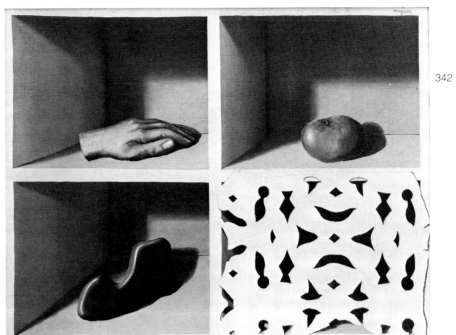

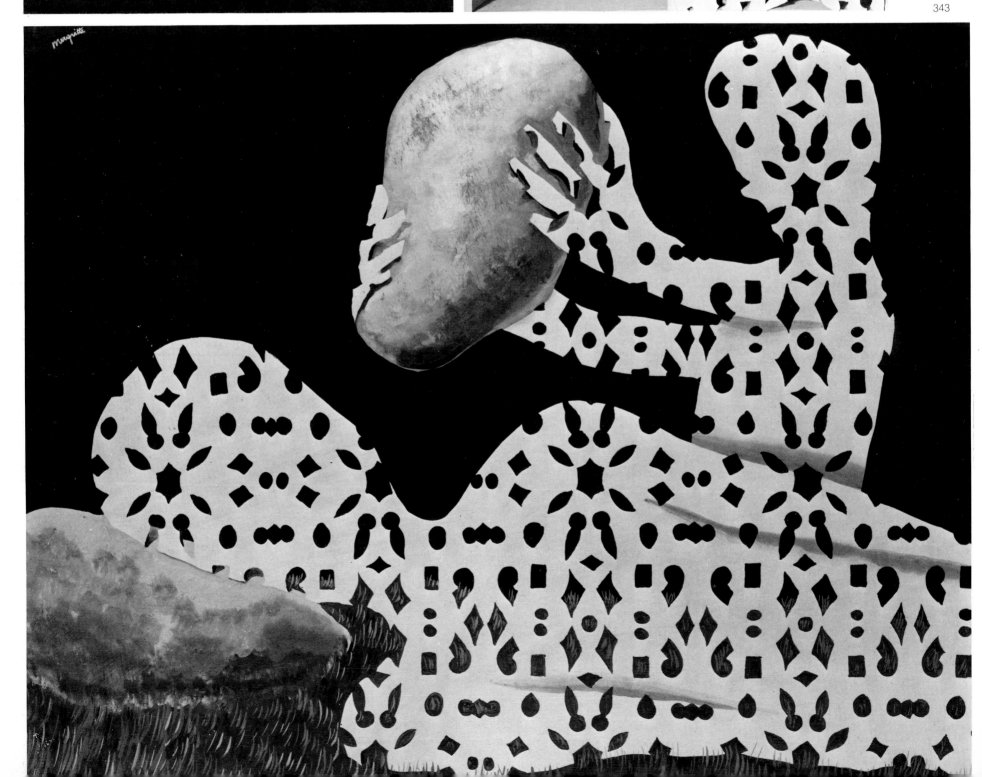

Candle

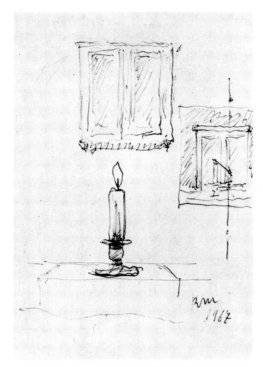

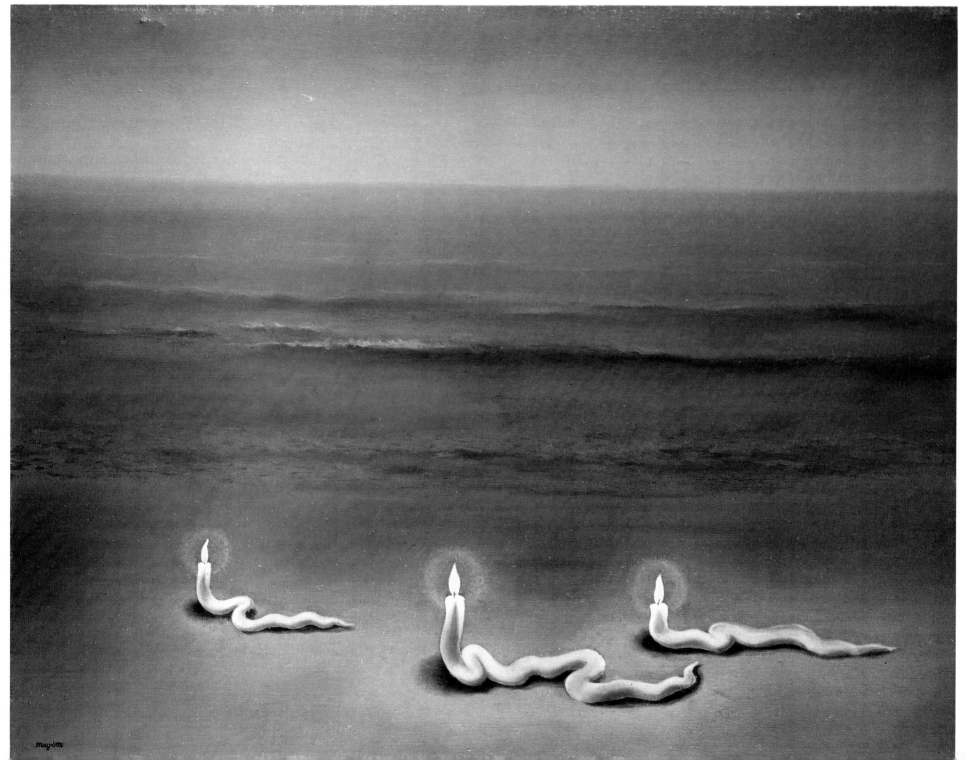

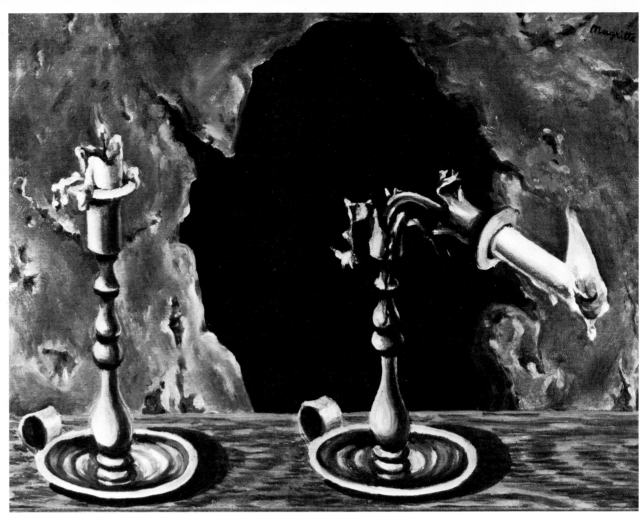

346 *Mélusine (Melusina)*. 1952. Oil on canvas, 11¾ x 15¾″ (30 x 40 cm). Galerie Isy Brachot, Brussels, Belgium

347 *Souvenir de voyage (Memory of a Voyage)*. 1962. Oil on canvas, 18⅛ x 21¼″ (46 x 54 cm). Collection Mme. Suzanne Ochinsky, Brussels, Belgium

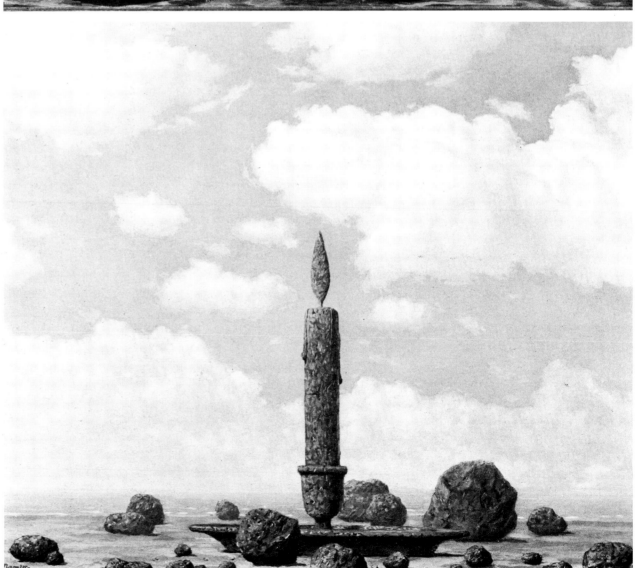

RESEMBLANCE AND SIMILITUDE

Familiar Objects

348 Untitled drawing. n.d. 4⅞ x 4⅞"
(12.5 x 12.5 cm). Collection Mme.
René Magritte, Brussels, Belgium

349 *Les objets familiers (The Familiar
Objects).* 1928. Oil on canvas,
31⅞ x 45⅝" (81 x 116 cm). Private
collection, Brussels, Belgium

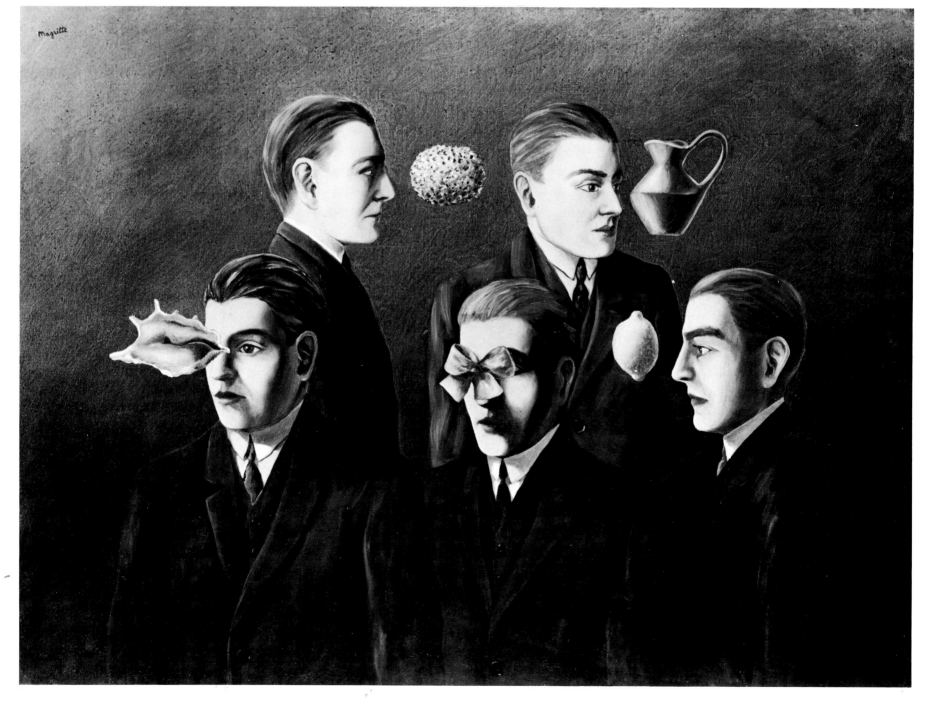

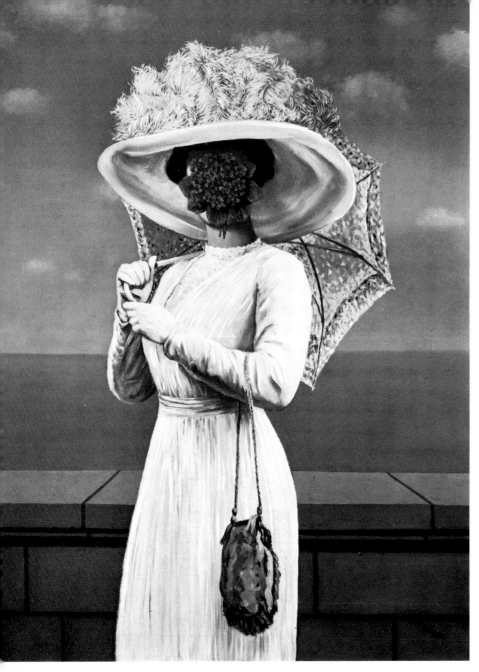

350 *La grande guerre (The Great War)*. 1964. Oil on canvas, 31½ x 24″ (80 x 61 cm). Collection Veranneman Foundation, Kruishouten, Belgium

Apropos the "invisible," I mean what is not visible: for example, heat, weight, pleasure, etc.

There is the visible we see: *the apple in front of the face in "La grande guerre" (The Great War),* and the hidden visible: *the face hidden by the visible apple.* In *Le banquet (The Banquet)* the sun hidden by the row of trees is invisible, etc. Mystery is invisible. It (like nothingness) is important not because it is invisible, *but because it is absolutely necessary.*
——*Letter from René Magritte to André Bosmans, September 25, 1964*

351 *La bonne foi (The Good Faith)*. 1962. Oil on canvas, 15¾ x 12⅝″ (40 x 32 cm). Private collection, Brussels, Belgium

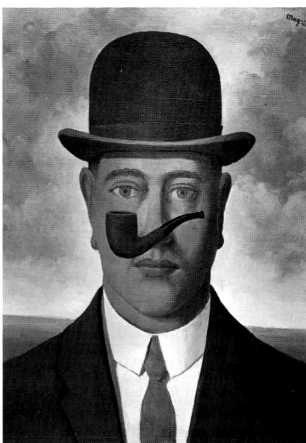

Those of my pictures that show very familiar objects, an apple, for example, pose questions. We no longer understand when we look at an apple; its mysterious quality has thus been evoked. In a recent painting, I have shown an apple in front of a person's face. . . .

At least it partially hides the face. Well then, here we have the apparent visible, the apple, hiding the hidden visible, the person's face. This process occurs endlessly. Each thing we see hides another, we always want to see what is being hidden by what we see. There is an interest in what is hidden and what the visible does not show us. This interest can take the form of a fairly intense feeling, a kind of contest, I could say, between the hidden visible and apparent visible.
——*From an interview by Jean Neyens, 1965*

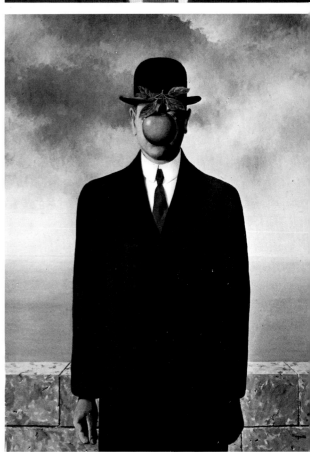

352 *Le fils de l'homme (The Son of Man)*. 1964. Oil on canvas, 45⅝ x 35″ (116 x 89 cm). Collection Harry Torczyner, New York, New York

The Human Condition

353 *L'immaculée conception (The Immaculate Conception).* 1960. Drawing, 5 x 7½" (12.75 x 19 cm). Collection Harry Torczyner, New York, New York

354 *La maison de verre (The Glass House).* 1939. Gouache, 13¾ x 15¾" (35 x 40 cm). Collection Edward James Foundation, Chichester, England

355 *Le chant des sirènes (The Song of the Sirens).* 1952. Oil on canvas, 39⅜ x 31⅞" (100 x 81 cm). Private collection, United States

356 *Le poète récompensé (The Recompensed Poet).* 1956. Oil on canvas. Private collection, United States

353

354

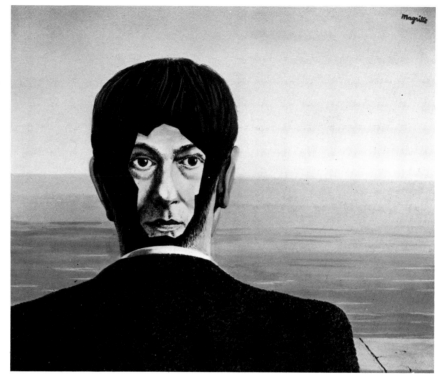

356

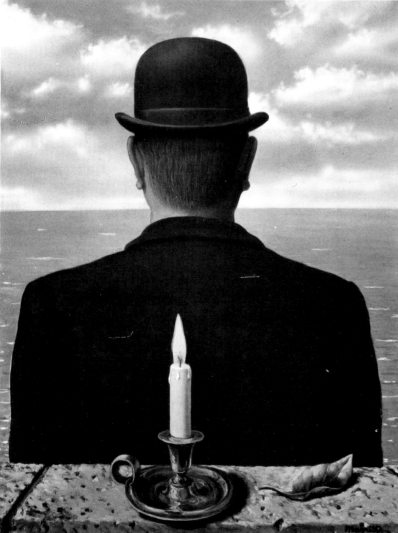

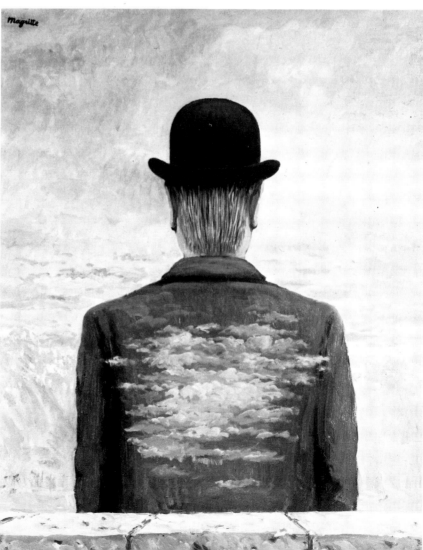

The Healer

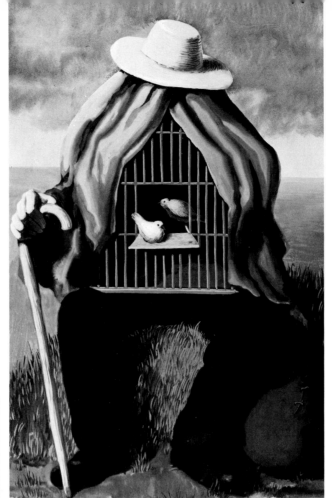

357

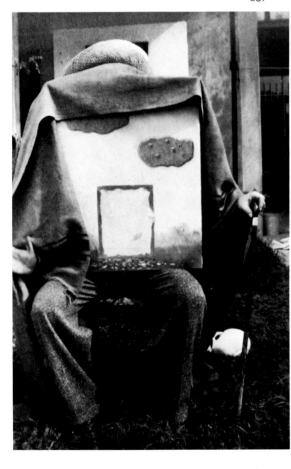

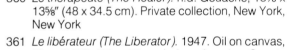

358

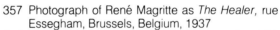

357 Photograph of René Magritte as *The Healer,* rue Essegham, Brussels, Belgium, 1937
358 *Le thérapeute (The Healer).* 1936. Gouache, 18⅛ x 11¾" (46 x 30 cm). Private collection, Brussels, Belgium
359 *Le thérapeute (The Healer).* 1937. Oil on canvas, 36¼ x 25⅝" (92 x 65 cm). Collection Baron Joseph-Berthold Urvater, Paris, France

359

360 *Le thérapeute (The Healer).* n.d. Gouache, 18⅞ x 13⅝" (48 x 34.5 cm). Private collection, New York, New York

361 *Le libérateur (The Liberator).* 1947. Oil on canvas, 39 x 31⅛" (99 x 79 cm). Los Angeles County Museum of Art, Los Angeles, California. Gift of William N. Copley

360

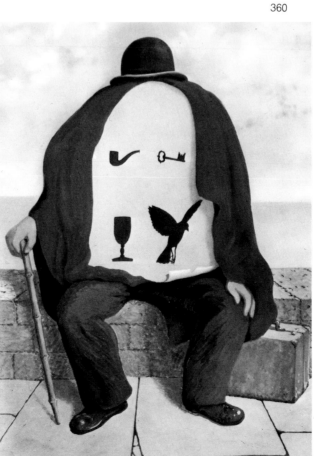

361

Black Magic

I'm searching for a title for the picture of the nude woman (naked torso) in the room with the rock. One idea is that the stone is linked by some "affinity" to the earth, it can't raise itself, we can rely on its generic fidelity to terrestrial attraction. The woman too, if you like. From another point of view, the hard existence of the stone, well-defined, "a hard feeling," and the mental and physical system of a human being are not unconnected.
——Letter from René Magritte to Paul Nougé, January 1948

[Magritte] relates: The story of a short, bearded priest met at the post office, invited to the house, where he sees *La magie noire (Black Magic):* "I never knew women were made differently from men, but recently while administering Extreme Unction and annointing the feet of a dying woman, the sheet slipped off."
——Harry Torczyner, diary entry, Nice, June 2, 1964

362

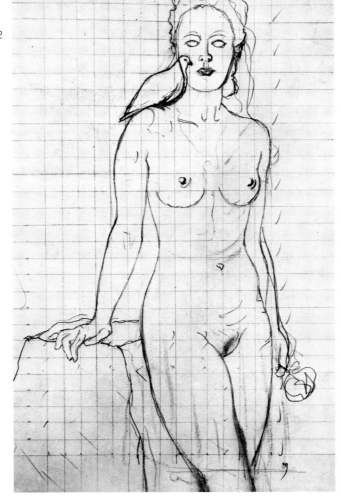

364

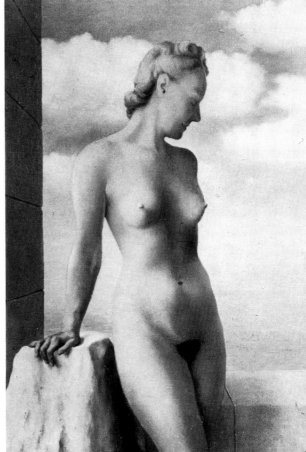

363

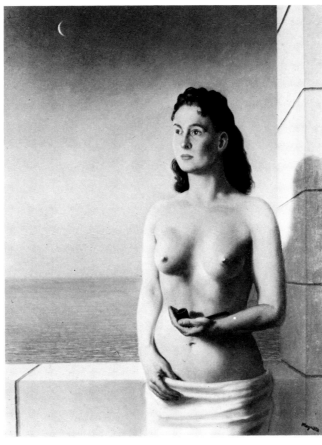

362 Study for *La magie noire (Black Magic).* n.d. Drawing, 18½ x 13″ (47 x 33 cm). Collection Mme. René Magritte, Brussels, Belgium

363 *La liberté de l'esprit (Freedom of Thought).* 1948. Oil on canvas, 38⅛ x 31⅛″ (97 x 79 cm). Musée Communal des Beaux-Arts, Charleroi, Belgium

364 *La magie noire (Black Magic).* 1935. Oil on canvas, 31½ x 23⅝″ (80 x 60 cm). Collection Mme. René Magritte, Brussels, Belgium

365 *La ligne de vie/La femme au fusil (The Lifeline/Woman with Shotgun).* 1930. Oil on canvas, 28⅜ x 20⅝″ (72 x 52.5 cm). Private collection, Osaka, Japan

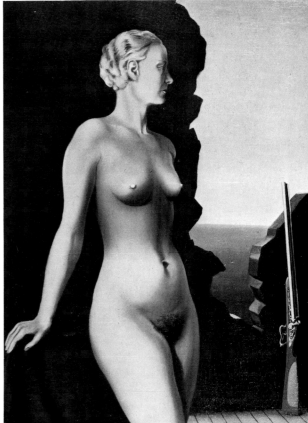

365

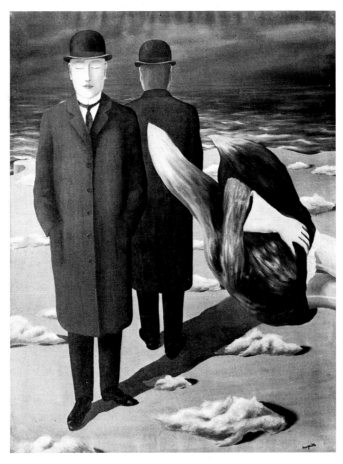

Man and His Shadow

As for the light, I think that if it has the power to make objects visible, its existence is manifest only if the objects receive it. Light is invisible as matter. I think this has been made clear in *La lumière des coïncidences (The Light of Coincidences),* in which some object, a woman's torso, is lighted by a candle flame. Here the lighted object seems to give life to the light.

—*René Magritte, La Ligne de Vie II, February 1940*

366 *Le coeur (The Heart).* 1967. Drawing, 6¾ x 3⅞″ (17 x 10 cm). Collection Evelyn Musher, New York, New York

367 *Au pays de la nuit (In the Land of Night).* 1928. Oil on canvas, 74 x 41⅜″ (168 x 105 cm). Collection William N. Copley, New York, New York

368 *L'imprudent (The Daredevil).* 1927. Oil on canvas, 39⅜ x 28⅞″ (100 x 73.5 cm). Collection Harry G. Sundheim, Jr., Chicago, Illinois

369 *La fin des contemplations (The End of Contemplation).* 1930. Oil on canvas, 31⅛ x 45¼″ (79 x 115 cm). Private collection, Brussels, Belgium

370 *Les pierreries (The Jewels).* 1966. Oil on canvas, 11¾ x 15¾″ (30 x 40 cm). Collection Mme. Suzanne Ochinsky, Brussels, Belgium

371 *La porte ouverte (The Open Door).* 1965. Oil on canvas, 21½ x 26″ (54.5 x 66 cm). Private collection, Belgium

369

370

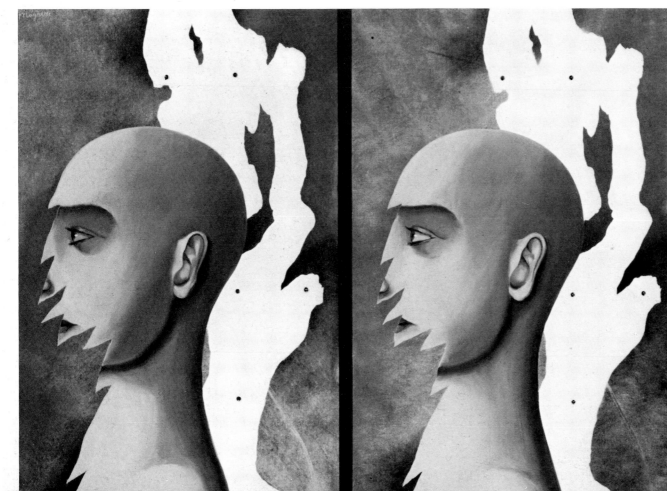

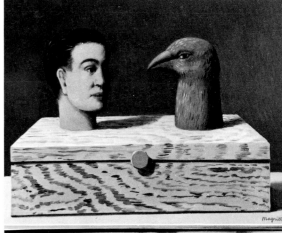

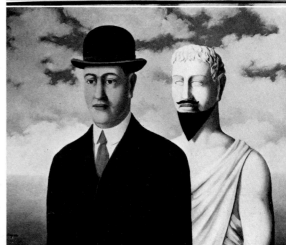

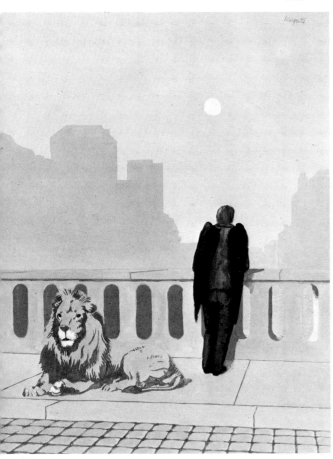

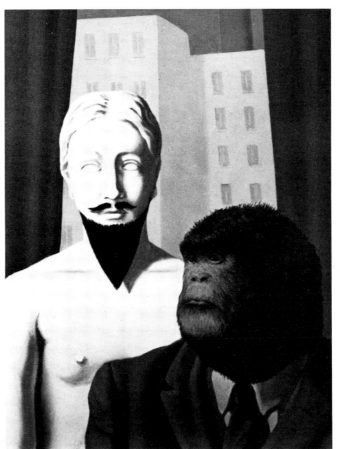

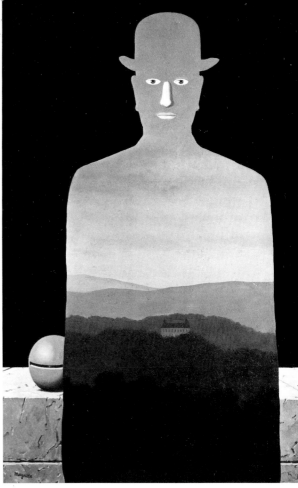

372 *Le mal du pays (Homesickness)*. 1940. Gouache, 17¾ x 13⅜" (45 x 34 cm). The Art Institute of Chicago, Chicago, Illinois

373 *La lampe d'Aladin (Aladdin's Lamp)*. 1955. Oil on canvas, 25⅜ x 19⅞" (64.5 x 50.5 cm). Private collection, New York, New York

374 *Le musée du roi (The King's Museum)*. 1966. Oil on canvas, 51⅛ x 35" (130 x 89 cm). Collection Arturo Alvez Lima, Paris, France

375 *La pensée qui voit (The Thought That Sees)*. 1965. Black lead drawing, 15¾ x 11⅝" (40 x 29.7 cm). The Museum of Modern Art, New York, New York. Gift of Mr. and Mrs. Charles B. Benenson

376 *Décalcomanie (Decalcomania)*. 1966. Oil on canvas, 37⅞ x 39⅜" (81 x 100 cm). Collection Mme. Chaim Perelman, Brussels, Belgium

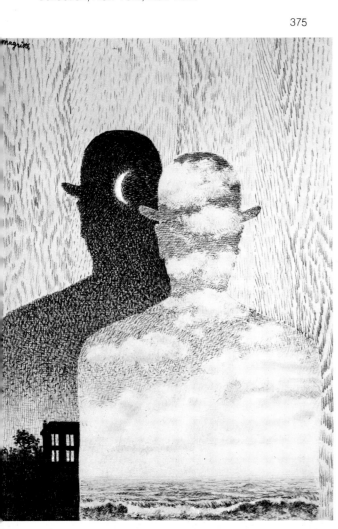

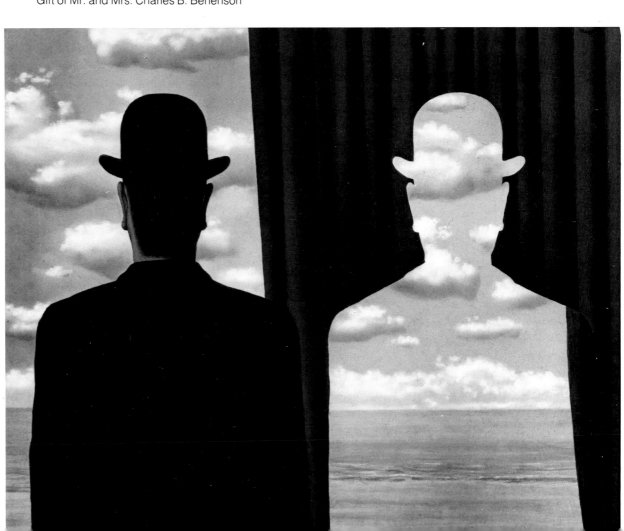

Panic in the Middle Ages

377 *Entracte (Intermission).* 1927–1928. Oil on canvas, 45¼ x 64⅛" (115 x 163 cm). Private collection, Brussels, Belgium

378 *La ruse symétrique (The Symmetrical Trick).* 1927. Oil on canvas, 21¼ x 28¾" (54 x 73 cm). Collection M. and Mme. Marcel Mabille, Rhode-St.-Genèse, Belgium

379 *Une panique au Moyen Age (A Panic in the Middle Ages).* 1927. Oil on canvas, 38⅝ x 29⅛" (98 x 74 cm). Collection M. and Mme. Louis Scutenaire, Brussels, Belgium

380 *Les idées de l'acrobate (The Ideas of the Acrobat).* 1928. Oil on canvas, 45⅝ x 31⅞" (116 x 81 cm). Private collection, Brussels, Belgium

377

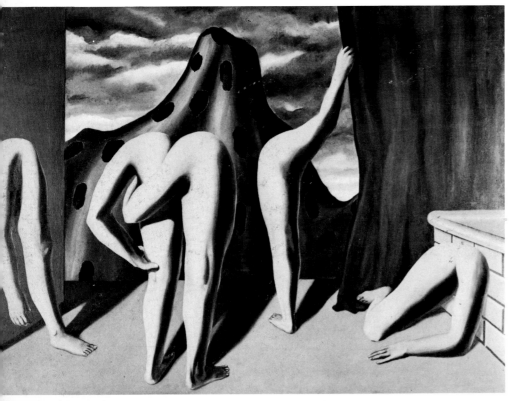

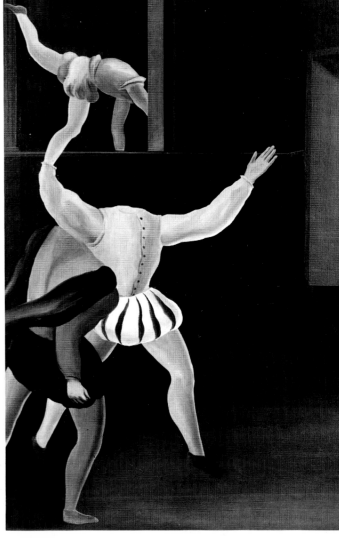

379

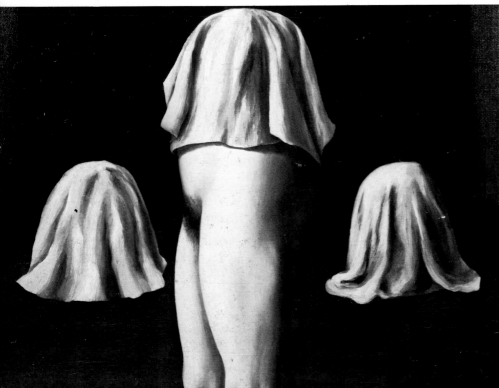

378

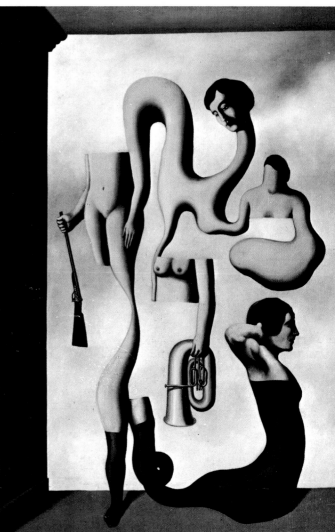

380

The Empire of Lights

For me, the conception of a picture is an idea of one thing or of several things that can become visible through my painting.

It is understood that all ideas are not conceptions for pictures. Obviously, an idea must be sufficiently stimulating for me to undertake to paint faithfully the thing or things I have ideated.

The conception of a picture, that is, the idea, is not visible in the picture: an idea cannot be seen with the eyes.

What is represented in a picture is what is visible to the eyes, it is the thing or things that must have been ideated.

Thus, what is represented in the picture *L'empire des lumières (The Empire of Lights)* are the things I ideated, i.e., a nighttime landscape and a sky such as we see during the day. The landscape evokes night and the sky evokes day.

I find this evocation of night and day is endowed with the power to surprise and enchant us. I call this power: poetry.

If I believe this evocation has such poetic power, it is because, among other reasons, I have always felt the greatest interest in night and in day, yet without ever having preferred one or the other.

This great personal interest in night and day is a feeling of admiration and astonishment.
—*René Magritte, late April 1956*

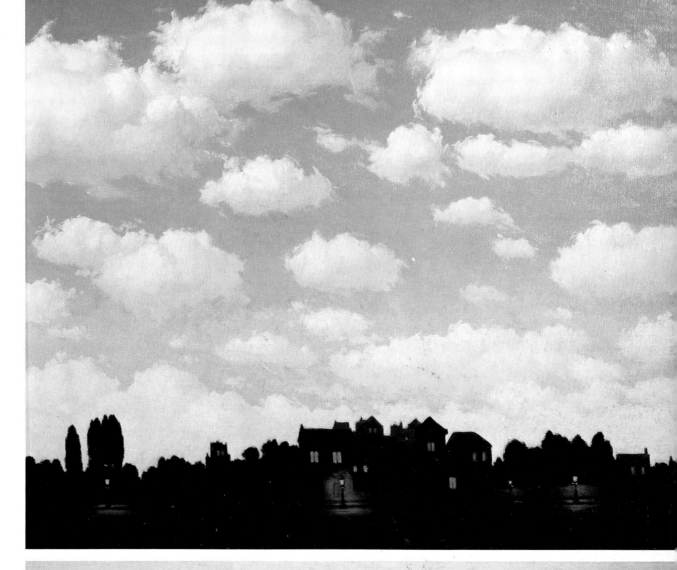

381 *L'empire des lumières (The Empire of Lights)*. 1953. Oil on canvas, 14⅝ x 17¾″ (37 x 45 cm). Collection Arnold Weissberger, New York, New York

382 *L'empire des lumières II (The Empire of Lights II)*. 1950. Oil on canvas, 31⅛ x 39″ (79 x 99 cm). The Museum of Modern Art, New York, New York. Gift of Dominique and John de Menil, 1951

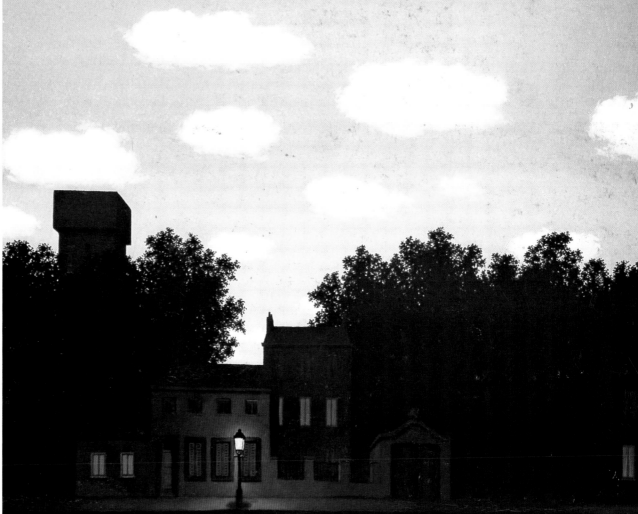

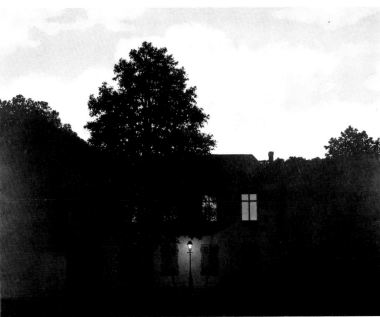

383

383 *L'empire des lumières (The Empire of Lights).*
1961. Oil on canvas, 44⅞ x 57½" (114 x 146 cm).
Private collection, Brussels, Belgium

384 *L'empire des lumières (The Empire of Lights).* n.d.
Oil on canvas. Private collection, Brussels, Belgium

384

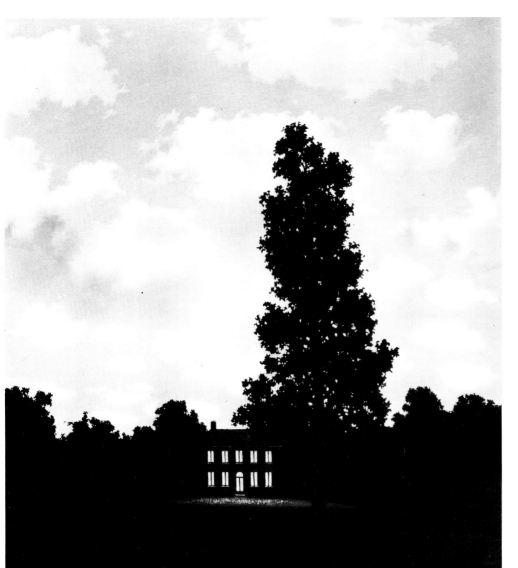

385

I'd like to tell you I've brought off a very difficult picture, but which is probably too difficult to be successful? It involves a painting of a daylit landscape with a nocturnal sky (stars and crescent moon). I've painted and repainted this picture and I'm at the disenchanted stage: it's a total failure! A friend found as title *Le salon de Dieu (God's Drawing Room);* I hesitated a long time in adopting it; a title such as *Le bal masqué (The Masked Ball)* seemed preferable to me for many reasons, the main one being the total ban on saying anything at all about God. But to see it and reproduce it in paint is possible only if one is a God. While waiting to become one, I'm abandoning the project.
——*Letter from René Magritte to Suzi Gablik, undated*

385 *L'empire des lumières III (The Empire of Lights III).* 1951. Oil on canvas, 31 x 26" (78.7 x 66 cm). Collection William Alexander, New York, New York

386 *L'empire des lumières VIII (The Empire of Lights VIII).* 1954. Oil on canvas, 51⅛ x 37¼" (129.9 x 94.6 cm). Private collection, United States

387 *L'empire des lumières (The Empire of Lights).* 1967, unfinished. Oil on canvas, 17¾ x 19⅝" (45 x 50 cm). Collection Mme. René Magritte, Brussels, Belgium

387

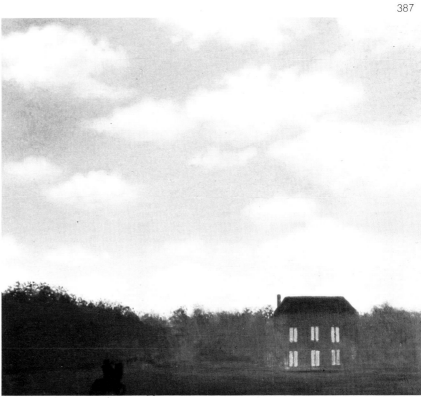

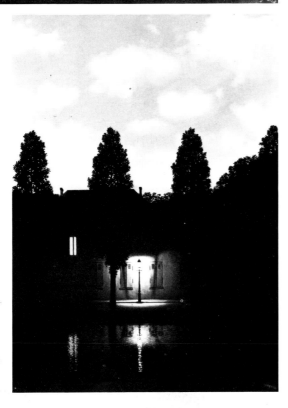

386

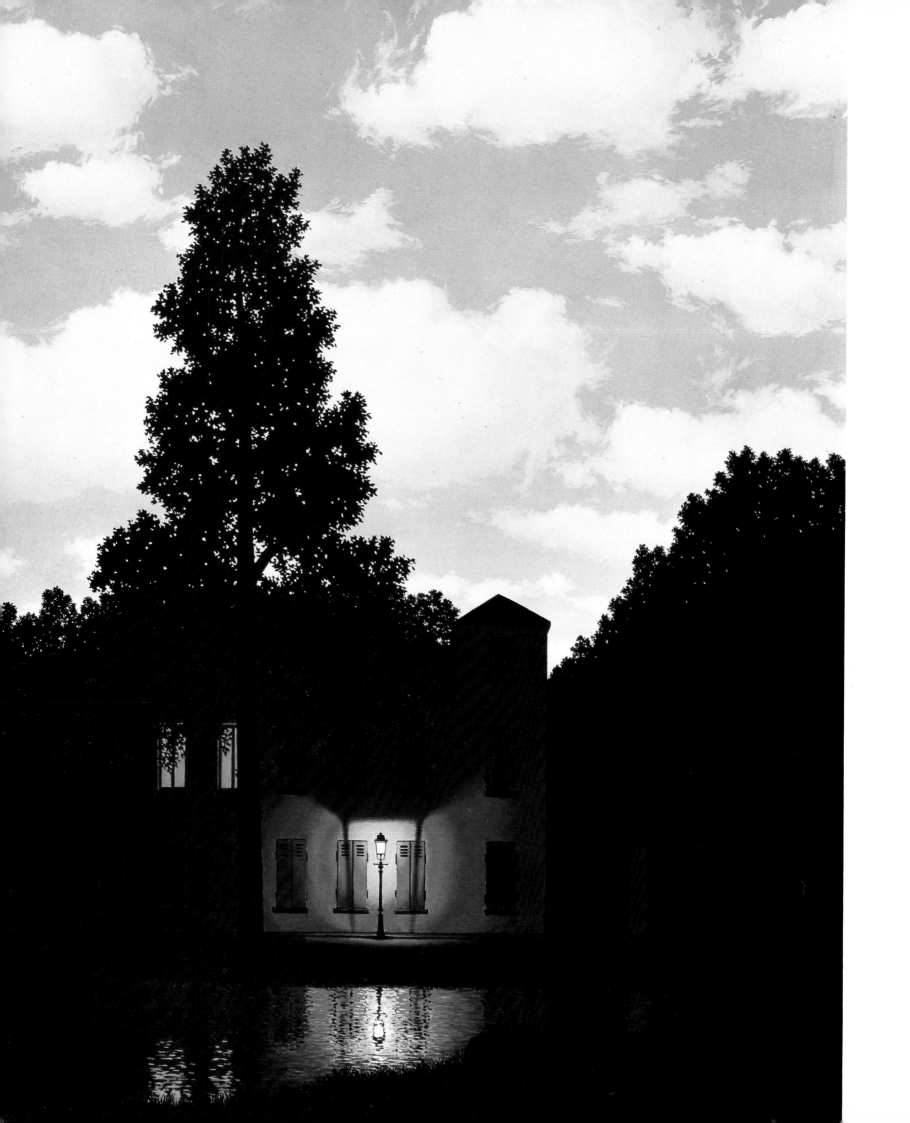

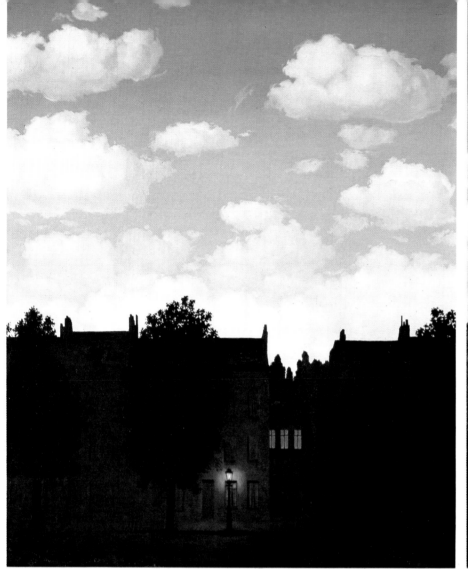

389

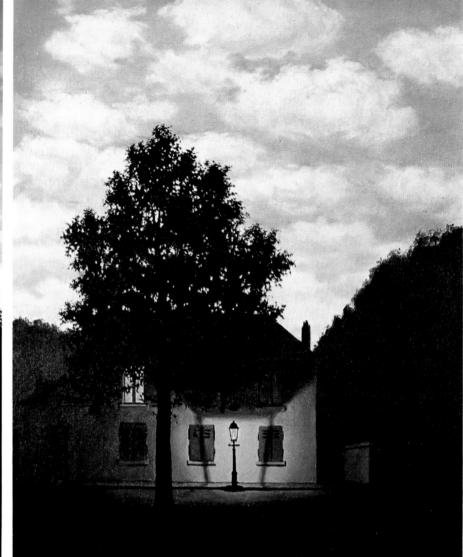

391

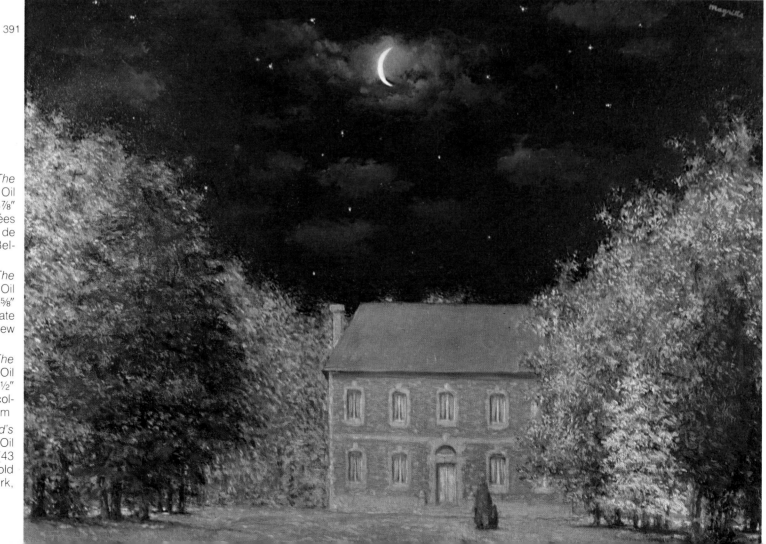

388 *L'empire des lumières (The Empire of Lights)*. 1954. Oil on canvas, 57½ x 44⅞″ (146 x 114 cm). Musées Royaux des Beaux-Arts de Belgique, Brussels, Belgium

389 *L'empire des lumières (The Empire of Lights)*. 1958. Oil on canvas, 19½ x 15⅝″ (49.5 x 39.5 cm). Private collection, New York, New York

390 *L'empire des lumières (The Empire of Lights)*. 1948. Oil on canvas, 39⅜ x 31½″ (100 x 80 cm). Private collection, Brussels, Belgium

391 *Le salon de Dieu (God's Drawing Room)*. 1958. Oil on canvas, 16⅞ x 23¼″ (43 x 59 cm). Collection Arnold Weissberger, New York, New York

Masked and Unmasked

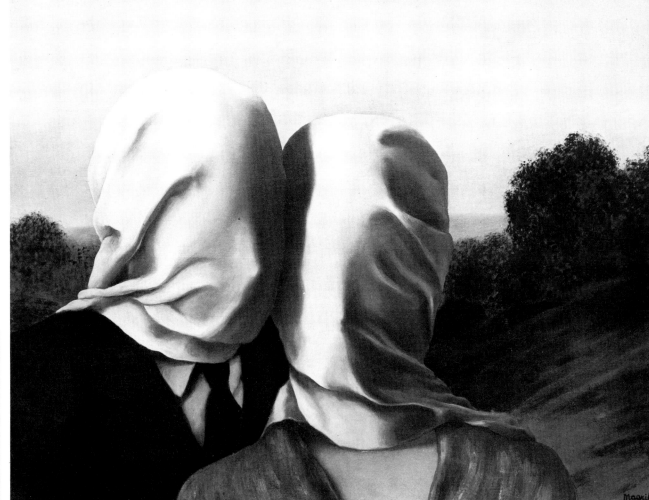

392

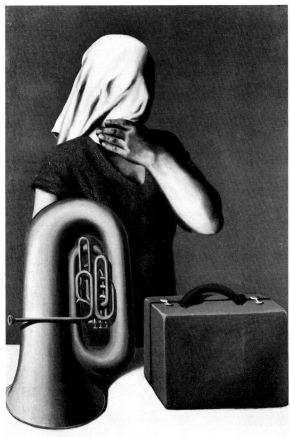

392 *L'histoire centrale (The Heart of
the Matter)*. 1927. Oil on can-
vas, 45⅝ x 31⅞" (116 x 81 cm).
Collection M. and Mme. Marcel
Mabille, Rhode-St.-Genèse,
Belgium

393 *Les amants (The Lovers)*. 1928.
Oil on canvas, 21¼ x 28¾" (54 x
73 cm). Collection Mme. J. Van
Parys, Brussels, Belgium

394 *L'invention de la vie (The Inven-
tion of Life)*. 1926. Oil on can-
vas, 31½ x 47¼" (80 x 120 cm).
Collection M. and Mme. Louis
Scutenaire, Brussels, Belgium

394

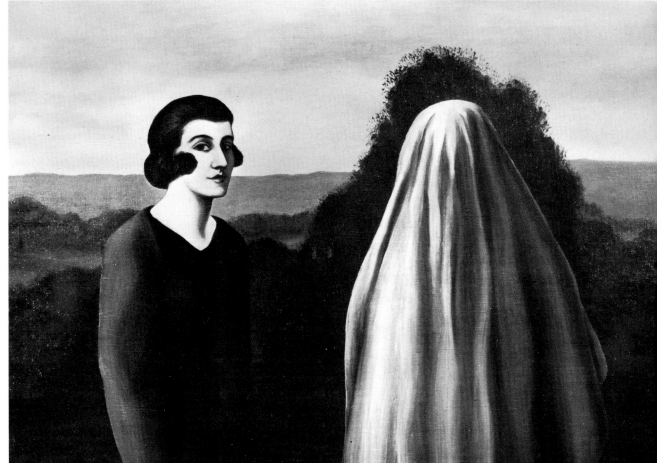

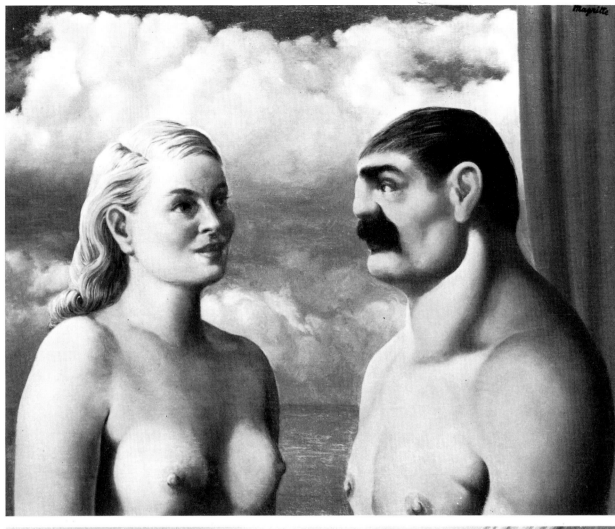

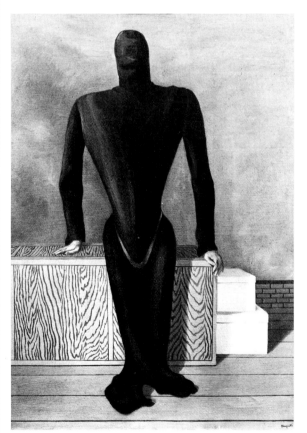

397

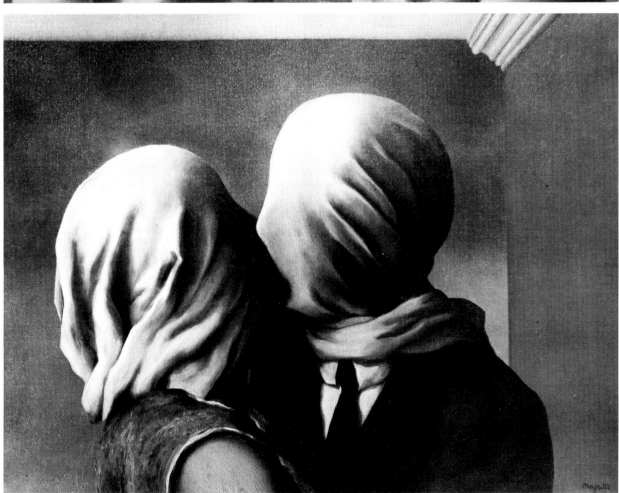

396

183

INTERMISSION

Cubist Period

I'm neither a "Surrealist" nor a "Cubist" nor a "Patawhatever,"* even though I have a fairly strong weakness for the so-called Cubist and Futurist "schools." Were I really an *artiste-peintre,* I would waver between these two disciplines. Were I an innocent intellectual, I would be content with what Surrealism entails in a large, very large part of unimportant matters.
——*Letter from René Magritte to André Bosmans, April 1959*

* Pataphysics ("Patawhatever") is a philosophy invented by Alfred Jarry, which was taken up by the Surrealists and Dadaists.

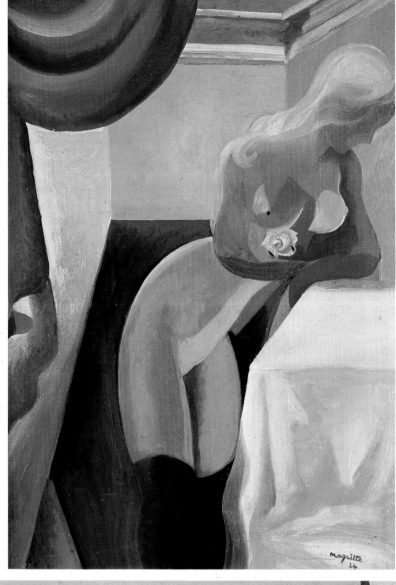

398 *Jeune fille (Young Woman).* 1924. Oil on canvas, 21⅝ x 15¾" (55 x 40 cm). Collection Mme. René Magritte, Brussels, Belgium

399 *La baigneuse (The Bather).* 1923. Oil on canvas, 19⅝ x 39⅜" (50 x 100 cm). Collection M. and Mme. Berger-Hoyez, Brussels, Belgium

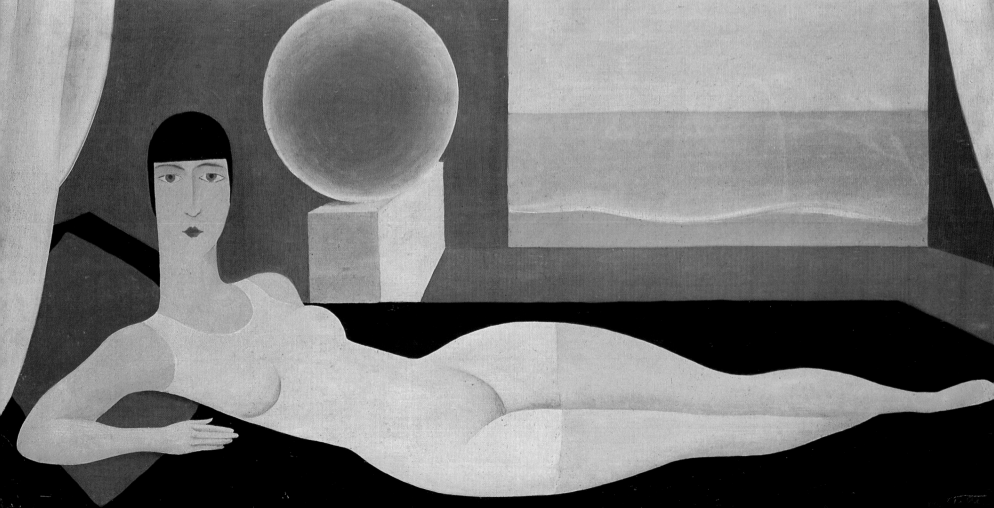

401 *Portrait de Pierre Bourgeois (Portrait of Pierre Bourgeois).* 1920. Oil on canvas, 33⅞ x 21⅝" (86 x 55 cm). Collection Government of Belgium, Brussels, Belgium

400 *Portrait de Pierre Broodcorens (Portrait of Pierre Broodcorens).* 1921. Oil on canvas, 23⅜ x 14¾" (59.5 x 37.5 cm). Musées Royaux des Beaux-Arts de Belgique, Brussels, Belgium

To Pierre Broodcorens, whose strong personality and beautiful art I love.
——*Dedication on the portrait of Broodcorens by René Magritte*

402 *L'éclair (The Lightning Flash)*. 1944. Oil on canvas, 23⅝ x 15¾″ (60 x 40 cm). Collection M. and Mme. Berger-Hoyez, Brussels, Belgium

Renoir Period

For the period I call "Surrealism in full sunlight," I am trying to join together two mutually exclusive things:

1) a feeling of levity, intoxication, happiness, which depends on a certain mood and on an atmosphere that certain Impressionists—or rather, Impressionism in general—have managed to render in painting. Without Impressionism, I do not believe we would know this feeling of real objects perceived through colors and nuances, and free of all classical reminiscences. The public has never liked the Impressionists, although it may seem to; it always sees these pictures with an eye dominated by mental analysis—otherwise, we must agree that freedom runs riot.

and, 2) a feeling of the mysterious existence of objects (which should not depend upon classical or literary reminiscences), which is experienced only by means of a certain clairvoyance.

Some of the paintings of this period have succeeded in uniting these two mutually exclusive things. I gave up—why? It's not too clear— perhaps out of a need for unity?
——*Letter from René Magritte to G. Puel, March 8, 1955*

THE SUN: TOPIC OF DISPUTE

The argument is hard to get into, since it is (one believes) a question of protecting one's own skin. Ever since the scholastic disputes in which partisans ran the risk of being burned alive for ideas or feelings, the stakes have always been the same: each side strives to gain victory for opposing ways of thinking. In the final analysis, there are those who want to uphold an ancient or recent tradition against those who are for change. Both believe they are defending their very existence, or at the very least something that lends color to their existence. With the help of obstinacy and an inferiority complex, the adversaries hold firm to their positions and do not relinquish an inch of ground, even if fatigue causes them to lose sight of the true merits of the principles they are upholding and tempts them to give up.

In 1946, a dispute has arisen concerning the pros and cons of employing, in the painting of "Surrealist" pictures, the Impressionist technique used to represent sunlight without complications.

The objectors invoke the maladroitness that has been demonstrated in the posthumous use of this Impressionist technique; it would seem that the painters of 1900 possessed a secret that is now lost forever.

The objectors also invoke the loss, through the use of this technique, of a certain pictorial atmosphere, characterized both by the ambiguity of the image (a living head that seems to be made of wax, or the reverse) and by the precision of this image (a head, not a foot), which may be achieved through the use of a kind of *trompe l'oeil* treatment of the objects being considered (objects without adventitious lighting, idea-objects of objects). The objectors also defend painting in which the greatest ambiguity is achieved through a vague representation by means of a more or less distorted and summary delineation of the objects, or through a play of lines that, like cracks in a wall, vaguely suggests an image of the object. The pleasure we derive from these paintings *(independent of subject)* is above all in question; it is the pleasure appropriate to these ways of painting (since the subjects are the same in the paintings that are involved with sunlight). These ways of painting being based on ambiguity, the pleasure is likewise ambiguous. It is the imprecision of oneiric figures or nocturnal visual errors. It is the feeling of delicious discomfort when faced with figures that could be either alive or made of wax. It is the taste for vague cruelties that gives us the shivers, of platonic threats that produce an agreeable trembling. It is a kind of well-known and completely worn-out spell....

The desire to replace these deceptive pictorial atmospheres (because if the images are precise, in formal terms, the more precise they are, *the more perfect the trompe l'oeil, THE GREATER THE DECEPTION,* the more successful the visual error), with an "Impressionist" atmosphere—by which is meant neither trompe l'oeil nor its opposite, the nonfigurative image, but the equivalent of the colors of one's vision (which does not capture and does not pretend to capture the "object"), deliberately subjective, accidental, and not lending itself to any ambiguity. The pleasure we derive from [this Impressionist atmosphere] is complex: it is as natural as physical pleasures; it is refined, because to be able to appreciate it *we must admit that our seeing stops between the object viewed and ourselves,* which is far from easy, and we

must renounce the stereotyped images of objects with which indifference or spiritual laziness is content. It's not a good idea to represent objects according to the mental level of the man in the street; trompe l'oeil images risk provoking such profound admiration for the "skill" of the artist who has succeeded in creating an "illusion of reality," that this feeling pervades the ordinary spectator's entire consciousness, and sometimes, if he reflects a little with some skepticism, he may even believe that the sea can only be represented in watercolors and will refuse to be "duped" by an artist who would have him believe that a seascape was painted in oils. Most of the time it is "ideas" like these that "disturb" the man in the street, who knows little about painting. Morally, this subjective attitude does not hold the question of exterior reality to be knowable, but wants to act upon it. It is an honest admission that this problem does not exist for us, and thus imbues this notion of "exterior" with an affective content more tragic than that of any other more or less formulated concept of "exterior reality."

This refusal to consider the problem of the reality existing outside of consciousness is tragic, because it reveals to us the extent of our limitations and isolates us by increasing our perception of the unknown.

This Impressionist atmosphere can represent night as well as a sunlit landscape, but then it is always a question of a physical night or daylight: the variable physical impression of a night or a light, and not a fixed and abstract sensation of night or daylight.

The nights and the lights we know are variable and ought not be abandoned *for a fixed sensation of night or light that is fraudulent,* because once this feeling has reached a certain intensity, it is deemed to be an *exceptional knowledge* of true night or true daylight *per se* and creates a false feeling of danger owing to the unusual nature of the "revelation." The true danger, if danger there be, is on the contrary totally unknown.

Comparing the arguments on both sides, two attitudes emerge:

On one side, it boils down to the belief that the real world external to thought is a "domestic" unknown that can be evoked with the aid of old or new formulas.

On the other, that the unknown remains the unknown, because flashes of consciousness are not regarded as escapes from the mental universe, but rather as a vision of our mental prison, which we must transform.

On one side, a world of fake ambassadors from a fake unknown who are sometimes accredited to the mental universe.

On the other, the mental universe, at its "known" but extendable limits, touches the au-

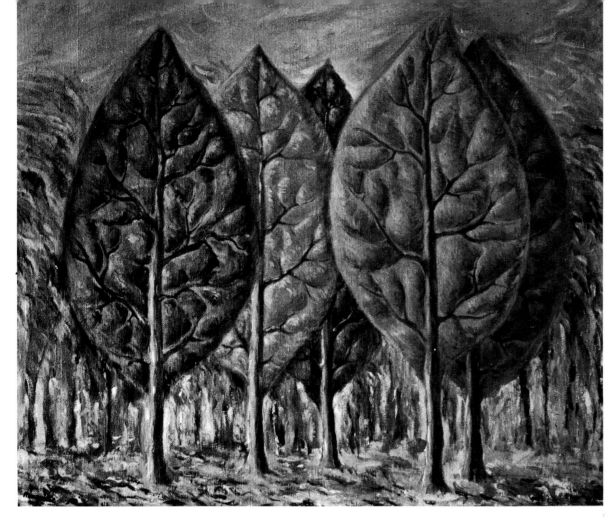

403 *L'incendie (The Fire)*. 1943. Oil on canvas, 21¼ x 25⅝" (54 x 65 cm).
Collection Mme. René Magritte, Brussels, Belgium

thentic unknown, which seems even more re-
doubtable compared to such a violently illumi-
nated mental universe, from which every shadow
has been removed. . . .

Our mental universe (which contains all we
know, feel, or fear about the real world in which
we live) can be charming, happy, tragic, comic,
etc. . . .

We have the capacity to transform it and to give
it a charm that adds to the value of life. More value
because life becomes joyful through the extraor-
dinary effort necessary to give this charm.

In transforming life in the direction of terror, life
is lost through the easiness that creates this terror.
This is very easy, for mental sloth tends to make us
believe that the feeble powers of terror create a
feeling of "truth," that this terror is the recognition
of the "extramental" world. We also take the easy
way, which offers a terrorist and mediocre expla-
nation of the universe.

Creating a spell is an energetic means of com-
bating this mediocre and depressing attitude. To
be effective, this spell must cast out all misun-
derstanding (more or less vulgar trompe l'oeil, the
ambiguity of nonfigurative representations). The
elements we have to work with in painting are
those of a sentimental representation of objects,
feeling being equated with subjective truth: visual
subjects (trees, skies, etc.), imaginary subjects
(fairies, phantoms, sirens, etc.), natural light ef-
fects (suns, dawns, twilights, nights, *chiaro-
scuro),* physical light, best reproduced by the
Impressionist technique (different from diffused

academic lighting). With these elements com-
bined in a particular way, it is possible to under-
take to create the spell we need.

When one sets out to create this spell, it is so
much more amusing, because one takes risks—
there are all kinds of risks (whereas to follow the
comfortable route of "disturbing poetry" is to ar-
rive at an unknown that is relaxing and has a solid
reputation).

Let us conquer this charm, with the revelation of
the unknown facet of each object, presented with
unambiguous pleasure and which in 1946 pre-
vents misunderstandings, "defend" this charm
from all improper contacts, and keep it out of the
hands of imposters. . . .

Sample picture: *Le paysage isolé (The Lonely
Landscape)* of 1928 shows a neutral landscape;
at that time one had to emphasize this neutrality
and the provocative meaning of this manner of
painting, so that the intention, the execution,
could be protected from artistic interpretation.

In 1946, the new *Le paysage isolé,* in full sun-
light (which would have been bad in 1928), is an
application of our principle, and with its bright
colors this brilliant landscape enables us better to
feel the "night" surrounding it, which one does not
see.

As in 1928, our severity was our bodyguard.
—*René Magritte, La Querelle du Soleil, 1946*

Dear Friend,

Today I am sending you a small painting, *La
liberté des cultes (The Freedom of Cults).* I hope
you will accept it and write me about it. The paint-
ing of my "solar" period is obviously counter to
many of the things we espoused before 1940. I
believe that is the main reason for the resistance it
is provoking. Yet I believe we no longer exist to
prophesy (always in a disagreeable way, it must
be said); at the international Surrealist exhibition
in Paris, one had to make one's way around with a
flashlight. We experienced this during the Occu-
pation, and it wasn't funny. The disarray, the panic
that Surrealism tried to create so as to call every-
thing into question again, the Nazi cretins
achieved that much better than we did, and there
was no getting around it. I painted a picture, *Le
drapeau noir (The Black Flag),* which gave a
foretaste of the terror of flying machines, and I'm
not proud of it. That and the need for change,
which is not necessarily the same as "progress,"
seem to me to justify this "eruption" of a new
atmosphere in my paintings and the desire actu-
ally to experience it in life. In the face of wide-
spread pessimism, I propose the search for joy,
for pleasure. This joy and pleasure, which are so
commonplace and yet so out of reach, seem to
me to be up to us alone; we who know something
about *how feelings are invented* [should perhaps]
make these things more accessible? We need not
give up the science of objects and feelings that
Surrealism gave birth to, but rather use it for dif-
ferent purposes, or else we will be as bored stiff in
the Surrealist museums as we are in the others.

Your objection to my new painting is, among
others, that you do not experience the physical
sensation of pleasure I am trying to make it create.
In any event, let there be no mistake: that is what I
am trying to create, and if I don't succeed, one
can't maintain with a straight face that Matta,
Ernst, Brauner, etc., do achieve their goals; we
also know very well what they want—too well, as
far as I am concerned.

As for the reproach of imitating Renoir, there is
some misunderstanding: I have done pictures
"after" Renoir, Ingres, Rubens, etc., but without
using Renoir's particular technique, but rather
that of Impressionism, including Renoir, Seurat,
and others. In this regard, some of my recent
pictures, according to the subject, have required
me to use my former technique (smooth, polished
painting), but with lighter colors, severity being
banished. SEVERITY IS FARTHER AWAY, less
measurable.

As you know, I'm having a show in Paris in
October. Would you do the catalogue preface?
Even if you refuse to let yourself be seduced by
these sunny images, wouldn't you like to point out
what is involved, without taking sides, and give
these images some chance to shine?

I await your news on this matter. I was very
happy to see you and I count on our seeing each
other often.

Until very soon, dear friend, and please believe
my sincere feelings of friendship and trust.
P.S. Don't forget Good Manners!
—*Letter from René Magritte (Jette-Bruxelles) to André Breton, June
24, 1946*

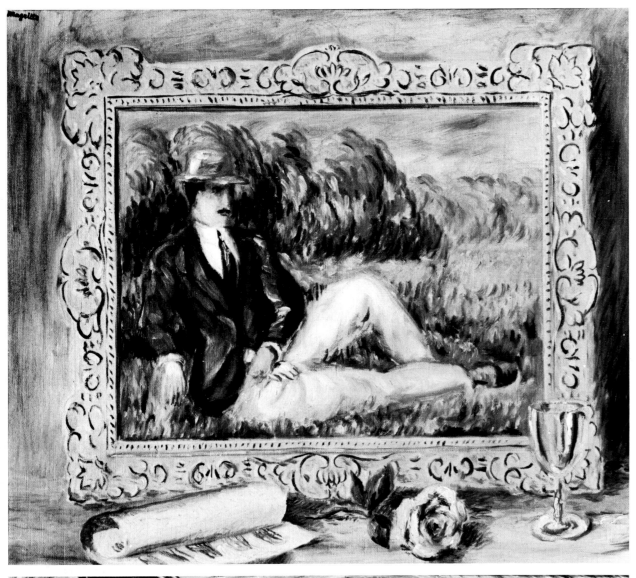

404 *Les adieux (The Farewell)*. 1943. Oil on canvas, 19⅝ x 23⅝" (50 x 60 cm). Private collection, Brussels, Belgium

A few additional lines, thrown out at random:

Surrealism must no longer be a bridge between two wars. Fixed forms (like those of magic, by the way) must be rejected so that minor detail doesn't end up becoming a means of crystallization.

The moment has come for quitting this easy road, which Surrealism has taken twenty years to open up for the many adherents who are innocently following it, like those dust-covered archaeologists who "love" some academic Egypt, but who wouldn't spend a second of their lives in the real ancient Egypt. These "Surrealists" are like those filthy creatures who "run" the world. They only imagine taking it over by second-rate means, such as terror. And the uneasiness thus obtained is only one more phony mystery to be overturned.

These are two contradictory elements to reconcile: Surrealist poetry and sunlight (the real vacation sun that one dreads inviting to the nocturnal celebrations of artistic endeavor and that scares off ghosts, this sun that draws you to Finistère rather than to Duchamp's studio).

Provoking the "grave crisis of conscience" by means of charm (freshness, joy, the lights of sunlit poetry) leaves behind the "disturbing" illuminations that are so picturesque and pleasing to third-raters. Both charm and menace can be heightened by being united. Sources are fairy stories, *Alice,* and, even nearer at hand, the film *Peter Ibbetson.* A new feeling able to confront the fiery light of the sun makes possible, within our own lifetime, this golden age that I refuse to place in some abstract future.

I turn over to the good of the socialist idea, whenever possible, that part of myself that can be of use.

It seems to me that if you accept my arguments, you *must* recognize the experimentation they involve as something that upon occasion you may undertake to defend against your enemies, who are mine as well, even if you aren't enthusiastic about it.

There is nothing to learn. There are things to know, in order to use them. Will we end up agreeing on this matter?

——*Letter from René Magritte to André Breton, August 11, 1946*

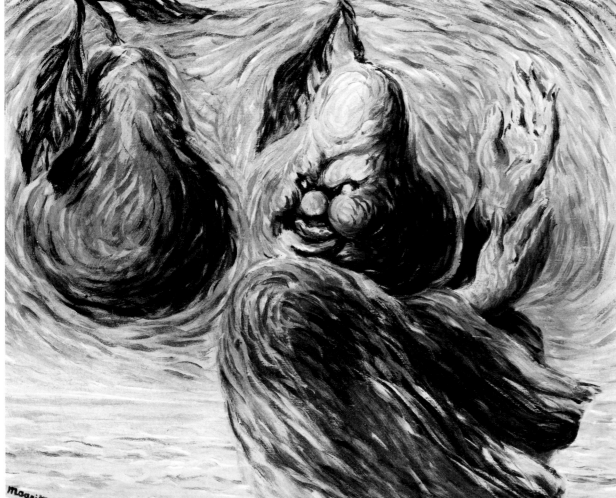

405 *Le lyrisme (Lyricism)*. 1947. Oil on canvas, 19⅝ x 25⅝" (50 x 65 cm). Collection M. and Mme. Louis Scutenaire, Brussels, Belgium

407

406 *Le premier jour (The First Day)*. 1943. Oil on canvas, 23⅝ x 21⅝" (60 x 55 cm). Collection Dr. Jean Robert, Brussels, Belgium

407 *La moisson (The Harvest)*. 1944. Oil on canvas, 23⅝ x 31½" (60 x 80 cm). Collection M. and Mme. Louis Scutenaire, Brussels, Belgium

408 *Les heureux présages (The Good Omens)*. 1944. Oil on canvas, 23⅝ x 15¾" (60 x 40 cm). Collection M. and Mme. Berger-Hoyez, Brussels, Belgium

408

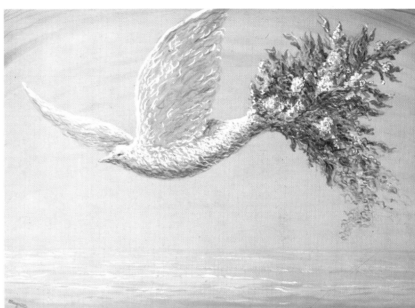

My dear friend,

It might be amusing for us to write each other tit for tat. You write me: "The sun is not in you," and I would answer: of course, I mean the "extramental" sun, and so on. However, I believe you would tire of this game as quickly as I. You know, for some time now I have had the depressing feeling that the life is leaking out through the cracks of "crystallized Surrealism" and that energetic steps are called for. The means seemed to me to be this rather confusing lighting that is new to us, for refurbishing and rejuvenating a mental universe that at present is inadequate. This lighting, which we are provisionally calling "solar," is to my mind the appeal of the extramental world, the real, outside world in which we live. Comparing this with the intentions of Chirico, there is a resemblance where Chirico was trying to escape from an epoch that was ended and none at all where Chirico called upon the outmoded joys of Italian painting, going back to school instead of playing hooky.*

Not just anything can be brought face to face with our existence and constitute a valid proof of it (Italian art, military art, or existentialism, for example, are not contradictory terms to make us hope for a higher synthesis).

I am planning to redo such a painting as *Le paysage isolé* (where in a *neutral* landscape one sees a person from the back, looking at the landscape and saying: "I see nothing around the landscape"). I would like to give the person and the landscape the hardness and perhaps the se-

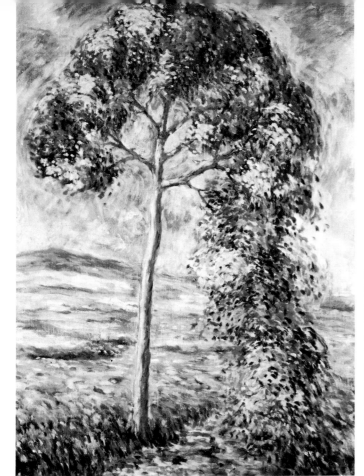

409 410

cret of existence by flooding them with light. (In passing, I note that I'm abandoning without regret one of these "fine ideas" that would be to obscure the person in this brilliant landscape.) The darkness of the night *one does not see* around the landscape is the darkness *we cannot conceive, that exists outside our mental universe.*

The colors of the picture will be the most cheerful I can possibly obtain. I will do my best to employ the technique perfected by the worthy Impressionists and which is perfectly suited to this end.

Do you find all this spurious? I hope I will soon be able to send you a reproduction of this picture, which I think will be a kind of *coup de grâce* for our phantoms. In friendship. . . .
——*Letter from René Magritte to André Breton, August 20, 1946*

*Title of a picture by René Magritte.

. . . pictures of "Surrealism in full sunlight." Pictures we say—to laugh and to stop laughing—are from my "Black Period," given the futility of having shown them to the public up to now.
——*Letter from René Magritte to Mirabelle Dors and Maurice Rapin, March 30, 1956*

I recall this picture that I painted about 1938–1940, when I was trying to bring together two doubtless incompatible things: the charm of the Impressionist vision and the severe charm of an extrapictorial thought. . . .

The idea for this picture may perhaps deserve to be repeated and described if for no other reason than to achieve the greatest possible precision.
——*Letter from René Magritte to Harry Torczyner, February 17, 1961*

409 *La vague (The Wave).* n.d. Oil on canvas, 21 x 19½″ (53.5 x 45.5 cm). Private collection, New York, New York

410 *L'océan (The Ocean).* n.d. Drawing, 13¾ x 19⅝″ (35 x 50 cm). Collection Mme. René Magritte, Brussels, Belgium

411 *Alice au pays des merveilles (Alice in Wonderland).* 1946. Oil on canvas, 44½ x 57¼″ (113 x 145.5 cm). Private collection, United States

Fauvist Period

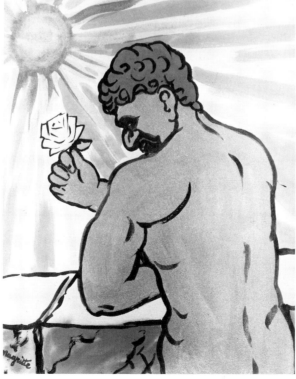

414

CATALOGUE OF WORKS EXHIBITED
Galerie d'Art du Faubourg, Paris, May 7–29

OILS

1. *La vie des insectes (The Life of the Insects)*
2. *Le galet (The Pebble)*
3. *Le montagnard (The Mountaineer)*
4. *Le contenu pictural (Pictorial Content)*
5. *L'étoupillon (The Touchpan)*
6. *L'ellipse (Ellipse)*
7. *Le mal de mer (Seasickness)*
8. *La part du feu (Take the Bad with the Good)*
9. *Le suspect (The Suspect)*
10. *Le psychologue (The Psychologist)*
11. *La marche triomphale (Triumphal March)*
12. *L'étape (The Stopover)*
13. *Jean-Marie*
14. *Les voies et les moyens (Ways and Means)*
15. *La famine (Famine)*

GOUACHES

16. *Flûte! (Basta!)*
17. *Le crime du pape (The Pope's Crime)*
18. *Lola de Valence*
19. *L'arc-en-ciel (The Rainbow)*
20. *Pom' po pom' po pon po pon pon
 (Tra-la tra-la la la la)*
21. *La nuit d'amour (Night of Love)*
22. *La magie noire (Black Magic)*
23. *Les profondeurs du plaisir
 (The Depths of Pleasure)*
24. *Le prince charmant (Prince Charming)*
25. *Les démangeaisons (Itchings)*

416

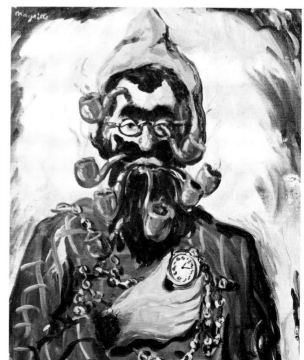

412

412 Letter from René Magritte to Louis
 Scutenaire and Irène Hamoir, 1948. *See
 Appendix for translation*
413 Untitled drawing. n.d. Collection M. and
 Mme. Louis Scutenaire, Brussels, Belgium
414 *Le suspect (The Suspect)*. 1948. Oil on can-
 vas, 25⅜ x 20⅞" (64.5 x 53 cm). Private
 collection, United States
415 *Le psychologue (The Psychologist)*. 1948.
 Gouache, 18⅞ x 12⅜" (48 x 31.5 cm). Col-
 lection M. and Mme. Louis Scutenaire,
 Brussels, Belgium
416 *L'estropiat (The Halt)*. 1947. Oil on canvas,
 19⅝ x 23⅝" (50 x 60 cm). Galerie Isy
 Brachot, Brussels, Belgium

415

417 *Lola de Valence.* 1948. Oil on canvas, 39⅜ x
23⅝″ (100 x 60 cm). Collection M. and Mme.
Louis Scutenaire, Brussels, Belgium

418 *Le prince charmant (Prince Charming).* 1948.
Gouache, 17¾ x 12⅝″ (45 x 32 cm). Collection
M. and Mme. Louis Scutenaire, Brussels, Bel-
gium

419 *Le galet (The Pebble).* 1948. Oil on canvas,
39⅜ x 31½″ (100 x 80 cm). Collection Mme.
René Magritte, Brussels, Belgium

417

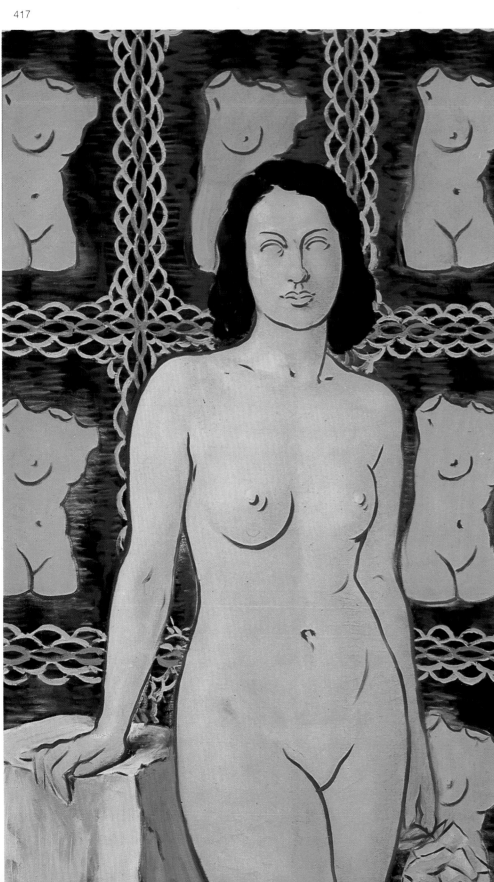

418

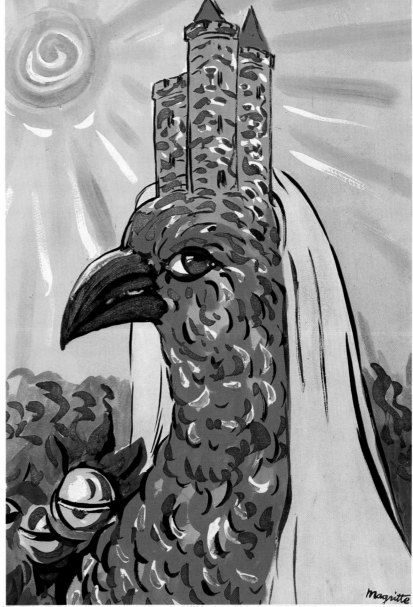

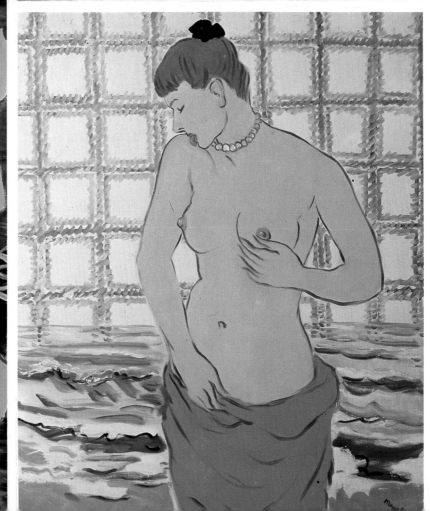

Dear Compatriots,

I receive your card in a foreign town just as I'm beginning this letter. Here is the news in bulk: exhibition opening with visitors, including some Belgians—Lambrix, who doesn't like the preface because, he says, it lacks thought; Servranckx, dripping wet because it began to rain buckets; Wergifosse, who's helping me. Many visitors from Paris and America. Hugnet, whom I mistake for Brumier, and whom I ask for news of Mesens, to his great astonishment and irritation. Jean-Marie, to whom I give a sonorous and final "Bonjour, Mossieu." A young American who is the living image of the "Psychologist" and who has seen gangsters in New York, both dead and alive. This psychologist is in television and is going to film my exhibition on Friday for an American television company. A Swiss woman, wife of the gallery owner, also does television; I told her I'd like very much to perform with her, and that's the truth. For owing to the ambience and its psychological or Freudian influence, I am having quite decent and regular erections here. It would be interesting to see if this continues as one gets used to living here? I also saw Roux, whom I'm always confusing with Brun. We spoke about you all and about little else, not being great conversationalists. Then, after the opening, Labisse had arranged a cocktail party for about thirty people, the best known among them being Queneau, J.-L. Barrault, and P. Brasseur. There were also some of the Comédie Française people (there is some good ass in the Comédie Française, which is nice). As was to be expected, the sorry workings of the human mind were exhibited as usual: Barrault, who was talking to me, was eclipsed by Brasseur, who immediately had to take center stage. I soon began to *tutoyer* him like a little boy, and abetted by the cocktail fumes, I said to his wife: "I'll just chuck a little more whisky into your brew."

Labisse owns a mill at Zoute where it's possible to go for vacations. Here he has a studio with his wife, who is a sort of bean pole with blond hair. His apartment is over the studio and the bathroom is over the toilet. There are lots of images and cards and crime serials in color, and mannequins like in big department stores.

In short, it doesn't thrill you. I like the idea of distributing strongboxes, commodes, coffins, etc. . . . I hope for more news from you soon, since it's a great spiritual comfort to me.

I'm sending a catalog to Wolf.
Friendly greetings.

Mag.

P.S. Mariën asked me to write him, but right now I have a hangover and I'd rather you gave him the news on my behalf. Thank you in advance, and in this way you'll have the benefit of a fruitful contact with Mariën.
—*Letter from René Magritte (St. Mandé, Seine) to Irène Hamoir and Louis Scutenaire, May 12, 1948*

This is probably my last holographic ejaculation for you from Paris. Taking stock, we come to the result zero, as our friends warned us. (Zero if the results are indeed measurable.) Spiritually, however, I have made a few acquisitions: for example, I think (provisionally) that what distinguishes us from the genial way of thinking (in spite of ourselves, since it would be out of the question to want to distinguish oneself at any price) is for example our total lack of belief in substance and in form. Those who are very active here seem to cling to form, the only bone they have left to gnaw on. Thus this shit Baron Mollet, who honeyed up to me and now tells everyone that *Les pieds dans le plat (The Faux Pas)* wasn't suitable for Paris (true, it doesn't suit, but not in the way this cretin thinks). The basics: feelings are "basically" totally boring, except when they are experienced in daily life (outside literature).

The whole thing makes me think that my "business" of making pictures boils down to mere fabrication, like making old furniture, for example. Surrounding this enterprise are other forms of craftsmanship, such as writing, theater, etc. . . . that is what makes up the art world—but its substance and form don't interest me.

There are some visitors to the exhibition (the young girls have a tendency to laugh, but they restrain themselves since it's unbecoming in art galleries), visitors who make the usual asshole remarks: "It's less profound than it was," it's "Belgian wit," you can feel it's not "Parisian," "What brush work!," "What a lovely torso" (for the "psychologist"), etc. . . . There's a review in *Arts,* which you can buy for yourselves in Brussels. I'm incapable of buying the issue and sending it to you. I feel nauseated just thinking of it. As for sales, that too is Zero up until now; perhaps it will change, nothing is permanently decided. Also, for pleasure, we go for walks in the Bois de Vincennes, which is near to our quarters so we can avoid trips and noises. Another source of pleasure is that there are some good charcuteries here. I'm expecting a visit from Iolas in a day or two. Even if he doesn't come or is late, I'm taking off on Thursday. If you'd like, we could see each other Friday at my place, as usual.
—*Letter from René Magritte to Irène Hamoir and Louis Scutenaire, May 17, 1958*

420 *Le montagnard (The Mountaineer).* 1947. Oil on canvas, 29⅛ x 19⅝" (74 x 50 cm). Private collection, Brussels, Belgium

PORTRAIT GALLERY

It can happen that a portrait tries to resemble its model. However, one can hope that this model will try to resemble its portrait.
—*René Magritte, quoted by Louis Scutenaire*, Magritte, *1943*

421 *Anne Judith*. 1952. Oil on canvas, 18⅛ x 14⅛″ (46 x 38 cm). Collection Van Loock, Brussels, Belgium
422 *Alex Salkin*. 1945. Oil on canvas, 19⅞ x 15⅜″ (50.5 x 39 cm). Brook Street Gallery Ltd., London, England

423 *Marnix Gijsen*. 1960. Gouache, 7⅛ x 10″ (18 x 25.5 cm). Collection Baroness Jan Albert Goris, Brussels, Belgium
424 *Madeleine*. 1960. Gouache, 7⅛ x 10″ (18 x 25.5 cm). Collection Baroness Jan Albert Goris, Brussels, Belgium

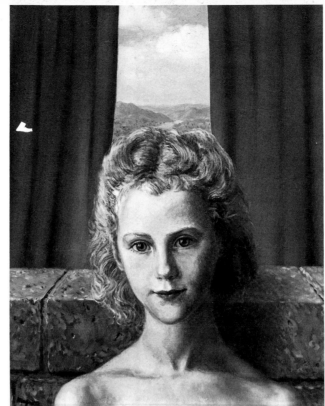

421

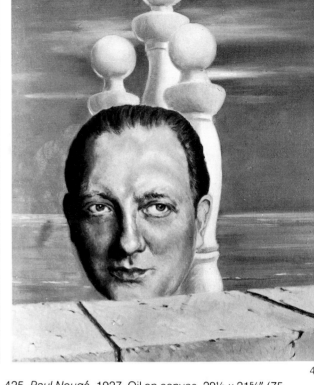

4

425 *Paul Nougé*. 1927. Oil on canvas, 29½ x 21⅝″ (75 x 55 cm). Collection M. and Mme. Louis Scutenaire, Brussels, Belgium
426 *Irène Hamoir*. 1936. Oil on canvas, 23⅝ x 31½″ (60 x 80 cm). Collection M. and Mme. Louis Scutenaire, Brussels, Belgium
427 *Suzanne Spaak*. 1933. Oil on canvas, 23¾ x 31⅞″ (60.3 x 81 cm). Private collection, Paris, France

423

4

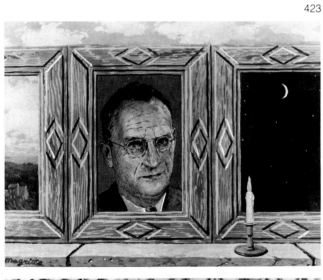

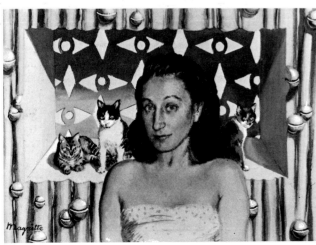

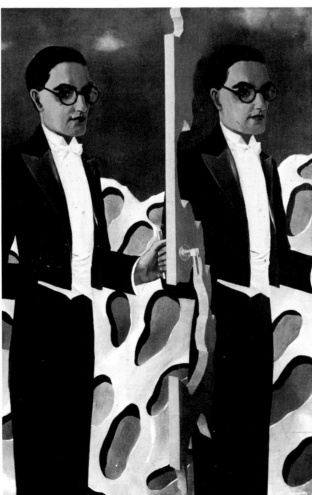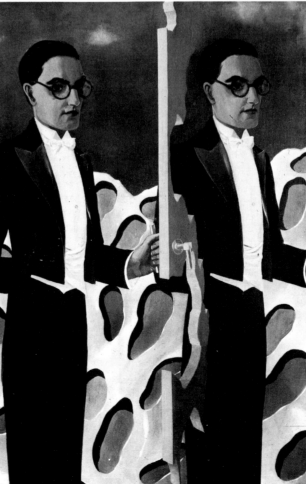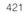

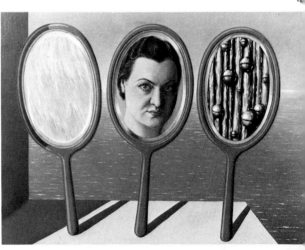

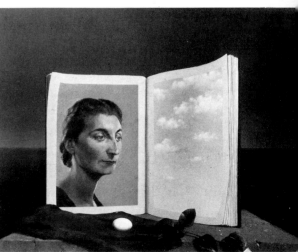

424

425

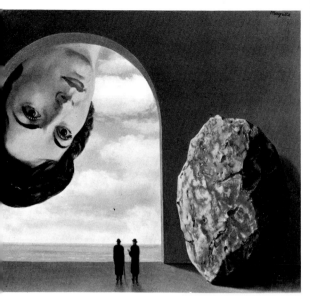

428

429

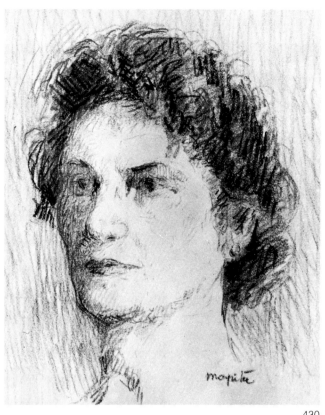

430

428 *Stephie Langui.* 1961. Oil on canvas, 19⅝ x 23⅝″ (50 x 60 cm). Collection Mme. Émile Langui, Brussels, Belgium

429 *Georgette.* 1945. Oil on canvas, 21⅝ x 17¾″ (55 x 45 cm). Collection M. and Mme. Berger-Hoyez, Brussels, Belgium

430 *Leontine.* 1964. Red chalk, 11¼ x 9½″ (28.5 x 24 cm). Collection M. and Mme. Berger-Hoyez, Brussels, Belgium

431 *Portrait.* 1962. Oil on canvas, 9⅝ x 5⅞″ (24.5 x 15 cm). Collection M. and Mme. Louis Scutenaire, Brussels, Belgium

432 *Portrait (M. Merlot).* 1961. Oil on canvas, 49¼ x 33½″ (125 x 85 cm). Collection Merlot, Brussels, Belgium

433 *Germaine Nellens.* 1962. Gouache, 14⅛ x 9½″ (36 x 24 cm). Collection Nellens, Knokke-Le Zoute, Belgium

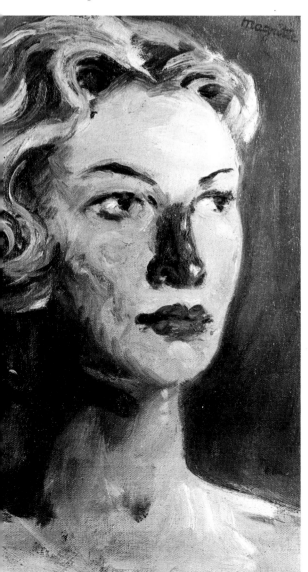

431

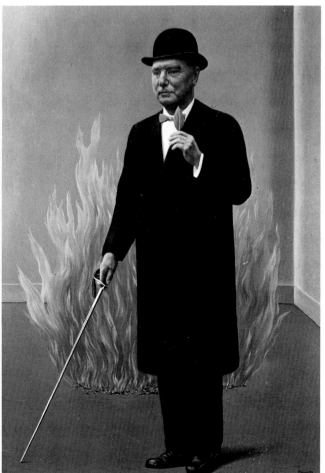

432

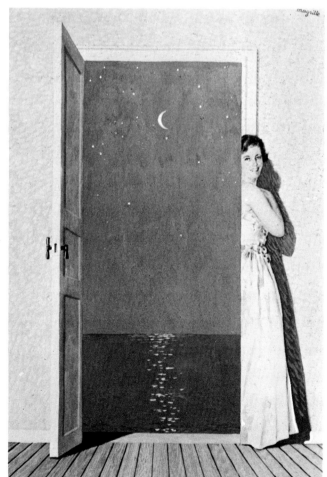

433

Self-Portrait

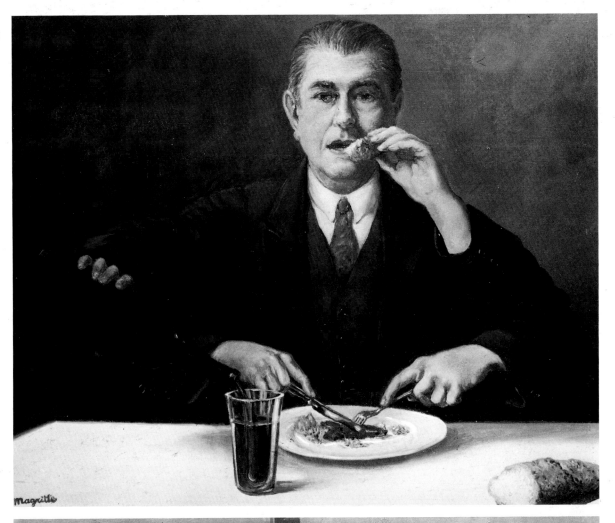

Your idea for a "portrait of the artist" brings up a "question of conscience": I have on occasion (three times) painted myself in a picture, but at the outset there was an idea for a picture, not for a portrait. I can paint (or rather, could have) some portraits starting with the idea of a portrait, but if it concerns me, my visual appearance, that presents a problem I'm not sure I can resolve. *Of necessity* I will think about it, since the problem has come up. I cannot promise to see the end of it this year! However that may be, inspiration — which comes spontaneously — may break through in the meantime.
——*Letter from René Magritte to Harry Torczyner, July 2, 1963*

Le sorcier (The Magician) is simultaneously the *auto (mobile) portrait* (self-portrait) of its author.
——*Letter from René Magritte to G. Puel, November 4, 1953*

Maniacs of movement and maniacs of immobility will not find this image to their taste.
——*René Magritte, Rhétorique, no. 7, October 1962*

434 *Le sorcier (The Magician).* Self-portrait with four arms. 1952. Oil on canvas, 13¾ x 18⅛" (35 x 46 cm). Collection Mme. J. Van Parys, Brussels, Belgium
435 *Autoportrait (Self-Portrait).* 1923. Oil on canvas. Location unknown
436 *La clairvoyance (Clairvoyance).* 1936. Oil on canvas. Private collection, Belgium

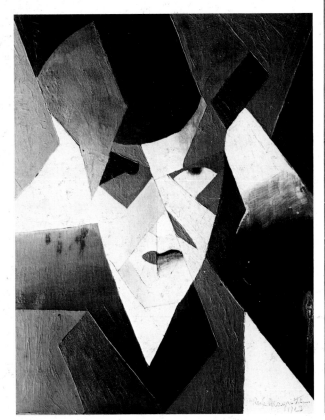

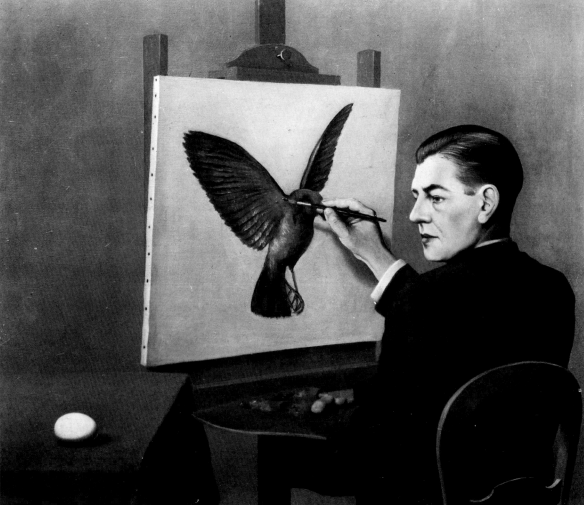

TOWARD PLEASURE

437 *A la rencontre du plaisir (Toward Pleasure)*. Drawing in a letter from René Magritte to Louis Scutenaire and Irène Hamoir (date illegible)

For Magritte, inspiration was very simply the recognition of a subject worthy of being represented in painting. He did not begin with an idea, but, on the contrary, he arrived at an idea that had to be able to stand up to his criticism and to impose itself upon him. Sometimes, this inspiration was slow to come. Bad luck. He refused to provoke or to hasten its arrival through imagination. Inspiration permitted him to evoke mystery by uniting in one image the visible offered by the world.

Once painted, this image had to be given a name, like a newborn child that must be baptized. A strange and indissoluble bond exists between each newborn and its name. A name is annunciatory, revelatory, serving neither to define nor to interpret its bearer. So it is with the titles given Magritte's pictures. Sometimes he asked advice by letter, or he would convoke an actual family council. His circle of close friends would then gather under his presidency to decide on a name. Sometimes Magritte would decree that a work was to bear the title of one of his favorite books.

What mattered to him was discovering what must be painted, not the way to paint. In order to discover an answer to his research, Magritte had to solve a series of problems and relentlessly to pursue his mental calculations.

He followed his pictorial "Lifeline" obstinately, faithfully, and not without a certain austerity; and with characteristic lucidity and sense of moderation, he has explained to us why his images demand no explanation.

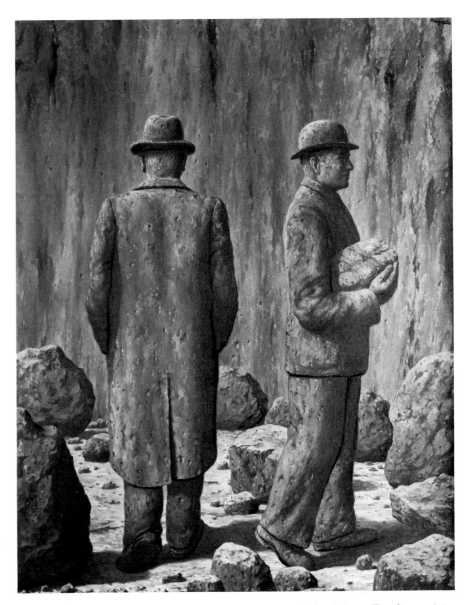

438 *Le chant de la violette (The Song of the Violet)*. 1951. Oil on canvas, 39⅜ x 31⅞" (100 x 81 cm). Private collection, Brussels, Belgium

439 Photograph of René Magritte,
Brussels, Belgium, 1934
440 *A la rencontre du plaisir (Toward
Pleasure)*. 1950. Oil on canvas,
19¼ x 23″ (49 x 58.5 cm). Collection Harry Torczyner, New York,
New York

439

440

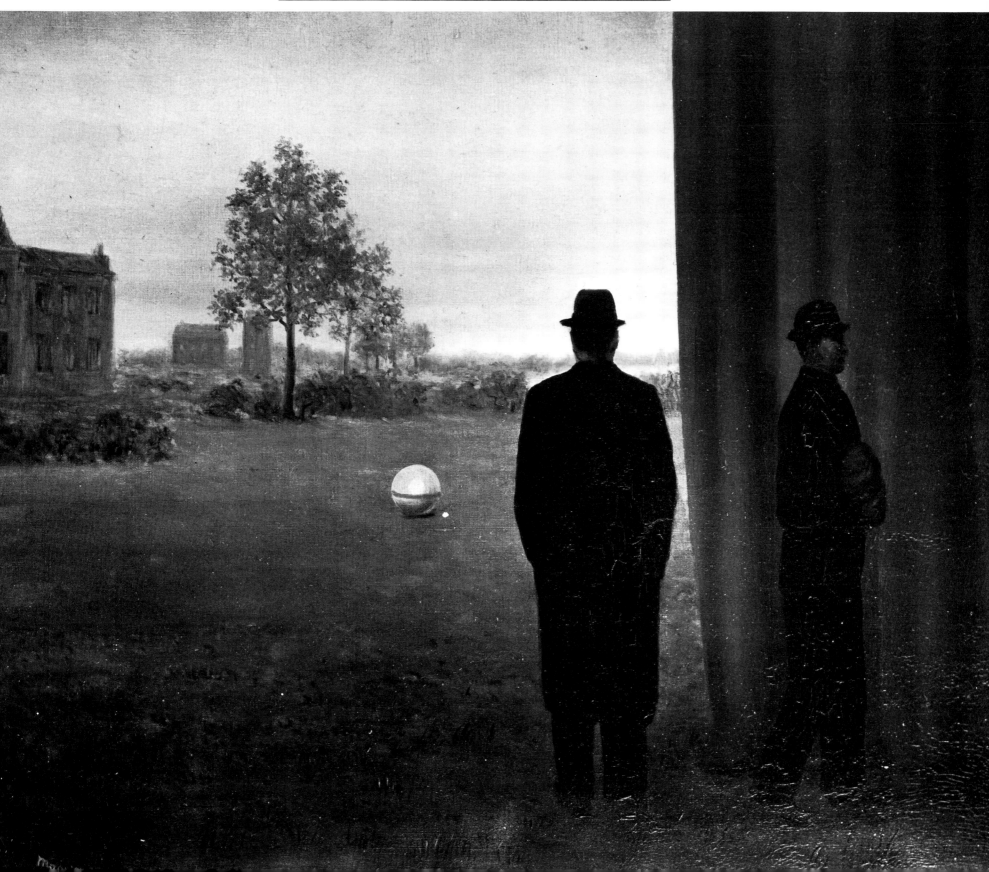

CREATIVE INSPIRATION

I get up very late; I need an enormous amount of sleep. When I open my eyes, thoughts crowd in upon me. They are of things I saw the previous evening. Sometimes, I also recall things I have dreamed during the night. I always remember them with great happiness. It is like a victory for me when I manage to recapture the world of my dreams. I had already thought how strange my morning thoughts were; it seemed to me it was like as many things as possible, and, so far as I remember, I never delved further than twenty-four hours into the past. No sooner did I become aware of this than it occurred to me to verify it.

This morning, I reencountered some of the characters of my slumbers: a woman on a bicycle who brushed past me, accompanied by a man, also on a bicycle. It was night, and I clearly saw the woman move away, her stockings white, and I was still very much aware of her even after she had disappeared around the corner. Next, I was overwhelmed by a magical object, an apparition. I watched someone unroll a length of blue silk and the silk frightened me; I was afraid to come near it. Yet there was nothing threatening about it. The person showing it to me and smiling barely paid attention to it. At that moment, I became aware of where I was. We were on a Pacific island, and there were women clinging to my sides, faces to the ground, not daring to look at this piece of silk they were seeing for the first time.

441 *L'art de la conversation (The Art of Conversation).* n.d. Oil on canvas, 18⅞ x 24″ (48 x 61 cm). Private collection, New York, New York

As I recalled these things, I suddenly discovered that they did not belong to a dream. I had seen the woman on the bicycle the evening before as I was coming out of a movie theater. I had been with some people who had paid no attention to her, but they remember quite clearly that many cyclists passed quite close to us. I have the same conviction about the piece of blue silk, but it's only a feeling; I cannot find a way to remove from it the magic it still retains, nor to place it on the same level as the objects that only have to be touched or looked at once.
—René Magritte, 1927–1928

. . . the word *dream* is misused with regard to my painting. We believe the world of dreams is worthwhile, but our labors are not oneiric—*on the contrary*. If we deal with "dreams," they are very different from the "dreams" we have when asleep. These are very *voluntary* "dreams" with none of the vagueness of feeling we have when escaping into dream. And this impetus that drives me to look for images that appear to be dream images to some people is one some of us share, and consists above all in shedding *as much light as possible*. (Goemans says that dreams are not made to put us to sleep, but to awaken us [or make us aware].)
—Letter from René Magritte to Louis Scutenaire, February 5, 1948

Concerning the "genesis" of my pictures, I gave a few indications in "La Carte d'Après Nature, no. 1." They involved the images obtained through voluntary and conscious research based on some object that has been taken as a "question." (*Le séducteur* [*The Seducer*] was the response found to the "question of water," the research consisted of a kind of "frenzied contemplation". . . of the question. Practically speaking, this took place through days of making drawings almost all alike, all of water, until the day when the suggestion of a form for water appeared in a drawing; the rest was nothing more than technique.)

Can other images perhaps result from what is known as the "unconscious"? *L'art de la conversation (The Art of Conversation)* is linked to *Le séducteur* by the water that forms the word *love* and to another picture, also named *L'art de la conversation,* in which two figures converse in front of a gigantic pile of stones, some of which form the word *dream*. These images or ideas of images seem to me to be "given." In the tree trunk, the cutout portion is irregular, and there are splinters. . . .

Golconde (Golconda) is another painting of an instantaneous vision. It may have been the result of a research into the "question of space." I don't believe a dream would go this far, and indeed, the problem is an important one: *Le séducteur* therefore may appear to be fulfillment of a dream. I feel that painting images seen in dreams is tantamount to realism, equal to someone painting images of waking life.
—Letter from René Magritte to G. Puel, November 13, 1953

Genius does not consist of having magnificent ideas . . . but in realizing that one has just had a magnificent idea, or that someone else has. For example, I had a magnificent idea, without either you or I being aware of it, when I pointed out to you a couple of years ago that when one stood in certain spots the moon was exactly above a chimney or a tree. At the time, we thought that was "odd," "amusing," and not terribly interesting. Now, thanks to some new pictures—*Les filles du ciel (The Daughters of Heaven), Robe du soir (The Evening Dress), Le maitre d'école (The Schoolmaster),* and *Le chef d'oeuvre (The Masterpiece)*—we can be considered geniuses if we admit that the "odd" notion was really a magnificent one. In Mesens' waiting room, I tried to give a man who was totally unaware of anything an appreciation of genius, and I used two examples: De Smet* and Jespers,** who could have had genius had they realized that they might have had magnificent ideas, but who made sure they did no such thing. These imbeciles were aiming at something quite different: they wanted to have a place in "modern painting," the former in Flemish Cubism, the latter in the decorative arts. Because of that, if [De Smet] thought one could see the moon above a person's head, for example, and [if Jespers thought] of continuing the sea onto the silhouette of a boat *(Le séducteur),* they would merely have attributed to these ideas an "odd" significance far inferior to the value they granted their crude artistic pursuits.
—Letter from René Magritte to Maurice Rapin, early 1955

*Gustave De Smet (1877–1943)
**Floris Jespers (1889–1965)

Certain clear, precise images are models for the pictures I like to paint. In my opinion, only images are worth representing by means of pictorial technique. Thus, I am not trying to express ideas or feelings in paintings, even if they strike me as outstanding (nor anything emanating from some so-called unconscious).
—René Magritte, address upon accepting membership in the Académie Picard, April 5, 1957

We're not concerned with the multitude of ideas (ingenious or intelligent as they may be), are we? On the other hand, some ideas that seem "poor" concern us *dramatically*. Since in the final analysis we too are "nothing special," spiritual poverty [at least] rules out the deception that "fine minds" respect without "presence of mind."
—Letter from René Magritte to Paul Colinet, 1957

I have just decided that among beautiful *images,* Christ carrying the Cross is a very beautiful image if we take away the meaning it is meant to express. Venus emerging from a shell is also beautiful when deprived of its usual meaning. It is a matter of not thinking about what these images are supposed to express, but about the feelings or ideas one had (without expressing them) when conceiving such images.
—Letter from René Magritte to André Bosmans, July 3, 1957

I'm working very little right now; I'm waiting for "inspiration." My lassitude makes me very "critical" about what it is possible to paint. The good side of this is that I must have something worth looking at, and only then will I do a new picture.
—Letter from René Magritte to Maurice Rapin, March 28, 1958

le tableau que vous as vu à la Nouvelle Orléans? Serait-il possible avoir tous les renseignements à ce sujet? J'ai peint deux versions "L'art de la conversation" - une de 80 x 60 cm qui appartenait une dernière encore à M. Robiliard Bruxelles et une de 60 (environ) qui serait donc à la N. O.? Comment est-elle là? Je ne saurais le dire et j'aimerais le savoir. Cette version exposée à la Galerie Obélisco en Italie il y a 5 ou 6 ans - Je qu'elle est revenue chez moi et depuis ce retour je ne me souviens pas qu'y avait peu se passer. D'après notre document: "rocher + rêve conversation." Je suppose qu'il s'agit bien de ce tableau art de la conversation? dont voici un schéma (2ème Version) à la seconde, 1er si Robiliard à la 1ère date: 1950 - 1952 ??

50 x 60 cm
est-ce la 1ère ou la 2ème? il se peut. Robiliard à celle qui mesure 80 x 60: certainement

a secrétaire qui aime évidemment ce genre de chose, aurait à notre instigation perfide, bonne occasion de satisfaire son vice favori: faire un ... de machine à écrire pour le musée de la N. O. demandait

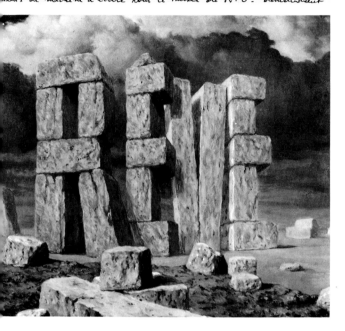

A painter invited me to look at his works. When showing me a picture, he found it absolutely necessary to tell me of his "idea." For example: "These geometric objects symbolize precision amid these indeterminate shapes," or "I was trying to express Christ's suffering in a new way. . . ."

I envy his "happiness," but I cannot share it, since—if we are talking about the same thing—he can achieve the "happiness" of having a felicitous idea on the basis of some "idea" that expresses or symbolizes something, whereas I can achieve it only by "getting" an idea that no power on earth can give me. This distinction is indispensable for those happy folk who "express themselves" through "new" ways of communicating such uninteresting "ideas" as suffering, justice, progress, truth, etc They think it is sufficient to say "suffering" in a new way and one will suffer. Which is untrue. If it were true, why make anyone suffer? If we suffer, the expression of that suffering cannot be respected unless it isn't "artistic" and doesn't concern itself with some new way of expressing itself. Ideas are also respected in this way—without our necessarily being interested in them.
——Letter from René Magritte to André Bosmans, May 4, 1959

442 Letter from René Magritte to Harry Torczyner, February 2, 1959. See Appendix *for translation*

443 *L'art de la conversation (The Art of Conversation).* 1958. Oil on canvas, 20¼ x 23¼" (51.5 x 59 cm). Isaac Delgado Museum of Art, New Orleans, Louisiana

Ideas, if they are beautiful, are self-sufficient. It's a pity to "illustrate" them with metaphors. If they are uninteresting, I find no pleasure in illustrating them.

It's "in" to reduce a poetic image to an idea; it's possible even if the image is irreducible. Thus, a marble hand is poetic on condition that we think a woman has a hand of marble—not that the flesh of her hand is as hard and cold as marble. Correct language demands . . . the suppression of this kind of ambiguity.
——*Letter from René Magritte to André Bosmans, May 28, 1959*

Recently I had occasion to reply to a letter asking me for a picture inspired by the misfortune of displaced persons, to be sold for some charity function. It occurred to me that a subject (misfortune, for example) can never "inspire" me in the right way for me to conceive a picture. This clearly sets me apart from inspired artists. However, I have managed to give this word *inspiration* a meaning that I find valid. While a subject may give rise to an unwanted inspiration, true inspiration is the only thing that can make a "subject" known, a subject worthy of being represented in painting. Example: the bicycle is not a subject that inspires me. It is inspiration that gives me the subject to be painted: a bicycle on a cigar.

The essential thing is what must be painted or written, and inspiration is what makes it known. "How" is only the correct articulation of this essential thing, devoid of fantasy.
——*Letter from René Magritte to André Bosmans, October 23, 1959*

Inspiration is a special moment in which we are truly in the world, united with it. It cannot be attained by juxtaposing any old thing in any old way, but rather *arises* by uniting what the world offers us in an order that evokes mystery, without which neither thought nor world would be possible.
——*Letter from René Magritte to Pierre Demarne, May 12, 1961*

Some people introduce good ideas that unfortunately are "dreams" that lessen the value of the ideas (as in stories that end by saying "it was but a dream"). Here, for example: paint the walls, mirrors, windowpanes, of a room all white. Pay to look at the ocean. Live on a train that never stops.

These "dream-inspired" ideas seem to pertain only to the world as dream. In the real "world" they would be worthless *if indeed we believe there are different worlds.* To say the world offers itself as a dream is not to say there are two worlds, that of dreams and that of reality. The mind dreams no more asleep than awake, nor is it necessarily even awake in the waking state. The mind can be lucid and exceptionally awake when asleep, making exactly the same valid discoveries it makes when awake.

The mind can be (and *almost* always is) as stupid awake as asleep. In noting how futile it can be in the waking state, we must recognize that it is no less so, *almost* always, when asleep, and that nightmares exist awake just as much as asleep. The mind can be inspired at any time, and to say that it is during the waking or the sleeping state adds absolutely nothing.

To so state turns sleeping and waking into imaginary things that are supposed to have some revelatory value (as though "lying down" or "standing up" were important).
——*Letter from René Magritte to André Bosmans, June 8, 1962*

I have to . . . wait for inspiration: things I deliberately imagine nauseate me.
——*Letter from René Magritte to Harry Torczyner, August 22, 1962*

Dear Harry and Marcelle,

Thank you for your birthday telegram confirming a tenacity for life that has lasted sixty-four years! I'm grateful for your kind attention and the agreeable feeling that I am its cause. It assures me that I must persist insofar as is reasonable—despite ever-present fatigue.

For the moment, as you can imagine, I am rather tired and fairly short on ideas: I have none at all. Perhaps my forthcoming visit to Milan will shake up my "gray matter" and procure for me (or give rise to) some pictorial perspectives that will be worth serious consideration.

In any case, this birthday coincides with total intellectual vacuity. Fortunately, this has happened to me before so it doesn't alarm me (if "good weather always follows the rain").

In this state of total vacuity, I am receiving endless commissions. A director of a gallery in Rome came to see me this morning; he would like "exclusive representation for Italy." But of what? I don't even have any idea for a picture I might be interested in painting. I can't even "satisfy" Iolas' needs.

The gouache for Containers is an exception to this lack of ideas. I will be sending it to you in two weeks or so.

Thank you again for your kind wishes, and with affection for you and Marcelle,

René Magritte
——*Letter from René Magritte to Mr. and Mrs. Harry Torczyner, November 21, 1962*

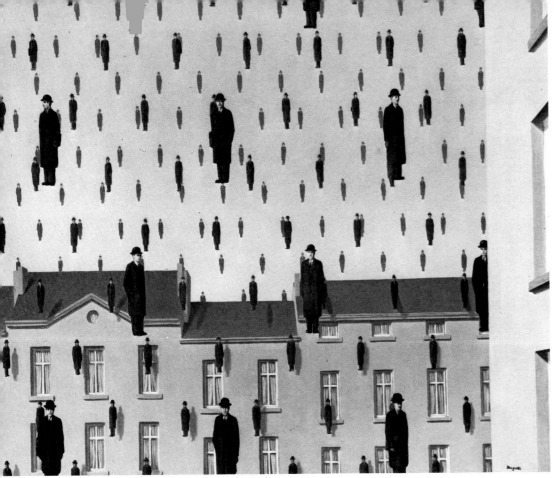

444 *Golconde (Golconda)*. 1953. Oil on canvas, 31⅞ x 39⅜" (81 x 100 cm). Private collection, United States

445 *Golconde (Golconda)*. 1953. Gouache, 5⅞ x 6¾" (15 x 17 cm). Collection M. and Mme. Louis Scutenaire, Brussels, Belgium

The ideas I have about death are uninteresting. In addition, they would have to be written, described in writing. I cannot conceive them in paint (unless I were to agree to become part of the hoax consisting of "expressing" ideas, feelings, or sensations through colors on a canvas).

I have no idea about mystery, only a feeling. I need inspiration to *evoke* mystery (and not to "express" the feeling I might have about it). This inspiration consists in uniting in one image the *visible* the world offers in such a way that mystery will be evoked. This inspiration is never based on a desire to evoke something general or particular: death, for example, love, melancholy, joy, etc. . . .
——*Letter from René Magritte to A. Penent, December 8, 1964*

The creative imagination . . . does not necessarily conceive of imaginary [things]: from it one gets, for example, the locomotive, table, Venus de Milo, the black sun of melancholy. The "imaginary," for its part, is only responsible for vacuities: "escape," advertising slogans, everything in contemporary art that "shines" because of an inveterate, basic confusion.
——*Letter from René Magritte to André Bosmans, January 7, 1965*

The imaginary has no value in and of itself (nor does the chimerical). Yet without confusing it with poetic reality, the chimerical is one of the things I like most. What one likes is not necessarily of a poetic, moral, intellectual, or practical order. (Poetry's absolute reality does not depend on the greater or lesser importance we attribute to it.)
——*Letter from René Magritte to San Lazzaro, January 19, 1965*

It doesn't seem possible to me to make it clear that authentic imagination has nothing to do with the imaginary. Imagination is surely the inspiration that enables us to say or paint (without originality) what must be said or painted. There is no question then of interpreting more or less brilliantly some subject picked out of a long, trite list.
——*Letter from René Magritte to Harry Torczyner, September 11, 1965*

. . . sometimes I paint from a model, and when that occurs I sometimes finish the figure . . . without using the model. Sometimes the model is a live one, or a photograph, such as one of the Tower of Pisa, which is in a foreign country. However, I believe all this to be of very little interest.
——*Letter from René Magritte to Volker Kahmen, April 27, 1966*

We won't speak of themes, if you don't mind. These are not themes. These are images that come together, that impose themselves upon me. Always images of the simplest objects, those anyone can see around him: a hat, a bell, an apple, an easel, a bird, a street lamp, a brick wall, shoes, a three-piece suit. Except that sometimes the hat is resting on the apple, the bird is made of stone, the shoes are feet with real toes, the brick wall takes the form of a desk, and the three-piece suit is really a pleasant valley. These ideas for combining images occur to me without my looking for them.
——*Remarks by René Magritte reported by Pierre Descargues, Tribune de Lausanne, January 15, 1967*

Painting gouaches whose subjects would be selected by the "Middle West"* would be beyond my powers. I already have more than enough resistance to overcome to paint the "subjects" I imagine. I'd be very grateful if you could employ any "legal technicalities" you can think up to give the discussions—so long as it amuses you—an inextricable confusion without any possible outcome or—if it doesn't amuse you at all—to let the "Middle West" know that his case can have no possible outcome.
——*Letter from René Magritte to Harry Torczyner, February 17, 1967*

*"The Middle West": a collector in Chicago who importuned Magritte for another gouache to add to his already sizable collection of Magritte's gouaches

202

Poetic Attributions

A title "justifies" the image by completing it. Nietzsche also said "there is no thought without language." Could the painting that affects us be a language without thought? Because it is evident that pictures representing ideas—justice, for example—fail to affect us.
——René Magritte, Paroles Datées, June 19, 1956, in Les Brouillons Sacrés, I, Paris, November 1956

The titles of my paintings accompany them like the names attached to objects without illustrating or explaining them.
——Letter from René Magritte to Barnet Hodes, 1957

Titles . . . become "eloquent" as names for paintings on condition that they fit exactly. Their meaning has strength and charm thanks to the paintings, and paintings acquire greater precision by being well named.
——Letter from René Magritte to André Bosmans, March 7, 1959

Titles should be images that are precisely joined with the pictures. In fact, the titles I might call purely "intellectual" are not satisfactory at all. Titles that can suit any picture are hardly any better, such as *The Image Itself, Resemblance,* and others that are intelligent, but perhaps too much so.
——Letter from René Magritte to Marcel Lecomte, June 13, 1960

The titles go with my paintings as well as they can. They are not keys. There are only false keys.
——From an interview with René Magritte by Guy Mertens, Pourquoi Pas, 1966

Literary Sources

Many of Magritte's images are known to have derived their titles from happy memories of reading:
L'Au-Delà (F. Grégoire)
"The Domain of Arnheim" (Edgar Allan Poe)
Les Fleurs du Mal (Charles Baudelaire)
Gaspard de la Nuit (Bertrand)
"La Géante" (Charles Baudelaire)
Treasure Island (L'Ile du Trésor) (Robert Louis Stevenson)
Les Liaisons Dangereuses (Choderlos de Laclos)
Souvenirs du Voyage (J. A. Gobineau)
Visions of a Castle of the Pyrenees (Ann Radcliffe)
(See list of Magritte's favorite authors, p. 51)

Les Fleurs du Mal

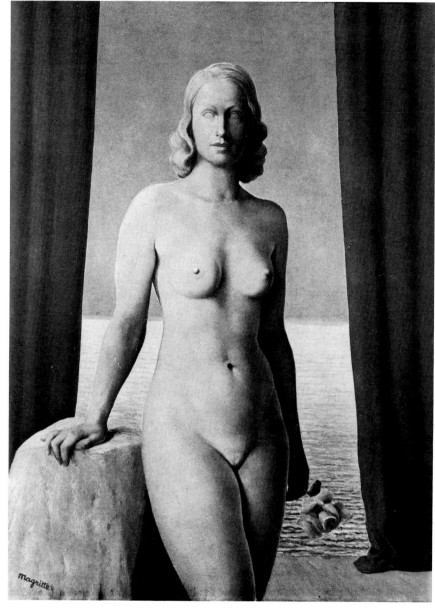

446
Les fleurs du mal (The Flowers of Evil). 1946. Oil on canvas, 31½ x 23⅝" (80 x 60 cm). Collection M. and Mme. Berger-Hoyez, Brussels, Belgium

Unexpected images sometimes appear to me when my eyes are open or closed, and they become the models of pictures I like to paint.

In depicting the image that appeared to me one day, I painted *Les fleurs du mal (The Flowers of Evil).* It was the unexpected image of a statue made of flesh, a woman made completely of flesh, holding in her hand a rose made of flesh, in front of the sea I had seen between two red curtains.

The title *Les fleurs du mal* goes with the picture just as a noun corresponds to an object without either illustrating or explaining it.

It would be useless to posit some mental process of which I am ignorant and to charge it with having determined the content of what I call an "unexpected image." It would be just as easy to assert that latent memories of Baudelaire's poems were, unbeknownst to me, the origin for the painting *Les fleurs du mal.*
——René Magritte, address given upon being made a member of the Académie Picard, April 5, 1957

The flesh statue of a young woman holding a rose made of flesh in her hand. Her other hand is leaning against a rock. The curtains open onto the sea and a summer sky.
——René Magritte, June 22, 1946, in Fait Accompli, nos. 111–113, April 1974

The Castle of the Pyrenees

447

Vieux château (presque ou aussi fort) de pierre sur une pierre dans la nuit —
(Peut être également vu et représenté) dans le jour

Bruxelles, le 21 mars 1959

Cher ami,

Je vais me mettre à l'œuvre pour condamner la fenêtre coupable. Ce sera donc la pierre dans les airs, porteuse d'un vieux château et de quelques arbres autour du château, la vue montrera de jour persistant, ciel bleu et nuages au-dessus d'une mer du Nord un peu démontée. (La mesure du démontage est à fixer en cours d'exécution) Pour la balustrade, il ne faut pas évidemment de pierres : c'est dans l'air qu'il y a de la pierre — Je me demande même si une balustrade est nécessaire ? Et, si elle ne gênerait pas la pierre dans les airs ?

avec balustrade : *sans balustrade :*

Il semble que sans balustrade, les vagues de la mer sont plus visibles, la pierre plus "à l'aise" et l'on a le sentiment de voir ces choses de la plage et non confiné dans un intérieur — ? Avec la balustrade, les choses sont un peu "encaquées", elles paraissent être à l'étroit — alors que pour ce tableau l'espace ne doit pas donner l'idée qu'il est comprimé — Mon exposition chez Iolas va bientôt finir. Pensez-vous qu'elle a fait de l'"effet" ? Bien amicalement à vous. René Magritte

448

Le château des Pyrénées is coming along very well. It will, I believe, be an image worthy of its name: with an *apparition* quality that Ann Radcliffe would have liked if indeed her book *Visions of a Castle of the Pyrenees* is any indication of what she really liked. Around the middle of next May, this apparition will leave the old world for the new. Your office will be haunted by it. A haunted New York office will begin its "career" thanks to our *entente* that is more than *cordiale*.
—*Letter from René Magritte to Harry Torczyner, April 20, 1959*

Radcliffe's *Visions of a Castle of the Pyrenees* is a romantic Gothic novel that has the charm and the shortcomings of a literary school not noted for its liberties. You may be disappointed when you read it, but the atmosphere it evokes will delight you. As for the painting, it is not without rigor, that is, *hardness*. That is why the little flag on one tower and the trees have been sacrificed. The sky, clouds, the castle on the stone above the turbulent sea *necessarily* subsist. . . .
—*Letter from René Magritte to Harry Torczyner, April 27, 1959*

The Domain of Arnheim

For the development of *La fontaine de jouvence (The Fountain of Youth),* I can say that it began about 1933–1934; I was trying to paint a mountain and thought of giving it a bird's shape and calling this image *Le domaine d'Arnheim,* the title of one of Poe's stories. Poe would have liked seeing this mountain (he shows us landscapes and mountains in his story).

Fortune faite (The Fortune Made) and *La fontaine de jouvence* are stones bearing such inscriptions as "Coblenz," "Roseau" (or the date in *Les verres fumés* [*The Dark Glasses*]) "à boire," "à manger" *(to drink, to eat)* as in *Fortune faite.* These stones can be seen as a little piece of *Le domaine d'Arnheim.*

To be more thorough, I mustn't forget to say that between *Le domaine d'Arnheim* and *La fontaine de jouvence* came *Le sourire (The Smile),* which was a very old stone—without the bird's head—bearing a date of five figures.

——*Letter from René Magritte to André Bosmans, April 6, 1959*

The first concept of a mountaintop shaped like a bird, which led to *Le domaine d'Arnheim* some thirty years later.

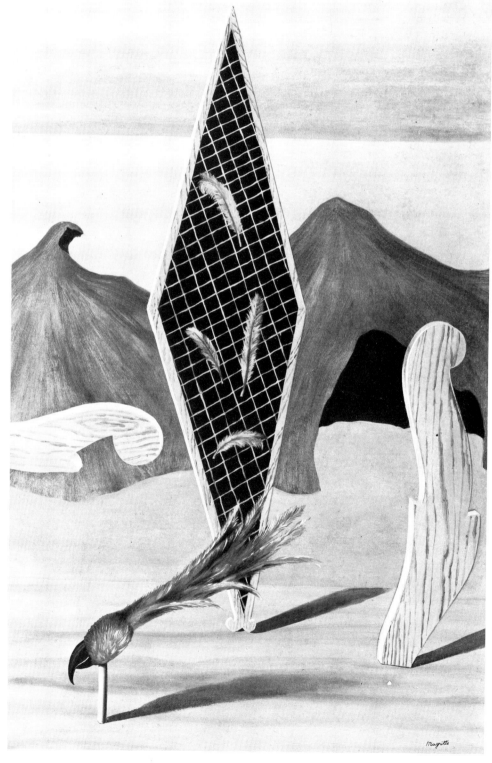

450 Untitled drawing. n.d. 4⅜ x 5⅞" (11 x 15 cm). Collection M. and Mme. Marcel Mabille, Rhode-St.-Genèse, Belgium

451 *Les épaves de l'ombre (The Shadow's Wreckage).* n.d. Oil on canvas, 47¼ x 31½" (120 x 80 cm). Musée de Grenoble, Grenoble, France

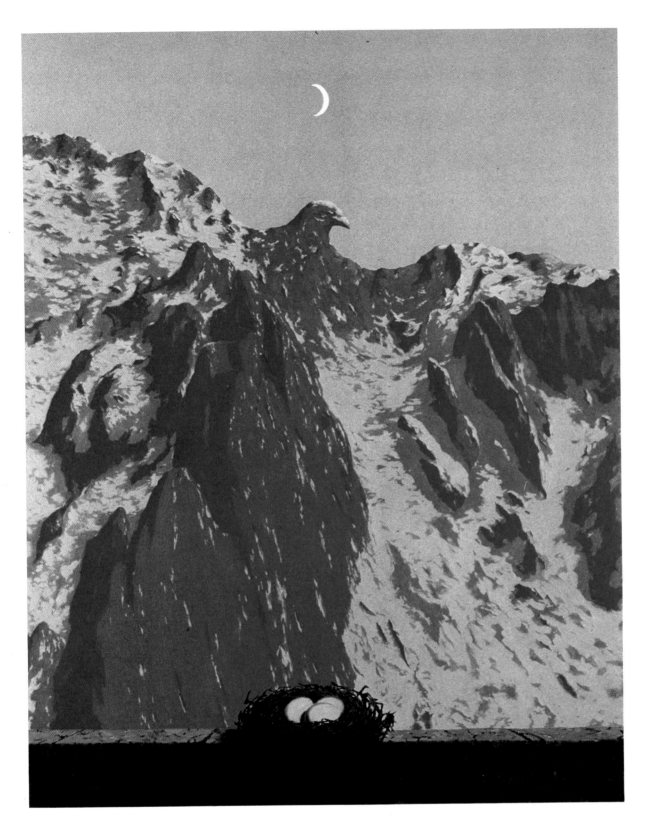

452 *Le domaine d'Arnheim (The Domain of Arnheim).* 1962. Oil on canvas, 57½ x 44⅞" (146 x 114 cm). Collection Mme. René Magritte, Brussels, Belgium

453 Letter from René Magritte to Maurice Rapin, February 21, 1956. *See* Appendix *for translation*

454 *Le sourire (The Smile).* 1947. Gouache, 14⅝ x 18⅛" (37 x 46 cm). Private collection, United States

455 *Fortune faite (The Fortune Made).* 1957. Oil on canvas, 23⅝ x 19⅝" (60 x 50 cm). Location unknown

454

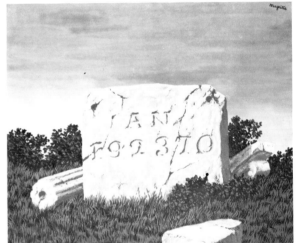

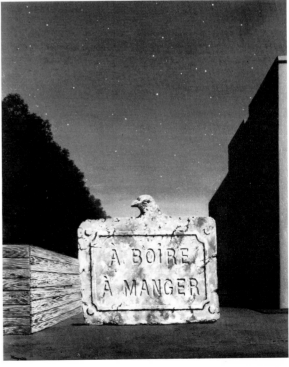

453

455

206

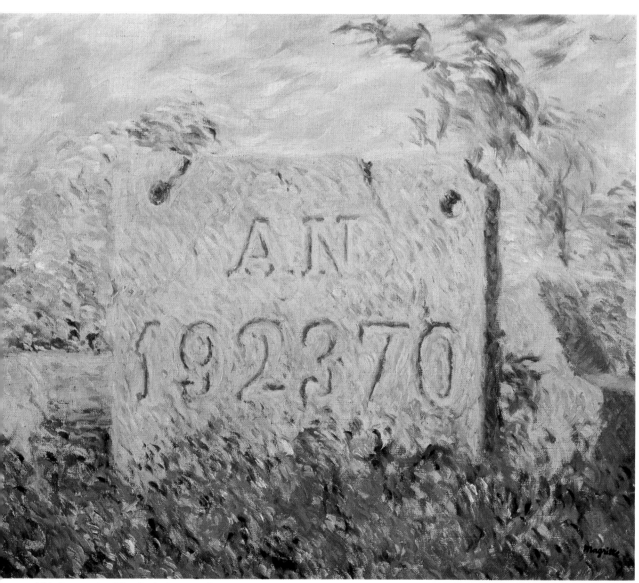

456 *Le sourire (The Smile)*. 1944. Oil on canvas, 21⅝ x 25⅝" (55 x 65 cm). Collection M. and Mme. Louis Scutenaire, Brussels, Belgium

. . . there is a stone base supporting a stone apple surmounted by two leaves also of stone, one of which is a horse (its tail is attached to the apple like a stem). The date ANNO 18765 is engraved on the base—I don't remember the exact number now, but it has five figures. Not only is there this relationship because of the base, but also because of the picture's title, *Les verres fumés,* a title Colinet came up with.
———*Letter from René Magritte to André Bosmans, April 6, 1959*

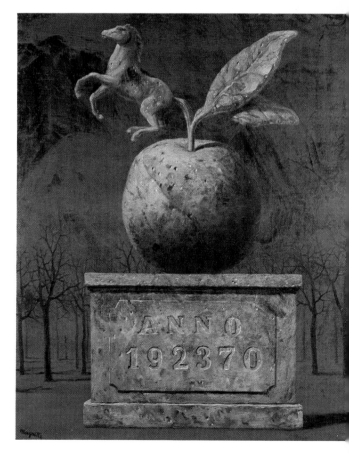

457 *Les verres fumés (The Dark Glasses)*. 1951. Oil on canvas, 22⅝ x 19⅛" (57.5 x 48.5 cm). Private collection, New York, New York

The Nightingale/ Consultation with Close Friends

458 *Le rossignol (The Nightingale)*. 1955. Gouache, 9⅞ x 7⅞" (25 x 20 cm). Museum of Art, Carnegie Institute, Pittsburgh, Pennsylvania

459 Letter from René Magritte to André Bosmans, April 21, 1962. *See* Appendix *for translation*

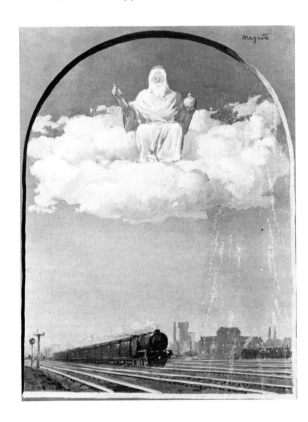

In the workshop (where I haven't worked very much for some time now, since I have the feeling that the workshop usually works on its own), I noticed that a picture called *Le rossignol (The Nightingale)* is at a very ambiguous stage of completion. There is a kind of railroad yard—a view of tracks, signals, machines, etc. On a cloud in the sky the figure of God the Father sits on his throne, as in some of the pictures at Saint-Sulpice. For some people, *rossignol* means something that has been pawned, and for others he is the king of the birds. When it is finished, *Le rossignol* will signify a "collage" effect for some "connoisseurs," a couple of reminders of my trip to Paris for connoisseurs of another kind, a profession of deism or atheism, etc., for still others. The number of "additional" interpretations such an image can have confirms my feeling of its validity: its being at the heart of the matter (which can be expressed only in some ambiguous and fairly dangerous way).
——*Letter from René Magritte to Mirabelle Dors and Maurice Rapin, January 31, 1956*

As I told you, I've been thinking about *Le rossignol*. I am sending you a sketch to indicate what I've been able to clarify—obfuscate would be more like it, since I don't know how much about God the Father and I don't know exactly how he ought to look on his cloud. However, at Saint-Sulpice I saw a picture that — according to my somewhat foggy memory—was a good enough representation of him for the role he is to play in *Le rossignol*.
——*Letter from René Magritte to Mirabelle Dors and Maurice Rapin, February 24, 1956*

I recently took it as a personal insult when someone told me that "they" would construe *Le rossignol* as a practical joke. . . . My feelings were deeply hurt. . . . And because of this moment of weakness I have stopped worrying about what the stupid public may think about *Le rossignol* and have stopped thinking about the "uselessness" of exhibiting it . . . because if one had to anticipate every consequence, one would have so many things to worry about before painting a picture that the picture would never get painted.
——*Letter from René Magritte to Mirabelle Dors and Maurice Rapin, March 30, 1956*

The Well of Truth

[*L'étalon (The Standard)*]:
 "What was the pun in the title for *L'étalon*? *(les talons* [the heels])."
——*Letter from René Magritte to Suzi Gablik, January 28, 1961*

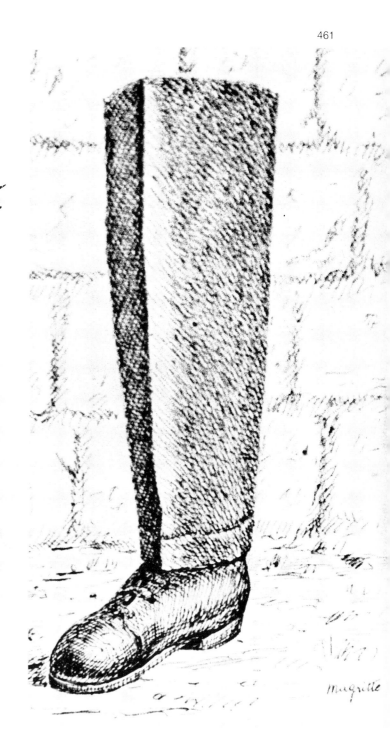

461

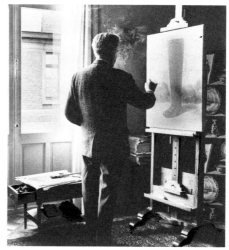

462

460

460 Pen sketch of *Le puits de vérité (The Well of Truth)*
 in a letter from René Magritte to Harry Torczyner,
 January 13, 1962. *See* Appendix *for translation*
461 *Le puits de vérité (The Well of Truth)*. c. 1962–
 1963. Pen and ink drawing, 11⅜ x 8¼″ (30 x 8¼
 cm). Collection Mme. Sabine Sonabend-Binder,
 Brussels, Belgium
462 Photograph of René Magritte painting *Le puits de
 vérité (The Well of Truth)*, 1963

463 Ink drawing in a letter from René Magritte to Mirabelle Dors and Maurice Rapin, August 22, 1956

The Voyager

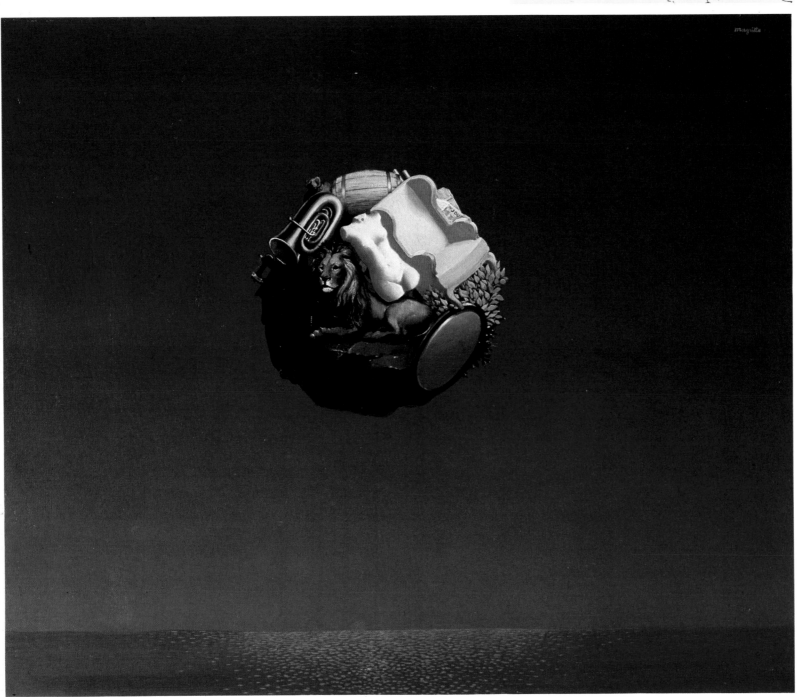

464 *Le voyageur (The Traveler).* 1935. Oil on canvas, 21⅝ x 26″ (55 x 66 cm). Private collection, Brussels, Belgium

A Little of the Bandits' Soul

Someone called Roger Shattuck* has discovered a new method of art criticism. We already knew that the words making up the titles for my pictures could be found in the dictionary, but thanks to Mr. Shattuck we now know that alphabetic order provides the key to the pictorial mysteries for which I am responsible.
——Letter from René Magritte to Harry Torczyner, September 22, 1966

*American art critic, author of "This Is Not Magritte," Artforum, September 1966 special number on Surrealism

Coming back to L'âme des bandits (The Bandits' Soul), Shattuck is right to call upon the Petit Larousse, but he is wrong to do it so stupidly. Words and their usual meanings are to be found in the dictionary. One must first know the dictionary—at least in part—in order to come up with a picture title. The method of research is less important than its outcome. Scutenaire, who found this title, could obviously have remembered that in the dictionary [the definition under] the word violin explains what a violin is made of—including a soundpost (âme)—and the same word âme could have reminded him of the title of a book read long ago, Un peu de l'âme des bandits, thus suggesting the book's title as an appropriate name for the picture I had painted. I don't know whether it was the word âme that put the idea into his head, or whether he found this excellent title by another route.

The dictionary has an importance we may overlook; Shattuck doesn't overlook it, but he doesn't seem to think much of it.

On the other hand, if indeed the discovery was made by the proximity of the "b" in bandit and the "a" in "âme"—which is not really proximity (all the words in the Petit Larousse are next to each other, after all)—what should have been noted was not the fact that "b" follows "a," but rather the choice that was made along with an explanation of why that choice was an excellent one. But that would have been asking too much of Mr. Sattuk [sic]. I see I could go on and on in a kind of litany wherein Mr. Sattuk's [sic] name would recur with comic effects, so I think it's time to quit.
——Letter from René Magritte to Harry Torczyner, September 26, 1966

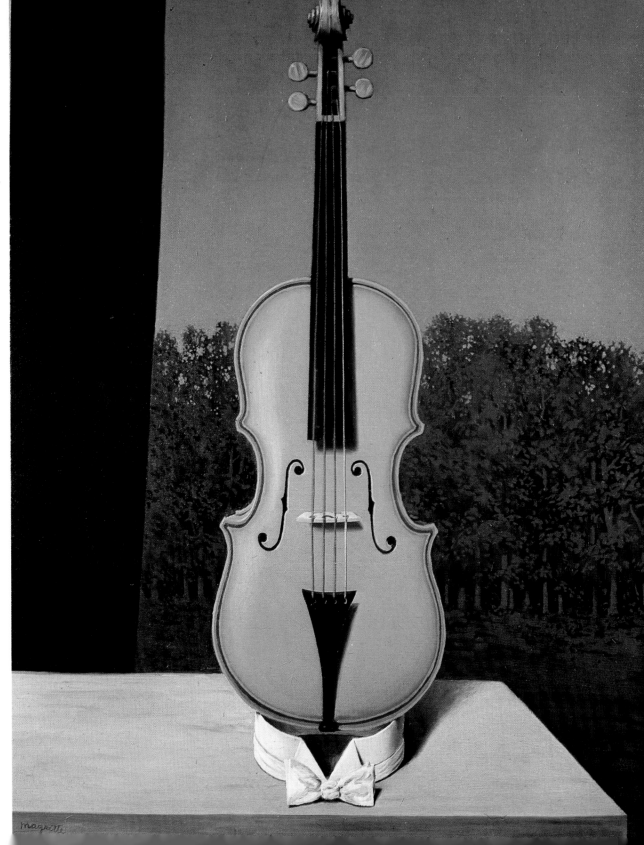

465 Un peu de l'âme des bandits (A Little of the Bandits' Soul). 1960. Oil on canvas, 25½ x 19¾" (65 x 50 cm). Location unknown

The Chariot of the Virgin

466 *Le char de la Vierge (The Chariot of the Virgin).* 1965. Gouache, 10 x 13⅛"
(25.5 x 33.5 cm). Private collection, Athens, Greece
467 *Le char de la Vierge II (The Chariot of the Virgin II).* n.d. Drawing, 7⅛ x 10¼"
(18 x 26 cm). Private collection, New York, New York

468

467

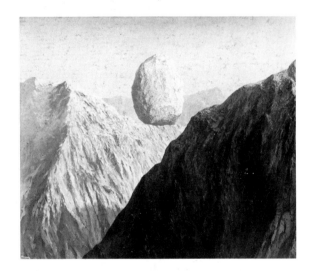

468 *Le char de la Vierge I (The Chariot of the Virgin I).* n.d. Pen and ink drawing, 7⅛ x 10¼" (18 x 26 cm). Private collection, New York, New York
469 *La clef de verre (The Glass Key).* 1959. Oil on canvas, 51 x 63¾" (129.5 x 161.9 cm). Private collection, Houston, Texas

I've come up with and painted a "sublime" picture! What can you find as titles (plural) or title (singular) if it's the one title [you prefer] above all others, which shows *a stone on a mountain.*
——*Letter from René Magritte to André Bosmans, February 26, 1959*

The hoped-for title has not yet been found. After *La page 88 (Page Eighty-eight),* Scutenaire suggested *Opéra (Opera), La sainte famille, (The Holy Family), La Noël (The Christmas),* which were abandoned because of the privacy (confessional or decorative) they seemed to suggest. Another friend (an able but overly rational individual with a very lively mind) suggested *Le métronome* (which measures something quite different from guitar strings!). Alas, the unpoetic title that would go with it seems to me to be something like *Le monde dit réel (The So-called Real World)* or *Le monde invisible (The Invisible World),* which are hardly enough to rouse thought from its slumbers. Perhaps *La vie de la pensée (The Life of Thought) . . . La nuit et le jour (Night and Day)* [would do] for lack of something better. It would signify that all mountains are alike to us, that their shapes are ordinary to the point where we don't distinguish among them, and that they are like the dim night. Is the stone *one* stone by day because it seems to derive from the night of the mountains?
. . .
 Each title risks an "intelligent" interpretation. Could *La nuit et le jour* be understood as meaning the mountain in the foreground, which is in

shadow, and the one where there is a stone, which is illuminated?
——*Letter from René Magritte to André Bosmans, March 1959*

The title that has finally been found for this difficult-to-name picture—*La clé de verre (The Glass Key)*—appears to meet with no objection.
——*Letter from René Magritte to André Bosmans, May 1958*

"Informed objectivity"—in other words, correct thinking—obliges us to see a stone *set* on a mountain in the picture *La clé de verre.*
 There isn't any levitation or "motionless" avalanche. Levitation is, of course, not totally absent, if we think of the earth as being in a vacuum along with everything else on earth, the stone on the mountain included. My intention was to paint the image of a stone, and inspiration showed me it should be set atop a mountain.
——*Letter from René Magritte to Pierre Demarne, May 12, 1961*

[*Le char de la vierge (The Chariot of the Virgin)*]: I am about to paint a picture whose title will, I feel, be particularly hard to find.
——*Letter from René Magritte to Harry Torczyner, July 1965*

THE TRUE ART OF PAINTING

I believe I've made an altogether startling discovery in painting: up until now I used combined objects, or perhaps the position of an object was enough to render it mysterious. But as a result of the research I have pursued here, I have found a new possibility things may have: that of *gradually* becoming something else—an object *melts* into an object other than itself. For instance, at certain spots the sky allows wood to appear. This is something completely different from a compound object, since there is no break between the two materials, no boundary. Using this means, I get pictures in which the eye "must think" in a way entirely different from the usual; the things are tangible, yet a few planks of ordinary wood grow imperceptibly transparent in certain areas, or a nude woman has parts that also become a different material.

—*Letter from René Magritte (Le Perreux-sur-Marne) to Paul Nougé, November 1927*

The Lifeline

Comrades, Ladies and Gentlemen.

That old question "Who are we?" receives a disappointing answer in the world in which we must live. Actually, we are merely the subjects of this so-called civilized world, in which intelligence, baseness, heroism, and stupidity get on very well together and are alternately being pushed to the fore. We are the subjects of this incoherent, absurd world in which weapons are manufactured to prevent war, in which science is used to destroy, to construct, to kill, to prolong the life of the dying, in which the most insane undertaking works against itself; we are living in a world in which one marries for money, in which one constructs palaces that rot, abandoned, by the sea. This world is still holding up, more or less, but we can already see the signs of its approaching ruin glimmering in the darkness.

It would be naïve and useless to restate these facts for those who are not bothered by them, and who are peaceably taking advantage of this state of affairs. Those who thrive on this disorder hope to consolidate it, and, the only means available to them being further disorders, they are contributing to its imminent collapse, albeit unwittingly, by replastering the crumbling structure in their so-called realistic way.

Other men, among whom I am proud to count myself, despite the utopianism they are accused of, consciously desire the proletarian revolution that will transform the world; and we are acting

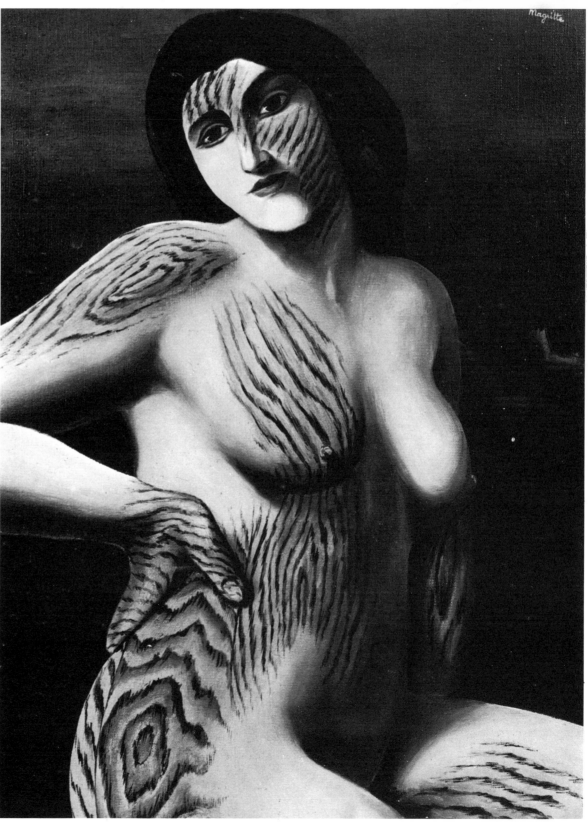

toward this end, each according to the means available to him.

Nevertheless, we must protect ourselves against this second-rate reality that has been fashioned by centuries of worshipping money, races, fatherlands, gods, and, I might add, art.

Nature, which bourgeois society has not completely succeeded in extinguishing, provides us with the dream state, which endows our bodies and our minds with the freedom they need so imperatively.

Nature seems to have been overly generous in creating for those who are too impatient or too weak the refuge of insanity, which protects them from the stifling atmosphere of the real world.

The great strength for defense is the love that binds lovers together in an enchanted world made precisely to their order, and which is admirably protected by isolation.

Finally, Surrealism provides mankind with a methodology and a mental orientation appropriate to the pursuit of investigations in areas that have been ignored or underrated but that, nonetheless, directly concern man. Surrealism demands for our waking lives a liberty comparable to that that we possess in dreams.

The mind possesses this freedom to a high degree, and as a practical matter new technicians must devote themselves to the task of destroying some complexes—such as ridicule, perhaps—and of looking for those slight modifications that must be made in our habits so that this faculty that we possess of seeing only what we choose to see might become the faculty of discovering at once the object of our desires. Daily experience, even hobbled as it is by religious, civil, or military moralities, is already achieving these possibilities to some degree.

In any case, the Surrealists know how to be free. As André Breton cries: "Liberty is the color of man."

In 1910, Chirico played with beauty; he imagined and achieved what he wanted: he painted *Le chant d'amour (The Song of Love),* in which we see boxing gloves together with the face of an antique statue. He painted *Melancholia* in a land of high factory chimneys and infinite walls. This triumphant poetry replaced the stereotyped effects of traditional painting. It was a total break with the mental habits characteristic of artists who were prisoners of talent, virtuosity, and all the minor aesthetic specialities. It meant a new vision in which the spectator rediscovered his isolation and listened to the world's silence.

In his illustrations to Paul Éluard's *Répétitions,* Max Ernst superbly demonstrated, through the shattering effect of collages made from old magazine illustrations, that one could easily dispense with everything that had given traditional painting its prestige. Scissors, paste, images, and some genius effectively replaced the brushes, colors, model, style, sensibility, and the divine afflatus of artists.

The labors of Chirico, of Max Ernst, certain works by Derain, *L'homme au journal (Man with Newspaper)* among others, in which a real newspaper is pasted into a figure's hands, Picasso's experiments, Duchamp's anti-artistic activity, which casually proposed using a Rembrandt as

an ironing board: these are the beginnings of what is now called Surrealist painting.

In my childhood, I liked playing with a little girl in the old, abandoned cemetery of a small country town. We visited those underground vaults whose heavy iron doors we could lift and we reascended into the light, where an artist from the capital was painting in one of the cemetery's paths, picturesque with its broken stone columns amid piles of dead leaves. At that moment, the art of painting seemed somehow magical, and the painter endowed with superior powers. Alas! I later learned that painting had little to do with real life, and that each attempt at freedom had always been foiled by the public: Millet's *Angelus* created a scandal when it appeared; the painter was accused of having insulted the peasants by representing them as he had. People wanted to destroy Manet's *Olympia,* and the critics reproached the painter for showing women cut into pieces because he had only shown the top half of a girl standing behind a bar counter, the bottom half being hidden by it. During Courbet's life, it was agreed that he showed very poor taste in vociferously showing off his spurious talent. I also saw that examples of this kind were infinite, and that they extended into every realm of thought. As for the artists themselves, most readily renounced their freedom and placed their art at the service of anyone or anything. Their concerns and ambitions were usually the same as those of any opportunist. In this way I acquired complete mistrust of art and artists, whether they were officially blessed or only aspired to be, and I felt I·had nothing in common with such company. I possessed a point of reference that placed me elsewhere—it was that magic of art that I had known in my childhood.

In 1915, I tried to rediscover the stance that would enable me to see the world other than as others wanted to impose it upon me. I had mastered certain techniques of the art of painting, and, in isolation, I made attempts that were deliberately different from anything I knew in painting. I tasted the pleasures of freedom in painting the least conformist images. Then, by a singular chance, I was handed—with a pitying smile and probably the idiotic idea of having a good joke on me—the illustrated catalogue of an exhibition of Futurist paintings. I had before my eyes a powerful challenge to the good sense with which I was so bored. For me, it was like the light I had found again upon emerging from the underground vaults of the old cemetery where I had spent my childhood vacations.

In a state of real intoxication, I painted a whole series of Futurist pictures.

Yet, I don't believe I was a truly orthodox Futurist because the lyricism I wanted to capture had an unchanging center unrelated to aesthetic Futurism.

It was a pure and powerful feeling: eroticism. The little girl I had known in the old cemetery was the object of my reveries, and she became involved in the animated ambiences of stations, fairs, or towns that I created for her. Thanks to this magical painting I recaptured the same sensations I had had in my childhood.

The elements that entered into the composi-

tions of my paintings were represented by means of flexible shapes and colors, so that those shapes and colors could be modified and shaped to the demands imposed by a rhythm of movement.

For example, the elongated rectangle representing the trunk of a tree was sometimes sectioned, sometimes bent, sometimes barely visible, according to the role it played. These completely free forms were not in disagreement with nature, which does not insist (in the case of the tree in question) on producing trees of a rigorously invariable color, dimension, and form.

These kinds of concerns gradually raised the question of the relationship between an object and its form, and between its apparent form and the essential thing it must possess in order for it to exist. I tried to find the plastic equivalents of this essential thing, and my attention turned away from the movement of objects. Then I painted pictures representing immobile objects shorn of their details and their secondary characteristics. These objects revealed to the eye only their essentials, and, in contrast to the image we have of them in real life, where they are concrete, the painted image signified a very lively perception of abstract existence.

This contrast was reduced; I ended up by finding in the appearance of the real world itself the same abstraction as in my paintings; for despite the complex combinations of details and nuances in a real landscape, I managed to see it as though it were only a curtain hanging in front of me. I became uncertain of the depth of the countryside, unconvinced of the remoteness of the light blue of the horizon; direct experience simply placed it at eye level.

I was in the same innocent state as the child in his cradle who believes he can catch the bird flying in the sky. Paul Valéry, it seems, experienced this same state by the sea, which, he says, rises up before the eyes of the spectator. The French Impressionist painters, Seurat among others, saw the world in exactly this way when they broke down the colors of objects.

Now I had to animate this world that, even when in motion, had no depth and had lost all consistency. I then thought that the objects themselves should eloquently reveal their existence, and I looked for the means to achieve this end.

The novelty of this undertaking made me lose sight of the fact that my earlier experiments, which had led to an abstract representation of the world, had become useless when this very abstraction became characteristic of the real world. In addi-

tion, it was still with my old manner of painting that I began to execute paintings with a new point of departure; this discord kept me from thoroughly exploiting the researches I was undertaking; my attempts up to this point to show the evidence, the existence of an object, had been hampered by the abstract image I was giving of that object. The rose I put on the bosom of a nude girl did not create the overwhelming effect I had anticipated.

I subsequently introduced into my paintings elements complete with all the details they show us in reality, and I soon realized, that when represented in this fashion, they immediately brought into question their corresponding elements in the real world.

Thus I decided about 1925 to paint only the superficial characteristics of objects because my researches could be developed under no other condition. I was actually renouncing only a certain manner of painting that had brought me to a point I had to go beyond. This decision, which caused me to break with a comfortable habit, was the outcome of a lengthy meditation I had in a working-class restaurant in Brussels. My state of mind made the moldings of a door seem endowed with a mysterious existence, and for a long time I remained in contact with their reality.

That was when I used to meet my friends Paul Nougé, E. L. T. Mesens, and Jean [sic] Scutenaire. We were united by shared concerns. We met the Surrealists, who were violently demonstrating their disgust for bourgeois society. Since their revolutionary demands were the same as ours, we joined with them in the service of the proletarian revolution.

This was a setback. The politicians leading the workers' parties were in fact too vain and too lacking in perspicacity to appreciate the Surrealists' contribution. These people in high places were allowed to compromise seriously the proletarian cause in 1914. They also indulged in every cowardice, every baseness. In Germany, at a time when they still represented a perfectly disciplined worker population and when this power could have been exploited to crush easily that asshole Hitler, they gave in to him and his handful of fanatics. Recently, in France, Monsieur Blum helped the Germans and Italians murder the young Spanish Republic and, purportedly fearing a revolutionary situation, he seems to be ignoring the people's rights and prerogatives by giving way in his turn to a threatening reactionary minority. It should be noted in passing that a political leader of the proletariat has to be very courageous to dare declare his faith in the cause he defends. Such men are assassinated.

The subversive aspect of Surrealism has clearly worried the traditional labor politicians, who at times are indistinguishable from the most fanatic defenders of the bourgeois world. Surrealist thought is revolutionary on all levels and is necessarily opposed to the bourgeois conception of art. As it turns out, the leftist politicians ascribe to this bourgeois conception, and they want nothing to do with painting if it does not conform.

However, the bourgeois conception of art should be inimical to the politician who calls himself revolutionary and who should thus be looking toward the future, since [this conception's]

characteristics are a cult dedicated exclusively to past achievements and a desire to halt artistic development. Further, the value of a work of art is gauged in the bourgeois world by its rarity, by its value in gold; its intrinsic value interests only a few old-fashioned innocents who are as satisfied by the sight of a wildflower as by the possession of a real or paste diamond. A conscientious revolutionary like Lenin judges gold at its true value. He wrote: "When we have achieved victory on a world scale, I think we will build public latrines in gold on the streets of some of the world's largest cities." A feeble-minded reactionary such as Clémenceau, the zealous lackey of every bourgeois myth, made this outrageous statement about art: "Yes, I won the World War, but if I am to be honored in future history, I owe it to my incursions into the realms of art."

Surrealism is revolutionary because it is the indomitable foe of all the bourgeois ideological values that are keeping the world in its present appalling condition.

From 1925 to 1926, I painted some sixty pictures, which were shown at the Centaur Gallery in Brussels. The proof of freedom they revealed naturally outraged the critics, from whom I had expected nothing interesting anyway. I was accused of everything. I was faulted for the absence of certain things and for the presence of others.

The lack of plastic qualities noted by the critics had actually been filled by an objective representation of things, which was clearly understood and comprehended by those whose taste had not been ruined by the literature that had been created around painting. I believed this detached way of representing objects corresponded to a universal style, in which one person's manias and petty preferences no longer played a part. For example, I used light blue to represent the sky, unlike the bourgeois artists who paint sky as an excuse to show their favorite blue next to their favorite gray. I consider such petty little preferences to be irrelevant, and these artists to be lending themselves to a most ridiculous spectacle, albeit with great seriousness.

Traditional picturesqueness, the only one granted critical approval, had good reasons for not appearing in my paintings: by itself, the picturesque is inoperable and negates itself each time it reappears in the same guise. Before it became traditional, its charm was derived from unexpectedness, the novelty of a mood, and unfamiliarity. But by repeating a few such effects, picturesqueness has become disgustingly monotonous. How can the public at each spring salon continue to look without nausea at the same

sunny or moonlit old church wall? Those onions and eggs either to the right or to the left of the inevitable copper pot with its predictable highlights? Or the swan that since antiquity has been about to penetrate those thousands of Ledas?

I think the picturesque can be employed like any other element, provided it is placed in a new order or particular circumstances, for example: a legless veteran will create a sensation at a court ball. The traditional picturesqueness of that ruined cemetery path seemed magical to me in my childhood because I came upon it after the darkness of the underground vaults.

I was criticized for the ambiguity of my paintings. That was quite an admission for the ones who were complaining: they unwittingly reveal their timidity when, left to themselves, they no longer have the guarantees of some expert, the sanction of time, or any other guideline to reassure them.

I was criticized for the rarefied nature of my interests—a singular reproach, coming from people for whom rarity indicates great value.

I was also criticized for many other things, and finally for having shown objects situated in places where we never really find them. Yet this is the fulfillment of a real, if unconscious, desire common to most men. In fact, ordinary painting is already attempting, within the limits set for it, to upset in some small way the order in which it generally views objects. It has allowed itself some timid bravado, a few vague allusions. Given my desire to make the most ordinary objects shock if at all possible, I obviously had to upset the order in which one generally places them. I found the cracks we see in our houses and on our faces to be more eloquent in the sky; turned wooden table legs lost their innocent existence if they suddenly appeared towering over a forest; a woman's body floating above a city advantageously replaced the angels that never appeared to me; I found it useful to envisage the Virgin Mary's underwear, and showed her in this new light; I preferred to believe that the iron bells hanging from our fine horses' necks grew there like dangerous plants on the edge of precipices. . . .

As for the mystery, the enigma my paintings embodied, I will say that this was the best proof of my break with all the absurd mental habits that commonly replace any authentic feeling of existence.

The pictures painted in the following years, from 1925 to 1936, were also the result of a systematic search for an overwhelming poetic effect through the arrangement of objects borrowed from reality, which would give the real world from

which those objects had been borrowed an overwhelming poetic meaning by a natural process of exchange.

The means I used were analyzed in a work by Paul Nougé entitled *Les images défendues (Forbidden Images)*. Those means were, first, the displacement of objects, for example: a Louis-Philippe table on an ice floe, the flag on a dung heap. The choice of things to be displaced was made from among very ordinary objects in order to give the displacement maximum effectiveness. A burning child affects us much more than the self-destruction of a distant planet. Paul Nougé rightly noted that certain objects, devoid of any special affective content in themselves, retained this precise meaning when removed to unfamiliar surroundings. Thus, women's undergarments were particularly resistant to any sudden change.

The creation of new objects; the transformation of known objects; the alteration of certain objects' substance—a wooden sky, for example; the use of words associated with images; the false labeling of an image; the realization of ideas suggested by friends; the representation of certain day-dreaming visions—all these, in sum, were ways of forcing objects finally to become sensational.

In *Les images défendues,* Paul Nougé also remarks that the titles of my paintings are conversational commodities rather than explications. The titles are chosen in such a way that they also impede their being situated in some reassuring realm that automatic thought processes might otherwise find for them in order to underestimate their significance. The titles should provide additional protection in discouraging any attempt to reduce real poetry to an inconsequential game.

One night in 1936 I awoke in a room in which someone had put a cage with a sleeping bird. A wonderful aberration made me see the cage with the bird gone and replaced by an egg. There and then, I grasped a new and astonishing poetic secret, for the shock I felt had been caused precisely by the affinity of two objects, the cage and the egg, whereas previously this shock had been caused by the encounter between two completely unrelated objects.

From that moment, I sought to find out whether objects besides the cage could also disclose—by bringing to light an element characteristic of them and absolutely predestined for them—the same unmistakable poetry the union of the egg and cage had managed to produce. In the course of my experiments I came to the conviction that I always knew beforehand that element to be discovered, that certain thing above all the others attached obscurely to each object; but this knowledge had lain as if lost in the depths of my thoughts.

Since this research could only yield one right answer for each object, my investigations were like problem solving in which I had three givens: the object, the entity linked with it in the recesses of my mind, and the light under which that entity would emerge.

The problem of the door called for an opening one could pass through. In *La réponse imprévue (The Unexpected Answer),* I showed a closed door in a room; in the door an irregular-shaped opening revealed the night.

Painting *La découverte du feu (The Discovery of Fire)* granted me the privilege of sharing early man's feeling when he gave birth to fire by striking together two pieces of stone. In my turn, I imagined setting fire to a piece of paper, an egg, and a key.

The problem of the window gave rise to *La condition humaine (The Human Condition).* In front of a window seen from inside a room, I placed a painting representing exactly that portion of the landscape covered by the painting. Thus, the tree in the picture hid the tree behind it, outside the room. For the spectator, it was both inside the room within the painting and outside in the real landscape. This simultaneous existence in two different spaces is like living simultaneously in the past and in the present, as in cases of déjà vu.

The tree as subject of a problem became a large leaf whose stem was a trunk with its roots stuck straight into the ground. In remembrance of a poem by Baudelaire, I called it *La géante (The Giantess).*

For the house, I showed, through an open window in the façade of a house, a room containing a house. This became *L'éloge de la dialectique (In Praise of Dialectic).*

L'invention collective (The Collective Invention) was the answer to the problem of the sea. On the beach I laid a new species of siren, whose head and upper body were those of a fish and whose lower parts, from stomach to legs, were those of a woman.

I came to an understanding of the problem of light by illuminating both the bust of a woman painted in a picture and the painting itself with the same candle. This solution was called *La lumière des coïncidences (The Light of Coincidences).*

La domaine d'Arnheim (The Domain of Arnheim) is the realization of a vision Edgard[sic] Poe would have liked: it shows a vast mountain shaped exactly like a bird with spread wings. It is seen through an open bay window on whose ledge sit two eggs.

Woman gave me *Le viol (The Rape).* It is a woman's face comprised of parts of her body: the breasts are eyes, the navel the nose, and the sexual organs replace the mouth.

The problem of shoes demonstrates how the most frightening things can, through inattention, become completely innocuous. Thanks to *Le modèle rouge (The Red Model),* we realize that the union of a human foot and a shoe is actually a monstrous custom.

In *Le printemps éternel (The Eternal Spring),* a dancer has replaced the genitals of a Hercules lying by the sea.

The problem of rain led to huge clouds hovering on the ground within the panorama of a rainy countryside. *La sélection naturelle (Natural Selection), Union libre (Free Union),* and *Le chant de l'orage (The Song of the Storm)* are three versions of this solution.

The last problem I addressed myself to was that of the horse. During my researches, I was again shown that I had known unconsciously long beforehand the thing that had to be brought to light. Indeed, my first idea was a vaguely perceived notion of the final solution: it was the idea of a horse carrying three shapeless masses whose significance I did not understand until after a series of trials and errors. I made an object consisting of a jar and a label bearing the image of a horse and the inscription in printed letters *Confiture de cheval (Horse Preserves).* Next I imagined a horse whose head was replaced by a hand with the little finger pointing forward, but I realized that this was merely the equivalent of a unicorn. I dwelt for some time on one intriguing combination: in a dark room I placed a horsewoman sitting by a table, her head resting on her hand while she gazed dreamily at a landscape shaped like a horse. The horse's lower body and legs were the colors of the sky and clouds. What put me at last on the right track was a rider in the position one takes when riding a galloping horse; from the sleeve of the arm thrust forward emerged the head of a race horse, and the other arm, thrown back, held a whip. Next to this horseman, I placed an American Indian in the same posture, and suddenly I sensed the meaning of the three shapeless masses I had set upon the horse at the beginning of my experiments. I knew they were riders, and I finished off *La Chaine sans fin (The Endless Chain)* as follows: in a deserted landscape, under a dark sky, a rearing horse carries a modern horseman, a knight of the Late Middle Ages, and a horseman from antiquity.

Nietzsche believed that without an overheated sexual makeup Raphael would never have painted his hordes of Madonnas. . . . This is at striking variance with the motives usually attributed to this Old Master; according to priests, it

was the ardor of his Christian faith; aesthetes contend it was the desire for pure beauty, etc. . . . But [Nietzsche's] opinion brings us back to a healthier interpretation of pictorial phenomena. This disorderly world of ours, full of contradictions, keeps going more or less because of explanations, by turns complex and ingenious, that seem to justify it and render it acceptable to the majority of mankind. Such explanations account for one kind of experiment. It must be remarked, however, that what is involved is a "ready-made" experiment and that while it may give rise to brilliant analyses, this experiment is not itself based on an analysis of its own real circumstances.

Future society will develop an experiment that will be the fruit of a profound analysis, whose perspectives are being outlined under our very eyes.

It is thanks to a rigorous preliminary analysis that pictorial experiment as I understand it can now be set up. This pictorial experiment confirms my faith in life's unexpected possibilities.

All these overlooked things that are coming to light lead me to believe that our happiness, as well, depends on an enigma concerning man, and that our only duty is to attempt to understand it.

—René Magritte, lecture given November 20, 1938, at the Musée Royal des Beaux-Arts, Antwerp. A later abridged version, La Ligne de Vie II, *dates from February 1940*

The True Art of Painting

The effects of the art of painting are as numerous as the possible ways of understanding and practicing it.

The earliest drawings of prehistoric times required an immense mental effort from the caveman, not only to conceive them, but also to *dare* to conceive them despite the prejudices that held sway.

It is extremely likely that the first draftsman was killed for practicing black magic, and afterwards, when people had grown used to it, other draftsmen probably came to be regarded as gods, and finally, in the dawning age of heraldry, as mere disseminators of information.

In the twentieth century, these different prehistoric ways of understanding the art of painting

persist. The painter who desires spiritual freedom still encounters widespread hostility, the official painter is an honored figure, the commercial painter is a salaried employee commissioned to decorate bordellos, churches, department store windows, advertising posters, and other means of modern propaganda.

Archaeology, both past and present, made note of all the methods of painting. But this reckoning is not very useful to someone who is looking for a manner of painting that would be useful to mankind.

The art of painting is an art of thinking, and its existence emphasizes the importance to life of the human body's eyes; the sense of sight is actually the only one concerned in painting.

The goal of the art of painting is to perfect sight through a pure visual perception of the exterior world by means of sight alone. A picture conceived with this goal in mind is a means of replacing nature's awesome spectacles, which generally require only a mechanical functioning of the eye because of the familiarity that obscures such repetitious or predictable natural phenomena. On the other hand, should nature suddenly take on a threatening aspect, it is not only sight but also the other senses—hearing, smell, touch, taste—that help throw us into a state of panic hardly conducive to our making fruitful contact with the exterior world.

Thus we see that a painter is mediocre if he doesn't give special consideration to the importance of his spectators' eyes. One example of a mediocre painting would be one executed to flatter a rich banker's patriotic sentiments and libidinous proclivities. It might show the banker before an unfurled flag, one arm brandishing an unsheathed sword and the other holding a lovely, swooning woman, her flesh revealed by a dress that has been torn by some routed barbarian. Clearly sight plays no especial role in such a painting: it presents the same painful spectacle as the sight of the door to a safe. The painting may be useful to the banker as an erotic or heroic stimulant, but these utterly banal excitements do not allow for a pure visual perception of the exterior world.

A less mediocre painter, one who recognized that the sole aim of painting is to involve the sense of sight, would still misunderstand this aim if he executed a painting like the following: a blindfolded man walking through a forest is being approached by a murderer armed with a knife. This would be a mistake, because although the man's sight would be necessary for his survival, it only becomes important at this moment of danger due to a temporary feeling of anxiety. This picture

would mean that if it weren't for the murderer the man's sight would be less important.

Modified, the same subject could give way to the following: a blindfolded man walking through a forest (without a murderer). In this case the importance of the man's sense of sight would undoubtedly be called into question, but not as effectively as it would if the spectator's own eyes were given the opportunity to realize their full potential.

To achieve this result, the painter must invent his pictures and bring them to completion under very difficult circumstances. He must start off with a contempt for fame and thus forgo the material comforts that might enable him to work in peace. He must have contempt for fame, since in order to win that fame he would have to paint mediocre pictures like those described earlier. Fame will come on its own, or it won't. (The fame of Da Vinci, Galileo, [or] Mozart adds nothing to their achievements.)

In addition to a life subject to ridicule, insult, or worse (since he will be considered a humbug or degenerate), the painter is constantly faced with professional problems because his way of understanding and practicing the art of true painting obeys an implacable law: the perfect picture does not allow for meditation, which is a feeling as banal and uninteresting as patriotism, eroticism, etc. The perfect picture produces an intense effect only for a brief moment, and the feelings that recall the initial response are to a greater or lesser degree mitigated by habit. This inexorable law forces the painter to outdo himself with each new picture, not in the sense of some futile elaboration but rather as a productive renewal. In accordance with this law, the spectator must be disposed to experience a moment of unique awareness and to admit his powerlessness to prolong it. This unique contact for the spectator takes place in front of the picture (the first spectator is the painter himself), and it is vital at the moment this contact is made that the picture not be divorced from the wall on which it is hung, the floor, the ceiling, the spectator, or from anything else that exists.

The special problems the painter must resolve are psychological in nature. The painter must not allow himself to be led astray by the technique of the art of painting, which has been further complicated by the succession of different manners of painting that have emerged over the past century. The caveman's simple linear representation was replaced by the same representation increasingly perfected so as to fill in the body's outline with its apparent volume. The science of perspective and the study of anatomy placed at the painter's disposal infallible means for achieving trompe l'oeil

effects to the point where easy experiments can leave no room for doubt of this fact.

About 1900, at the moment when this technique had reached perfection, it became clear that it was operating in a vacuum: the countless landscapes and portraits were unable, despite their numbers, to inspire anything but boredom.

The century began with discoveries that replaced old techniques with new ones in every field of endeavor. Painters, tired of lifeless painting, joined in the general infatuation with technique and attempted to give painting renewed youth. The cinema showed them images in motion on a screen, and this astonishing novelty incited them to compete with it. Unfortunately, the problem was badly posed. The technique of the art of painting having been perfected, it was useless to seek painting's rejuvenation in still another technique. In fact, a perfect technique of the art of painting was available, but it was being used without intelligence or effectiveness while the clumsy technique of the newborn art of cinema still derived its effects from its novelty.

So painters, misunderstanding the problem of painting, cast about for new techniques, and through them managed to restore to painting a few fleeting moments of superficial vitality. The Impressionists, Cubists, Futurists, all experienced moments of agitation and excitement due to original techniques, but they were futile, since these same moments of agitation and excitement could be achieved, and better, through other means than those related to painting.

Now that these technical experiments have come to an end (along with their successors such as abstract or nonfigurative art, Constructivism, Orphism, etc.), the technical problem can be posed to the painter correctly as a function of the desired result; and the great importance of technique, assuming one has mastered it, can be restored to its proper proportions as a *means*.

Since the true goal of the art of painting is to conceive and execute paintings that are able to give the viewer a pure visual perception of the exterior world, the painter must not contravene the natural workings of the eye, which sees objects according to a universal visual code: for example, the eye perceives the object "sky" as a blue surface. If the painter wishes to give a pure visual perception of the sky, he must employ a blue surface, adopting all the visual characteristics of that surface (nuances, perspective, luminosity, etc.). This presents no technical problem to the painter who has mastered the technique necessary to represent this blue surface, which, for the sense of sight, is all that is needed to depict the sky. However, it does present a psychological problem: how can the sky be represented according to the desired result? What should be done with the sky? There are some fine possibilities open to us; we have only to know how to use them. Some solutions will be found in the painter's technique, while others are better suited to the cinematographic technique, which is also capable of creating pure visual perception. Thus, the idea of an immobile flash of lightning can be of little help to a painter, since this image in a painting would be associated with the idea of its flashing movement; whereas on a screen, by means of simple trick photography, the spectator could see a stroke of lightning immobilized in a tumultuous sky. In this regard, the cinema ideally should, like painting, obey the psychological law mentioned earlier and only show a stroke of lightning long enough for the eyes to register its immobility, because once this moment has passed the lightning's immobility will become devoid of any interest.

For the painter, the search for ways to convey the sky, a pipe, a woman, a tree, or any other object, is his principal labor. This work is carried out in total obscurity, even though [the painter] must protect his sense of freedom within his obscurity if he wants to keep from being carried off course by the magnetic pull of chance.
——*René Magritte, Le Véritable Art de Peindre, 1949*

I am thinking of further researches, because of the idea I had about what could make certain pictures valid. Their realization depended on the exactness of the solutions found for the problems that had been posed, in the following manner: once an object or any subject had been chosen as a question, another object had to be found in answer, one secretly linked to the first by complex bonds so as to verify the answer. If the answer asserted itself, self-evident, the union of the two objects was striking.

The researches that led up to these revelations were undertaken, I realize now, to find a unilateral, irreversible meaning in some objects. Although the answers clarify the questions, the questions do not clarify the answers. If the dagger is the answer to the rose, the rose is not the answer to the dagger; neither is water to the boat, nor the piano to the ring. This verification allows us to go on to investigate the answers that are also questions, resolved by the objects that originally played the role of questions. Is this possible? It seems to demand that the human will attain that quality Edgard [sic] Poe attributes to divine works, "where cause and effect are reversible." If we can conceive this quality, it is perhaps not impossible for us to attain it through a process of enlightenment.
——*René Magritte, La Carte d'Après Nature, no. 1, October 1952*

I had a little idea: instead of writing a strange word under an object, I thought of trying to paint a plum on a pear, or something else, such as a locomotive on a recumbent lion, etc.
——*Letter from René Magritte to Mirabelle Dors and Maurice Rapin, February 14, 1956*

I'm also sending you a sketch of a variant of *La place au soleil (The Place in the Sun)*. It occurs to me that this image could be joined successfully with a volume of *La Femme Assise (The Seated Woman)**. Be joined with, not illustrate.
——*Letter from René Magritte to Mirabelle Dors and Maurice Rapin, February 24, 1956*

*By Guillaume Apollinaire

I'm continuing *La place au soleil*. The latest thing I've done is the delineation of the Egyptian scribe on a lovely apple.
——*Letter from René Magritte to Mirabelle Dors and Maurice Rapin, March 13, 1956*

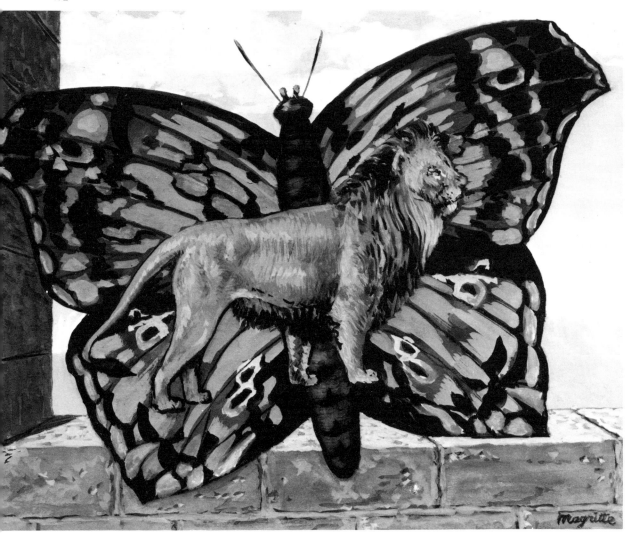

I would reproduce six different paintings* of *La place au soleil,* including:

The scribe "on" the apple

Botticelli's *Primavera* "on" a bowler-hatted individual seen from behind

Gérard's *Madame Recamier* "on" her chair

A bird "on" a leaf, and two other pictures whose objects remain to be found. . . .

The *origin* that I *know* for *La place au soleil* was an often overlooked "chance." On sketches we often see indications that remind the painter of what he has seen: one painter, for example, *writes* "pale green, red," etc., on his sketches. On a map made to give directions, we write: "road to . . . square, theater, etc. . . ." On an architect's plan: "room, corridor, garden, etc. . . ."

The words written on drawings are not put there without some mental process. "Chance" intervenes when one realizes one can write words on a drawing not to "inform," but just to write them, to describe a drawing on which words are written. And these words are not meant to be decorative motifs, but rather to be joined with images—to the extent of words that mean what they designate; to the extent of images that represent objects. . . .

La place au soleil is an "objective stimulation," if you like, with the difference that the image placed "on" another takes on an even stranger character: instead of an apple "on" the same apple, we have a scribe.

——*Letter from René Magritte to Mirabelle Dors and Maurice Rapin, March 21, 1956*

*For a book whose title, *La Place au Soleil,* would relate to these new images.

I have continued my *Places au soleil* [sic], but see how the title is no longer good for a big tree in the evening on which one sees a crescent moon! In this case, we are given a better, or in any event another, description of *La place au soleil:* what we see on one object is another object hidden by the one that comes between us and the hidden object.

——*Letter from René Magritte to Mirabelle Dors and Maurice Rapin, April 20, 1956*

I have just painted the moon on a tree in the blue-gray colors of evening. Scutenaire has come up with a very beautiful title: *Le seize septembre (September Sixteenth).* I think it "fits," so from September 16th on, we'll call it done.

——*Letter from René Magritte to Mirabelle Dors and Maurice Rapin, August 6, 1956*

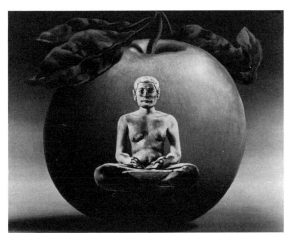

One can question the obligation to experience a feeling "determined" by what we look at. Something familiar is sometimes seen with a feeling of strangeness, and we can have a familiar feeling with regard to so-called mysterious things. In both possibilities, one finds the union either of a feeling of strangeness, the familiar object, and ourselves, or of a familiar feeling, the mysterious object, and ourselves. This does not imply that our feelings are "determined," nor that the painter can decide which feeling a painting ought to inspire. It should be noted in this regard that everything that is "determined" (or rather is considered to be) conspicuously lacks charm and interest: we don't really like a picture upon learning what it has allegedly "determined." It is immediately "lost sight of" in favor of a tedious and irrelevant commentary.

The feeling we experience while looking at a picture cannot be separated from either the picture or ourselves. The feeling, the picture, we, are joined in our mystery.
—Letter from René Magritte to Paul Colinet, 1957

If painting were obliged to express emotions or set forth ideas, I would express neither optimism nor its opposite.

We cannot be too unsure of the effectiveness of our so-called power of expression. What we feel when looking at a painting, or when looking into a blue distance, for example, does not imply that we are "determined" by what appears to us. Yet painting—like the blue distance and everything else—reveals images of the world, and it can happen that in looking at them, painting them, thinking about them, we have this unfamiliar feeling of our mystery—one we also have sometimes with our eyes closed.
—Letter from René Magritte to Paul Colinet, 1957

Things are neither as simple nor as complicated; in my opinion, the *theme* consists of the following: *a picture inside out*—whatever the subject it represents in this way—within something (like a landscape) right side out. One version of the picture *Le réveille-matin (The Alarm Clock)* would be possible by representing a face (or a landscape) on the inside-out picture. But if I paint on an easel representing, for example, an afternoon sky (right side out) against a nocturnal sky (right side out), it's another "theme," although there's still a picture and an easel.

I'm called a "Surrealist," but I don't worry about it. I sometimes care about stating clearly certain ideas that are completely useless. I consider "wasting one's time" in this way is as good as another. Like everyone, I believed in the existence of the "unconscious" as though I really needed to believe in it. I've given that and other things up without feeling diminished or extended and without becoming simpler or more complicated.
—Letter from René Magritte to Defosse, February 3, 1958

"Large formats." Their dimensions alone produce an "effect." Any idiot's picture enlarged on a 50-yard-high surface set up in a field would create a sensational "effect." I am wary of such an effect, and that of miniatures. . . .

The question of "going beyond" art seems to exist on a level that means nothing to me. I "paint pictures," officially I am an *artiste-peintre.* I'm neither this side nor the other of artistic thought: I think I'm somewhere else.
—Letter from René Magritte to Maurice Rapin, March 31, 1958

Attached are the replies I made during an interview that's supposed to be broadcast. I hope they amuse you. Yours, René Magritte.

1. René Magritte, at this moment an exhibition of your paintings is being held at the Museum of Ixelles. I believe it's a retrospective, isn't it?

Yes, it is. The Museum of Ixelles has hung almost a hundred pictures chosen from among those I painted from 1926 to fairly recently.

2. How do you feel when you see your works again some time after having painted them?

My feeling is that I didn't do too badly in painting pictures that can surprise me as though I hadn't actually created them.

3. Don't you feel somewhat paternal when you see such a large exhibition of your work?

Of course, but with the perplexity of a father who doesn't really know why his children turned out so beautiful or ugly.

4. If you, the painter, are perplexed when you look at your paintings, it's understandable that people visiting your exhibition are confused, especially if they have some aesthetic preference for painters they feel they can more easily understand.

It's not only understandable, but I think it demonstrates that if certain things seem familiar or "nonperplexing" to us, it's because of notions that make them pass as such. I've taken care to paint precisely those pictures that don't have a familiar look and have nothing to do with naïve or sophisticated notions.

5. One could say, then, that you avoid like the plague expressing ideas in your painting?

I avoid it as much as possible. I feel that words express enough ideas, sometimes very beautiful ones but all too frequently tedious, without painting having to add its own. As I see it, painting is not meant to express ideas, even ideas of genius. If the painter has genius, he has a genius for images, not for ideas.

6. But don't the titles of your paintings evoke ideas?

Perhaps, since even a misunderstood word can evoke the idea that there is meaning. But the words we do understand do not always necessarily evoke ideas. The title of a picture is an image made up of words. It joins up with a painted image without trying to satisfy a need to understand ideas. The title and the picture enrich and refine thought, which enjoys images whose meaning is unknown.

7. I'm tempted to ask you why thought enjoys images with unknown meanings?

It seems obvious that enigmas and puzzles are appealing to thought. The game consists in finding what is hidden. But the game has nothing to do with images whose meanings remain unknown. I believe that thought enjoys the unknown, that is to say, what is unknowable, since the meaning of thought itself is unknown.
—Letter from René Magritte to André Bosmans, April 16, 1959

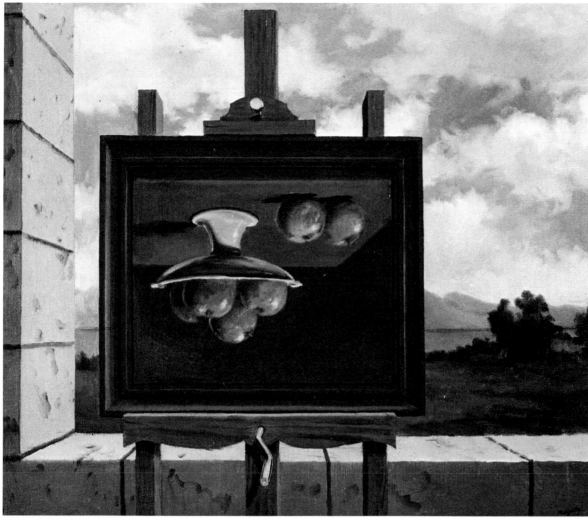

476 *Le réveil-matin (The Alarm Clock).*
1953. Oil on canvas, 20½ x 24⅝"
(52 x 62.5 cm). Private collection,
Rome, Italy

The pictorial language, like other languages, evokes mystery de facto if not de jure.

I try—insofar as possible—to paint pictures that evoke mystery with the precision and charm necessary to the realm of thought. It's obvious that this precise and charming evocation of mystery is composed of images of familiar objects, brought together or transformed in such a way that they no longer satisfy our naïve or sophisticated notions.

In coming to know these images, we discover the precision and charm that are lacking in the "real" world in which they appear.
——*René Magritte, Preface to exhibition catalogue,* René Magritte, *Musée d'Ixelles, April 19, 1959*

An image (after having been conceived with the sole intention of creating a beautiful image) can be successfully joined with a text. . . . The word "illustration" should be eliminated. It is the "joining" of an existing text with an image chosen from among preexisting images that establishes the felicitous encounter between images and words. . . .
——*Letter from René Magritte to André Bosmans, May 11, 1959*

This manner [of representing the image] is indispensable, otherwise there is no visible representation of the image. What is superfluous and best avoided are the originality, fantasy, and awkwardness that can become part of the manner.
——*Letter from René Magritte to André Bosmans, October 1960*

Have thought some more about the "art of mime." It must be avoided as far as possible. Mime "expresses" emotions (if one indeed recognizes a certain facial expression as expressing a specific emotion, as taught us by convention).

If you could tell Dallas that my painting is wholly alien to anything conventional, it would be wonderful, but would it be difficult to say? Especially since in Dallas they seem so taken with the notion of mimicry!

I'm giving you a lot of problems, but fortunately they are only those befitting a magnificent and outstanding ambassador.
——*Letter from René Magritte to Harry Torczyner, October 21, 1960*

I'm happy to learn that you put "squarely" to Dallas what I thought about comparing mime and my painting. I particularly maintain that my painting *expresses nothing* (nor do other paintings, for that matter). Just because painting corresponds to (or engenders) some of our feelings doesn't mean it expresses them. To believe it expresses feeling would be to admit, for example, that an onion expresses the tears we shed when peeling it. The tear-onion peeling relationship is an obvious and inevitable one (except for those with blocked tear ducts). The painting-emotion relationship is just as clear (except for the blind or the wooden). But the conclusion—onion expressing tears or painting-onion the emotions we feel upon looking at it—is one of those mistaken notions whose elimination is a utopian dream. (A brave man asked me only yesterday, "What painting 'expresses'

joy?"! With all the goodwill in the world, I was unable to make him understand that it was the painting he took joy in looking at.)
——*Letter from René Magritte to Harry Torczyner, October 24, 1960*

As for the onion story—written in a letter—if it is to be printed. I think it should be "cleaned up" as follows:

There is a mistaken idea about painting that is very widespread—namely, that painting has the power to express emotion, something of which it is certainly incapable. It is possible that one may be moved while looking at a painting, but to deduce by this that the picture expresses an emotion is like saying, for example, that a cake "expresses" the baker's feelings and expresses the pleasure we derive from tasting it. . . . (I've replaced onion with cake, thereby avoiding the objection that the onion is not [like the picture] a manmade object.)
——*Letter from René Magritte to Harry Torczyner, November 1960*

Mr. Mc Agy has unintentionally given me the opportunity to clear up this question of "expression": a mime doubtless "expresses" emotions, if one agrees that this or that grimace is the expression of this or that feeling. Without forgetting that the mime is not expressing his own feelings—in fact, he can express goodness and yet be wicked and thoroughly incapable of a good action—without forgetting this, can we still believe that what he is expressing deserves to be called an expression of goodness? And what interest does this kind of caricature of expression have?
——*Letter from René Magritte to Harry Torczyner, November 14, 1960*

Resemblance—as the word is used in everyday language—is attributed to things that have or do not have qualities in common. People say "they resemble each other like two drops of water," and they say just as easily that the imitation resembles the original. This so-called resemblance consists of relationships of similarity and is distinguished by the mind, which examines, evaluates, and compares. Such mental processes are carried out without being aware of anything other than possible similarities. To this awareness things reveal only their similar qualities.

Resemblance is part of the essential mental process: that of resembling. Thought "resembles" by becoming what the world presents to it, and by restoring what it has been offered to the mystery without which there would be no possibility of either world or thought. Inspiration is the result of the emergence of resemblance.

The art of painting—when not construed as a relatively harmless hoax—can neither expound ideas nor express emotions. The image of a weeping face does not express sorrow, nor does it articulate the idea of sorrow: ideas and emotions have no visible form.

I particularly like this idea that my paintings *say nothing*. (Neither, by the way, do other paintings.)

There is a mistaken idea about painting that is very widespread—namely, that painting has the power to express emotion, something of which it is certainly incapable. Emotions do not have any concrete form that could be reproduced in paint.

It is possible that one may be moved while looking at a painting, but to deduce by this that the picture "expresses" that emotion is like saying that, for example, a cake "expresses" the ideas and emotions of those of us who see it or eat it, or again, that the cake "expresses" the thoughts of the chef while baking a good cake. (To the man who asked me, "Which is the picture that 'expresses' joy?" I could only answer "The one that gives you joy to see.")

The art of painting—which actually should be called the art of resemblance—enables us to describe in painting a thought that has the potential of becoming visible. This thought includes only those images the world offers: people, curtains, weapons, stars, solids, inscriptions, etc. Resemblance spontaneously unites these figures in an order that immediately evokes mystery.

The description of such a thought need not be original. Originality or fantasy would only add weakness and poverty. The precision and charm of an image of resemblance depend on the resemblance, and not on some imaginative manner of describing it.

"How to paint" the description of the resemblance must be strictly confined to spreading colors on a surface in such a way that their effective aspect recedes and allows the image of resemblance to emerge.

An image of resemblance shows all that there is, *namely, a group of figures that implies nothing*. To try to interpret—in order to exercise some supposed freedom—is to misunderstand an inspired image and to substitute for it a gratuitous interpretation, which, in turn, can become the subject of an endless series of superfluous interpretations.

An image is not to be confused with any aspect of the world or with anything tangible. The image of bread and jam is obviously not edible, and by the same token taking a piece of bread and jam and showing it in an exhibition of paintings in no way alters its effective aspect. It would be absurd to believe [this appearance] capable of giving rise to the description of any thought whatsoever.

The same may be said in passing to be true of paint spread about or thrown on a canvas, whether for pleasure or for some private purpose.

An image of resemblance never results from the illustration of a "subject," whether banal or extraordinary, nor from the expression of an idea or an emotion. *Inspiration gives the painter what must be painted:* that resemblance that is a thought capable of becoming visible through painting—for example, an idea the component terms of which are a piece of bread and jam and the inscription, "This is not bread and jam"; or further, an idea composed of a nocturnal landscape beneath a sunlit sky. De jure such images suggest mystery, whereas de facto the mystery would be suggested only by the slice of bread and jam or the nocturnal scene under a starry sky.

However, all images that contradict "commonsense" do not necessarily evoke mystery de jure. Contradiction can only arise from a manner of thought whose vitality depends on the possibility of contradiction. Inspiration has nothing to do with either bad or good will. Resemblance is an inspired thought that cares neither about naïveté nor sophistication. Reason and absurdity are necessarily its opposites.

It is with words that titles are given to images. But these words cease being familiar or strange once they have aptly named the images of resemblance. Inspiration is necessary to say them or hear them.
——*René Magritte, statement in exhibition catalogue* René Magritte in America, *the Dallas Museum for Contemporary Arts and The Museum of Fine Arts of Houston, 1960*

. . . the word *illustrator* (here in its true sense: one who renders illustrious) also means in other cases something we should be wary of. An image that accompanies a text—if it is valid—is never an "illustration," and it never results from an illustrator's procedure. Yes, there are sometimes pleasant illustrations, but they add nothing to the text illustrated. However, an image conceived with no thought other than its conception can felicitously *join* a text and enrich it by accompanying it. Then it's not a question of illustration, nor of pleasant art.
——*Letter from René Magritte to Pierre Demarne, July 22, 1961*

Similarity

Similarity can be verified by various means of measurement. It must not be confused, however, with resemblance, despite the habit of considering peas to resemble each other, or an imitation and the original, or even the sky and its reflection in the water of a lake—things that only share varying degrees of similarity. Things that are inherently different or not thus find themselves endowed with so-called resemblance. Resemblance pertains only to thought; it resembles by becoming the world as it is invisibly manifest (ideas, emotions, sensations) and as it is visibly manifest (people, skies, mountains, furniture, solids, inscriptions, images, etc.). Without recourse to mystification, the art of painting does not consider itself the art of describing the invisible. Painting is assuredly inappropriate to the articulation of ideas, the expression of emotions, and the description of sensations. The art of painting must confine itself to the description of the thought that resembles the visible the world offers.

Inspiration is when thought has the power to evoke the mystery without which neither world nor thought would be possible.

I identify poetry with the description of inspired thought.

The art of painting—as I conceive it—is limited to the description of the inspired thought that can be made visible, that is, the thought that unites the visible manifested by the world in an order that conveys mystery.

The description of inspired thought in painting allows for the advent of visible poetry.
——*René Magritte, Preface to the exhibition catalogue* René Magritte, *Milan, 1962*

I visited the exhibition *La Part du Rêve (The Dream Share)** with interest; I think it is very well done.

However, I must point out one mistake: there is a notice in one vitrine describing the objects represented in my pictures as "symbols." I'd appreciate your correcting this. They are *objects* (bells, skies, trees, etc.) and not "symbols." In the representational arts, symbols are for the most part employed by artists who are very respectful of a certain way of thinking: that of endowing an object with some conventional and commonplace meaning. My concept of painting, on the contrary, tends to restore to the objects their value as objects (which never fails to shock those who cannot look at a painting without automatically wondering what may be symbolic, allegorical, etc., about it).

I feel it best to avoid confusion on this matter insofar as possible.
——*Letter from René Magritte to P. Roberts-Jones, April 26, 1964*

*Musée d'Art Moderne, Brussels, April 25–July 19, 1964

My concept of painting is opposed to the notion of "illustrating" a given subject.

For example: in an edition of the *Chants du Maldoror,* there is an "illustration" of mine that was made before there was any question of this edition. It's a drawing for *Le viol (The Rape),* a picture that was painted some years before the *Chants du Maldoror* appeared, and without my having thought of Lautréamont's book. . . .

To return to illustrations, I've only "been clear" about them for a few years. Before then, I used to do some from time to time, but never with much interest: I "felt" I had better things to do, without exactly knowing why. De facto, I have always (since 1926) looked for *what* to paint rather than concerned myself with a manner of painting, like nearly all painters. For several years now, I know that it has to be like this, de jure, despite the importance people give to originality in the various manners of painting.

One more or one less is all the same as far as I am concerned, along with the "interpretation" of a familiar subject by a painter who is fooling himself as well as others. It seems impossible to make people understand that true imagination has nothing to do with the imaginary. Imagination is the inspiration that enables one to say or to paint (without originality) what has to be said or painted. It is not a question of interpreting, brilliantly or not, any "subject" chosen from a long and oft-used list.
——*Letter from René Magritte to Harry Torczyner, September 11, 1965*

With time, I have become committed to the renunciation of painterly researches that give primacy to the "manner of painting." I now know that since 1926 I have no longer been concerned with anything but "what must be painted." This became clear only a fairly long time after "instinctively" researching what had to be painted.
——*Letter from René Magritte to Harry Torczyner, September 18, 1965*

478 Letter from René Magritte to Volker Kahmen, November 25, 1964. *See* Appendix *for translation*

RENÉ MAGRITTE
97, RUE DES MIMOSAS, BRUXELLES 3
TÉLÉPHONE 15.97.30

le 25 Novembre 1964

Cher Monsieur,

Je vous adresse ci-joint la documentation que vous désirez. Je ne puis malheureusement pas vous aider à trouver d'autres ouvrages, beaucoup sont "épuisés". Mais j'espère que d'heureux hasards se présenteront pour compléter votre documentation.

Je vous remercie de votre intérêt et de vos vœux d'anniversaire. Avec le temps (à peu près quarante années de peinture!) beaucoup de préoccupations artistiques ne me semblent plus mériter que l'on s'en soucie. Avec Vinci, le peintre a cessé d'être un domestique, mais les choses ont "évolué" de telle sorte que les artistes peintres modernes sont devenus des esclaves de leur art : c'est la "peinture" (le morceau de toile recouverte de peinture) qui les intéresse et à quoi ils se consacrent.

Je suis assuré d'être en *rupture* avec cette manière de vivre. La peinture est un moyen, pour moi, qui permet de décrire une pensée *constituée uniquement* par ce que le monde offre de visible. Cette pensée n'est pas celle d'un spécialiste, elle ne prétend qu'à voir, mieux : qu'à devenir, *le monde tel qu'il est.* Il ne peut être question d'imaginaire, de fantaisie, de fantastique, d'espoir, de désespoir, d'activité d'art "d'avant-garde, etc.

Cette pensée qui mérite d'être décrite, correctement, se distingue de la conscience habituelle pour qui le monde est un "objet" à exploiter d'une manière ou d'une autre : par le commerce, la religion, la guerre, la politique, la science, l'activité artistique etc.. (celle-ci n'exploite pas, mais "traite" le monde d'une manière particulière).

Cette pensée ne surgit que dans l'inspiration : l'inspiration ne consiste pas pour moi à traiter un sujet (la mort de Socrate p. ex.) mais *à savoir ce qu'il faut peindre* pour que : ce que le monde offre de visible soit uni de telle sorte que le mystère du visible et de l'invisible soit évoqué.

Le monde tel qu'il est, est inséparable de son mystère.

Bien cordialement à vous

René Magritte

I portray images, and the human figure appears in my pictures for the same reason as objects or things—a tree, sky, animal, etc. Man is a visible appearance in the same way as a tree, a house, and everything else we see. I don't deny his importance, but neither do I accord him primacy in any hierarchy of objects the world visibly offers. Actually, if I show a person it is his existence that is in play and not some activity he might be undertaking. This activity conveys nothing mysterious for me, whereas his existence is itself a mystery, like that of everything else, for that matter. . . .

With the invisible, one must nevertheless distinguish between invisible and hidden. There is the visible that is hidden—a letter in an envelope, for example, is a hidden visible, not invisible. An unknown being at the bottom of the sea is not the invisible, but the hidden visible. . . .

Painting is not something in motion, it is an image, with the immobility that that entails. I have no wish to fool myself or to fool others by pretending to show movement. On the contrary, if I could show immobility or bring to mind absolute immobility, I would achieve, I believe, a kind of perfection, because that absolute immobility would imply a suspension of thought—which cannot transcend certain limitations, which cannot understand that the world exists. The existence of the world and our own existence are shocking to contemplate. They are absolutely incomprehensible whatever explanations are proffered.

—From an interview with René Magritte by Jean Neyens, 1965

479 *La bonne nouvelle (Good News).* 1930. Oil on canvas, 31½ x 24″ (80 x 61 cm). Private collection, United States. *See* Appendix *for translation of inscription*

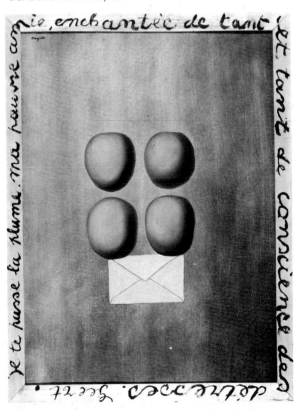

May 23, 1966

Dear Sir,

I hope you will enjoy these few reflections upon reading your book *Les Mots et les Choses (The Order of Things).*

The words "resemblance" and "similarity" enable you to suggest convincingly the presence—totally strange—of the world and of ourselves. However, I believe that these two words are inadequately differentiated, [and] dictionaries are unenlightening about the distinction between them.

For example, it seems to me that peas are related by similarity relationship, both visible (color, shape, size) and invisible (nature, taste, weight). The same is true of an imitation and the original, and so on. "Things" have no resemblance, they merely have or do not have similarities.

It pertains only to thought to resemble. It resembles by being what it sees, hears, or knows, thereby becoming what the world offers it.

[Thought] is as invisible as pleasure or pain. Painting, however, interposes a difficulty: there is thought that sees and that can be visibly described. *Las Meninas* is the visible image of Velázquez's invisible thought. Therefore, can the invisible sometimes be visible? Yes, if thought is made up exclusively of visible entities.

In this regard, it is obvious that a painted image—by nature intangible—conceals nothing, whereas the tangible visible inevitably conceals another visible, if we are to rely on our experience.

For some time now, the "invisible" has been accorded a curious primacy due to an ambiguous literature, but its interest vanishes if one recognizes that the visible can be hidden, whereas the invisible hides nothing: it can be known or ignored no more. There are no grounds for granting greater importance to the invisible than to the visible, or vice versa.

What is not "lacking" in importance is the mystery evoked de facto by the visible and the invisible, and that can be evoked de jure by thought, which unites "things" in an order evocative of mystery.

I take the liberty of bringing to your attention the enclosed reproductions of pictures I painted without concerning myself with any original research on painting.

Sincerely,

René Magritte

—Letter from René Magritte to Michel Foucault, the author of Les Mots et les Choses, *published in* Ceci n'est pas une pipe, *Fata Morgana, 1973*

In the images I paint, there is no question of either dream, escape, or symbols. My images are not substitutes for either sleeping or waking dreams. They do not give us the illusion of escaping from reality. They do not replace the habit of degrading what we see into conventional symbols, old or new.

I conceive painting as the art of juxtaposing colors in such a way that their effective aspect disappears and allows a poetic image to become visible. This image is the total description of a thought that unites—in a poetic order—familiar figures of the visible: skies, people, trees, mountains, furniture, stars, solids, inscriptions, etc. The poetic order evokes mystery, it responds to our natural interest in the unknown.

Poetic images are visible, but they are as intangible as the universe. These poetic images *hide nothing:* they show nothing but the figures of the visible. Painting is totally unfitted for representing the invisible, that is, what cannot be illuminated by the light: pleasure, sorrow, knowledge and ignorance, speech and silence, etc.

After having attempted to understand nontraditional painting, we admit that it cannot be understood. In any case, we are not assuming any serious responsibility: we do not have to know or to learn anything. Imaginary irrationality is futile and boring. However, we can understand poetic thought by making it a part of ourselves and by taking care not to remove from the known the unknown elements it contains.

—Statement by René Magritte, 1967

THE ROYAL ROAD

480 Study of *La voie royale (The Royal Road)*. n.d. Location unknown

Magritte's work is laid out in our minds like a royal road, whose milestones are indicated by certain paintings. Anyone may, de facto or de jure, establish a different selection and mentally construct a variant of the road we are to take. So rich is Magritte's enchanted domain that the many majestic paths we discover there can all lead us to other visions.

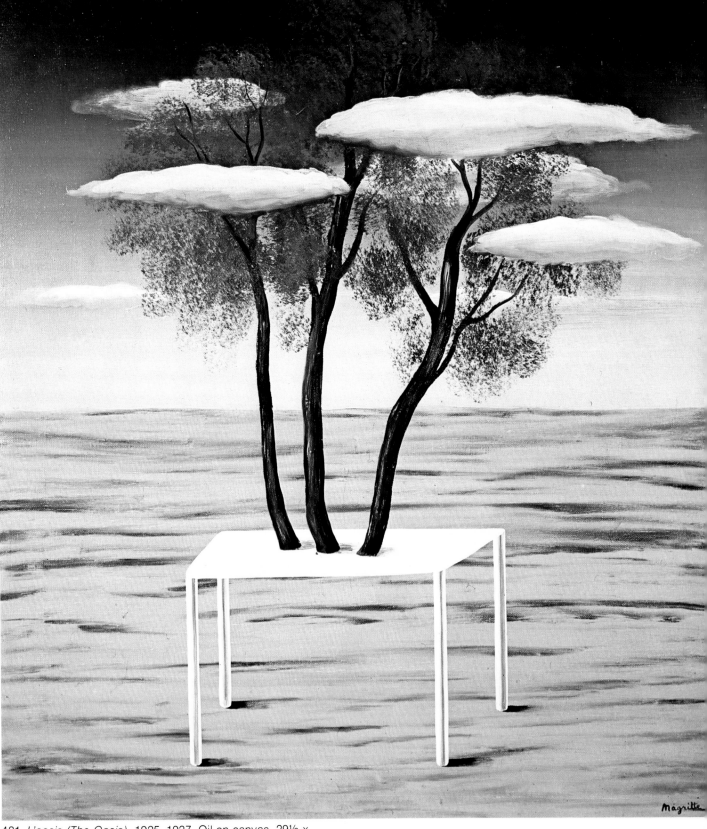

481 *L'oasis (The Oasis).* 1925–1927. Oil on canvas, 29½ x 25⅝" (75 x 65 cm). Collection Mme. J. Van Parys, Brussels, Belgium

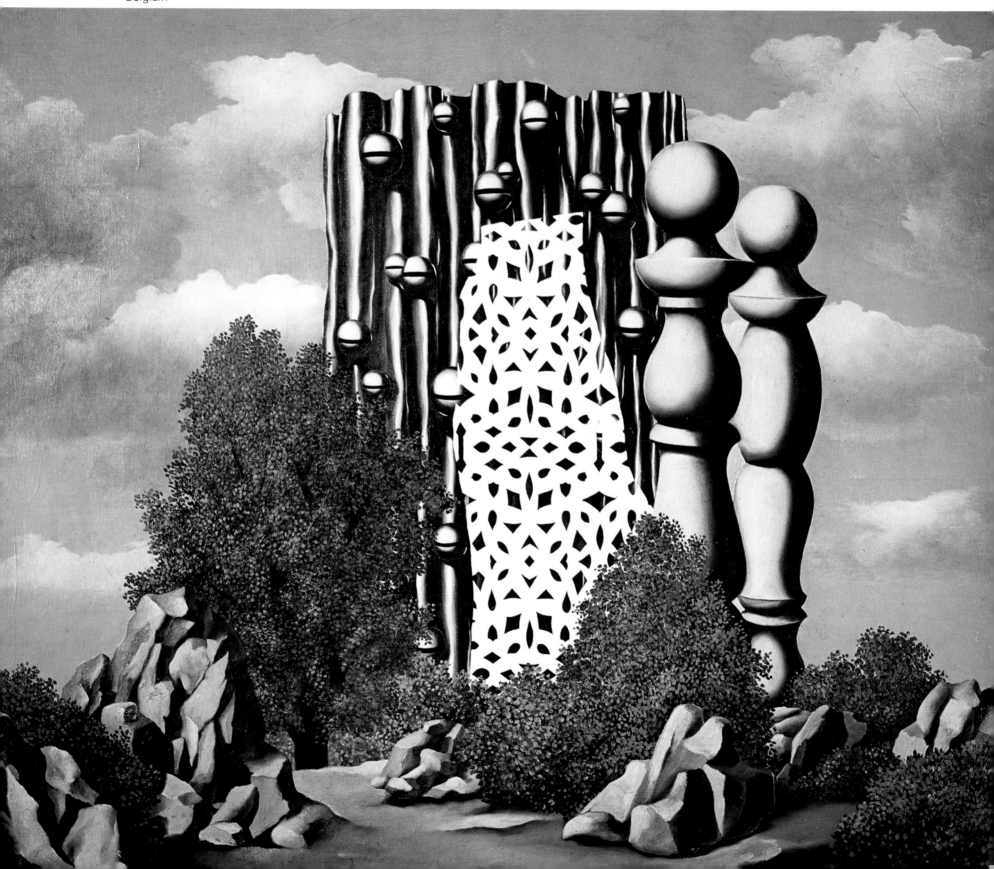

482 *L'annonciation (The Annunciation).* 1930. Oil on canvas, 44⅞ x 57½" (114 x 146 cm). Private collection, Brussels, Belgium

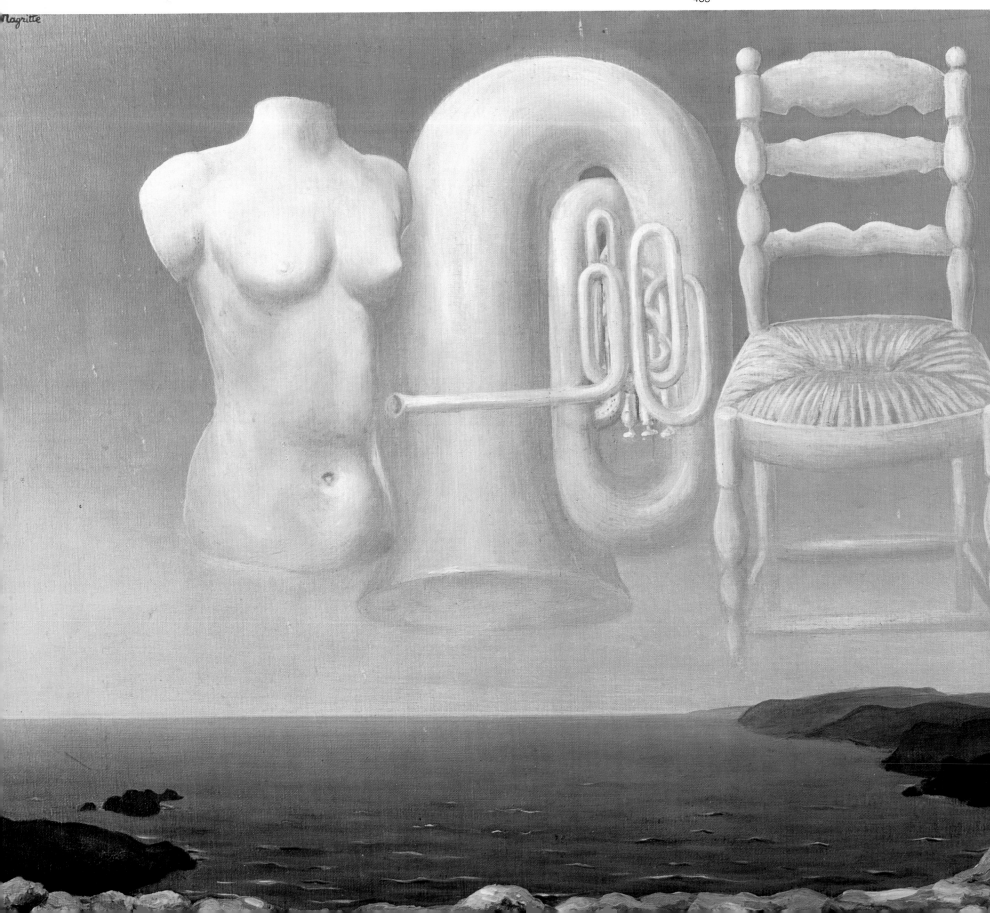

483 *Le temps menaçant (Threatening Weather)*. 1928. Oil on canvas, 21¼ x 28¾" (54 x 73 cm). Collection Sir Roland Penrose, London, England

484 *La réponse imprévue (The Unexpected Answer)*. 1933. Oil on canvas, 32¼ x 21½" (82 x 54.5 cm). Musées Royaux des Beaux-Arts de Belgique, Brussels, Belgium

483

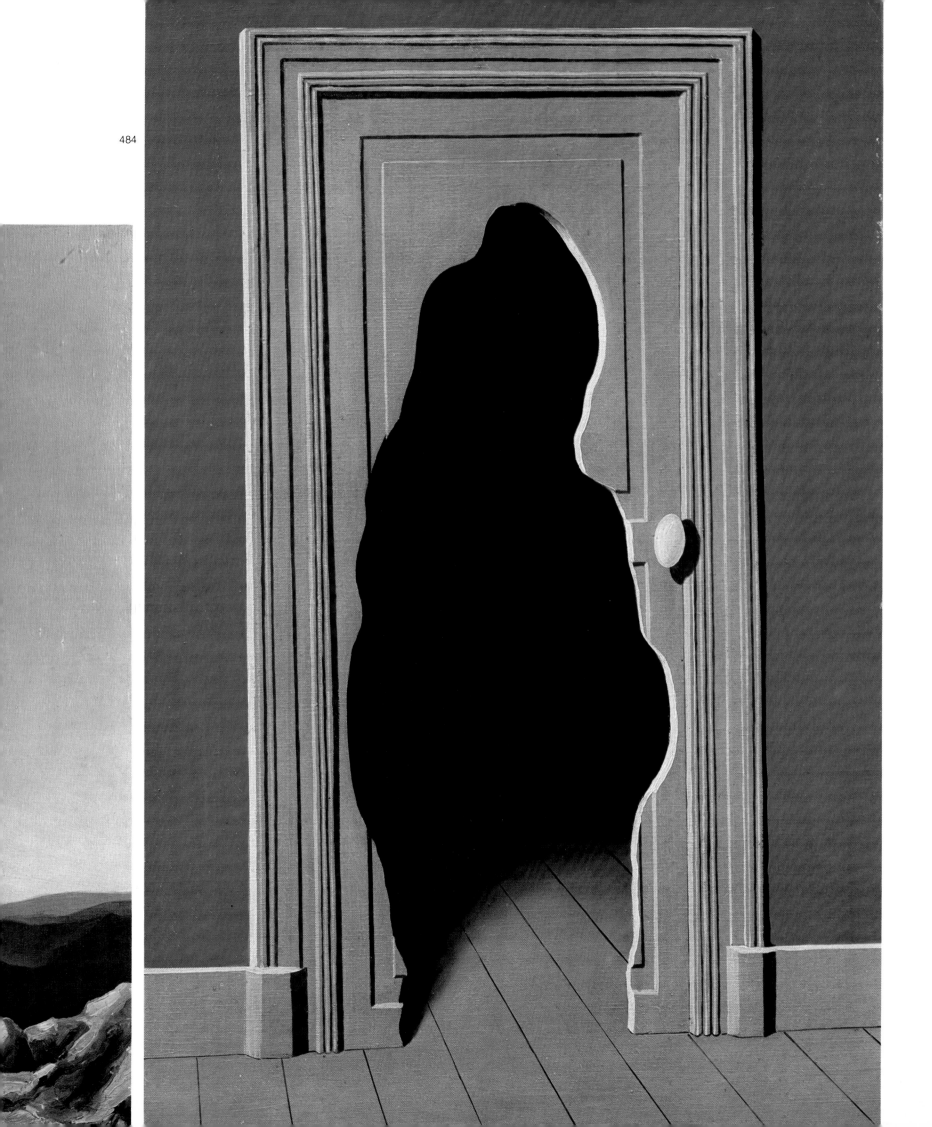

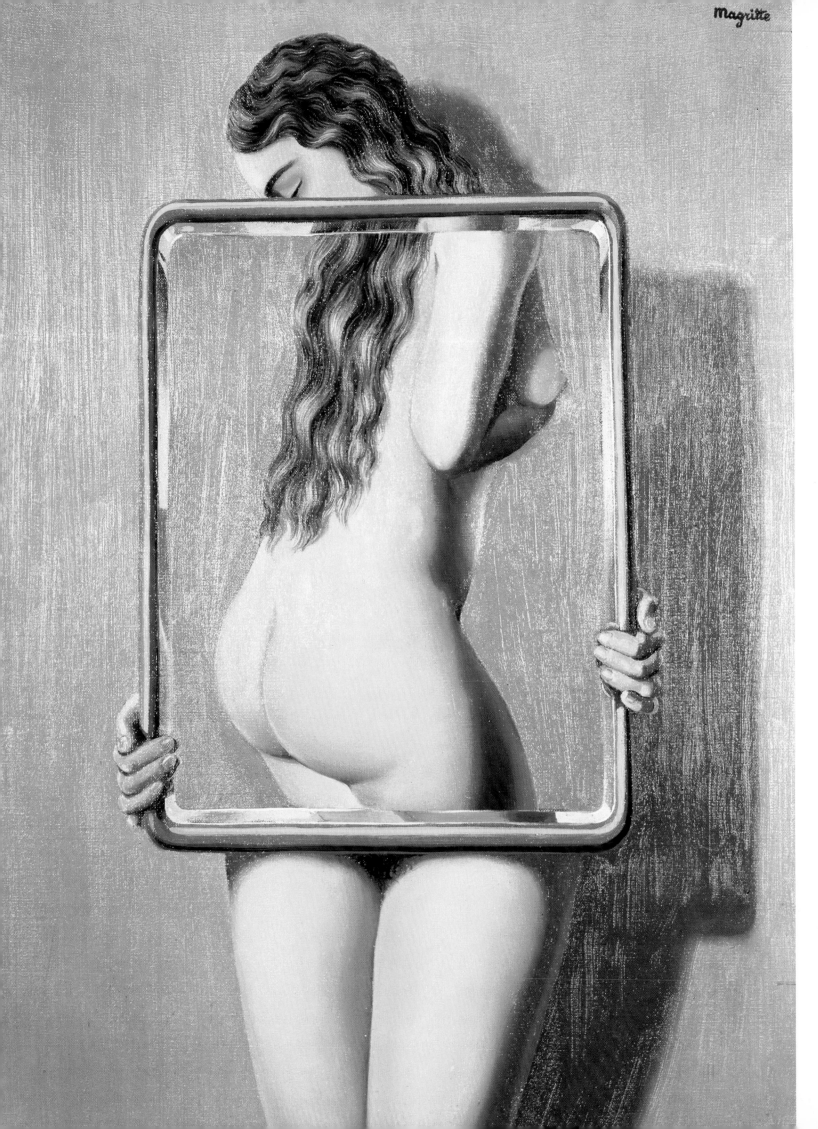

485 *Les liaisons danger-euses (Dangerous Re-lationships)*. 1936. Oil on canvas, 28⅜ x 25¼" (72 x 64 cm). Private collection, Calvados, France

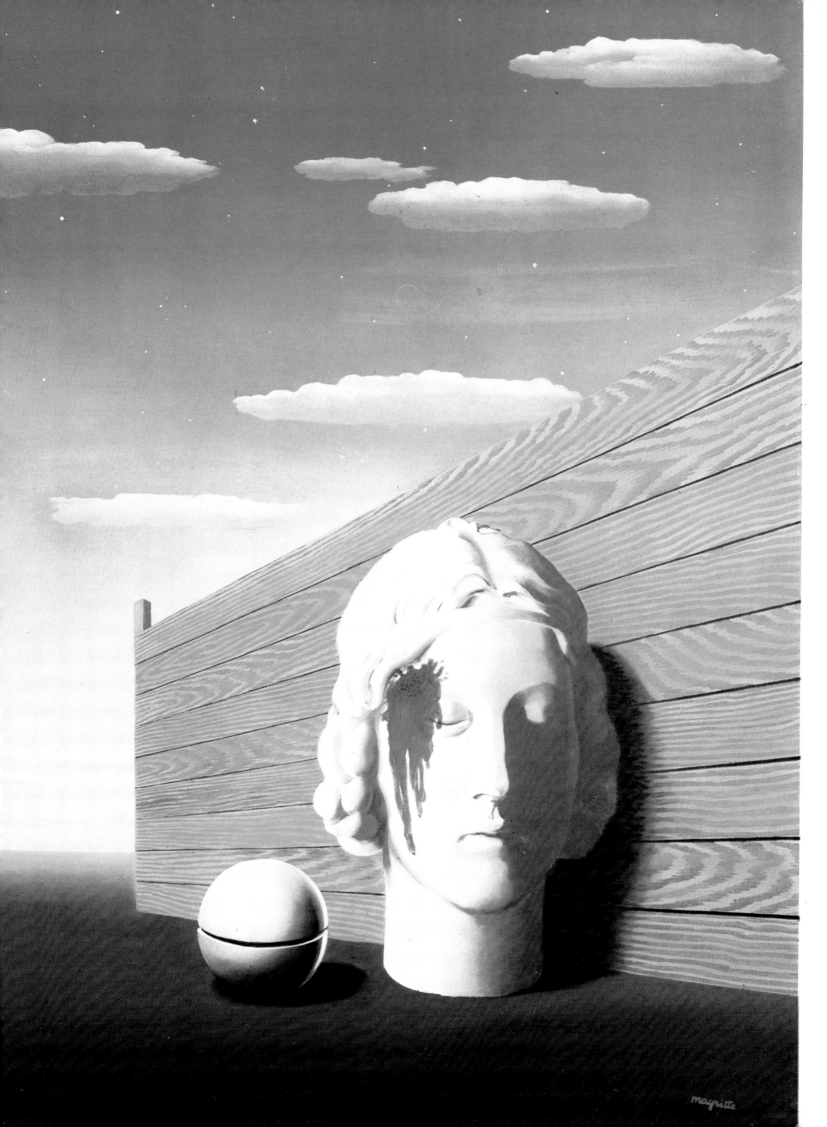

486 *La mémoire (Memory).* 1938. Oil on canvas, 28½ x 21¼″ (72.5 x 54 cm). Collection Menil Foundation, Houston, Texas

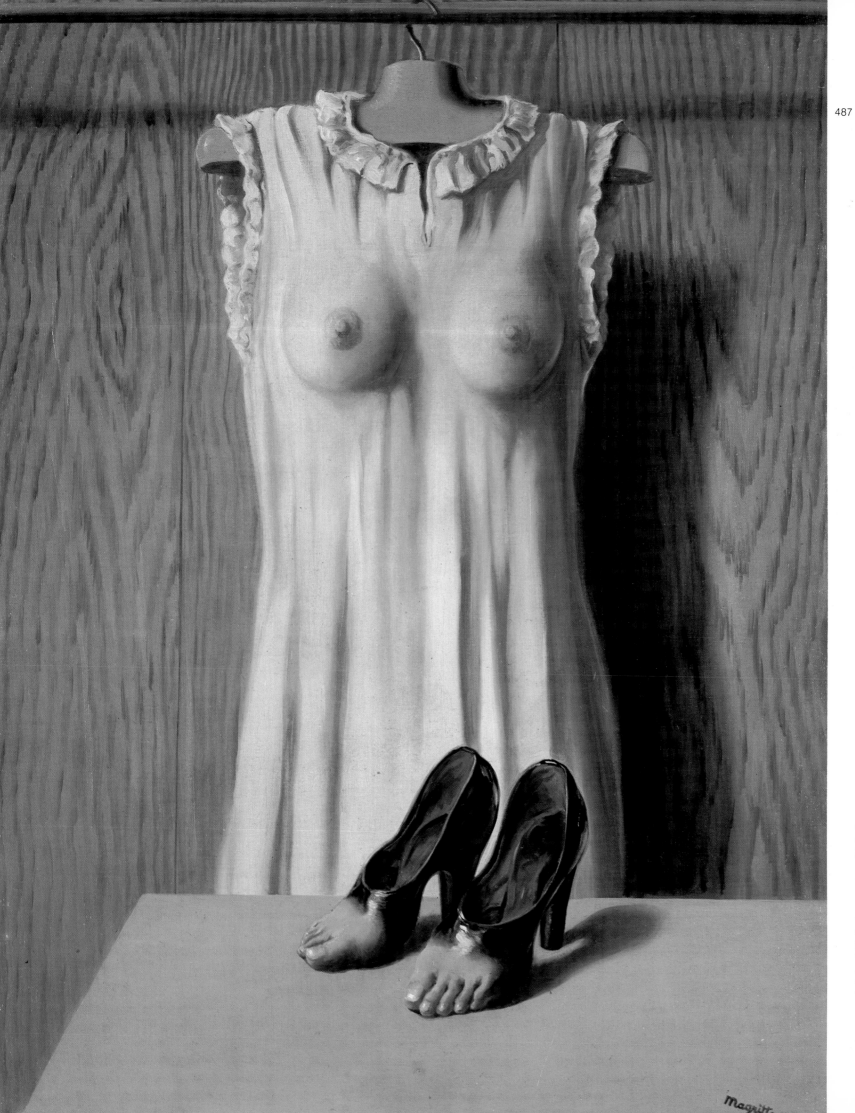

487
*La philosophie dans le
boudoir (Philosophy in
the Boudoir).*1947. Oil on
canvas, 31⅞ x 24″ (81 x
61 cm). Private collec-
tion, Washington, D.C.

488
*Les valeurs personnelles
(Personal Values).* 1952.
Oil on canvas, 31⅞ x
39⅜″ (81 x 100 cm). Pri-
vate collection, New
York, New York

If you look at this painting with the point of view necessary to admit that the work is a work of art whatever it is, you will change your opinion.* This point of view is not possible if outside preoccupations, utilitarian or rational, occupy the mind. Indeed, from the point of view of immediate usefulness, what would correspond to the idea that, for example, the sky covers the walls of a room, that a gigantic match lies on the rug, that an enormous comb is on a bed?

Such an idea would be *impotent* to resolve a utilitarian problem posed by life in society. The social individual needs a repertory of ideas in which, for example, the comb becomes the *symbol* that permits him to combine certain events, permitting him, the social individual, to act in society in accordance with movements intelligible to society: the comb will part his hair, the comb will be manufactured, will be sold, etc. In my painting, the comb (and the other objects also) have lost precisely their "social character." It is only a superfluous luxury object that can, even as you put it, disarm the onlooker and even make him sick. Well, this is exactly the proof of the efficacy of this painting. A really vibrant painting has to make the onlooker sick and if the onlookers are not sick, it is because: (1) they are too gross; (2) they are used to this malaise, which they mistake for pleasure (my painting of 1931–32 (?) *Le modèle rouge* [*The Red Model*] is now accepted, but when it was new, it made quite a number of people sick). The contact with reality (and not the symbolic reality that serves social exchanges and violences) always makes people sick.

——*Letter from René Magritte to Alexandre Iolas, October 24, 1952*

*Iolas had written to Magritte on October 15, 1952, that *Les valeurs personnelles* (*Personal Values*) depressed him, deranged him, and made him sick.

488

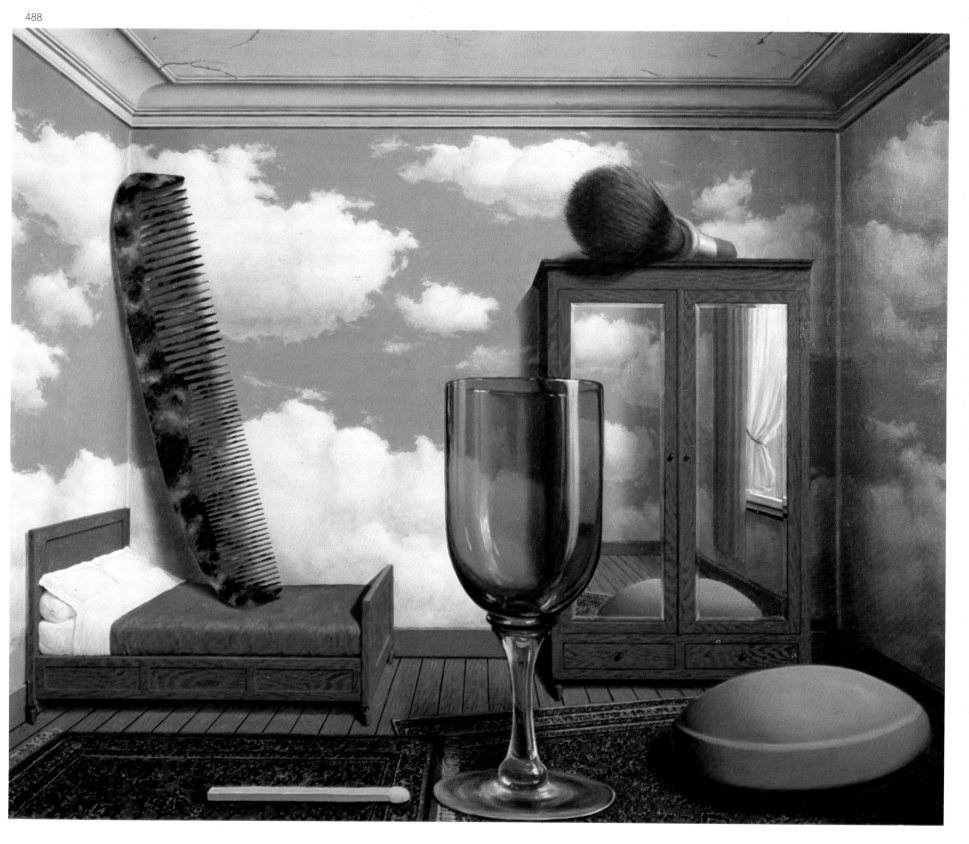

« Les promenades d'Euclide », qui est une nouvelle version du tableau « La condition humaine ». Le paysage de la "condition humaine" qui était aussi anonyme que possible, est cette fois « intéressant » par lui-même, car une large route qui aboutit à l'horizon a la même forme qu'une tour vue à l'avant plan :

et la même couleur

489 Pen sketch of *Les promenades d'Euclide (Euclidean Walks)* in a letter from René Magritte to Mirabelle Dors and Maurice Rapin, September 5, 1955. *See* Appendix *for translation*

490 *Les promenades d'Euclide (Euclidean Walks)*. c. 1955. Gouache. Private collection, Brussels, Belgium
491 Untitled drawing. n.d. Pencil, 6⅞ x 8¼″ (17.3 x 21 cm). Private collection, New York, New York
492 *Les promenades d'Euclide (Euclidean Walks)*. 1955. Oil on canvas, 64⅛ x 51⅛″ (163 x 130 cm). The Minneapolis Institute of Arts, Minneapolis, Minnesota

490

491

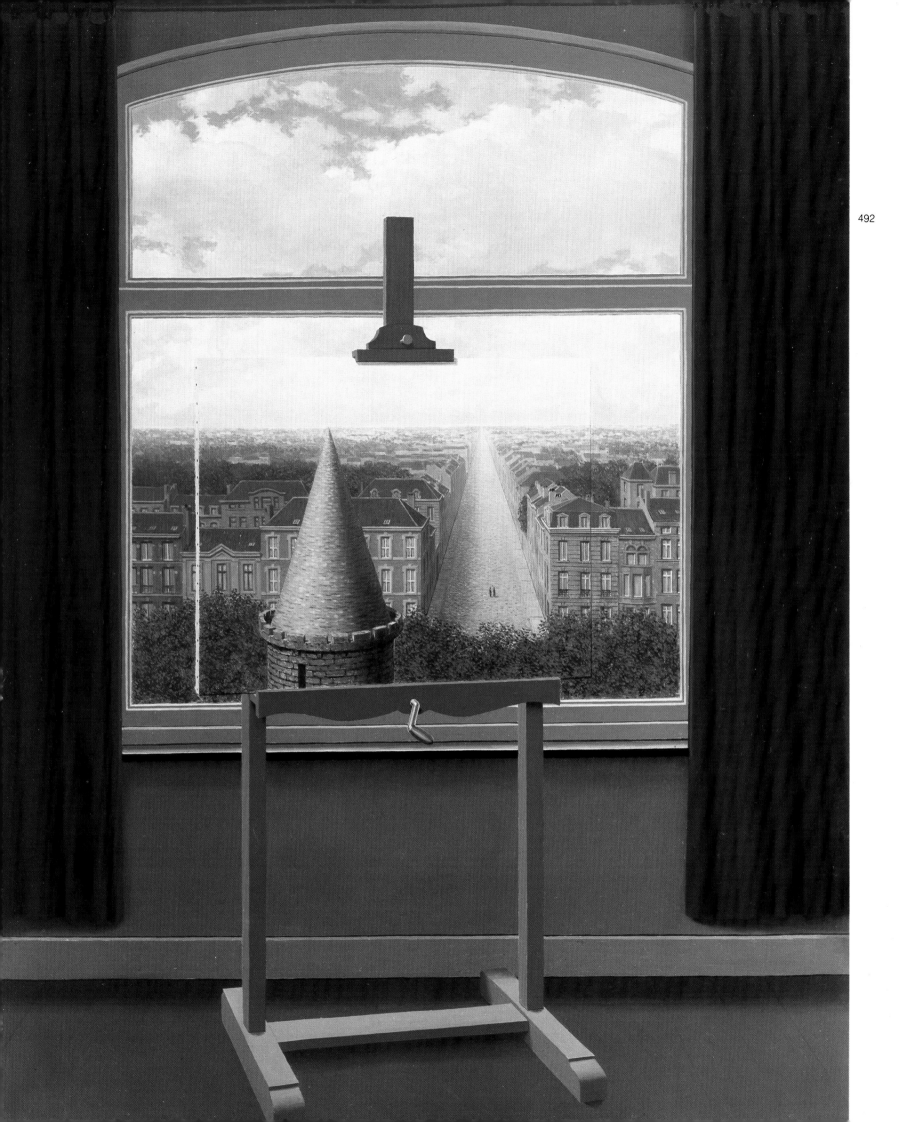

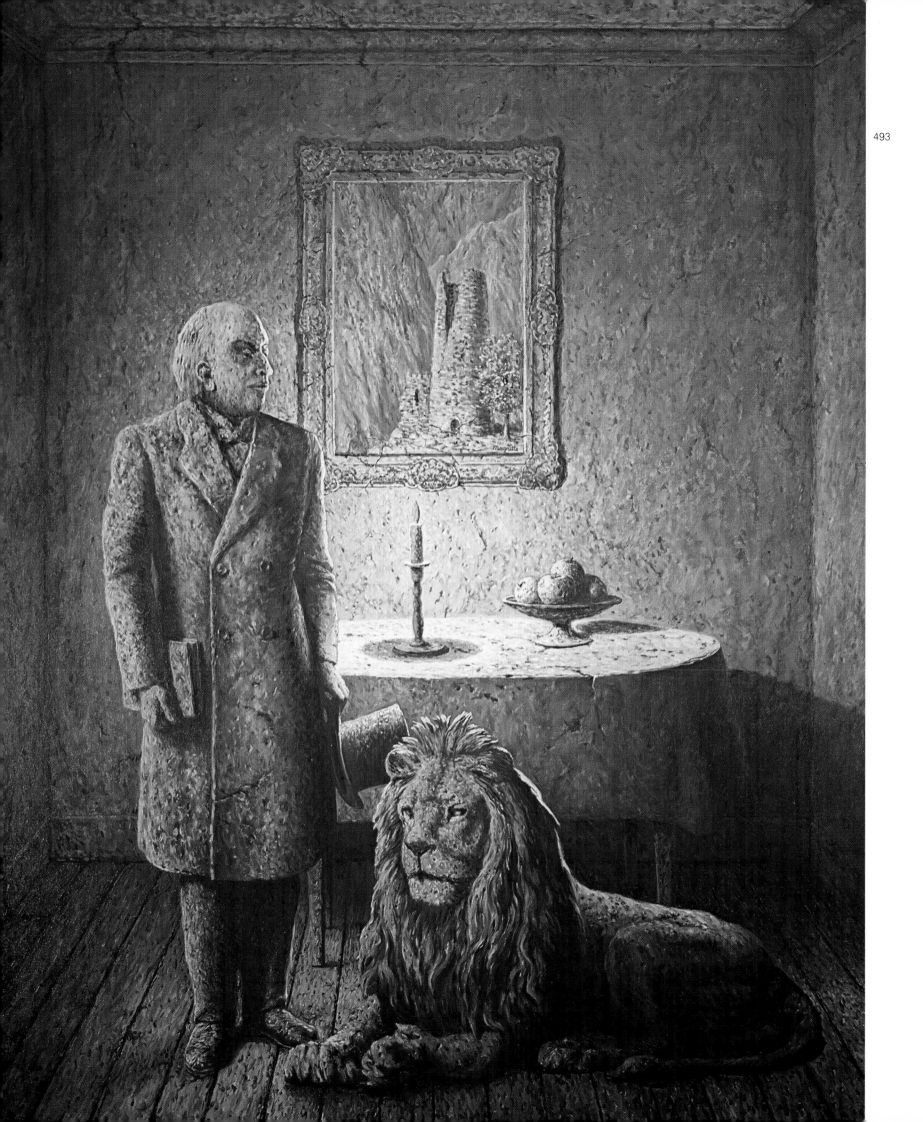

493 *Souvenir de voyage (Memory of a Voyage)*. 1955. Oil on canvas, 63⅞ x 51¼" (162.2 x 130 cm). The Museum of Modern Art, New York, New York

494 Pen sketches of *L'ami intime (The Intimate Friend)* and *La légende dorée (The Golden Legend)* in a letter from René Magritte to Maurice Rapin, January 17, 1958. *See* Appendix *for translation*

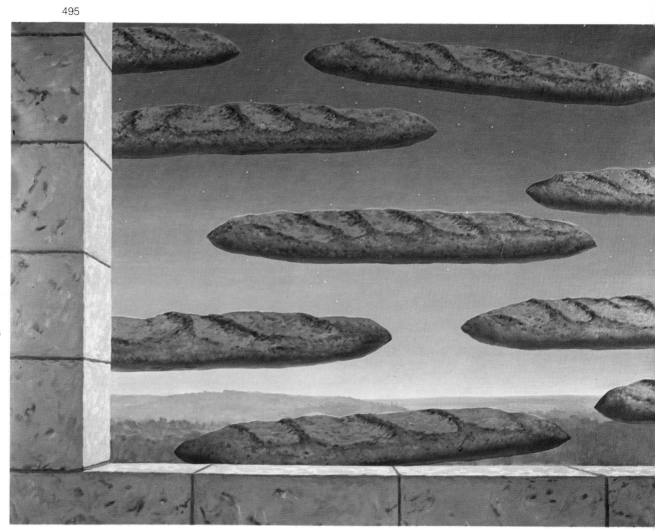

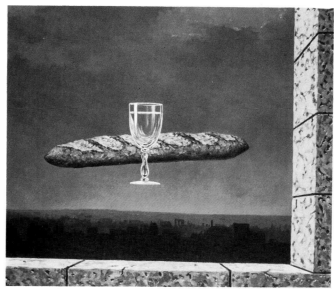

495 *La légende dorée (The Golden Legend)*. 1958. Oil on canvas, 37⅜ x 50¾" (95 x 129 cm). Private collection, New York, New York

496 *La force des choses (The Power of Things)*. 1958. Oil on canvas, 19½ x 23½" (49.6 x 59.7 cm). Collection University of St. Thomas, Houston, Texas

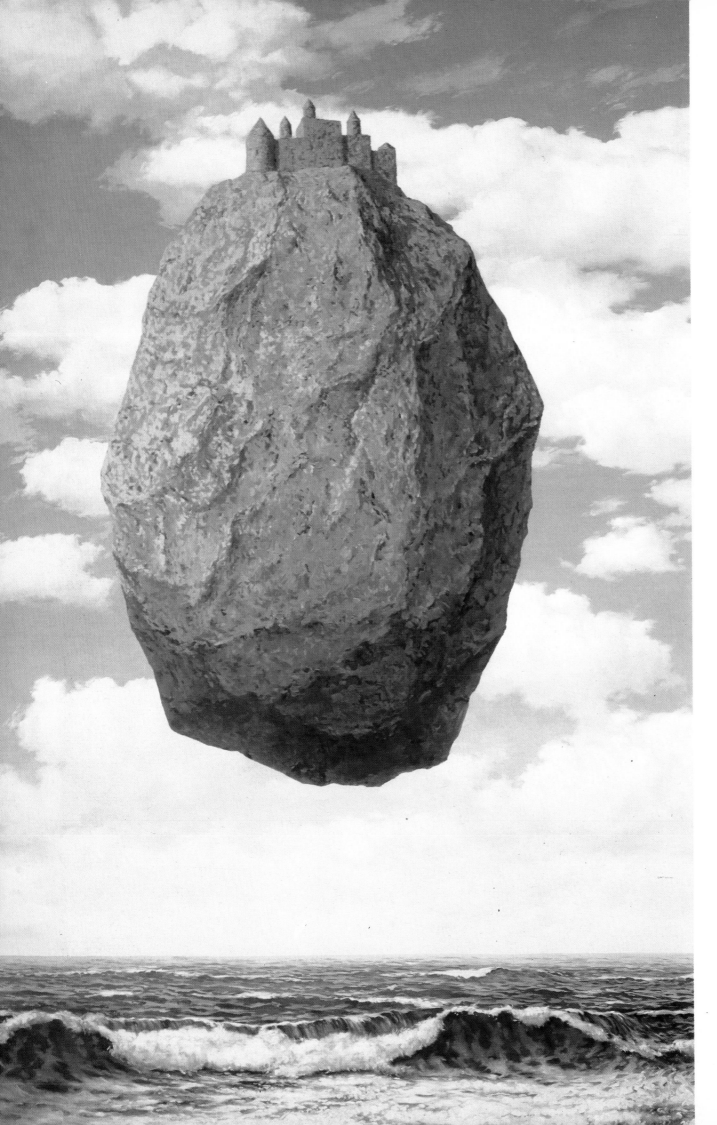

497 *Le château des Pyrénées (The Castle of the Pyrenees)*. 1959. Oil on canvas, 78¾ x 57⅛" (200 x 140.5 cm). Collection Harry Torczyner, New York, New York

498 *Le mois des vendanges (The Time of the Harvest)*. 1959. Ink drawing, 7 x 10½″ (17.8 x 26.7 cm). Private collection, New York, New York

499 *Le mois des vendanges (The Time of the Harvest)*. 1959. Oil on canvas, 51⅛ x 63″ (130 x 160 cm). Private collection, Paris, France

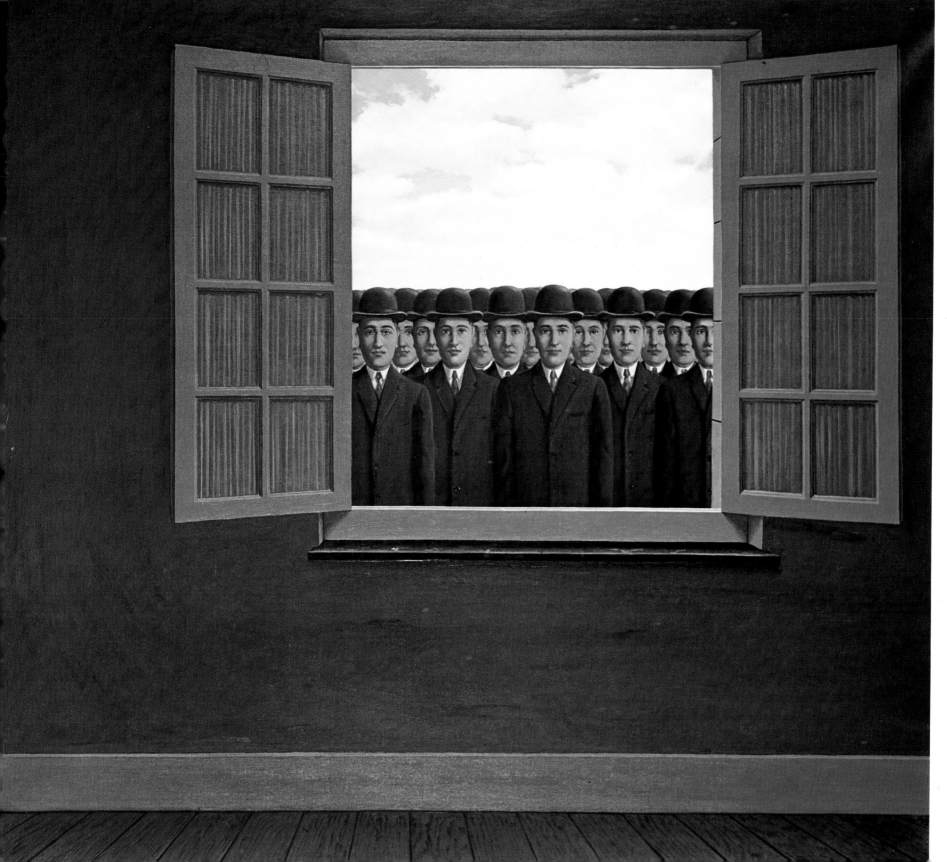

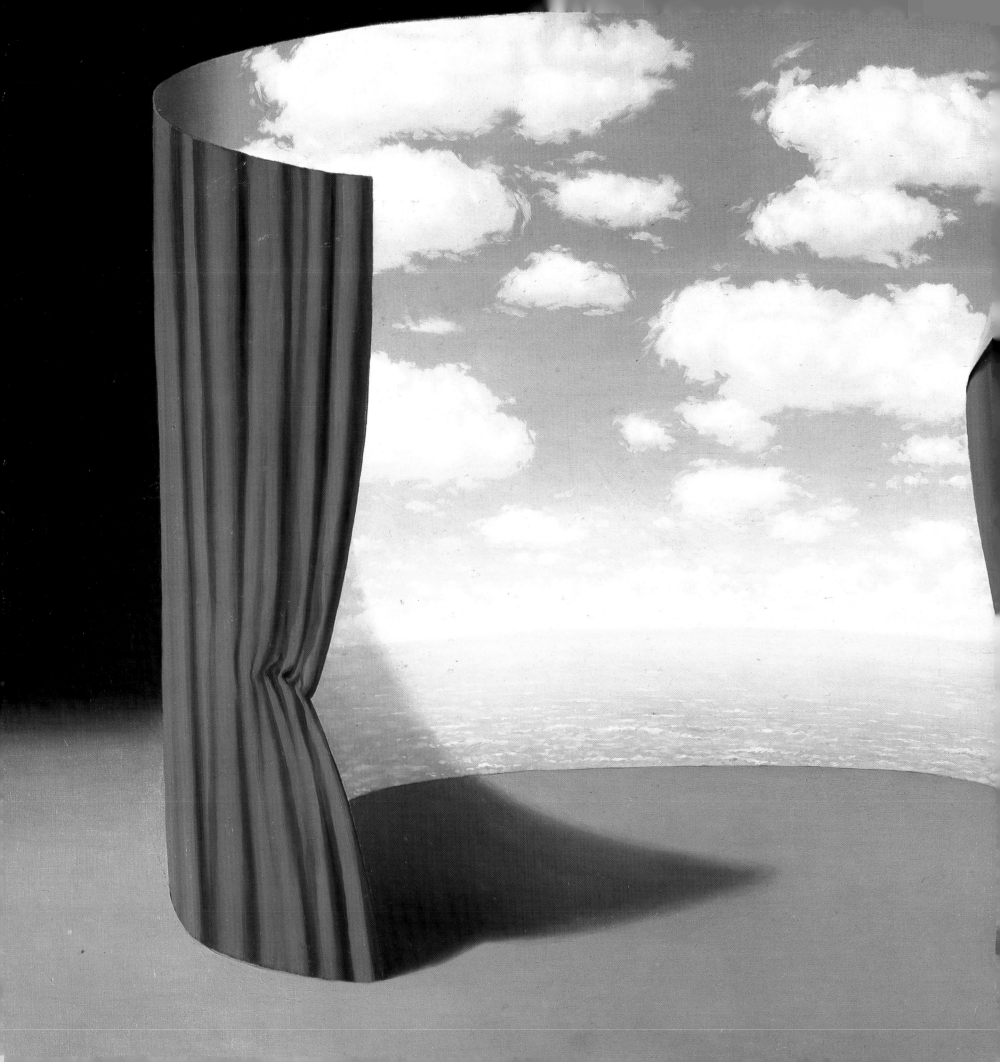

500 *Les mémoires d'un saint (The Memoirs of a Saint).* 1960. Oil on canvas, 31½ x 39⅜" (80 x 100 cm). Collection Menil Foundation, Houston, Texas

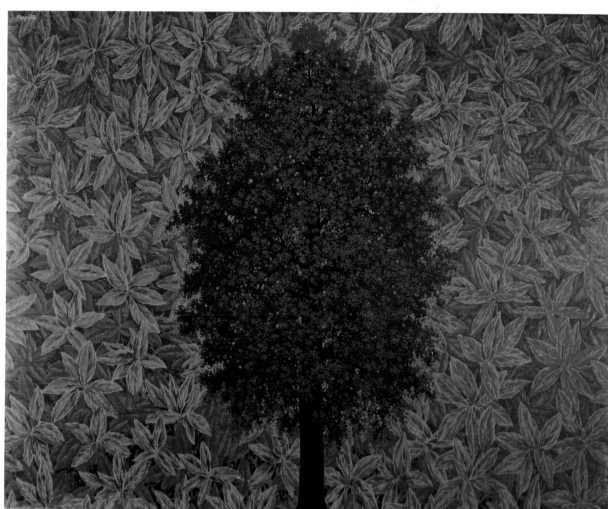

501 *L'arc de triomphe (The Arch of Triumph).* 1962. Oil on canvas, 51⅛ x 65" (130 x 165 cm). Private collection, New York, New York

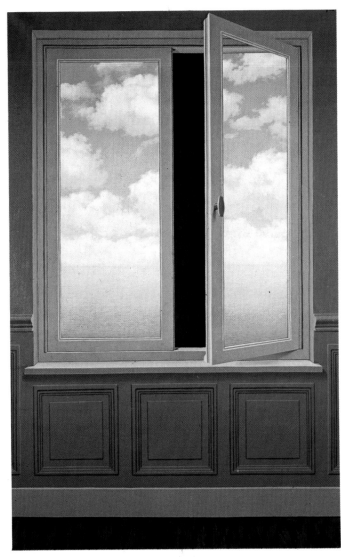

502 *La lunette d'approache (The Field Glass).* 1963. Oil on canvas, 69⅛ × 45⅝″(175,5 × 116 cm). Collection Menil Foundation, Houston, Texas

503 *L'idole (The Idol).* 1965. Oil on canvas, 21¼ x 25⅝″ (54 x 65 cm). Private collection, Washington, D.C.

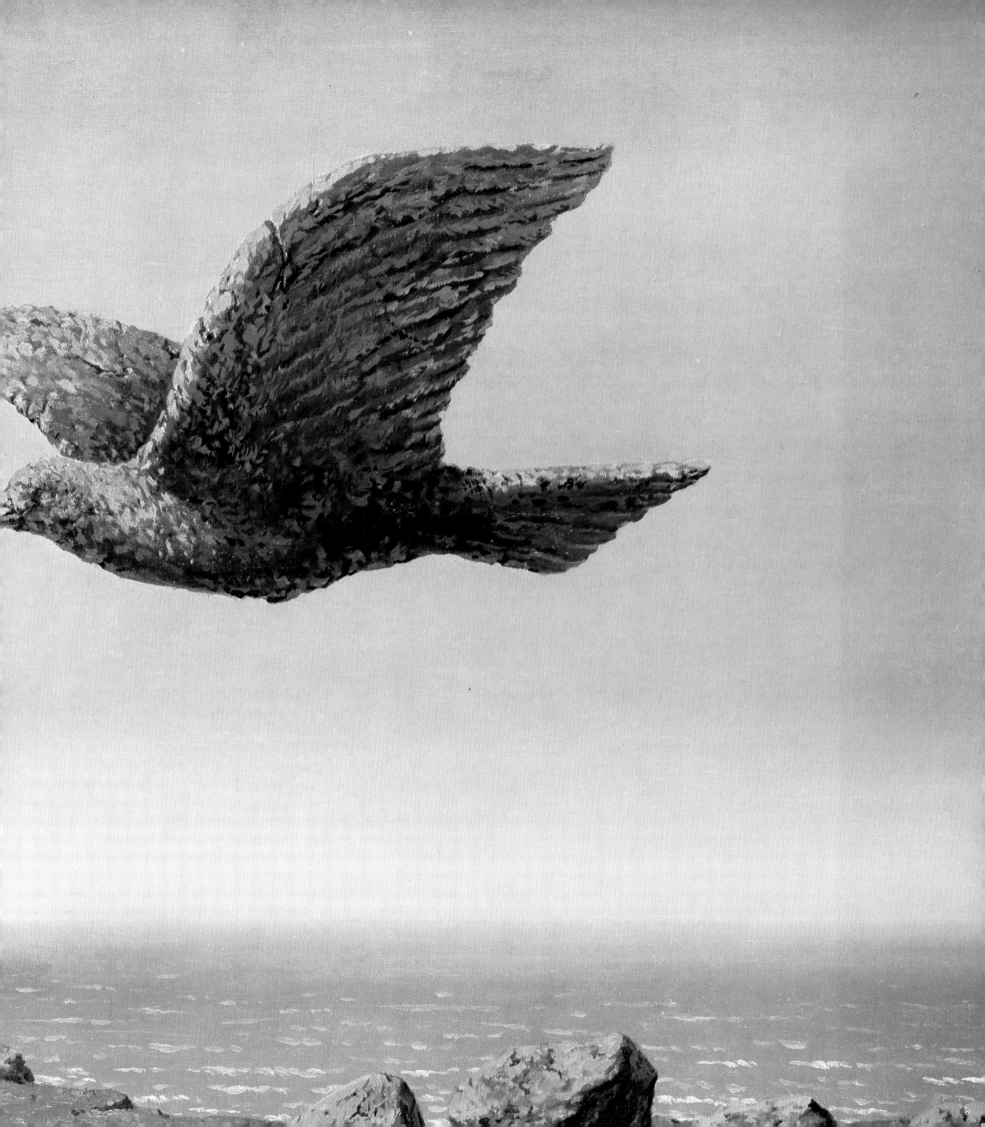

504 Study for *Le blanc-seing (Carte Blanche).* c. 1965. Drawing. Collection Mme. René Magritte, Brussels, Belgium

505 *Le blanc-seing (Carte Blanche).* 1965. Oil on canvas, 31⅞ x 25⅝″ (81 x 65 cm). Collection Paul Mellon, Washington, D.C.

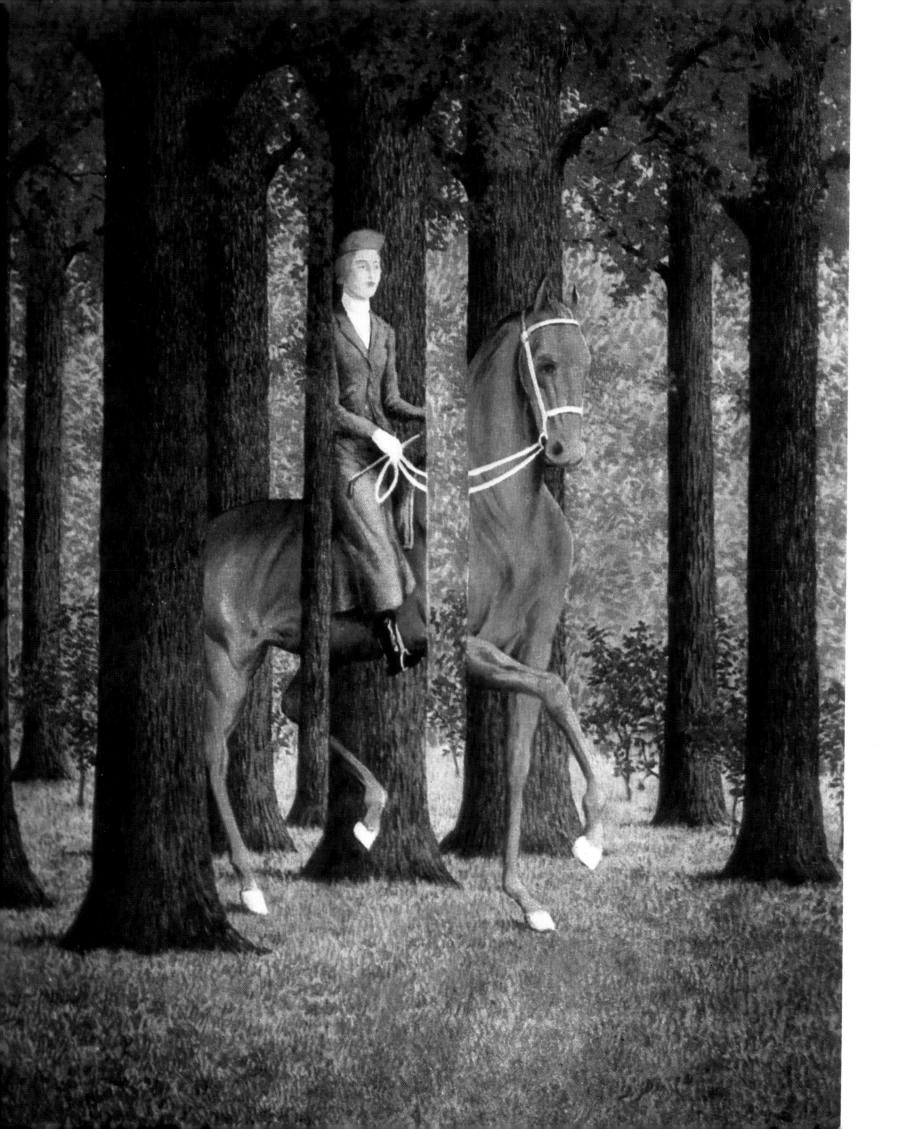

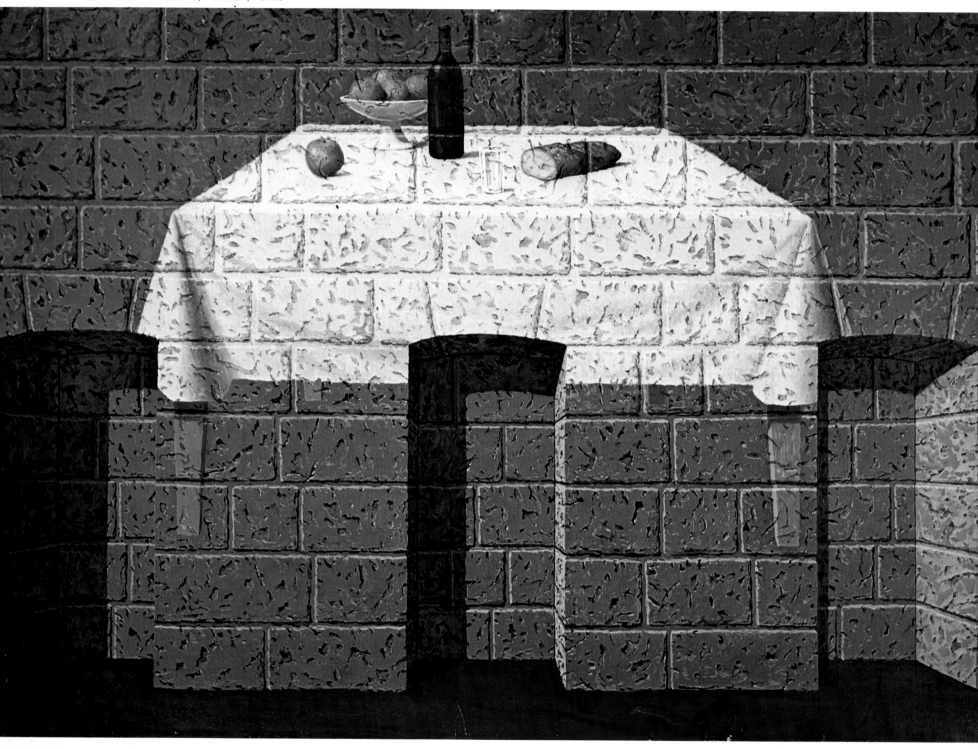

506 *L'aimable vérité (The Sweet Truth).* 1966. Oil on canvas, 35 x 51⅛″ (89 x 130 cm). Collection Menil Foundation, Houston, Texas

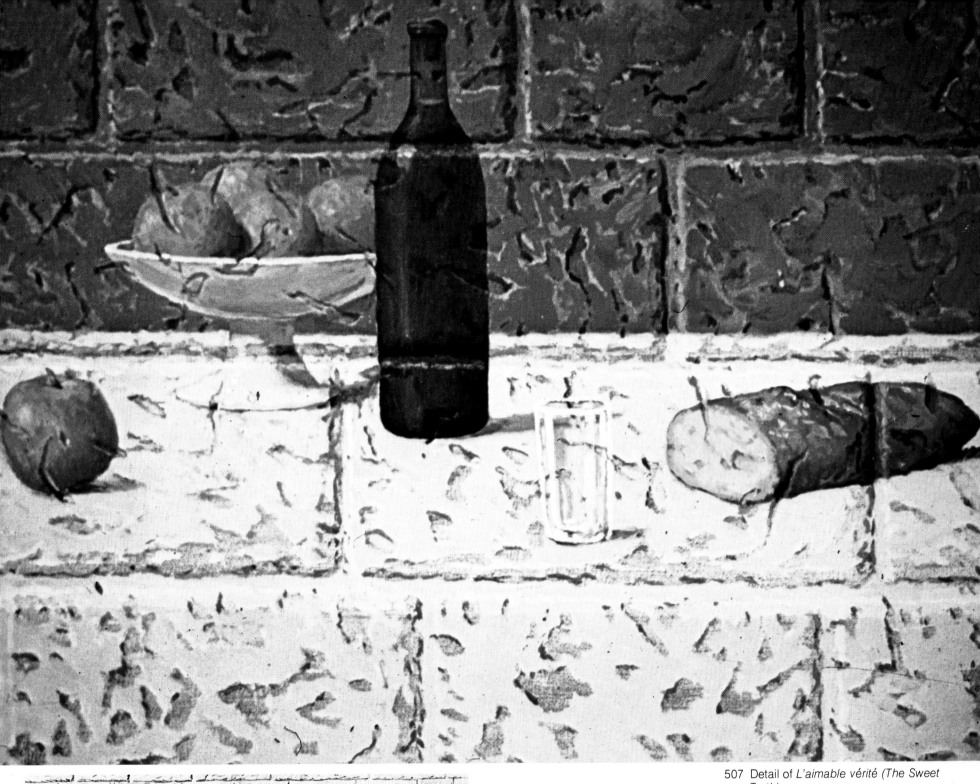

507 Detail of *L'aimable vérité (The Sweet Truth)*

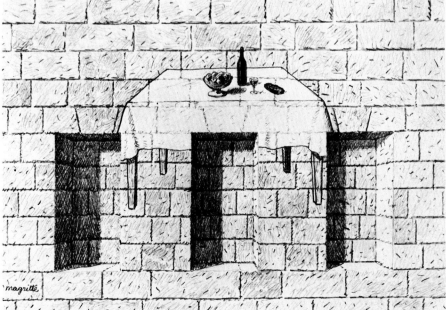

508 *L'aimable vérité (The Sweet Truth)*. 1966. Pencil drawing, 12⅝ x 7⅛" (32 x 18 cm). Collection Mrs. Denise Elisabeth Wiseman, New York, New York

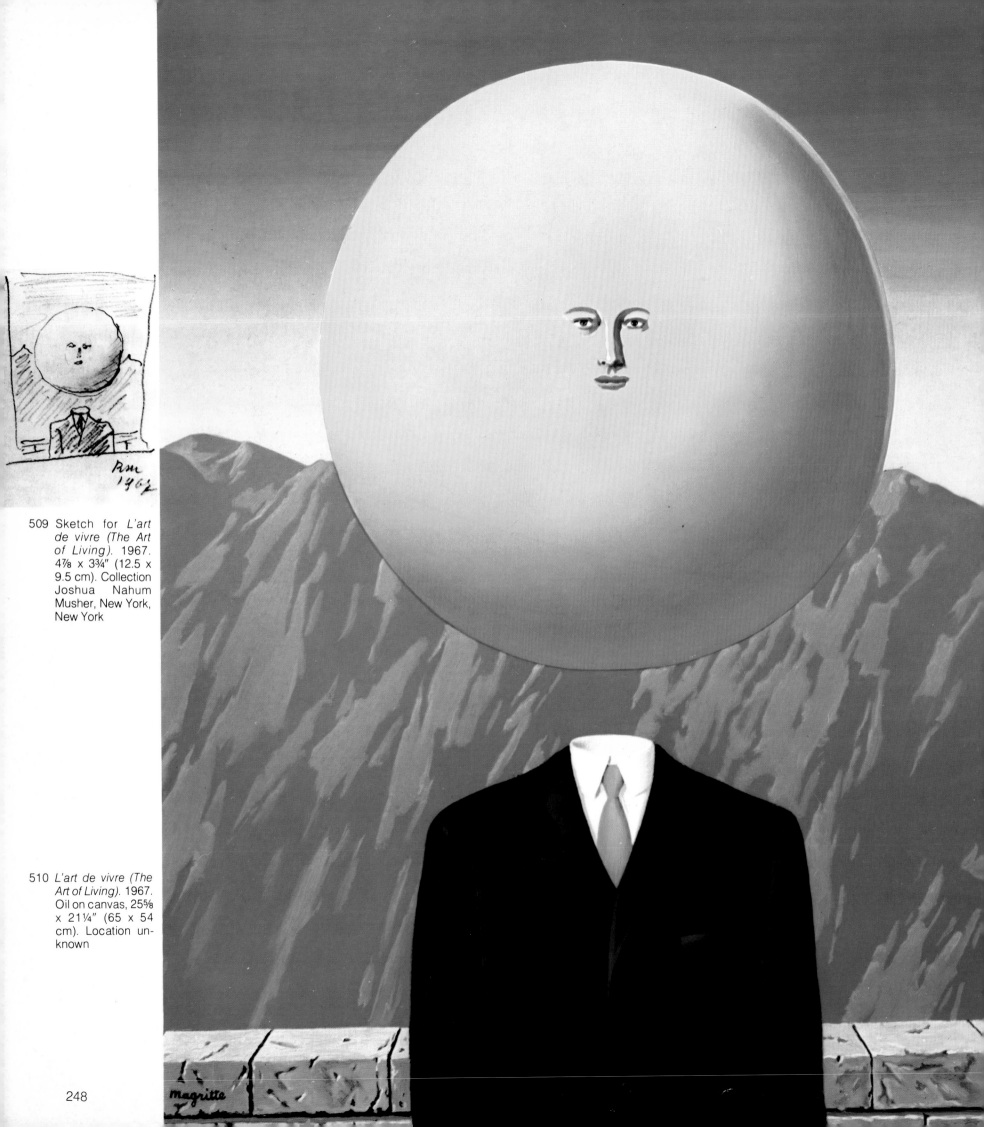

509 Sketch for *L'art de vivre (The Art of Living)*. 1967. 4⅞ x 3¾" (12.5 x 9.5 cm). Collection Joshua Nahum Musher, New York, New York

510 *L'art de vivre (The Art of Living)*. 1967. Oil on canvas, 25⅝ x 21¼" (65 x 54 cm). Location unknown

THREATENING WEATHER

511 Untitled drawing. n.d. Location unknown

In July 1967 Magritte set down some images in his last sketchbook. He marked with a cross in my presence those he did not like, those he was condemning to oblivion.

In August most of the companions of his difficult early days having already disappeared, and his own end drawing near, he drew on a large sheet of paper the premonitory sign of a forever lifeless hand.

518-525 Eight pen and ink drawings from
René Magritte's last sketchbook.
July 1967. 3⅞ x 5½" (10 x 14 cm).
Collection Harry Torczyner, New
York, New York

526 Untitled sketch (unfinished) for Magritte's last painting. Collection Mme. René Magritte, Brussels, Belgium ▶

527 *La Joconde (La Gioconda)*. 1967. Bronze, height 96½″ (245 cm). Private collection, Brussels, Belgium

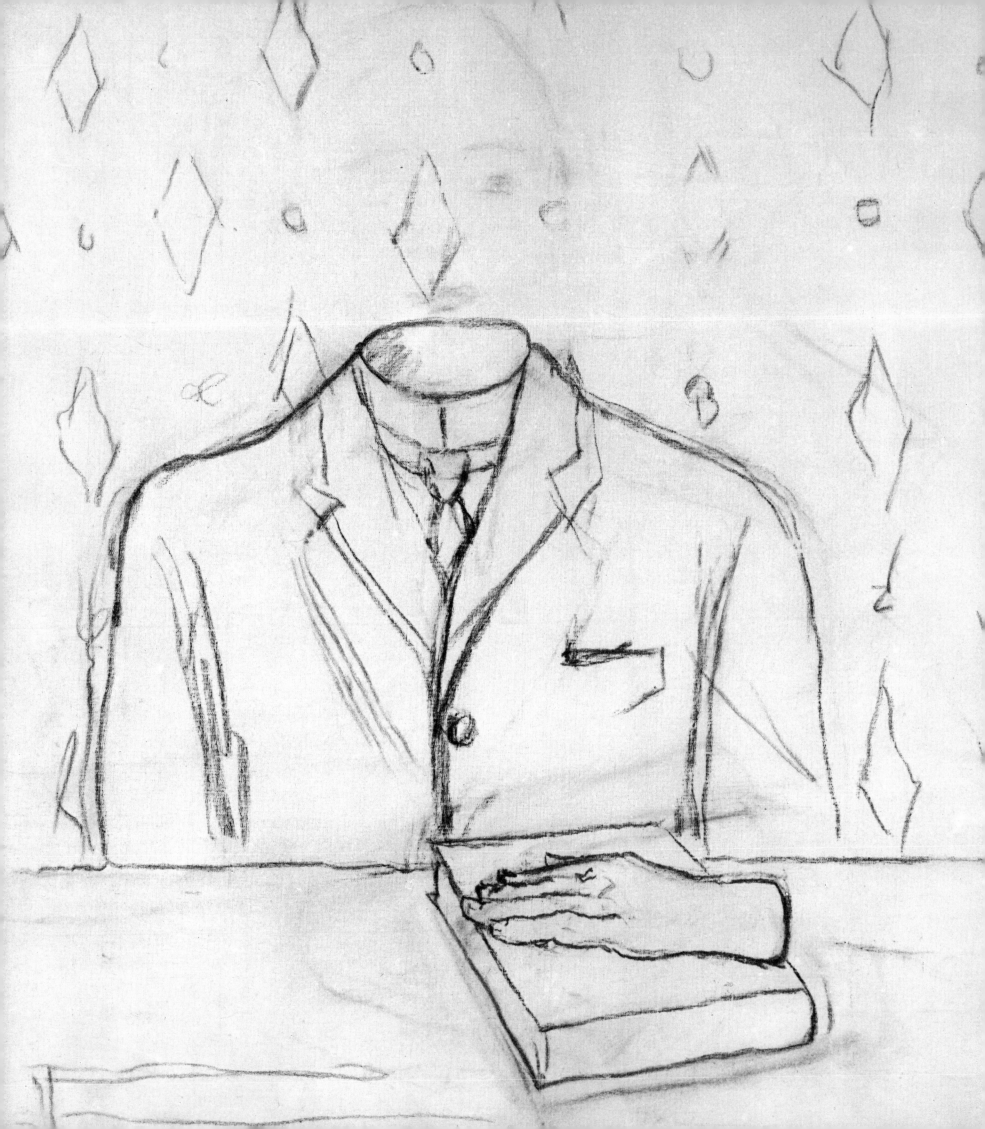

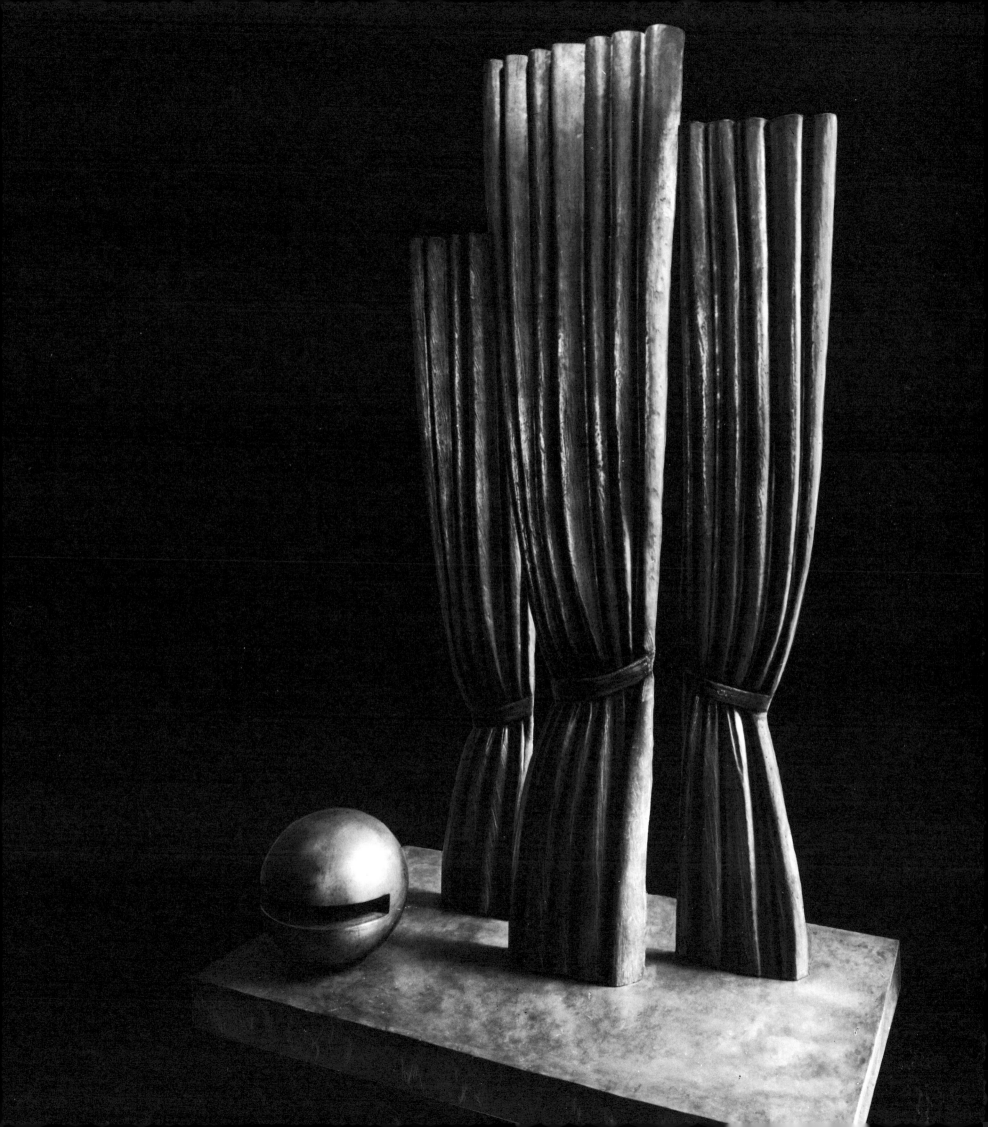

APPENDIX/TRANSLATIONS

This appendix contains English translations of the fifty-one letters and documents printed in facsimile in the text either in whole or in part. The figure number of each facsimile illustration, together with the number of the page on which it appears, has been provided for each item in this appendix.

1 Fig. 16 (page 27)
Untitled drawing with caricatures (left to right) of Louis Scutenaire, René Magritte, Paul Colinet, 1954

[*above center*]
Two caricatures of the Master of Jette (executed near the beach at Knokke at the point of dawn on 11 July 54)

[*below left*]
Scut
The Master of Ollignies ozonized by a slice of Jewish bread and some sexually explicit images

[*between caricatures of Scutenaire and Colinet*]
The Master of Jette* René Magritte 1954 (*of Boulevard Lambermont since he moved)

[*below right*]
Col
The Master of Arquennes arrayed as a nice guy

2 Fig.17 (Page 28)
Letter from René Magritte to E.L.T. Mesens, not dated

[*The facsimile reads from right to left*]

Dear ELT,

I suggest that you celebrate Christmas in the company of Messrs.
> Bourgeois, P.
> Flouquet, P.
> Servranckx, V.

myself, sisters, spouses, who will convene at my home, 7 rue Ledeganck on Sunday at 6 PM. The menu for the supper, which will commence at 10 PM, is constructed as follows:
> Split pea soup with croutons
> Lobster mayonnaise
> White wine
> *Boudin frit,* applesauce
> Roast beef, braised lettuce *au gratin*
> Potatoes *au nature*

Page two:
> Fruit, cakes, coffee
> Wine, cigarettes

The construction of this gastronomical feast will be underlined by the service of authentic vintage wines.

Notwithstanding the thinness of my wallet, it is logical that each guest assist me in bearing the expense by contributing the modest sum of 20 francs each.

If this suits you, please reply so that I will know by Saturday morning at the latest. My regards, oh very sweet ELT,

René Magritte, Painter of Genius

3 Fig. 19 (page 29)
Letter from René Magritte to Harry Torczyner, postmarked July 6, 1960

July 6 (October)

Dear Friend,

Thank you for your letter and the Dallas copies, which Miss Gablik has translated without too much difficulty. Miss Gablik arrived safely (as she wrote you) and seems to like it here. She's a bit taller than I imagined, which doesn't keep her from being very nice. I have the impression she will find material to satisfy her curiosity for specific painting (*specific* seems a good word for it)? and for what is specifically Belgian.

Returning to your admirable correspondence with Dallas, I would indeed rather think that I won't be presented to the public by the curator of the Dallas Museum as an example of the mimetic art.

There is no mention of that text on resemblance that I sent you: did you forget about it, or do you think we should keep the translation that you might make of it for another occasion, for *Horizon* magazine, for example?

I'm beginning a picture with an English inscription, thanks to the collaboration of Miss Gablik, who showed me how to write it:

> I don't see any

> [*illustration*]

> in the garden.

Will we be seeing you in Brussels during these last days of the year?

Yours in friendship,
René Magritte

4 Fig. 27 (page 32)
Letter from René Magritte to Paul Colinet, 1957

Latest idea: *Hope is well-being*
Dear Friend,
30 rue Paul Spaak. 30−3+0 = 3−3x3 = 9
The die is cast, we are leaving *Jette* on the 18th.
You will have already noticed that 18 consists of 1 and 8, thus 1+8 = 9.
You will also, I'm sure, have noticed that the *home* we are living in is 1 *home,* the one we left makes another 1, and the one we are moving to another 1. Together, they make 3 *homes,* and the number 3 multiplied by itself gives 9.
(The number in brackets is the same as the 9-month formation of a baby.)
Fine. The *home* we left in Paris before we moved to Jette was number 201, or 2+0+1 = 3, 3x3 =9
Our *home* in Jette was 135—1+3+5 = 9
The *home* we will soon be in bears the number 207—2+0+7 = 9
The number 9, multiplied by itself, gives 81, and 8+1 = 9
What do you think?
It's on the Boulevard Lambermont, Brussels, 3, thus 3x3 = 9
Would you work out a formula for changing

5 Fig. 31 (page 33)
Letter (excerpt) from René Magritte to Maurice Rapin, December 20, 1957, showing floor plan of the Magritte house at 97 rue des Mimosas, Brussels, Belgium

The house I've just rented is also a question mark. Since my wedding, I've always lived in apartments. Will I be too "calm" there?
Here's the plan for the ground floor:

> tree tree

> No. 97, rue des Mimosas (Brussels III)

> tree tree tree

> There will be a guest room and I hope you'll use it when vacation time comes.

A house is fine in some ways, but I recall an *unreadable* book by Souvestre (the brother of the author of FANTÔMAS), called *A Garret Philosopher,* and I'd like just to live in a room or a garret like the one Souvestre describes. I think it must be a really perfect pleasure to read FANTÔMAS in such a dwelling.

Until soon dear friend,
yours,
René Magritte

[*The words in the floor plan are*]
pine tree, gate to the garden, easel, piano, dining room, hall, kitchen, toilet, and fence.

6 Fig. 47 (page 39)
Letter from René Magritte to Harry Torczyner, June 5, 1967

Montecatini, June 5, 1967
Dear Harry,
I'm returning to you the *Harper's Bazaar* document signed and dated. (The date is scratched out, I thought we were still in May.) Thus we reached our destination as planned. The plans are for us to meet up with Iolas in Verona around June 10, but I can't promise it since he is sometimes not too punctual about appointments. I'll keep you informed of the progress of my sculptural projects—if they do progress.

The international situation continues to cause concern, the germ of endemic war seems to be becoming epidemic once and for all. I admit I can't tell too well what is really happening: the notions of democracy or dictatorship, racism or antiracism are not the ones that would enable us to see very clearly. *Instead of trying to figure it out, just now, around 10:40, the hotel manager tells me that war has broken out between Israel and Egypt!* (We only have the news in three-day-old French newspapers, the manager having the latest Italian ones.)

So the vultures are triumphant over the doves. This justifies my pessimism, but I take no pleasure from that. I wonder if it wouldn't be wise for us to return to Brussels as soon as possible? In 1940, I

addresses that I could have printed up for distribution? For and until Friday evening, or 11 o'clock with the [?]? I hope,

Mag.

experienced transportation problems in rejoining Georgette from Carcassonne, where I had gone into exile. Now, with her and Loulou, if there are problems, they'll be even worse?

I can only hope that the damage will be limited? If I have to return quickly, I'll let you know at once. With much friendship for you and Marcelle,

René Magritte

7 Fig. 50 (page 41)
Letter from René Magritte to Harry Torczyner, February 6, 1962

Dear Friend,

I've received your letter, Suzi's with her translation, and today a visit from Peter De Maerel.

15th day of liver attack. The doctor has decided I can be cured in two weeks, but that on the other hand it could last another six months?...

I'm on a very strict diet—I can't eat or drink anything I like, coffee, tomatoes, french fried potatoes, etc. I have to sleep almost all day and not go out: it seems the cold is very bad for me.

Iolas came to see me last Sunday (February 4th). He is leaving for New York at any moment and is only waiting for my pictures and the catalogues to open the exhibition we decided on some time ago.

As for the collage with the pipe and bird, the title Moments musicaux seems to me to fit. This title can apply to many works (as do titles like L'art de la conversation, Stimulation objective, etc.).

Good luck at Freetown!

Yours,
René Magritte

8 Fig. 51 (page 41)
Letter from René Magritte to Harry Torczyner, May 18, 1965

May 18, 1965

Dear Friend,

Thank you for your letter and for the annex no. 2 you sent with it.

I accept Mr. Seitz's plans, which are to my taste: "history is not my strong point," and it seems to me to be more intelligent to plan an exhibition oriented around the choice (preferably wise) of works to be shown, rather than around some chronology that makes very little sense.

Is the treatment taking effect, or the medicine my doctor has prescribed so that most of my pain is gone for the moment? Whatever the case may be, the "state of my health" is fairly satisfactory, aside from fatigue (which is perhaps congenital).

However, there's a less amusing aspect: the tests have shown anemia, the cause of which has to be discovered. Well then (or bad then), in a few days they're going to open my stomach (just a bit, but open it all the same) in order to explore with a lighted instrument what it's about. This anemia can mean all sorts of things, even things one shouldn't find: leukemia, for example. I'll tell you what it is as soon as I can. While waiting to find out, my habitual optimism, already minimal, has no reason to increase right now.

Affectionately to you and to Marcelle,
R.M.

9 Fig. 52 (page 42)
Letter from René Magritte to Harry Torczyner, May 30, 1965

May 30, 1965

Dear Friend,

Your letter of the 28th leaves me in the dark about whether my exhibition at the Modern Art is "taking shape." During his trip to Belgium, Mr. Seitz will probably have some details for me as to the choice of pictures you're making with him.

I hope that then (around the 11th of June), I will know more about my health: at the moment, I can't complain too much. Aside from stiffness in my arms, hands, and legs, and a persistent fatigue, I can easily put up with the mild and intermittent pain of these rheumatic effects which are now the cause. My doctor, however, wants to know why I am anemic. He's sent me to a specialist and as a result he persuaded me that a "laparoscopy" should be performed. It's set for next Wednesday, June 2. In the meantime, I consulted another specialist, who thinks that "laparoscopy" is useless and who suggests "simply" an operation on the vesicle (remove the vesicle, which is blocked, according to the X-rays). I'd prefer putting off that operation, and so I prefer the advice given by my doctor and his specialist, which is less categorical than the advice of the other specialist I've consulted. This advice doesn't include a fairly serious operation on the vesicle. If the examination I'm to undergo on Wednesday reveals the necessity for such an operation, I'll have to make up my mind to have it. However, the examination is only to discover the cause of my anemia, and I hope that afterward I'll only need therapy and not surgery.

Whatever happens, these questions are upsetting, and I barely think about painting enough to "put my heart" into any work, even less so than usual.

A Mr. Crispolti from Rome came to see me about an exhibition of my pictures he is organizing for mid-July at La Quilla [sic]* in Italy. He showed me voluminous catalogues from earlier exhibitions he has put on at La Quilla. It seems to be serious. He's undertaking to assemble documents and find collectors who will lend pictures.

I'll send you some drawings in a few days,
Affectionately,

R.M.

*L'Aquila

10 Fig. 54 (page 43)
Letter from René Magritte to Harry Torczyner, January 17, 1967

January 17, 1967

Dear Harry,

Here we are back from Paris, where my exhibition is in "full swing." I had neither the mental nor physical strength to write postcards, that is, my fatigue increased nearly to the point of coma.

The crowd that goes to openings was there, "interviews," and all those usual things that are easy to imagine. The reviews in the newspapers

ago in Paris. They were also more attentive and, curiously, I paid less attention to them.

I'm beginning to awaken from this nightmare and I'm rediscovering the pleasure of sending you news, and particularly of getting back to our exchange of epistles and of friendship.

Until soon, probably? Best to you and Marcelle,
René Magritte

P.S. I hope you will get the catalogue that the Galerie Iolas is supposed to be sending you.

11 Fig. 57 (page 45)
Letter from René Magritte to Harry Torczyner, July 23, 1962

July 23, 1962

Dear Friend,

I was glad to get your letter of July 19, which tells me that you have returned without mishap (for which Miss Barman and her automobile may be to some degree responsible).

Speaking of automobiles, I've had enough (as you said about your illness, and to a percentage close to 0):

1st, my third day of lessons (Friday) an Opel ran into me near Stenokersele [sic] and bent my left front "fender."

2nd, on the fourth day, on a curve at St. Jossetenoode [sic] I hit a signpost, slightly damaging my bumper and the front part of the body—despite which I bravely continued on to Hall. However, for the return trip I turned the driving over to the instructor who was accompanying me.

3rd, since then I wouldn't touch a steering wheel with a ten-foot pole. I realize that my interest in the "pleasures" of driving a vehicle is nonexistent, and I'm going to get rid of my "car" as soon as I can. If it would be possible, I might consider having an internal-combustion vehicle equipped with an experienced chauffeur who would keep his distance (in every sense of the word). For the time being, it's out of the question, since my economic situation won't permit it.

Let's not talk about this nightmare anymore, but think about the future, and Arts in particular. I'm sorry that the 2,000-word article won't be written by you: we've already had experience of the cogitations of curators. Fortunately, the exhibition is the main thing.

In a kind of euphoria (at being rid of mechanical objects), I am finishing La peine perdue. Soon Menkes* will arrive here and undertake sending you this fine picture, duly framed in a fine frame.

Until then, I hope you will have good news about your medical problem.

Yours,
RM

*Menkes is a Belgian shipping and moving firm.

12 Fig. 58 (page 46)
Letter (excerpt) from René Magritte to Paul Colinet, 1957, including sketch of Von Stroheim

Saw Greed last night, an old film of Von Stroheim, which I was especially shown to "inspire" me to make a drawing for a seminar prospectus

announcing an "Homage to Von Stroheim." I've come up with the following idea for an illustration:

[Illustration]

R.M. to P. Colinet, 1957

13 Fig. 77 (page 58)
Letter from René Magritte to Harry Torczyner, October 2, 1958

2 October 1958

Dear Friend,

I'm still waiting for a sign from De Maerel to take the handsome little package to Sabena. I'm waiting patiently and I am eager to know what you'll think of my efforts, which were aimed at not disappointing you (as for me, I'm satisfied with your portrait, with the Tower of Pisa in the sunset, and the "country" with the lighted streetlamp under a noontime sky).

In short, everything is ready and waiting for De Maerel to ready himself.

I got the photo of Rex Stout, who has a strange face decorated with a scanty beard of white hairs—If you ever read detective novels, I recommend to you this author (obviously uneven, but very diverting).

Hoping to hear from you soon,
Yours,
René Magritte

14 Fig. 84 (page 61)
Letter from René Magritte to Harry Torczyner, April 22, 1965

22 ~~August~~ April 1965

Dear Friend,

I got your letter of April 17 with great pleasure: it's the first sign we've had of the existence of a land other than this Italian isle. Until now, it's been awfully cold here in the "land of sun." I don't know whether the benefits of the treatment aren't being compromised by the unsatisfactory temperature that prevails here. (The hotel doesn't have heat.) From a gastronomical point of view, there are astonishing "surprises" *ex contrario:* stringy chicken comes covered with a mound of raw spinach. "Cream of vegetable" soup is hard to tell from wallpaper paste. We are said to be in the best hotel in Casamicciola. I think we got here too early: the good season (if it's not a myth) will appear after our return to Brussels.

As for the cure, it lasts for a good hour: 1st, a mudbath; 2nd, a bath in mountain water; 3rd, rest; 4th, massage. This takes place at around 8 AM on an empty stomach. There hasn't been any improvement as yet in the health *status quo* that prevailed in Brussels. It's an effort for me to write, to sit, to lie down, etc.

I don't know what to tell you about filling requests for exhibitions. Kansas City, for example, ought perhaps to be canceled if the N.Y. museum has set a date that doesn't allow for organizing several exhibitions?

Georgette and I were very happy to hear your news. Our best wishes to you and Marcel [sic].

R.M.

(On the 16th I sent you an airmail card, and one to Suzi.)

15 Fig. 89 (page 63)
Letter from René Magritte to Louis Scutenaire and Irène Hamoir, December 17, 1965

Gladstone Hotel
114 East 52nd Street
New York City, U.S.A.
Room 703 17 December 1965

Dear Homing Pigeons,

This morning Georgette and I got a breath of our native land with your letter, which gave us the sentimental (not melancholy) refreshment we needed—as do you (despite your fondness for Southern parts). We'll hear from you again—probably from Nice—before we leave New York, Wednesday the 22nd, in the evening (or we will if you send it airmail). In sum—as our fathers used to say—my exhibition is a "triumph"—many visitors (3,000 in one day apparently), photographers everywhere, cocktail party after cocktail party (yesterday evening at Harry's, "tout New York" in black tie). Suzi is a strange case: Like Scut…she likes things without seeming to know that some don't fit with others. Thus, she has a high regard for my pictorial doctrine, or rather (like Scut) for my pictorial achievements. But she also has regard—if not higher regard—for authentic pictorial idiocies like Rausenberg's [sic], for example, one of whose works hangs on the wall of her "living" room. She (like Scut) likes Bach and Cimarosa, but she likes rock and roll just as much....

Poe's house is the most beautiful in the U.S.A. A raven greets you from the top of a narrow wardrobe, his desk and his meagre, admirable furniture (and an old coal stove, like in Picardy) are still there. Georgette and I spent a long time feeling the back of a chair that had held him—more than did the natives. Today we're going to Texas until Monday. Right now, it's as hot as summer there, which will be a change for us from New York, which is very like Brussels. We'll send you some picture postcards from Tucson (or Houtson? [sic]) for your archives (or wastebaskets), if wastebaskets are more deserving than archives.

I don't know if the *Coquille du Monde* was intentional? French "wit" is capable of coming out with things like that very intentionally. It's funny, amusing, and very shitty.

Dali paid his respects on two occasions—at his home, at a reception where Gala received from me the following in stentorian tones: "Gala, you look bored!" And then in a restaurant called La Côte Basque, where I paid him the compliment of going to greet Gala at their table, and which he returned by coming to greet me at mine. It was funny, and between ourselves, Dali's eyes are very touching because of their sadness (which we can easily comprehend).

Among the N.Y. upper-crust I met someone from Marchienne-au-Pont with whom I was able to talk about Charleroi in Walloon, in New York, U.S.A.

Have a good visit near the tomb of Gaston, our best and most affectionate greetings to you both,
Mag.
Georgette

(My hand is still a bit shaky, hence the questionable penmanship herein.)

16 Fig. 93 (page 66)
Letter from René Magritte to Harry Torczyner, September 18, 1965

18 September 1965

Dear Friend,

Your letter of the 15th contains a good question. Both good, and unfortunate: it makes me understand better Soby's ideas, which aren't very "catholic." Indeed, if there is any influence, it can be said that Chirico is responsible for it (since about 1925, the date when I first knew his work). For that matter, in a book on Max Ernst, Waldberg does not hide the fact that Ernst also underwent Chirico's influence. Max Ernst and I admit to it readily, but with a little bit of critical sense it is soon obvious that our "personalities" rapidly came to the fore and that our relationship to Chirico was no more than the one the other Surrealists shared to a greater or lesser degree, and in very different ways.

If it's a question of Max Ernst's influence, one has to talk about Frits van den Berghe, who was far from the Surrealist spirit; he only used the exterior aspect of Ernst's painting and in some people's eyes he passes for a "precursor of Surrealism in Belgium."

As for the books of Éluard and Ernst, I didn't know them until I met them in 1927. Then—as now—I was very little "in the know" about artistic goings on.

If one takes into consideration what I've painted since 1926 (*Le jockey perdu*—1926—for example, and what followed), I don't think one can talk about "Chirico's influence"—I was "struck" about 1925 when I saw a picture by Chirico: *Le chant d'amour.* If there is any influence—it's quite possible—there's no resemblance to Chirico's pictures in *Le jockey perdu.* In sum, the influence in question is limited to a great emotion, to a marvelous revelation when for the first time in my life I saw truly poetic painting. With time, I began to renounce researches into pictures in which the *manner of painting* was uppermost. Now, I know that since 1926 I've only worried about *what should be painted.* This became clear only some time after having "instinctively" sought what should be painted.

So there will be two drawings for Seitz and Lady X.

Until soon, dear Harry, and friendly greetings to you and Marcelle.

R.M.

17 Fig. 95 (page 66)
Letter from René Magritte to Harry Torczyner, January 24, 1959

January 24, 1959

Dear Friend,

Following up the letter I wrote yesterday, a perusal of your minute of the 22nd of this month (*minute* in the sense of an ambassadorial document) leads me to specify that the cultural offensive I have in mind should be planned "positively," that is, not consist of "comparisons" such as, for example, the one I told you about, *just between ourselves, merely* demonstrating that the person imitated is considered to be the imitator. This is gossip that we find amusing, but it risks being taken as gospel by the public. Indeed, they habitually proceed directly from gossip to History. We mustn't flatter these habits if we want to make "things" work in a less mechanical sense. If we begin an offensive, we must attack these habits by making known things that are habitually overlooked.—When I envisage a painting, it is *de facto* an offensive against these habits, even though *I don't consider them directly. De jure,* it involves only ideas that escape any discussion by their very nature.

As an illustration, behind closed doors, I pick one of my pictures, *La découverte du feu,* which shows a burning iron key (another picture shows a burning trumpet). No one had ever thought of that, or at any rate no one had ever mentioned it in speech or in paint. "Gossip" might say that *a few years after* this picture was brought into the world, Dali painted a burning giraffe, and that thanks to a lot of publicity he is the one who is supposed to have invented the idea of an unexpected object on fire. So "gossip" doesn't apply here, it doesn't recognize the purity and the *extent* of inventiveness, it only recognizes some superfluous exaggeration that makes the strict rigor of the original invention more palatable. In order to avoid this pitfall, a "positive" offensive, if we're talking about *La découverte du feu,* need only *enlighten* and not bother with extraneous matters, not bother with the clumsy applications that the idea of a burning object can be put to. This clumsiness—or this unintelligence, rather—reduces the large to the small, the unknown to the known, according to a habit that is the contrary of any true activity of the Mind. In confirmation of this, the public's interest in the current projects for exploring the Moon is in line with this habit of reduction and confusion: people want to reduce mystery to something knowable, and they confuse the *familiar* feeling they have for things about which they are ignorant (for example, the mystery as to the precise number of fleas on the youngest lion in the jungle, or a comprehensive "lunography") with the *nonfamiliar* feeling of mystery (the mystery of smoking a pipe in a pleasant room).

"Gossip" impresses people who learn from it that Racine was treated with contempt in his own lifetime and that some other now-forgotten so-called poet was widely admired. However, these people don't know Racine any the better for knowing this. (I'm not a Racinian, despite the unspoken obligation to be one.)

As for the ammunition our armies require, I must admit that the only ammunition I can provide is...the pictures I can paint. These are very demanding, and I have just enough strength to fulfil them, + or −.

However, I am hopeful I can "add my two cents" to any projects you may have in mind. The plan to bring out an article by Duchamp seems to me highly laudable. I'm curious to know what your meeting with a press potentate has produced.

I've had a nice letter from Miss Suzi. Tell her I have a friendly feeling of mystery for her.

Yours,
René Magritte

P.S. Not having any archives, I can't find the documents needed to illustrate any "gossip" with regard to imitated-imitator. You'll surely do better.
P.S. 2: Of course the cultural effort can be made independently of the galleries, although they can contribute with exhibits and can even, given the means at their disposal, assist in what we want to propagate to the public.

18 Fig. 96 (page 67)
Letter (excerpt) from René Magritte (written in London) to Louis Scutenaire and Irène Hamoir, February 18, 1937

I'm writing to you since I suppose that since you're crippled up—as Scut tells me among his usual jokes—you won't be coming to London this weekend.

London is a revelation. Of course, I'm only just beginning to discover it. But until now, everything is perfect (of course I don't speak English, but "there's something"). Yesterday evening we went to visit Henry Moore, a charming sculptor, sort of Arp-Picasso, the son of a miner, with a young Russian wife ADMIRABLY stacked (a sort of robust wasp). I'm expecting Georgette this coming Friday. Maybe Colinet will come with her? The joker hasn't written me yet. What does this mean?

Until soon, my friends, with my best wishes—
Magritte

19 Fig. 100 (page 71)
Letter (excerpt) from René Magritte to Maurice Rapin, May 22, 1958

My latest picture began with the question: how to paint a picture with a glass of water as the subject? I drew a number of glasses of water:

[illustrations]

a line [illustration] always appeared in these drawings.

Then this line [illustration] became deformed [illustration] and took the form of an umbrella [illustration]. Then this umbrella was put into the glass [illustration], and finally the umbrella opened up and was placed under the glass of water [illustration]. Which I feel answers the initial question.
The picture so conceived is called:

Les vacances de Hegel

I think Hegel would have liked this object that has two contrary functions: to repel and contain water. Wouldn't that have amused him as we are amused when on vacation?

Your friend,
René Magritte

20 Fig. 101 (page 73)
Letter (excerpt) from René Magritte to Paul Colinet, 1957

...springs immediately to mind:
[illustration] blackboard
however, it's like the preceding title: however amusing, it's insufficient. Along the same lines:
[illustrations]
PTO

21 Fig. 123 (page 87)
Notes (complete) for an illustrated lecture given by René Magritte at the Marlborough Fine Art Gallery, London, February 1937

THE NAMING OF THINGS

Ladies and Gentlemen,
The demonstration we are about to embark upon will attempt to show some of the characteristics proper to words, to images, and to real objects.
(1) A word can replace an image:
Chapeau HAT.
(2) An image can replace a word. I will demonstrate this by using a text of André Breton, in which I will replace a word with an image:
[illustration]
Si seulement IF ONLY THE *SUN* WOULD SHINE TONIGHT.
(Jean Scutenaire) *On ne peut pas* ONE CANNOT GIVE BIRTH TO A *FOAL* WITHOUT BEING ONE ONESELF. [illustration]
Paul Éluard: *Dans les plus sombres* yeux *se ferment les plus clairs.* THE DARKEST *EYES* ENCLOSE THE LIGHTEST.
[illustration]
[illustration]
(Paul Colinet) *Il y a* THERE IS A *SPHERE* PLACED ON YOUR SHOULDERS.
David Gascoigne
(Mesens) *Masque de veuve* WIDOW'S *MASK* FOR THE WALTZ.
Humfrey [sic] Jennings THE FLYING BREATH OF EDUCATION [illustration]
(3) A real object can replace a word:
Le pain du crime. THE *BREAD* OF CRIME.
(4) An undifferentiated form can replace a word:
Les naissent THE [illustration] ARE BORN IN WINTER.
(5) A word can act as an object:
Ce bouquet THIS BOUQUET IS TRANSPARENT
(6) An image or an object can be designated by another name:
L'oiseau [illustration] THE BIRD
La montagne [illustration] THE MOUNTAIN
Voici le ciel [illustration] BEHOLD THE SKY (skaie)
 (dis is de skaye)
(7) Certain images have a secret affinity. This also holds true for the objects these images represent. Let us search for what should be said. We know the bird in a cage. Our interest is increased

if we replace the bird with a fish, or with a slipper.

These images are strange. Unfortunately, they are arbitrary and fortuitous.

[illustrations]

However, it is possible to arrive at a new image that will stand up better beneath the specator's gaze. A large egg in the cage seems to offer the required solution.

[illustration]

Now let us turn to the door. The door can open onto a landscape seen backwards.

The landscape can be represented on the door.

Let us try something less arbitrary: next to the door, let us make a hole in the wall that will be another door.

This juxtaposition will be improved if we reduce these two objects to one. Thus, the hole comes naturally to be in the door, and through this hole we see darkness.

This image can be further enhanced if we illuminate the invisible object hidden by darkness. Our gaze always tries to go further, to see the object, the reason for our existence.

Notes for an illustrated lecture given by René Magritte at the London Gallery, London, February 1937.

22 Fig. 124 (page 88)
Les mots et les images (Words and Images). **Illustration in** *La Révolution Surréaliste* **(Paris), vol. 5, no. 12 (December 15, 1929), p. 32–33**

WORDS AND IMAGES

[*first column*]
An object is not so linked to its name that we cannot find a more suitable one for it
[illustration]
Some objects can do without a name:
[illustration]
Often a word is only self-descriptive:
[illustration]
An object encounters its image, an object encounters its name. It can happen that the object's name and its image encounter each other:
[illustration]
Sometimes an object's name can replace an image:
[illustration]
A word can replace an object in reality:
[illustration]

[*second column*]
An image can replace a word in a statement:
[illustration]
An object makes one suppose there are other objects behind it:
[illustration]
Everything leads us to think that there is little relation between an object and what it represents:
[illustration]
Words that serve to designate two different objects do not reveal what can separate these objects from each other:
[illustration]

In a picture, words have the same substance as images:
[illustration]
In a picture, we see images and words differently:
[illustration]

[*third column*]
An undifferentiated form can replace the image of an object:
[illustration]
An object never performs the same function as its name or its image:
[illustration]
Now, in reality the visible outlines of objects touch each other, as if they formed a mosaic:
[illustration]
Vague figures have a necessary meaning that is as perfect as precise figures:
[illustration]
Written words in a picture often designate precise objects, and images vague objects:
[illustration]
Or the opposite:
[illustration]

René Magritte

23 Fig. 140 (page 95)
Letter from René Magritte to Harry Torczyner, August 19, 1960

August 19, 1960

Dear Friend,

I have received your letter of August 16th and the "special" documents. Thank you. I'll get in touch with the manager of the Mayfair, whose name has something Dutch about it.

I am happy to hear about the welcome you've given *Le tombeau des lutteurs*. The date 1944 shows that during that period the painting I envisaged—attempting to bring it into harmony with the Impressionist spirit—wasn't *always* (in 1954) in accord with that spirit. "My usual manner" was sometimes, rather always, there to testify that I would recover once and for all. The 1944 pictures, such as *Le tombeau des lutteurs,** were, in fact, painted in "my usual manner," which has since come to be the only one that I feel is truly necessary for painting, without fantasy or eccentricity, ideas already "sublime" enough that they do not need to be anything but a precise description. I firmly believe that a beautiful idea is ill served by being "interestingly" expressed: the interest being in the idea. Those ideas that need eloquence to "get across," for example, are incapable of making an effect on their own.

This is one of my convictions—which are often solely tested by all kinds of interpreters, who try to add something "of themselves" when they recite poems, paint pictures, etc.

At the moment, I'm waiting for you to be freed from the chains fastening you to your desk so that you can think about making a little trip to Belgium.

Best wishes to you and your family, who have my heartfelt feelings,

René Magritte.

Le tombeau des lutteurs was, of course, painted in 1960

24 Fig. 151 (page 101)
Letter from René Magritte to Suzi Gablik, 1959

15th or 14th of the month (1959)
Dear Suzi Gablik,

Lately I've been trying to figure out how to paint a window picture for Harry Torczyner, and how to paint a picture showing a bicycle. I've already found the following:
[illustration]
For, as you are aware, dear Suzi Gablik, a bike sometimes runs over a cigar thrown down in the street.

I'm glad to get your news. I'm sorry it was so short: I'd prefer a 12-page letter to your images, which are nevertheless very agreeable.

Yours,
René Magritte

25 Fig. 159 (page 105)
Letter (excerpt) from René Magritte to Harry Torczyner, July 1958

I await your news. As for mine, the best I can do is tell you the solution to the problem of painting a picture with a chair as subject. I looked for a long time before realizing that the chair had to have a tail (which is more "striking" than the timid animal feet that chairs sometimes have). I'm very satisfied with this solution. What do you think?

Yours,
René Magritte

26 Fig. 197 (page 117)
Letter (excerpt) from René Magritte to André Bosmans, April 21, 1962

...usual "energy." However, I painted a picture which I think is a very surprising variation on *La Joconde*.
[illustration]
(*Blue* curtains, one with clouds, against a dark sky, the sea in the distance, and the beach in the foreground.) The interest of this image I think is *particularly* in showing the same curtain as the one in *La Joconde*, demanding from us a renewal of a fairly apt attention, that is, demanding that among other thoughts we can call this image something other than *La Joconde* (*Le beau monde* is already suitable....

27 Fig. 211 (page 121)
Letter (excerpt) from René Magritte to Mirabelle Dors and Maurice Rapin, August 6, 1956

I have just painted the moon on a tree in the blue-gray colors of evening. Scutenaire has come up with a very beautiful title: *Le Seize Septembre*. I think it "fits," so from September 16th on, we'll call it done.

28 Fig. 224 (page 125)
Letter (excerpt) from René Magritte to
Harry Torczyner, June 12, 1961

The weather continues to be fine. These drawings were already on the paper I'm using to write you with (stationery stores are few and far between here)
[illustrations]

Yours,
René Magritte
12 June 1961
131 Promenade des Anglais, Nice AM

29 Fig. 229 (page 126)
Letter from René Magritte to Volker
Kahmen, November 23, 1965, including ink
drawing for a 1965 version of *Le sourire du*
diable (The Devil's Smile)

23 November 1965
Dear Sir,
Thank you for your birthday greetings and for the print, which I was happy to receive.
I've thought of painting an image that is a kind of trap (I've just realized it, I didn't conceive this image as a trap).

[illustration]

The trap in question has to do with the inevitable question that people who like symbols will be sure to ask, and in so doing think about everything (in a symbolic sense) but the absolute thought that this image describes.
As for the imagination, it must be remembered that everything imagined is not always imaginary. The poet (writer or painter) imagines descriptions of absolute thought—inspired and spontaneous. It would be ridiculous to pretend that that thought is some imaginary "entity" lacking any absolutely certain reality.

Cordially,
René Magritte.

30 Fig. 250 (page 135)
Letter (excerpt) from René Magritte to
Harry Torczyner, November 24, 1963

[illustration]
I thought of a house like this, worth the trouble drawing and painting?
Yours,
R.M.

31 Fig. 252 (page 136)
Letter (excerpt) from René Magritte to
Harry Torczyner, December 24, 1963

The new picture I'm thinking of entails (if need be) that I avoid dreaming and dreaming even while knowing that I'm dreaming. It's a question of what the world offers us and which we cannot overlook if we're aware:
[illustration]
These are houses of various sizes (as houses are), but this difference in size is not "unnoticed" here, and for that reason seems "odd."

32 Fig. 258 (page 138)
Letter (excerpt) from René Magritte to
E. L. T. Mesens, 1955

Today I summoned the strength of will to get my hair cut. I took advantage of the occasion to get a manicure from a girl who looked like a young duchess, since I still have *envies* (as they're called in Charleroi, and maybe in Paris too), those bits of skin that grow up around the nails and sometimes hurt. The young duchess took care of my "desires" for me.
I'm working on my new pictures to be sent to America, and I've begun a picture for the exhibit of contemporary art: the 50th anniversary show to be held at the Antwerp museum from 14 May to 12 June 1955.
"The nucleus" they say "will consist of *100 masterpieces* by Belgian and foreign artists who have participated in our previous exhibitions." In reading this passage, I now wonder if my contribution (3 pictures) will be in or outside the nucleus?
In any event, the picture in question that I'm working on is a budding masterpiece. Here's a sketch:
[illustration]
LA ROBE DU SOIR

33 Fig. 263 (page 140)
Letter (excerpt) from René Magritte to
Harry Torczyner, July 4, 1958

For your portrait, I've thought of a balloon, but a Montgolfier balloon would perhaps be more fitting, since I plan to dress you in a toga such as the dialecticians wore in the Golden Age.
H-hour will soon be upon us, and I hope to be in maximal condition to begin portraying you.
Does my drawing remind you of a syringe? [illustration] Yes, but a rubber syringe bulb. [illustration]
It's something that I find difficult and futile to show in a picture. There are lots of objects I can't paint, and the syringe has pride of place among them, along with a carburetor, electric wiring, lighters, cameras—still or cinema, etc. Certain words likewise I feel degrade those who pronounce them: the word *contact* for example (and to *fix someone up* as though he were some kind of automobile).

34 Fig. 264 (page 140)
Letter (excerpt) from René Magritte to
Harry Torczyner, July 1958

One idea for your portrait is this one: I'm putting it to the usual tests (confrontations with anticipated criticism) while I look for other ideas.
[illustration]

Yours,
René Magritte

35 Fig. 274 (page 145)
Letter (excerpt) with drawings from René
Magritte to Marcel Mariën, 1953

To end this letter on a lyric note, I inform you that having been commissioned by Nougé to solve the Piano problem, after the usual delays, I came up with the following:
Definitive solution
[illustration]
(ring and piano)
The first titles are:
The Root of Miracles (Nougé)
Revelations 1.
Light Projection (Colinet)
The Great Movements (N.)
If you can do better, it would be better.
I have attached the first research sketch.
I also attach photos of some recent pictures to give this letter more real and figurative weight.
I await your news....

Yours,
Mag.

36 Fig. 275–276 (page 145)
Letter (excerpts) with drawings from René
Magritte to Marcel Mariën, 1953

[illustration]
1st sketch
(the *croissant* exists in the solution as the reflection of a ring)
[illustration]
2nd state

37 Fig. 304 (page 153)
Descriptive note on ink and pencil drawing,
La traversée difficile (The Difficult
***Crossing),* not dated**

Three objects by a curtain looking at a ship in a storm from a stone balcony.

38 Fig. 335 (page 163)
Sketch for a painting-object, *Ceci est un*
morceau de fromage (This is a Piece of
***Cheese),* 1936**

[*These words are written upside down on the illustration*]
Under a glass cheese cover, I've put a little painting of a piece of Gruyère. The signature Magritte should only appear on this little canvas. Getting away from the "door" idea and toward the "lovely captive" idea, with "something else"....

39 Fig. 337 (page 163)
Gouache study for an ashtray, *La*
métamorphose de l'objet (Metamorphosis
***of the Object),* 1933**

[illustration]

Dear Lady Admirer,
Here's the bottom. If the person with ashtrays wants to put a border on it, he should simply put

equal concentric circles on a white border: [illustration] the same white as in the drawing. I hope it will please you as much as Cleopatra pleased Bonaparte. Until one of these days soon. Yours, M

40 Fig. 338 (page 164)
Letter from René Magritte to Marcel Mabille, May 21, 1966

21 May 1966

Dear Mabille,
 To add to your collection of my imagined objects, I suggest the following:
[illustration]
 It's a bowler hat on which a label has been glued. If you want this object, here's how to do it:
 1st, you buy a black bowler hat
 2nd, you have a label printed like the ones on old pharmacy flasks, and stick it on the hat:
Approximately this size:

EXTERNAL USE I'll sign the
Magritte label here

in gilt paper, black block letter and black border
 The object is called *The Fearsome Bottle Cap*. I think that one of the ways of "presenting" this object might be to get a kind of glass box—like a square aquarium. The hat would be set on a stand inside the box.

Until soon, yours,
René Magritte

41 Fig. 412 (page 191)
Letter from René Magritte to Louis Scutenaire and Irène Hamoir, 1948

Dear Irène,
 Be nice—it would be impossible for you to be nicer—and add to what I asked you
 Works in Belgian national collections, The Museum of Modern Art in New York, and the Musée de Grenoble (completing the list of exhibitions immediately before the title "Illustrations")
 and make up another page, with a copy, containing the following inscription:

The Galerie d'Art du Faubourg invites you to attend the vernissage of an exhibition of recent works by René Magritte to be held on Friday, May 7, 1948, at 4 PM.

Six spaces

Capitals: EXHIBITION FROM 7 TO 29 MAY 1948
 Thank you in advance for helping me out.
 Until soon and come well,

Mag.

42 Fig. 442 (page 201)
Letter (excerpt) from René Magritte to Harry Torczyner, February 2, 1959

The picture Goris saw in New Orleans? Would it be possible to get some information about this? I painted *two* versions of *L'art de la conversation*, one *80 x 60 cm*, which *still* belonged to M. Robiliard in Brussels as of last year, and one *50 x 60 (approximately)* which must be the one in

N.O.? How did it get there? I couldn't tell and I'd like to know. This version was shown at the Obelisco Gallery in Italy 5 or 6 years ago—I think I got it back and since its return I don't remember what might have happened to it. According to your document: rock + dream = "conversation." I suppose it really is this picture, *L'art de la conversation*? which was laid out as follows:

[*to the left of illustration*]
The second version, (or the first, if Robiliard has the second), date: 1950–1952.
[illustration]
[*to the right of illustration*]
Is this the first or the second? It's *certainly* possible Robiliard owns the one measuring 80 x 60.

 Your secretary, who is so fond of this sort of thing, will, at your perfidious instigation, have a good opportunity to satisfy her favorite vice: make a typo on the typewriter for the N.O. museum asking....

43 Fig. 449 (page 204)
Letter from René Magritte to Harry Torczyner, March 21, 1959

Brussels, March 21, 1959

Dear Friend,
 I'm going to work on blocking up the guilty window. Then it will be the stone in the air crowned with an old castle with a few trees around it, the view will be in eternal daylight, blue sky and clouds above a restless Northern sea. (How restless will be decided as work progresses.) For the balustrade, stones are obviously wrong: the stone is in the air. I'm even wondering if a balustrade is necessary? And if it mightn't clash with the stone in the sky?
 With balustrade: Without balustrade:
 [illustration] [illustration]
 It appears that without the balustrade, the waves of the sea are more visible, the stone more "in the air," and one has the sensation of seeing things from the beach, and not from the confines of an interior?—With the balustrade, things are a bit "closed in," they seem to be confined—whereas for this picture, the space shouldn't give the impression of being compressed. My exhibition at Iolas will soon be over. Do you think it made an "effect"?

Best wishes,
René Magritte

44 Fig. 453 (page 206)
Letter (excerpt) from René Magritte to Maurice Rapin, February 21, 1956

...thought several days ago of making the following combination:
[illustration]
[*to the right of illustration*]
(Everything is in stone [old stones] here, and I am calling it *Le bain de jouvence*)

45 Fig. 459 (page 208)
Letter (excerpt) from René Magritte to André Bosmans, April 21, 1962

...however there are better things to say, I believe.) Another picture I'm painting at the moment (I made a sketch of it in gouache a few years ago) has a story I'm fond of: While visiting Saint-Sulpice in Paris to look at a picture by Delacroix there, I saw a picture showing "Jehovah" on a cloud, with the Apostles on the ground below engaged in some religious performance. In the train on the way back to Brussels, I passed a railroad yard, and I thought that the "given" landscape could have Jehovah above it on his cloud.
[illustration]
 Scutenaire found an excellent title for the sketch of this idea: *Le rossignol* [French slang for an object that has been pawned]. *Afterward*, I asked the name of the painter of the picture I had seen in Paris. He is called *Signol*! And in painting the sketch of my picture with "Jehovah" over a railroad yard, I made a sketch of a yard near the Boulevard Lambermont, the *Josaphat* Station— (Rossignol, a valueless object, the bird of song, Jehovah, Josaphat, I find these coincidences highly remarkable. There's no question of "transmissions" of ordinary thoughts, as we usually call them. Thought is not "transmittable" like some object passed from hand to hand. It is...).

[*sideways on the page to the left of the illustration*]
Railroad yard. A train going by, Jehovah in the sky.

46 Fig. 460 (page 209)
Letter (excerpt) from René Magritte to Harry Torczyner, with pen sketch of *Le puits de vérité (The Well of Truth)*, January 13, 1962

A while ago I sent Suzi the design of a new picture (a pant leg and a shoe), asking her what she would call it.

The title has finally been found: *L'étalon* [*The Standard*] (in the sense of the immutable— almost—unity of measurement.

[illustration]

47 Fig. 477 (page 222)
Autobiographical statement by René Magritte, March 20, 1962

After having taken courses at the Académie des Beaux-Arts in 1916 and 1917, I tried with the means I possessed to find a way to paint pictures that would interest me (I was indifferent to the paintings said to "express feelings," and, on the other hand, painting restricted to purely formal pictorial effects didn't seem to me worth looking at), and I tried—with the help of Futurist, Cubist, and Dadaist theories—to paint in a way that would satisfy. That was a research period that lasted for nearly ten years, without reaching any

conclusion. About 1926, these various investigations were abandoned because of what I deem to have been the revelation of *what was to be painted: what was to be painted was what must be painted now, in 1962.* What must be painted is limited to a thought that can be described in painting. Given the fact that feelings and ideas have no visible appearance, this thought (which can be described by painting and therefore becomes visible) includes no idea and no feeling. It is like what the apparent world offers to our awareness—Yet this thought is not passive, like a mirror: it is highly ordered, it unites—in the order evocative of the world's mystery and of thought—figures from the apparent world: skies, characters, curtains, inscriptions, solids, etc.—It should be noted that this thought (which is worth describing in painting) does not "assemble" just anything, it doesn't "compose": it unites objects in such a way that visible objects evoke the mystery without which there would be nothing. As examples, a nocturnal landscape beneath a sunny sky and, on the other hand, a mountain shaped like a bird, both demonstrate that painting—as I conceive it—is not guided by formal researches, but involves thought, exclusively because of its lack of solution of the world's continuity and mystery.

René Magritte
March 20, 1962

48 Fig. 478 (page 223)
Letter from René Magritte to Volker Kahmen, November 25, 1964

November 25, 1964
Dear Sir,
 I am attaching the documentation you request. Unfortunately, I am unable to help you in finding other works, many are "out of print," but I hope you will have good luck in completing your documentation.
 Thank you for your concern and your birthday wishes. With time (nearly forty years of painting!)

many artistic concerns no longer seem to me worth worrying about. With da Vinci, the painter stopped being a servant, but as things have "turned out," modern painters have become slaves to their art: it is the painting (the piece of canvas covered with paint) they are interested in and devoted to.
 I am told I am *cut off* from this way of life. For me, painting is a means of describing a thought *that consists uniquely* of the visible the world offers. This thought is not specialized, it aspires only to see, or, better, to become the *world as it is.* There's no question of the imaginary, of fantasy, of the fantastic, of hope, despair, of avant-garde artistic activity, etc.
 This thought, which deserves to be described correctly, is different from the ordinary awareness of the world as an "object," one to be exploited in one way or another: by business, religion, war, politics, science, artistic activity, etc. (this latter does not exploit, but "deals with" the world in a particular way). This thought only emanates from inspiration: inspiration for me doesn't consist in dealing with a subject (for example, the death of Socrates), but *in knowing what must be painted,* so that the visible the world offers is united in such a way as to evoke the mystery of the visible and the invisible.
 The world as it is is inseparable from its mystery.

Cordially,
René Magritte

49 Fig. 479 (page 224)
Inscription on *La bonne nouvelle (Good News),* oil on canvas, 1930.

[*this inscription runs around the illustration, beginning midway on the left border*]
My poor friend, enchanted by so so much awareness of distressful things. Geert. I'm handing the pen on to you.

50 Fig. 489 (page 234)
Letter (excerpt) from René Magritte to Mirabelle Dors and Maurice Rapin, with pen sketch of *Les promenades d'Euclide (Euclidean Walks),* September 5, 1955

Les promenades d'Euclide, a new version of the picture *La condition humaine.* The landscape in *La condition humaine,* which was as anonymous as possible, has here been made "interesting" in itself, since a wide street extending to the horizon has the same shape and color as a tower placed in the foreground:

[illustration]

51 Fig. 494 (page 237)
Letter (excerpt) from René Magritte to Maurice Rapin with pen sketches of *L'ami intime (The Intimate Friend)* and *La légende dorée (The Golden Legend),* January 17, 1958

In my present vacuous state, it so happens I have had two ideas for pictures:
"L'ami intime"
[illustration]
LA LÉGENDE DORÉE
[illustration]
Loaves of bread in the air.
Nocturnal sky and landscape
seen through a window.

MAGRITTE/CHRONOLOGY

1898 René-François-Ghislain Magritte born November 21 in Lessines, in the Belgian province of Hainaut, the son of Léopold and Régina Magritte (née Bertinchamp)

1910 The Magrittes move to Châtelet (Hainaut), where René studies drawing

1912 Magritte's mother commits suicide by drowning in the River Sambre. René studies at the Lycée Athénée

1913 Magritte, his father, and his brothers Raymond and Paul settle in Charleroi. Magritte meets the thirteen-year-old Georgette Berger at a fair

1916-18 Magritte studies, intermittently, at the Académie Royale des Beaux-Arts in Brussels

1918 The Magritte family moves to Brussels. René works in Pierre Flouquet's studio and discovers Futurism

1920 First exhibition in Brussels at the Galerie Le Centre d'Art

1921 Military service

1922 Magritte marries Georgette Berger. Works as a designer in a wallpaper factory with the painter Victor Servranckx. Together they write *L'art pur: Défense de l'esthétique* (unpublished). Magritte discovers De Chirico's painting *Le chant d'amour (The Song of Love,* 1914*).* Magritte's paintings are influenced by Cubism, Futurism, and abstract art. He makes poster designs and advertising sketches

1926 Paints *Le jockey perdu (The Lost Jockey)* and receives a contract from the Galerie Le Centaure in Brussels. In one year, he paints sixty canvases

1927 First one-man exhibition at the Galerie Le Centaure is unfavorably received. Moves to Le Perreux-sur-Marne, near Paris. Plays an active role in the Parisian Surrealist circle and shows his work at Camille Goemans' gallery the following year

1929 Publishes "Les mots et les images" ("Words and Images") in *La Révolution Surréaliste.* Visits Dali in Cadaqués, Spain

1930 Magritte returns to Belgium and resides at 135 rue Esseghem in Jette-Brussels

1936 First one-man exhibition in the United States at the Julien Levy Gallery, New York

1937 Stays for three weeks in London at the home of Edward James

1938 First one-man show in London at the London Gallery. On December 10 Magritte delivers a lecture entitled "La Ligne de Vie" ("The Lifeline") in Antwerp

1940 Joins the exodus of Belgians following the German invasion of May 19. Spends three months in Carcassonne, France, before returning to Georgette in Brussels

1943-45 Attempts Surrealist paintings "in full sunlight," employing the technique of the Impressionists

1945 Joins and abandons the Communist Party

1948 Fauvist period Magritte calls "l'époque vache"

1952-53 Paints *Le domaine enchanté (The Enchanted Domain),* a series of eight panels later enlarged under his supervision for murals at the Casino Communal, Knokke-Le Zoute, Belgium

1954 Retrospective at the Palais des Beaux-Arts, Brussels. Writes "La pensée et les images" ("Thought and Images") for the catalogue

1956 Awarded the Guggenheim prize for Belgium

1957 Moves to 97 rue des Mimosas, Brussels-Schaerbeek. Paints *La fée ignorante (The Ignorant Fairy),* the design for a mural in the Palais des Beaux-Arts at Charleroi, later executed under his supervision

1960 Retrospective exhibitions at the Dallas Museum for Contemporary Arts and The Museum of Fine Arts, Houston. Luc de Heusch makes a film with and about Magritte entitled *La leçon des choses, ou Magritte,* premiered April 7, 1960

1961 Designs and supervises a mural for the Palais des Congrès, Brussels, entitled *Les barricades mystérieuses (The Mysterious Barricades).* Writes "Le rappel à l'ordre ("The Call to Order"), *Rhétorique,* no. 1, May 1961

1962 Writes "La leçon des choses" ("The Object Lesson"), *Rhétorique,* no. 4, January 1962. Exhibition at the Walker Art Center, Minneapolis

1964 Writes "Ma conception de l'art de peindre" ("My Conception of the Art of Painting"), *Rhétorique,* no. 11, May 1964. Exhibition at the Arkansas Art Center, Little Rock

1965 Retrospective at The Museum of Modern Art, New York. Georgette and René Magritte visit the United States for the first time

1966 René and Georgette Magritte visit Israel

1967 Exhibition at the Museum Boymans-van Beuningen in Rotterdam. Magritte dies on August 15. Exhibition at the Moderna Museet, Stockholm

1969 Retrospective exhibitions at The Tate Gallery, London; Kestner-Gesellschaft, Hanover; and Kunsthaus, Zurich

1971 Exhibition at the National Museum of Modern Art, Tokyo, which travels to the National Museum of Modern Art, Kyoto

1973 Retrospective loan exhibition at Marlborough Fine Art, London

1976 Exhibition at the Institute for the Arts, Rice University, Houston

1977 Exhibition, "René Magritte: Ideas and Images," Sidney Janis Gallery, New York. The eight panels constituting *Le domaine enchanté* (from the Casino Communal, Knokke-Le Zoute, Belgium) exhibited at Metropolitan Museum of Art, New York

1978 Retrospective exhibitions planned for Palais des Beaux-Arts, Brussels, and for Centre National d'Art et Culture Georges Pompidou, Paris

SELECTED BIBLIOGRAPHY

WRITINGS BY MAGRITTE

René Magritte was a prolific writer of manifestos, statements, articles, and personal letters, which dealt with his own artistic activities and also constituted a running account of his views on the general artistic, political, and social issues of his time. The following material has been consulted in the formulation of this volume.

Dors, Mirabelle, and Rapin, Maurice. *Quatre-vingts Lettres de René Magritte à Mirabelle Dors et Maurice Rapin.* Paris: CBE Presses, 1976

Magritte, René. Unpublished letters and statements from the personal archives of Georgette Magritte, Pierre Alechinsky, André Blavier, André Bosmans, Dominique de Menil and the Menil Foundation, Pierre Demarne, Mirabelle Dors and Maurice Rapin, Marcel Mariën, Irène Hamoir and Louis Scutenaire, André Souris, and Harry Torczyner

Mariën, Marcel (ed). *René Magritte: Manifestes et autres écrits.* Brussels: Les Lèvres Nues, 1972

Rapin, Maurice. "René Magritte," in *Aporismes.* Viry-Chatillon, France: S.E.D.I.E.P., 1970, pp. 20–36

BOOKS ABOUT MAGRITTE

Blavier, André. General bibliography up to 1965 in Waldberg, Patrick, *René Magritte.* Brussels: André de Rache, 1965, pp. 285–336

————. *Ceci n'est pas une pipe. Contribution furtive à l'étude d'un tableau de René Magritte.* Verviers, Belgium: Temps Mêlés (publication of the Fondation René Magritte), 1973

Bussy, Christian. *Anthologie du Surréalisme en Belgique.* France: Éditions Gallimard, 1972

Demarne, Pierre. "René Magritte," *Rhétorique,* no. 3, September 1961

Foucault, Michel. *Ceci n'est pas une pipe.* Montpellier, France: Fata Morgana, 1973

Gablik, Suzi. *Magritte.* Greenwich, Connecticut: New York Graphic Society, 1973

Hammacher, A. M. *Magritte.* New York: Harry N. Abrams, 1974

Larkin, David. *Magritte.* New York: Ballantine Books, 1972

Lebel, Robert. *Magritte, peintures.* Paris: Fernand Hazan, 1969

Mariën, Marcel. *René Magritte.* Brussels: Les Auteurs Associés, 1943

Michaux, Henri. *En rêvant à partir des peintures énigmatiques.* Montpellier, France: Fata Morgana, 1972

Noël, Bernard. *Magritte.* Paris: Flammarion, 1976

Nougé, Paul. *Renè Magritte, ou les images défendues.* Brussels: Les Auteurs Associés, 1943

Passeron, René. *René Magritte.* Paris: Filipacchi-Odégé, 1970

Robbe-Grillet, Alain. *René Magritte: La belle captive.* Brussels: Cosmos Textes, 1975

Robert-Jones, Philippe. *Magritte: Poète visible.* Brussels: Laconti, 1972

Schneede, Uwe M. *René Magritte: Leben und Werk.* Cologne: M. DuMont Schauberg, 1973

Scutenaire, Louis. *René Magritte.* Brussels: Éditions Librairie Sélection, 1947

————. *René Magritte* (Monographies de l'Art Belge). Brussels: Ministère de l'Éducation Nationale et de la Culture, 1964. First edition published by De Sikkel, Antwerp, 1948

————. *La Fidélité des images —René Magritte: Le cinématographe et la photographie.* Brussels: Service de la Propagande Artistique du Ministère de la Culture Française, 1976

————. *Avec Magritte.* Brussels: Lebeer-Hossman, 1977

Vovelle, José. *Le Surréalisme en Belgique.* Brussels: André de Rache, 1972, pp. 63–164

Waldberg, Patrick. *René Magritte.* Brussels: André de Rache, 1965

MAJOR EXHIBITION CATALOGUES (arranged chronologically)

Sidney Janis Gallery, New York. *Magritte: Words vs. Image.* March 1–20, 1954. 21 works

Palais des Beaux-Arts, Brussels. *René Magritte.* Brussels: Éditions de la Connaissance, 1954. May 7–June 1, 1954. 93 works

Dallas Museum for Contemporary Arts. *René Magritte in America.* December 8, 1960–January 8, 1961. In collaboration with The Museum of Fine Arts, Houston. 82 works

Obelisk Gallery, London. *Magritte: Paintings, Drawings, Gouaches.* September 28–October 27, 1961. 28 works

Alexandre Iolas Gallery, New York. *René Magritte: Paintings, Gouaches, Collages, 1960–1961–1962.* May 3–26, 1962. 23 works

Casino Communal, Knokke-Le Zoute, Belgium. *L'Oeuvre de René Magritte.* Brussels: Éditions de la Connaissance, 1962. July–August, 1962. 104 works

Walker Art Center, Minneapolis. *The Vision of René Magritte.* September 16–October 14, 1962. 92 works

Arkansas Art Center, Little Rock. *Magritte.* May 15–June 30, 1964. 97 works

The Museum of Modern Art, New York. *Magritte.* Introduction by James Thrall Soby. 1965. In collaboration with the Rose Art Museum (Brandeis University, Waltham, Massachusetts), The Art Institute of Chicago, the University Art Museum (University of California, Berkeley), and the Pasadena Art Museum. 82 works

Museum Boymans-van Beuningen, Rotterdam. *René Magritte.* August 4–September 24, 1967

Moderna Museet, Stockholm. *René Magritte: Le mystère de la vérité.* October 7–November 12, 1967

Byron Gallery, New York. *René Magritte.* November 19–December 21, 1968. 55 works

The Tate Gallery, London. *Magritte.* London: Arts Council of Great Britain. Introduction by David Sylvester. February 14–March 30, 1969. 101 works

Kestner-Gesellschaft, Hanover. *René Magritte.* 1969. 107 works

National Museum of Modern Art, Tokyo. *Rétrospective René Magritte.* Traveled to National Museum of Modern Art, Kyoto. 1971

Grand Palais, Paris. *Peintres de l'imaginaire: Symbolistes et surréalistes belges.* 1972. Included 46 works by Magritte

Marlborough Fine Art, London. *Magritte.* October–November, 1973. 87 works

Institute for the Arts, Rice University, Houston. *Secret Affinities: Words and Images by René Magritte.* October 1, 1976–January 2, 1977. 48 works

LIST OF ILLUSTRATIONS

Each of the 90 colorplates is indicated by an asterisk ().*

267

INDEX

Entries in roman refer to page numbers; entries in *italics* refer to plate numbers

PHOTOGRAPH CREDITS